Reflections in a
Silver Spoon

Reflections in a Silver Spoon

A MEMOIR

by

Paul Mellon

with John Baskett

William Morrow and Company, Inc.
New York

It is the policy of William Morrow and Company, Inc., and its imprints and affiliates, recognizing the importance of preserving what has been written, to print the books we publish on acid-free paper, and we exert our best efforts to that end.

Library of Congress Cataloging-in-Publication Data

Mellon, Paul.
 Reflections in a silver spoon : a memoir / Paul Mellon with John Baskett.
 p. cm.
 Includes bibliographical references and index.
 ISBN 0-688-09723-5
1. Mellon, Paul. 2. Art patrons—United States—Biography. 3. Philanthropists—United States—Biography. 4. Thoroughbred horse racing and breeding.
 I. Baskett, John. II. Title
N5220.M552 1992
709'.2—dc20 91-23560
[B] CIP

Printed in the United States of America

First Edition

1 2 3 4 5 6 7 8 9 10

BOOK DESIGN BY MICHAEL MENDELSOHN/M'N O PRODUCTION SERVICES, INC.

For Bunny
with love

Acknowledgments

————•————

This book is a joint endeavor by my old friend and adviser in matters of art John Baskett and myself. Most of it is "as told to," although some parts are written additions of my own. The book owes everything to John's sensitivity as writer as well as editor, his unerring sense of proportion, his deft command of the English language, and his ever-present sense of humor. Whenever the fire of my own interest and commitment to the book began to die down, he reignited it by his enthusiasm and good spirits. I shall always be grateful.

John and I have been fortunate in having expert guidance from our professional editor, Alan Williams. I would also especially like to thank my archivist, Eric Lindquist, who, aided by my secretary Janet Stewart, has researched most of the material concerning foundations, trusteeships, and work in connection with museums. Beverly Carter, who has been the curator of our collections for twenty-eight years, has an addiction to work and a passion for accuracy and thoroughness that have no equal. She has carefully guarded the textual material and sent old family photographs to Joseph Szaszfai, who has skillfully copied them for us. Duncan Robinson, Director of the Yale Center for British Art, has provided us with valuable information relating to the Center. Angus Stirling, Director General of the National Trust in England, Christopher White, Director of the Ashmolean Museum, Oxford, and Dudley Snelgrove, who assisted me for many years with my collection of

drawings, have helped with the history of The Paul Mellon Foundation for British Art and its successor, The Paul Mellon Centre for Studies in British Art. My friend Charles Ryskamp, Director of the Frick Collection, has given us information on the history of that collection. William McGuire has helped us with details of Bollingen Foundation. Ian and Emma Balding and Priscilla Hastings have kindly assisted over matters relating to my racing interests in England, and my secretary Martha Tross has provided essential information from our racing and breeding records over here. I thank Thomas Beddall for advice bearing on philanthropy, as well as Carroll Cavanagh, my principal assistant, who has acted in liaison with the publishers. Pamela Grundy, Beverly Carter, and Eric Lindquist have helped with proofreading. A select bibliography begins on page 433, and I wish to thank the authors of these works. During the course of writing, information provided in them has been freely drawn upon.

Finally, my thanks to my wife Bunny for her suggestions toward the improvement of the dust jacket, a bonus deriving from her well-known designer's eye for gardens and landscapes.

Contents

Appendices

Photographs

Between pages 174 and 175

My pony, Hotspur

Chauncey Hubbard

Fran Carmody

Chunky Hatfield

Father taking the oath on being appointed Ambassador to
Great Britain

Ailsa and Father at her house at Syosset *(Gallery Archives, National
Gallery of Art, Washington, D.C.)*

With Father at Clare College, Cambridge

Hon. Jock Leslie, Ethel Sewell, Anna Belle Sewell, Chunky Hatfield,
and Mrs. Sewell

Clare College and bridge

Father, then aged eighty-two

With my fellow directors of the Pittsburgh Coal Company

The sleigh ride to the Casino in Central Park

Mary with Forrest Dishman, Cathy, and Tim in a pony cart

Mary being painted by Gerald Brockhurst

Bollingen Series *(Howard Allen, Middleburg, Virginia)*

C. G. Jung

Harold Brooke, Ivor Anthony, Priscilla Hastings, Peter Hastings,
Cathy Mellon, and the Hon. Mrs. Aubrey Hastings

Dublin

With Bunny, having won a Piedmont point-to-point *(Thomas Neil Darling
Photo, courtesy of Howard Allen, Middleburg, Virginia)*

Jack Skinner and "Hold 'em" Jones at the Greensburg Hunt Races
(Thomas Neil Darling Photo, courtesy of Howard Allen, Middleburg, Virginia)

Raoul Millais' painting of me on Knight of the Galtees

Weighing in at a Blue Ridge point-to point *(Thomas Neil Darling Photo,
courtesy of Howard Allen, Middleburg, Virginia)*

H.R.H. Prince Charles on my horse Long Wharf *(The Press Association,
London)*

Jim Ryan

Ian Balding and John Hallum with Mill Reef

Elliott Burch with Arts and Letters *(Raymond Woolfe, Jr.)*

MacKenzie Miller

Jack Skinner

Martha Tross *(Howard Allen, Middleburg, Virginia)*

On Enough Rope *(Marshall Hawkins, courtesy of Joan Hawkins)*

Jackie Kennedy taking a spill *(Marshall Hawkins, courtesy of Joan Hawkins)*

Leading in Mill Reef with Geoff Lewis up after winning the Epsom Derby

Bunny and I accepting Arc de Triomphe trophies

Between pages 270 and 271

Mill Reef

On Christmas Goose, with Billy Wilbur on Mongogo *(Ira Haas)*

The Reverend William "Bill" Parker *(Marshall Hawkins, courtesy of Joan Hawkins)*

Jack Barrett

George Wyckoff

Jimmy Brady

Tom Fitzwilliam at Milton

Charles Halifax at Garrowby

Whit Griswold

At the Cavalry School, Fort Riley

My Army and OSS documentation

Valerie Churchill-Longman

En route for Omaha Beach

As a First Lieutenant, Fort Riley

Cathy receiving a presentation pen from President Truman

Tim, Stacy, Bunny, Cathy, and Eliza *(Thomas Neil Darling Photo, courtesy of Howard Allen, Middleburg, Virginia)*

My son, Tim, and Louise, his wife

Bunny on a holiday in Nassau

With Bunny and Eliza *(Toni Frissel Collection, Library of Congress)*

My daughter, Cathy *(Diana Walker/Time)*

With H.M. Queen Elizabeth II

Ian Balding, myself, H.M. The Queen Mother, and Bunny *(Jack Knight)*

Bunny and myself with Carter Brown *(Rex Stucky, photographer, Gallery Archives, National Gallery of Art, Washington, D.C.)*

Bunny with former President Reagan *(Dean Beasom, photographer, Gallery Archives, National Gallery of Art, Washington, D.C.)*

John Baskett

Basil Taylor

Duncan Robinson *(Michael Marsland, Yale University, Office of Public Affairs)*

Stoddard Stevens

John Walker *(Diana Walker/Time)*

With Carter Brown and I. M. Pei *(Diana Walker/Time)*

With Ted Pillsbury, Christopher White, and Malcolm Cormack *(Diana Walker/Time)*

The East Building, National Gallery of Art *(Bill Sumits, photographer, Gallery Archives, National Gallery of Art, Washington, D.C.)*

The Yale Center for British Art *(Tom Brown)*

The Science Center and the Arts Center, Choate Rosemary Hall *(Bartlett Brainard & Eacott)*

The hall at Oak Spring

The living room at Oak Spring

Front view of Oak Spring

The Brick House

Bunny with Patrick *(Fred R. Conrad/NYT Pictures)*

In the Gulfstream II *(Diana Walker/Time)*

Color Plates

*Reflections in a
Silver Spoon*

CHAPTER 1

Ulster Origins:
A View from the Top of
My Grandfather

———◆———

I must study politics and war, that my sons may have liberty
to study mathematics and philosophy. My sons ought to
study mathematics and philosophy, geography, natural his-
tory and naval architecture, navigation, commerce, and ag-
riculture, in order to give their children a right to study
painting, poetry, music, architecture, statuary, tapestry,
and porcelain.

—JOHN ADAMS,
in a letter to his wife in 1780

On a dismal October day in 1986 my airplane touched down at
Aldergrove Airport, near Belfast, Northern Ireland. A light driz-
zle was falling on the nearly deserted field. Some military air-
craft and one or two Land Rovers pointed to the only sign of
life and provided a dreary welcome to the unhappy province of
Ulster. I had flown over from London, on the spur of the mo-
ment, to follow the example of other members of the family and,
in my eightieth year, go and see the small farmhouse where my
grandfather had been born. I rented a car and, with two English
friends, set off in a westerly direction toward Omagh in County
Tyrone, some seventy miles away. We were driven by a young
man past the heavily fortified police station, away from Belfast
and into the green and unspoiled Ulster countryside. Everyday
life appeared to be continuing normally except for strident pro-
tests against the recent Anglo-Irish Agreement posted at the

entrances to several Protestant farmhouses and occasional graffiti in support of the IRA. An evident sign of tension arose when the car passed a patrol of young British soldiers in camouflage uniforms and carrying automatic rifles.

When we arrived at the Ulster-American Folk Park, at Camp Hill near Omagh, I was met, to my surprise, by a delegation headed by the Curator, Denis MacNeice, and received a warm welcome. It never was explained how they got to know of my unannounced visit, but news travels fast in Ulster, and it seemed that my name on the car rental form had provided the clue. Before being entertained at luncheon in the Mellon Country Inn, named for my ancestors, we were escorted to Camp Hill Cottage, the farmhouse where my grandfather spent his early childhood. The park was established on the initiative of my cousin Matthew T. Mellon (grandson of my father's brother James Ross Mellon), and the farmhouse is a small whitewashed stone cottage with a thatched roof. I lowered my head and went into the dark interior. The room on the right, where there was a blazing fire, contained eight children seated at a table. They were having a day off from school and were there to learn a little about their forebears. The girls were dressed in mobcaps and pinafores, and the boys in caps and dungarees. They had been baking oatcakes. On the far wall hung a print of Thomas Mellon made when he was in his seventies and, apart from the effect of shrinking gums from the loss of teeth, looking remarkably like me. The kindly schoolteacher was standing back from the table and asking the children questions. "And when was Mr. Thomas Mellon born?" she inquired.

A hand shot up. "Eighteen-thirteen, ma'am," the child offered in a strong Ulster brogue.

"Quite right," she replied, at which Mr. MacNeice had the satisfaction of adding, as he pointed toward me, "And here is his grandson."

Eight heads turned in unison. The grandfather born before the Battle of Waterloo, the grandson standing with them in the room.

You see, I am a third-generation descendant of a Presbyterian emigrant from Northern Ireland, for Grandfather left the Omagh farmhouse at the age of four, in 1817, and delayed by an illness of his father Andrew, embarked with his parents for the United States in the summer of the following year. They landed in Baltimore at Fell's Point on or about October 1, 1818. On arrival they rented a Conestoga wagon pulled by four heavy horses and used in those days for the transportation of goods and immigrants between the eastern seaports and the west. The family made their way from Baltimore to western Pennsylvania, an arduous journey of some three weeks, and there met up with young Thomas Mellon's grandfather Archibald, who had come out the previous year to find a farm and was himself following in the footsteps of other members of the family, already settled a decade earlier in Westmoreland County.

While flying on the return journey from Belfast to Heathrow, my thoughts continually reverted to my grandfather. Would he have seen me as an effete wastrel or as the sensible son of a sensible son? Would he have praised me for retaining a large portion of the family fortune that began with him, or would he have frowned on the extravagance of a private airplane that whisked me over the Atlantic in a few hours, when it had taken him almost four months to get from Ireland to Baltimore?

Grandfather, describing his early life in his memoir, *Thomas Mellon and His Times*, published privately in 1885, says that "not unfrequently in the summer time I would walk home from the city, eleven miles, between sundown and midnight, to be ready for work in the harvest field the next day." He goes on to relate:

> I was put to the plow in my twelfth year [this would have been in 1825], and could soon handle it with facility although with much effort and fatigue. . . . It was whilst thus engaged in plowing I read the most of Shakespeare's plays. They had come to me separately in pamphlet form among some books and papers sent by my uncle Thomas, and were in convenient shape to carry in the pocket to read whilst the horses rested or during the recess for dinner.
>
> I never took to Shakespeare, however, so warmly as to

Pope and Burns and Goldsmith, and the other English and Scotch poets. The fine sentiments of Shakespeare seemed to cost too much sifting among the quarrels of kings and vulgar intrigues of their flunkies, and the obsolete manners of a rude age.

He launched himself into the classics and "perfected myself in Murray's Latin Grammar, committing to memory the entire seventy-six rules of syntax, with the more important notes, so that I could repeat them from beginning to end without once referring to the book. I accomplished this by repeating the rules when following the plow; keeping the book in the crown of my hat, I resorted to it whilst the team was turning at the end of the furrow, until finally I mastered the whole so perfectly that I could dispense with the book altogether. And I found this thorough mastery of the rules of the greatest service throughout all my subsequent college course." He continues:

> It was about my fourteenth year, at a neighbor's house, when plowing a field we had taken on his farm for buckwheat, that I happened upon a dilapidated copy of the autobiography of Dr. [Benjamin] Franklin. It delighted me with a wider view of life and inspired me with a new ambition—turned my thoughts into new channels. I had not before imagined any other course of life superior to farming, but the reading of Franklin's life led me to question this view. . . . I regard the reading of Franklin's Autobiography as the turning point of my life. . . .
>
> My heart was becoming alienated from farm work. The more I read and the more I saw I was the more convinced that I might do better, and that in both mind and body I was better fitted for some other occupation or pursuit.

Grandfather knew that his father would not approve of such untoward thoughts, and he adds, "I did not for some time disclose my wishes to my father. I knew they would displease him, and I could expect no encouragement from him. He looked upon farming as the best, safest, most worthy and independent of all the occupations of men; and any one who forsook it for some-

thing else was regarded as led astray by folly and nonsense."

The crisis finally erupted when Grandfather's father was arranging to buy a farm for him:

> So the day was fixed for Peter [the seller] and my father to go to Greensburg to have the papers drawn and the bargain closed. They started about seven o'clock in the morning, and I went to my work as usual, cutting rail timber on top of the hill above our house. I remember the spot and its surroundings well, as it was the scene on that morning of an exceedingly violent mental agitation, the result of which changed the whole course of my subsequent life. I had worked on for an hour or so, more vigorously perhaps than usual on account of the excitement over my fate, which was to be sealed that day at Greensburg. From where I stood I could overlook the farm that I was to own when I became of age and it was paid for; and on which, if I should marry, I was to spend my lifetime making an honest, frugal living by hard labor, but little more.
>
> The die was cast, or so nearly so as to be almost past recall. All my air castles and bright fancies of acquiring knowledge and wealth or distinction were wrecked and ruined, and to be abandoned forever. Must this be? I suddenly realized the tremendous importance of the moment. The utter collapse of all my fond young hopes thus suddenly precipitated nearly crazed me. I could stand it no longer. I put on my coat, ran down past the house, flung the axe over the fence into the yard, and without stopping made the best possible time on foot for the town.
>
> My father had taken the only available saddle horse, but my feet were light under the circumstances. It was ten rather long miles over a hilly, rough and muddy road, in March. I noticed little by the way, for time was precious. The papers might be signed before I got there. As I gained the top of the hill above the town, I could see Peter and my father standing on Welty's corner on Main street, and soon joined them, so much exhausted that it was difficult to express myself sufficiently to allay their alarm, as they supposed something awful had happened at home.
>
> All I could say was that I had come to stop it, and it must be stopped so far as I was concerned. My father seemed bewildered at such determined self-assertion. Peter seemed

rather [more] amused than displeased. They had only had their horses put up after getting into town. They had not hastened as I had done, and were consulting what lawyer they should call on to prepare the deed. There was no discussion. My long walk and sudden appearance indicated such resolution as precluded argument.

My father, although disappointed, offered no rebuke or remonstrance, and I was rejoiced that I had arrived in time, feeling as if I had escaped a great pending calamity; and our good natured neighbor, the other party interested, was most jubilant of all, saying he owed me a present for getting him out of the scrape, as he had wished ever so much to rue [the] bargain but disliked to say so. After a comfortable dinner we all returned in good humor, Peter or my father walking sometimes to allow me to ride in view of my fatigue.

It is always at this point in my recollections that I feel closest to old Thomas Mellon because somehow, symbolically, I threw down an ax in 1941, a few months before the entrance of the United States into World War II. I resigned from the boards of directors of the Mellon Bank and several other smaller banks, the Gulf Oil Corporation, and the Pittsburgh Coal Company. Of course, I had *had* my education, and instead of running into town, I ran into the ironically liberating arms of the Army of the United States. As Thomas Mellon's thoughts and yearnings were never really attuned to farming, so mine were never attuned to business. By the time I reached my thirties Pittsburgh had long bored me. Even though we owned a fine large house and my wife and I had many friends there, my heart was always longing for the fields and woods of my farm in Virginia.

My grandfather grew up to be a humorless man of strong principle, an iron will, and keen ambition. He worked his way through the University of Western Pennsylvania (later the University of Pittsburgh) and went on to read law, becoming a specialist in estate litigation. Established in Pittsburgh, his practice presented him with investment opportunities when land and houses became subject to mortgage foreclosures. He was in due

course elected Judge of the Common Pleas Court in Allegheny County. From the period of his ten-year term of office, my grandfather was invariably known as Judge Mellon, and he continued to dress for the rest of his life in a long-tailed frock coat and white shirt with a high, stand-up starched collar.

In 1870, one month after he had retired from the bench, aged fifty-six, he used his accumulated funds to open a private bank, T. Mellon & Sons, with a view to creating a business for his children. The Bank acquired a good reputation under Grandfather's sound and conservative stewardship and managed to survive several crises, crises that saw weaker competitors go under.

Four of Grandfather's six sons survived into full adulthood, and two of them ultimately took over the Bank. Richard Beatty Mellon, my uncle, was an able, gregarious businessman, but my father, Andrew William, his shy, retiring brother, had a genius for investment banking that made him a legend in his own lifetime. It also made them, with Henry Ford and John D. Rockefeller, two of the four richest men in the United States as well as the wealthiest inhabitants of their native Pittsburgh.

My father had an astonishing flair for recognizing nascent industrial potentialities. He lent money through the Bank and took shares in a small group of concerns that, under skilled management, eventually grew into some of the leading American industries. These were spread over the fields of energy, manufacture, and commodities and included such famous names as Gulf Oil Corporation, Standard Steel Car Company, Koppers Company, Aluminum Company of America, McClintic-Marshall Construction Company, and Carborundum. He entered public life in his mid-sixties, becoming Secretary of the Treasury, a post he held for eleven years, from 1921 to 1932. He rounded off this second career with a stay of a little under one year as Ambassador to the Court of St. James's in 1932 and 1933, an appointment ending with FDR's new administration. Father lived very modestly and always maintained a low public profile,

with the result that few, beyond his immediate circle, had much idea of the strength of his industrial holdings or of his enormous wealth.

I have never felt that "being born with a silver spoon in my mouth" has been a handicap although, as the varied reflections in this book will show, it does not always guarantee happiness. This was particularly true in my childhood. Many of these reflections are bright and sunny, but others project images of doubt and melancholy, as though the silver had momentarily become dim and tarnished. There were many days when the spoon reflected sunlight, but just as often, dark clouds passed over, dulling the luster.

As I grew up, I chose to pursue a different path from my father. I quietly rebelled against his values, while retaining my respect for him as a man. I then went on slowly to discover my own destiny. I have tried, along the lines of Grandfather's reminiscences, to make notes and assemble my thoughts to form the basis for a factual account of my own life and times. I considered it a worthwhile exercise, since I have had a long and varied life, and I thought it might amuse my family and perhaps others.

My Parents'
Ill-Fated Marriage

Fe fi fo fum!
I smell the blood of an Englishman;
Be he alive or be he dead,
I'll grind his bones to make my bread.

—*Jack and the Beanstalk*

Within eighteen months of my parents' marriage, in 1900, my mother fell in love with an Englishman who would have described himself as a gentleman but who was, in fact, nothing more than a devious adventurer. To try to find out why this passionate attachment was formed quite so quickly, I think it might help if we were to consider how my ill-matched parents met and how they found their way to the altar.

In June 1898 my father, a bachelor of forty-three, was traveling from New York to London in the company of Mr. and Mrs. Henry Clay Frick on board the White Star liner *Germanic*. Father and Frick were by then old friends and long-standing business associates. The family connection dated from 1870, when Frick had, as a young man of twenty-one, successfully approached my grandfather Thomas Mellon at his bank for a loan to develop coke ovens. Frick subsequently built up a great fortune in the heavy industries of Pittsburgh.

Six years after Frick had become a client of the Mellon Bank in Pittsburgh, my grandfather introduced him to his twenty-one-year-old son, my father. Early on, when Frick's creditworthiness was being reviewed by the Bank, he was assessed as a

25

good risk, with the caution, however, that he "may be a little too enthusiastic about pictures, but not enough to hurt." Father and Frick soon formed a close and lasting friendship, and Frick managed to convey the pleasure he was getting from seeing and collecting paintings. From 1879 onward Frick had acquired the habit of taking Father with him on trips to Europe. They moved around the Continent in stagecoaches as well as by railway, and in the course of their travels they visited the leading art dealers and many of the great art galleries.

Mr. and Mrs. Alexander McMullen of Hertford, England, and Nora, their nineteen-year-old daughter, later to be my mother, were also traveling on the *Germanic*. They were returning to England by way of the Pacific and the United States from a world tour of the Mediterranean, India, China, and Japan. The Fricks were already acquainted with the McMullens and their daughter and introduced them to my father. The McMullens invited Father to visit them at Hertford Castle in the town of Hertford, just north of London, the family home they rented from the Marquess of Salisbury. Father went up to see them before leaving on his planned trip to the Continent with the Fricks.

Mr. and Mrs. McMullen were a dull, sober Victorian couple. Their income was derived from a brewery, which is still a family business, McMullen Ales, in Hertfordshire. Father, at the onset of middle age, was quiet, handsome, lean-faced with a mustache, a firm chin, and charming manners. As the Fricks had undoubtedly informed Mother's parents, he was also immensely rich.

Father was intrigued by the nineteen-year-old Nora's vivaciousness, and this dyed-in-the-wool bachelor was beginning to fall in love. Mother had eight lighthearted brothers, all older than she, and no sisters, so as the youngest member of the family, and scarcely more than a schoolgirl, she was always the center of attention and must have been a pampered pet. In fact, she knew only seven of her brothers because the eldest had vanished, presumably after differences with his father, and was never spoken of in the family again.

Perhaps it was this disproportionate division of brothers and

the sister, seven to one, that holds the key to Mother's psychological makeup. She was bound to have had a happy and carefree existence of teasing and banter with her brothers, which in later life might account for her quiet humor and a certain playfulness. On the other hand, it could be argued that having been brought up entirely with boys (and her older brothers must actually have been men) might have propelled her into a dreamworld where men in general were idealized and perhaps posed constant temptations.

Following his visit to the McMullens, Father set off for the Continent with the Fricks. On their return to England he again took the train to Hertford Castle for tea, in company with Mr. and Mrs. Frick. Presumably the Fricks were not ignorant of the attraction that prompted this second visit, and they must have approved it, knowing that there were plenty of young ladies in Pittsburgh who would have been only too happy to attach themselves to its richest citizen. Back home Father wrote to Mother and sent her some books. He also wrote to Mr. McMullen, informing him of his intention to visit England the following spring, the spring of 1899.

Father sent Mr. McMullen a copy of his father's memoirs. There Grandfather Mellon describes meeting his wife to be in her parents' parlor: "I see her now in the mind's eye, as she stood there in the sunlight which was struggling through the window curtains giving me a full view of her appearance— quiet, pleasant and self-possessed. I remember thinking to myself, in person she would do if all right otherwise."

Grandfather goes on in a similar vein to describe his courtship of my grandmother Sarah Jane Negley, whom he married in 1843:

> At my next weekly visit we met on closer terms and more cordial feelings; the wall of separation was removed and I applied to her mother for her consent, and received a ready and satisfactory answer to the effect that as we had agreed she knew of no objection. I then applied to my affianced to set the day, suggesting a week or ten days as sufficient interval. This she opposed with some surprise, and insisted

on six weeks. We finally compromised on a month, and accordingly the transaction was consummated on the 22d of August, 1843. . . . Her distant and independent attitude, so well maintained during our preliminary acquaintance, had made me sometimes fear a cold and unsympathetic disposition; but I found her nature quite the contrary, her feelings warm and abiding, but undemonstrative.

When I think about Grandfather's cold and cerebral attitude toward his marriage, it does not seem impossible to me that my father inherited a similar coolness or calculating attitude not only toward marriage but also in his relationships with other people, men and women, and later not only with his wife but with his children.

Alexander McMullen was perplexed to read of my grandfather's impersonal courtship of my grandmother, and he told his wife that he thought the Mellons must be a strange family. He replied to Father's letter, however, inviting him to join them the next spring in Switzerland and saying that they planned to return to England in May. In any event, Father arrived in England with the Fricks in June, but the winter's absence from Mother had done nothing to reduce his interest in her.

Father was one of eight children. There were six boys, of whom he was the fourth, and two girls. At this period in his life, three of the brothers had died: Selwyn as a child, George as a young man, and Father's eldest brother, Thomas, the year before. The two girls died in infancy. James was spending most of his time in Florida, and Father's younger brother, my uncle Dick, had married Jennie King of Pittsburgh three years earlier, when he was thirty-nine. As a result, Father's life at home, alone with his aging parents, had become increasingly gloomy. Perhaps it was partly on account of this loneliness that he was drawn to my mother, then still a young girl. He later said of her, "I had been strongly attracted to Miss McMullen at first acquaintance and this feeling had grown upon me."

Father visited the McMullen family at Hertford Castle during that summer of 1899, as he had promised, and then, after returning from his trip to France, he spent a few days at their

holiday place by the sea, Guisnes Court, at Tollshunt d'Arcy, Essex. Finally he wrote from London seeking another visit, and during it he made his proposal of marriage. Mother asked for time to think, but when he got back to the Carlton Hotel in Pall Mall, he received a letter from her dated Monday, August 28, 1899. It read:

Dear Mr Mellon,

I have been thinking long & earnestly about what you have said to me, & it pains me, more than I can tell you, to say that I have come to the conclusion that I do not love you enough to marry you. You know without my telling you, how much I honour & respect you & I thank you a hundred times for the honour you have done me in asking me to be your wife.

But it would be utterly unfair to you to ask you to wait at all, because even if you asked me again in time to come, there might be no change in my feelings & then you would be just as unhappy as you are now, whereas if you take my final answer now, you will get over this sad mistake you have made. For it *is* a mistake I am sure. You only know the best side of my character. I feel certain that if you ever got to know me well you would be terribly disappointed. I am simply telling you this because I sincerely think it.

If I had thought that we should be happy, it would be different, but it would be downright wicked of me to promise to marry you when I knew that I do not love you as you do me. You must see that it would mean nothing but unhappiness for us both.

She goes on to suggest politely that he might care to write to her from time to time and perhaps visit them in England in the future. For all that, the import of the letter was perfectly plain: he had been turned down. Father was understandably upset by this rejection. He met Mother a few days later, as she was passing through London, to say good-bye, and shortly before he was to sail, he sent her a present of a riding whip for her horse, Knapp. He must have indicated in his accompanying letter that he had not given up hope, for in her reply, addressed to

"A. W. Mellon, Esqre. Pittsburgh, U.S. America," thanking him for the whip, she says, "I do wish I could have made the voyage a happier one to you. Of course I cannot prevent your still hoping that I shall someday change, but I am afraid I cannot give you any encouragement, for at present I do not see any likelihood of my altering—you see I am rather young still and have never thought much about leaving home." They exchanged a few letters that winter, and when Father returned to England the following spring, 1900, he again visited Hertford Castle.

On his arrival Mother told him at once that she had decided after all to accept his proposal, and he later described the family as being "very cordial" toward him. I have no idea what drove Mother to change her mind so completely. There being eight children, the income from the brewery was likely to be greatly dissipated after her father's death, and perhaps Mr. McMullen, who was to die two years later, had some presentiment that there was not much time left for him and wished to see his daughter settled. Whatever the reason, the wedding date was fixed for September 12, 1900. Father returned home to Pittsburgh on May 12, leaving the bride's parents to make preparations for the wedding. For his part, he set about purchasing and furnishing a house, for up until this time, aged forty-five, he had been living with his parents. He bought 5052 Forbes Street, a drab red-brick Victorian house with stepped gables in East Liberty, a suburb of Pittsburgh. There was hardly a bush or a tree to be seen, and there was not even a wall to hide its naked ugliness from the passersby in the street. There is no record of whether Mother had any say about it.

Father returned to England on the American Line's *St. Paul* on August 15. Following the wedding at St. Andrew's Church in Hertford on September 12, there was a reception just a stone's throw away in the gardens of the castle. A special coach was chartered to bring guests out on the train from London. Rowing contests on the little river running through the garden and a tug-of-war were arranged between the brothers and the townsfolk. A band of the Royal Artillery provided music. The wedding photograph shows Father, immaculately dressed and taut with

wedding-day nerves, looking toward his bride while she gazes indifferently at the camera. He is sporting lily of the valley in his buttonhole, while she holds a voluminous bouquet of roses and jasmine from the garden. Presents included a silver tea service from the American Ambassador to Switzerland, silver fruit dishes from Mr. and Mrs. Andrew Carnegie, and an antique gold lacquer cabinet which Mr. McMullen had procured from a temple in Japan. The newlyweds spent their honeymoon in the town of Schwerin in Mecklenburg, where Mother had passed a winter at finishing school to improve her German. They then returned to England by way of Berlin and Paris.

The hour of truth arrived when they got back to Pittsburgh in late November and established themselves at the Forbes Street house. As I look back, I find it extraordinary how two people living together could be so completely unaware of each other's feelings, even taking into account the fact that in the very early days of marriage there is usually a mutual desire not to rock the boat. Father's account, wistfully written in his deposition to the court at the time of their divorce, speaks of marital bliss:

> We immediately became much occupied socially. My mother, Mr. and Mrs. Frick and several others gave receptions for us and for her. Later in the winter we settled down. I had before our arrival engaged a housekeeper, but Mrs. Mellon after a few months expressed her preference to manage the household affairs herself and the housekeeper was dispensed with. She did the marketing and managed everything beautifully. She had the English instincts of economy which appealed to my admiration but I made everything easy and smooth. She kept the accounts and paid the bills carefully. In the evening when not going out she would play or sing and sometimes read the papers to me. We were devoted to each other and it seemed to me to be a state of happiness seldom reached.

There is no firsthand account from Mother about this period, but she often told me how terribly uprooted and lonely she felt in those early days in Pittsburgh and how the drabness and dirt of the city appalled her. She was always resentful of the attitude

of Father's friends and family about life: their smugness, provincialism, and crude materialism. She came from the clean, quiet rural charm of the English countryside to Pittsburgh at the end of the last century, and what a transition it must have been! The belching flames of the steel mills and the coke ovens glowing in the deep Pittsburgh dusk must certainly have seemed a prelude to hell.

On June 28 of the following year, 1901, Mother gave birth to my sister Ailsa. Mother took a fancy to this unusual name, which is given to Ailsa Craig, a small island at the mouth of the Firth of Clyde. My parents left Pittsburgh in August with their baby to spend a month at Hertford Castle. After their return to Forbes Street, Father later reported on life as he saw it during that winter: " . . . everything continued lovely—we did not go out or entertain a great deal and I haven't much recollection of events during that period—however, our life was all that could be wished."

It is not difficult to imagine him returning to the house after spending long hours at the Bank, kissing his wife, and scanning the financial pages of the newspapers before having dinner in the gloomy dining room. The meals probably went uninterrupted by any conversation because his mind would still be preoccupied with business matters and Mother knew by then that he did not enjoy small talk. Any remarks she made were likely to be subjected to analysis and questions. I can picture my mother in that dark Victorian house on Forbes Street on a smoky winter's evening listening to the interminable talk about business that he used to carry on with Uncle Dick or with any other business associates he had with him. She was continually shocked, she used to tell me, by the gross materialism of their attitudes in the deals that they discussed. She said Father was irrationally moody about many things and had a maddening tendency to brush aside her suggestions and wishes, as though they were always childish and frivolous. God knows, many of them must have been childish and frivolous, but I can see how his attitude and his treatment must have hurt and discouraged her. It was always a case of "Oh, you don't really want that, do

you?'' or ''What makes you think that is a good idea?'' These discouraging replies, also made to Ailsa's and my own childish questions, are indelibly imprinted on my own mind.

Father received a cable in February 1902 from my grandmother Mrs. McMullen to say that her husband, who had been suffering from cancer for some time, was sinking fast and would Mother come at once. Father was unable to travel at that time on account of business, so Mother set off on her own, sailing aboard the *St. Paul* from New York. It was their first separation since their marriage. Mother's father died shortly after her arrival in Hertford, and she returned to the United States by steamer the following month, accompanied by her mother. Father was at the pier in New York to meet them. As he was talking to Mother, a fellow passenger came up to bid her good-bye. Mother introduced the stranger to Father as Mr. Alfred Curphey, and that marked the start of the trail that led to the divorce court ten years later. Eventually, after my father's death, I came into possession of the court papers relating to his divorce action, and I have taken care to base my account strictly on the detailed depositions made by him and by another witness named Long.

Curphey opened his amorous campaign without delay. Mother told Father that Curphey and a Mr. Scott of Philadelphia, an associate who had traveled over with him on the ship, were coming to Pittsburgh on business, and perhaps it would be nice to ask them to dinner. They came. Later that summer Father took Mother and Ailsa with him to England. Curphey reappeared there, and they all dined together once or twice and went to the theater. Father found nothing untoward in it. As he pointed out later, ''I regarded him then as a casual acquaintance along with many others.'' During their stay in England Father bought a pair of blue roan coach horses from Curphey as a present for Mother because she had admired them so much, and Curphey had them shipped to America. Father wrote rather sourly, ''We named one Curphey and the other Cope, the name of a friend of Curphey's. Cope was all right, but Curphey turned out to be of little account.''

The following spring Curphey turned up again in America

and was invited to a house party organized by Mother. He stayed on long after all the other guests had left. Father put this down to English country house custom, but he had been a little disturbed by what had appeared to him to have been the seemingly hypnotic influence that Curphey had exercised over Mother during a game of blindfold mind reading. Curphey now turned his attention to Father and told him that he and Scott were looking into the prospect of negotiating three hundred thousand dollars in bonds on a tract of several thousand acres of coal in Raleigh County, West Virginia, that he said they owned. After discussing this and other grandiose schemes, Curphey intimated that he needed fifteen to twenty thousand dollars in excess of what he had anticipated in order to arrange a mortgage on some real estate and that he needed eight thousand dollars at once. Father sent him a check for the eight thousand dollars and shortly afterward accepted Curphey's note for the balance, payable in two months. Before the two months were up, Curphey was already asking for the note to be extended, and Father was beginning to chide himself for his own foolishness. He still, however, entertained no suspicions whatsoever about Mother, despite the fact that during Curphey's stay in New York Mother had suddenly become very enthusiastic about accompanying Father on his trips there. Curphey visited them at their hotel and dined with them, and they all went to the theater together. It would seem that Mother derived a great part of her pleasure from the affair in sailing close to the wind.

In June 1903 Father booked passage for himself, Mother, Ailsa, and Ailsa's nurse, Miss Abernethy, for their annual holiday in England. They had planned to look for a place by the Thames in which to spend the summer. At the last moment Father found himself unable to go because a man from the New York Shipbuilding Company, with whom he was doing business, died suddenly in his presence from a stroke. Father was left to inform the man's family, make funeral arrangements, and finish the business, so his trunks were removed from the steamer, and the others sailed without him. He promised to follow later in the month.

Arriving in England, Mother told Curphey that she was alone and asked him to help her find an attractive Thamesside house to rent. The enterprising Curphey knew a solicitor who acted for a Mr. Devitt, the owner of a suitable house called Sandlea at Datchet, near Windsor. As they visited the house together, it may have crossed Mother's mind that living at Sandlea with Alfred Curphey might be a good deal more agreeable than living in Forbes Street with Father. The only awkward thing now was that she had to let Miss Abernethy in on her secret, but Miss Abernethy didn't seem to mind and promised to keep it. Ailsa was by now two years old. She was receiving curious impressions and must have been vaguely aware even at that tender age that her mother's behavior was not like that of other mothers.

Mother then received a nasty shock. Her brother Leonard wrote to her to say that a man who worked with him at the London Stock Exchange had told him with a snicker that he had seen her at Ranelagh House, a sporting club in Fulham, not with Father but with Curphey. Mother told Curphey, who promptly telephoned Uncle Leonard. There was a heated exchange during which Uncle Leonard told Curphey that he was no gentleman and Curphey replied that he was coming around to give him a good thrashing. He never appeared. In due course Father turned up in England and later commented:

> It was delightful at Datchet. We had many visitors including Mrs. Mellon's family and friends and acquaintances of hers and mine. The time was employed with excursions on the river, riding, driving, etc. Curphey was a frequent visitor and was most apologetic about the money he owed me, explaining how his proposed mortgage had failed him through a flaw in the title of the country property he was to mortgage, and how Scott had failed him, etc. . . .
>
> We went riding then almost daily in Windsor Park, mostly just Mrs. Mellon and myself, but frequently some of her brothers were with us and several times Mr. Curphey.

Curphey was thoroughly enjoying himself. One evening, when out punting on the river with some of the party and quite

drunk, he fell into the water dressed in his evening clothes. He had to be brought in by the others and put to bed. And so it continued. My parents returned to Pittsburgh, and Mother kept up a secret correspondence with Curphey. At this time she established a friendship with a woman called Marian McLean. During the winter of 1903 and the spring of 1904 she saw a great deal of Marian McLean, who probably agreed to act as her mail drop. In June 1904 Father, as had become his habit, booked passage for England, but just before they were due to set out, Mother, fired by the love letters and urged on by Marian McLean, blurted out to him that she wanted a divorce and that she wanted to go live with Curphey in England. Father was horrified and stunned, but he discussed the matter in his quiet voice and thought that he had won her around.

Mother realized that she had gone too far, but she insisted that Marian McLean accompany them on the English trip, and Father wasn't in any fit state to argue. Curphey was, of course, loitering in London; Father spotted him at another table in their hotel and then again in a train on the way from Datchet to London. Unable to contain himself any longer, he went to Curphey's office in Victoria and accused him of paying improper attention to his wife. Curphey stood up to face Father. He was a consummate actor, and Father noticed that tears had welled into his eyes. Father reported that he said:

> Mr. Mellon I know that I was wrong, but I cannot help it, I haven't the power to keep away from her, although I know it is all wrong. It is terrible to have such love under the circumstances—I would have chucked up everything and gone away, but my affairs are so tangled and in such shape financially that I cannot do it. I would leave now and go to South Africa if I could get the means to go. I feel how wrong it all is to you and what a cad you must think me to be after all your kindness to me, etc.

Father noted the implication that he might be able to buy Curphey off, extracting a promise from him that he wouldn't see Mother again and that a deal could be struck to their mutual

satisfaction. Not long afterward Marian McLean, who had been enjoying the position of go-between, told Father that Mother was in great distress about Curphey's financial position, particularly regarding his "ancestral home" on the Isle of Man. Father later discovered that Curphey was married and about to be divorced; the divorce would have led to claims on his property. Marian showed Father a printed notice of sale for Curphey's establishment, and he asked her to find out discreetly how much it would cost to redeem the property. The sum appeared reasonable to Father until he discovered that it was in pounds, not dollars (at that time the exchange rate was about five dollars to the pound). Mother offered her brewery shares to Father if he was prepared to advance the money, and he agreed to accept them. The upshot of it all was that Father added Mother's McMullen brewery shares to his portfolio and paid off Curphey's debts. Mother and Curphey bade each other a tearful farewell, and my parents sailed for home.

It really looked as if the whole episode were over. Father even went so far as to suggest perversely that it had perhaps done more good than harm. In the late summer of 1906 they rented Sunninghill Park near Windsor. There were house parties, and they seemed very happy. Curphey was safely out of reach at his home on the Isle of Man, thanks to Father's self-serving generosity. During the autumn of that year, after returning from England, Father borrowed his nephew's houseboat and organized a river party in Florida. The party comprised Mother and Father, one of Father's brothers, James Ross Mellon, the latter's son William Larimer Mellon (the owner of the houseboat), Norman and Murray McMullen (two of Mother's brothers), and Miss Downing, a nurse who had been looking after Mother following a recent illness. Mother's few letters to Father during the year 1906 refer to inconsequential matters, but they are affectionate in tone. He was painfully thin, so she always addressed him teasingly at this time as "Dear Fatty."

CHAPTER 3

Their Married Life

———◆———

Oh, what a tangled web we weave,
When first we practice to deceive!
 —Sir Walter Scott
 Marmion, Canto VI

I was born on June 11, 1907, and within six weeks of this date
the family was off to England and a return to Sunninghill Park.
It was a happy summer for Father. He had a son who, he hoped,
would one day shoulder the burden of his growing financial
empire, just as he and his brother Dick had taken over from my
grandfather. Mother had told him that she felt remorseful over
the matter of Curphey. Father now expected that he would be
able to concentrate on his beloved dealings at the Bank and that
Mother would settle down to look after Ailsa and me. They
might continue with their long summer holidays in England,
and these would compensate for the dark, smoky existence of
winters in Pittsburgh.

A curious thing happened at the end of my parents' six-
month stay in England. They found themselves one day with
the Dean of Windsor, and it came up in conversation that I had
not been baptized. The Dean, horrified that an infant had
crossed the Atlantic not having received baptism, offered to per-
form the ceremony himself in St. George's Chapel at Windsor
Castle. So, on December 22, 1907, I was baptized in the historic
surroundings of this famous building, scene of many royal bap-
tisms, weddings, and funerals, which houses the remains of the
kings of England and their consorts over hundreds of years. I
have always felt conscious of this singular privilege, as if the

ceremony somehow foreshadowed my later addiction to English life and English places.

The happy period leading up to and surrounding my infancy proved to be no more than an interlude. The second act of the drama was still to come and was to have an ugly climax that cast a blight over Ailsa's life and mine. In the summer of 1908, one year after my birth, Curphey was back. Exactly how he reappeared on the scene remains unexplained, but Marian McLean is thought to have had something to do with it. While they were staying at Park Close, near Windsor, the house Father had rented that year, Mother, by then aged twenty-eight, asked for a regular allowance. Father suggested ten thousand dollars per annum and gave her a check for five hundred pounds to start with. Mother later returned, saying that she needed further sums for an undisclosed "charitable purpose." Eventually Father was induced to increase the allowance to twenty-five thousand dollars per annum. There can be little doubt about who was the recipient of the "charity." Mother's attitude toward Father changed at this time. She seemed to be perpetually dissatisfied and full of complaints.

Father and Mother were scheduled to return by ship to the United States on September 17, 1908, with my grandmother McMullen, who expected to go back to England with Mother before Christmas. Shortly before leaving, however, Mother managed to slip away from Father for a brief period. She suggested that he close up the house, while she took us to my grandmother's house in Wimbledon. The idea was that she would then go on to London for a day or two to make a few social calls before our departure.

Meanwhile, Curphey had engaged the services of a man called Ernest Long. He bestowed on Long the title of Steward of his Estates. In reality he was to act for the next two years as a go-between. Curphey met up with Long at the Sports Club in London on September 14, and over a drink Curphey said, "Come along. I want to introduce you to Nora." They bowled off to Mother's suite at the Savoy Hotel, and in no time after their meeting, Mother and Ernest Long were addressing each

other by their Christian names. It isn't difficult to imagine these two engaging rascals ordering champagne for Mother and themselves, while my hoodwinked father was busy putting up the shutters at Park Close.

A few days later, on September 17, the morning of my parents' departure, Mother went to have breakfast with Curphey at his "gentleman's chambers," 5 Bury Street, St. James's. Mother had spent the night at Wimbledon and had brought Ailsa and me, together with our grandmother, up to town early so that we all could meet Father in preparation for catching the boat train to Southampton. Mother's wild dash to see Curphey must have provoked a lot of laughter over breakfast at Bury Street, reminding her of life at Hertford Castle with her brothers and contrasting itself sadly with Father's brooding face and the silence of dinners at Forbes Street.

After three months back in Pittsburgh, Mother returned to England on December 22, 1908, just one year after I was baptized. She sailed over with Grandmother on the *Lusitania*, leaving Ailsa and me in the care of a nurse at Forbes Street. She registered at the Berkeley Hotel, at that time located in Piccadilly just a few minutes' walk from Bury Street and much handier than the Savoy. Curphey had told Long to look out for a good riding horse for her so that they all could ride together in Hyde Park in the mornings. As Long later explained in his deposition, he had gone to some trouble to school a young mare, but although Mother was a good horsewoman, he decided that the mare was too "green" for her and had started to look for a replacement. He found himself walking along King Street at the bottom of Bury Street on Christmas Eve 1908, when he noticed a small horse harnessed to a hansom cab standing outside the Feathers, a pub situated on the site now occupied by Spink and Son, next door to Christie's auction rooms. Without further ado he persuaded the coachman to remove the horse from the traces so that he could try it out. The horse met with his approval, and he bought it on the spot for ten pounds in cash. The deal completed, he walked around to Curphey's apartment, where he found Curphey in the sitting room with Mother. Long told

them what had happened. They were delighted and decided to call the horse Tenner.

Those days from mid-December to mid-January were passed agreeably. Dressed in her riding habit, Mother would call at Bury Street about ten-thirty or eleven, and they went for a ride in the park, returning in time for luncheon. In the afternoon they might take in a matinée, after that tea at Bury Street, and then they often had dinner at a little restaurant called Dieudonne's, which was just around the corner in Ryder Street. Ernest Long was usually with them in public.

It had been arranged that two of Mother's sisters-in-law, my aunts Maud and Gee (wives respectively of Mother's brothers Percy and Leonard), would go back to the United States with her and take a holiday there at Father's expense. Mother had already let them in on her secret, so they decided to make up a party with Curphey and Long and sail together for America on January 17. They took the Hamburg-Amerika liner *Kaiserin Augusta Victoria*. Apart from Maud and Gee, her mysterious traveling companions were registered under the names of Herr E. Long and Herr C. Long.

Father was at the dock to meet Mother and her relatives when the ship berthed on January 25. My father's mother, Thomas Mellon's "self-possessed and undemonstrative" wife, Sarah, had died just a few days earlier, and he had wired Mother to break the news. He expected her to express sympathy for his loss when they first greeted each other, but her only concern appeared to be to get away from the dock as quickly as possible. She expressed a sudden and irresistible urge to see Ailsa and me, so Father was hurried off that same evening to Pittsburgh, an overnight train journey of some eight hours, leaving Maud and Gee at the Plaza Hotel in New York, with promises that Mother would return the following night. Curphey and Long stayed at another hotel for a couple of weeks and then took rooms in a house on West 68th Street. After this a routine established itself not dissimilar to the one at Bury Street. Curphey and Long had breakfast in their rooms, then, accompanied by Mother, Maud, and Gee, spent the mornings at the St. Nicholas

skating rink. Sometimes, in the afternoons, they went to a matinée.

Father arrived sometime later in New York with Ailsa and me, together with our nurse, and one evening he invited Maud and Gee, together with his friend Thomas Chadbourne and his wife, Grace, to dine with him and Mother at the Plaza. After dinner the ladies withdrew, and Mr. Chadbourne and Father smoked their cigars. They talked for a while, and time passed, but the ladies did not return. Finally Father was obliged to go off and look for them. As he started searching the building, they suddenly appeared, laughing like silly schoolgirls. Unknown to him, they had taken their coffee down in the Grill Room with Curphey and Long.

Intrigue continued with a visit to Niagara Falls by Mother, Maud, and Gee. Father had hoped to go along but was dissuaded by Mother, who knew, of course, that Curphey and Long would be waiting for her at the Iroquois Hotel in Buffalo. Curphey's and Long's final escapade was a fleeting visit to "Indian Country"— Pittsburgh itself, where Mother engaged in a last act of stage romance. One evening, as she and Father were being driven out to dinner in the car, she saw Curphey standing on the corner of the street. She took off a large rose that she was wearing and, putting her hand out the window, unseen by Father, dropped the flower onto the sidewalk at Curphey's feet. Curphey and Long returned to England on April 14, 1909, from New York on board the *Mauretania* under the names of Murphy and Song.

Five days earlier Father and Mother had been in New York to meet Uncle Leonard, who had come over to take Aunt Gee home. At that time Mother was busy preparing her bombshell, which she was to explode on Easter Sunday, April 15, 1909, the day after Curphey's departure. She piously told Father that she was going to church with Grace, and mentioned, almost as an afterthought, that Chadbourne would be coming by because he had something he wanted to discuss with Father. Chadbourne arrived. He was a pleasant, old-fashioned, if rather wordy, New York lawyer. He didn't act professionally for Father but was more by way of being a friend of the family. It took a great deal

of circumlocution before he could bring himself to the point. The point was that Mother had made an irreversible decision to seek a divorce. Father said, "It was a bolt out of a clear sky to me." Until that moment he had had his head as firmly thrust into the sand as any ostrich.

My uncle Dick, who was a gregarious extrovert compared with Father, wasn't in the least surprised and said to him, "You will find it is Curphey." Father was unable to accept Uncle Dick's blunt comment and told him that he had received a personal assurance from Mother that no other man was involved. For his part, Uncle Dick had probably long since formed the opinion that Mother was an inveterate liar but didn't wish to say anything further at this stage to add to my father's distress.

Normally Father would have listened carefully to anything Uncle Dick had to say to him. As I think back on it, the only close personal male relationship that Father ever had was with Uncle Dick. It appears to me that when my grandfather discovered that harsh treatment of his children wasn't fair, he eased up on my father and Uncle Dick, so that they became his favorites and the family representatives to whom he subsequently passed over the running of the Bank. They shared all the early interest in business, even to the point of having a joint investment account during most of their lives. I remember Uncle Dick as having a very dry sense of humor. He told me once that if ever he built another house, he'd have a chute running from the mail slot in the front door directly to the furnace. My aunt Jennie, Uncle Dick's wife, had a warm personality and was very outgoing. I'm sure she made it easy for Father to have access to Uncle Dick, and Uncle Dick was really the only person in whom Father felt he could confide.

It was some time before Father could assimilate what his lawyers were advising him to do. The three factors that had to be agreed on in a divorce suit were, according to the laws of Pennsylvania, first, the cause (i.e., adultery or desertion), second, the settlement, and last, provisions regarding access to and care of Ailsa and me. In any event, they seem to have been pursued in that order of importance. To start with, Judge James H. Reed,

of Knox & Reed, the Pittsburgh corporate lawyers, who had been engaged by Father to act for him, tried "friendly offices" in the presence of Thomas Chadbourne. They sat alone with my twenty-nine-year-old mother in the drawing room at Forbes Street, and Reed began with "Now I am nearly old enough to be your father, and I think I will talk to you in a fatherly way." He made no impression whatsoever, and after a while the kindly Chadbourne began walking up and down the room, muttering, rather unhelpfully, "This is a tragedy." Mother had already decided what she wanted. She wanted a quick and clean divorce (she had heard, incorrectly, as it turned out, that one could be obtained in Reno). She wanted sole custody of us, saying that Father didn't care for us and hardly knew us, although he would be welcome to come and visit us at any time. She wanted to go back and live in England, and she wanted a settlement that would allow her to live in the style to which she had grown accustomed. Provided these terms were met, she was prepared to be entirely reasonable. The lawyers departed chastened.

Father, for his part, was numbed, shocked, and angry. What had he done to deserve this? Furthermore, it had never crossed his mind until now that he might lose his children. Thirteen days had passed since Mother's announcement. Father went home to Pittsburgh, discovered that Miss Abernethy, our nurse, had been in league with Mother and dismissed her on the spot. The following night Mother arrived with Uncle Leonard and Aunt Gee for their long-planned visit. The house must have been filled with a dreadful atmosphere of tension. Mother came to see us and found Ailsa on the verge of hysterics because Memma (Miss Abernethy) had left. Father talked to seven-year-old Ailsa and, realizing how much the nurse meant to her, promised to get Miss Abernethy back at once. The next day they agreed that Mother, Aunt Gee, and the recently returned Miss Abernethy would take their meals with Ailsa and me in the nursery, while Father and Uncle Leonard ate downstairs. Uncle Leonard, who was not a very strong character, tried making sympathetic noises toward Father and was shouted at by Mother whenever she caught him doing it. Even Aunt Gee must have

found that any amusement she had been deriving from the situation had entirely vanished. She and Uncle Leonard whispered together about how soon they could decently leave. They departed after four days and hurried off to New York, where they caught a boat for England on May 5.

At this time Marian McLean, now married and called Mrs. Schultz, took it upon herself to call on Uncle Dick's wife. She knew that Aunt Jennie liked Mother and, after giving my aunt her version of the events, asked whether she would be prepared to contribute to a "war chest" to provide funds to gather evidence against Father. Her proposal was that Aunt Jennie lend Mother five thousand dollars. My aunt, although she was fond of Mother, sent Marian Schultz packing. Back at home, Mother was aware that Father's weak spot was fear of adverse publicity or, indeed, publicity of any sort. She had engaged the services of a lawyer called Paul Ache to act for her over the divorce. I never liked the aptly named Paul Ache; as a child I didn't like the sound of his name, and I didn't trust his rosy, round face. Whether it was at Ache's instigation or Mother's isn't clear, but a campaign was begun to frighten Father into giving in to her demands. Father was led to understand that a bottle of medicine taken from his bathroom cupboard contained substances that might lead people to suspect that he had a venereal disease, and there were suggestions that a witness might be found who would claim that he had procured an abortion for a young girl. Mother told him personally that if he did not come into line, she was going to make the town "ring with scandal." He asked her if she had no regard for us, to which she replied, "If the children suffered they would have to suffer."

All this was bluff, but it worked. Father was advised that Mother appeared to be totally reckless and determined to raise a public scandal to gain her ends. He was doubtlessly sincere in saying that it was as much for us as for himself that he wanted to avoid a scandal, but what grated more than anything was the thought of our associating with Curphey during that part of the year when we would be with Mother and, on a more mundane level, the thought of *his* money, paid over by way of mainte-

nance, ending up in that rogue's pocket. Until this moment he had observed a policy of masterly inactivity in the hope that, if he did nothing, Mother would change her mind, as she had done five years earlier. But now a settlement was drawn up for a legal separation. A trust fund of one hundred fifty thousand dollars was to provide income for our maintenance. Mother was to receive the interest from a further trust fund of six hundred thousand dollars, the principal passing to us on her death. Mother also benefited from the income of yet another trust fund of four hundred thousand dollars as long as she should not remarry, and a direct cash payment of two hundred fifty thousand dollars was made to her when she signed the deeds in July and August 1909. The total payment, made mostly in the form of securities, was therefore one million four hundred thousand dollars, a figure worth about twenty-five times as much today.

Although a substantial sum, it represented only the tip of the iceberg of Father's fortune. The newspapers estimated this to be in the region of one hundred million dollars at the time. The figure meant nothing. It was probably a grossly inaccurate guess, and since Father's securities were nearly all in stocks, their value rested entirely on their negotiability. Just the same, the sum total of his holdings was undoubtedly disproportionate to the amount of the settlement. Father, however, would have regarded his financial assets not as spendable wealth but rather as working capital for that small group of industries for which he was the godfather. He had no particular wish to spend cash or own property. Business was his life, and to him business was one enormous financial game of chess. He believed the settlement provided enough for Mother's needs, and it was fairly generous. To sell a lot of shares to provide more would to him have been like removing valuable pieces from his side of the chessboard. He needed them to continue the game. Finally, Father and Mother were to have custody of us on an alternating basis.

These were the terms of the separation, but Mother also wished to go to Europe to provide cause, after the required

three-year period, for a divorce on the basis of desertion. At Father's request she gave an oral undertaking to him that when we were with her, she would not bring us into contact with Curphey. As far as such arrangements can ever be fair, it does not seem to have been too unreasonable. Mother sailed for Europe on August 2, 1909, along with Ache and her friend Marian Schultz. She had told Ache that because several members of her family were spurning her, she did not wish to live in England but that her brother Alan, who worked for the Guinness brewery in Dublin, was coming over to stay with her in Paris. Father was to follow her to Paris shortly afterward, bringing with him Ailsa, Miss Abernethy, and me. The atmosphere at Forbes Street after Mother's departure must have resembled the grim silence after a prolonged bombardment.

Father sailed for Europe with his sad little party at the end of August. There was the untrustworthy nurse, whom Ailsa adored; poor Ailsa, then aged eight, needed someone to whom she could show her affections. There was I, aged two, who worshiped Ailsa, and there was Father, aged fifty-five, whose affections were much more difficult to predict. I do not know, and I doubt if anyone will ever know, why Father was so seemingly devoid of feeling and so tightly contained in his lifeless, hard shell. One always had the impression that deep in his psyche there was an unbounded sadness, a deep despair that it would have been death for him to realize or reveal. One saw it sometimes in the shadows of his eyes when he seemed to be far away or dreaming. I have a little snapshot of him, taken when he was a small boy of no more than twelve. He is barefoot and in old country clothes with a little, shabby flat-crowned hat. Even at that age his eyes were sad and his expression was lifeless. It is an impassive look that has been captured in both photographic and painted portraits made at different periods throughout his life.

We got to Paris, and Father discovered that Mother was about to take an apartment at 41 Avenue du Bois de Boulogne (renamed Avenue Foch after the First World War). It now appeared

that Uncle Alan was not able to come to Paris. Mother promised
to write a newsletter to Father each week about us. In London,
on his way home, Father learned via Uncle Leonard from Uncle
Alan that Curphey was off to South Africa on a hunting trip.
Father sent a private detective by the name of Taber to travel
on the same boat and to report Curphey's safe arrival there. The
report seemed satisfactory at the time, but it was overtaken a
few months later, in January 1910, by the news in an anonymous
letter from Paris that Curphey was back in the city and living at
41 Avenue du Bois de Boulogne. Father contacted Taber again
and asked him to investigate. Taber confirmed that this was
indeed the case. In the knowledge that we would be back with
him in eight weeks, Father didn't do anything.

One of my earliest recollections stems from this period in
Paris when I was two. I had a small crystal cup, and I carried it
in my hand into the kitchen, where I vaguely remember seeing
a man there with Mother, a large dark-haired man with a ruddy
face and a black mustache, who laughed loudly and chucked
me under the chin. Anyway, something happened in that
kitchen to break my cup; perhaps I dropped it on the floor. I
cried as though my heart would break and felt that the world
had come to an end. There are confused sounds in my memory
of someone laughing and perhaps the slamming of a door. It is
typical of a fragmented memory retained over the years from
early childhood.

In March 1910 Father sailed over and collected us. Then he
wrote *his* weekly letters to Mother until her turn to have us again
came around in mid-June. In the meantime, she had been mak-
ing arrangements for the summer. Toward the end of April
Mother and Curphey were in England, and they visited Vale
Farm, near Windsor, with Mr. Hunnybun, an estate agent. Vale
Farm was a rambling, romantic old house, and it was for rent.
Curphey, who addressed Mother only as "my dear" in Mr.
Hunnybun's presence, told him they would take it for a period
of not less than six months. He took Hunnybun to one side and
explained that inasmuch as he, Curphey, was presently an un-
discharged bankrupt, payment would have to be made through

solicitors, funded by an undisclosed name. Mr. Hunnybun checked with the solicitors and ascertained that everything was in order.

Mother sailed to New York in early June to take us back with her. Taber reported to Father that Curphey had seen her off at Liverpool docks. Curphey had had a falling-out with Ernest Long earlier in the year, and he had got his new associate, Captain Kirkbride, to travel with Mother on the ship. She arrived in Pittsburgh on June 11, 1910—my third birthday. The housekeeper had arranged a birthday lunch. Father came back from the Bank, and we sat around the table at Forbes Street, with my parents trying to maintain a festive spirit. Directly after lunch Father took Mother to one side and told her he had evidence that she had broken her promise to him that she would not allow Curphey to associate with us. She tried bluffing but finally repeated her assurance. He telephoned her the next day, when she had returned to New York, and said that her oral promise was no longer enough; he wanted it in writing. He also wanted to know where she was taking us. Mother said that she had written it down somewhere, that he would not understand if she tried to repeat it over the telephone. She promised she would call her lawyer, Ache, and let him know.

The next day Father spoke to Ache, who said that he had not been given the address, but that he had been assured by Mother that we would not be brought into contact with Curphey. Father thought he had to be satisfied with that, and on the evening of June 14, 1910, he set off from Forbes Street with Ailsa, Miss Jordan (another nurse), and me to catch the 7:22 P.M. train from East Liberty Station bound for New York, where he was going to pass us over to Mother's care. Just as Father was leaving the house, a messenger arrived bearing a cable. Father knew it was from his agent Taber, but he also knew that it was in code, and he couldn't very well stand on the doorstep in front of us and the nurse trying to fathom the dispatch. As soon as we all were seated together in the train, however, he got out his little code book and started to decipher the message.

I was too young, but Ailsa would have observed the expres-

sion of dismay and anger develop on his face as the message unfolded. It read: "Vale Farm a stronghold. Only old retainers of Curphey and Long there. . . . Curphey, [your] wife and children expected in two weeks from New York, you may not get children again easily." We know now that Taber had got a little carried away with the drama of the situation. For one thing, Long was already out of the picture, and for another, it is highly unlikely that Curphey relished the idea of having us join him and Mother at their country retreat on a permanent footing. The effect on Father, however, must have been electrifying. The sentence "You may not get children again easily" embedded itself in his mind, and from that moment on he completely lost confidence in Mother's intentions.

When we arrived in New York the following morning, June 15, instead of taking Ailsa and me to the *Oceanic,* as he had agreed, he left us with Miss Jordan at the Holland House and made his way to Mother's hotel. He was incensed that she should be double-crossing him, but he was not prepared to let her know that he had been spying on her. He told her, without giving any reason, that he was not going to let us go with her. When he asked her where she had intended taking us, she evaded the question by saying that she had not yet decided. They both became very angry and excited. Mother said she would not sail without us; Father said he would not let us go to some mysterious destination, although he knew about it only too well. It had come to the point where physical possession of Ailsa and me was everything. Father had us tucked away in the Holland House, and he returned there as quickly as possible.

Mother, however, was hot on his heels and arrived soon after he did, demanding to see us. Miss Jordan brought us into the room, and Ailsa and I stood there awkwardly, watching our silent and distraught parents. Mother was thinking rapidly. There was no way she could grab us now and run for the boat. On the other hand, it was almost certain that Father would take us home. She could either sail away without us or go back to Pittsburgh. Furious that her plans about Vale Farm had been foiled, she decided that she would return to Pittsburgh, but not

just to live in a hotel. No, she would return to Forbes Street and make life unbearable for Father.

Five days after his return with us from New York, Father filed his Libel in Divorce citing Mother's adultery as the cause. He had abandoned the idea of a legal separation, leading after three years to a divorce action based on desertion. The change was effectively a declaration of war because at that time to be divorced for adultery was almost unheard of. It not only meant social ostracism and disgrace but was also an indictable offense. For this last reason the state of Pennsylvania had, since 1815, allowed such cases to be tried before a jury, should either party wish it. It was a curious and, as things turned out, ill-advised decision on Father's part. His lawyers and agents were gathering a mass of evidence that, added together, painted a pretty dark picture, but all this evidence was circumstantial. No witness could be produced who would swear to having found Mother and Curphey in *flagrante delicto*, and they had always been careful to register occupancy in separate rooms, even in Paris. It is unlikely that Father was acting out of spite; he was not that sort of man. The most plausible explanation for his action is that he was frightened of our being kidnapped by Mother and that a divorce on the basis of adultery with its concomitant court orders relating to children could be obtained much more quickly than the extenuated process of a separation, followed by a divorce on the grounds of desertion.

Some two weeks had passed when Mother arrived in Pittsburgh. Father finally accepted the idea of her living with us at the house on Forbes Street, where he felt he could keep an eye on her, but he himself decamped to the University Club. It wasn't very satisfactory, but it was, after all, only for two months, and then on September 1 he would have us back for his period of custody. The most disturbing aspect for Father was that he felt Mother was slowly turning Ailsa and me against him. It was difficult for him to be certain of this, but on his morning and evening visits to Forbes Street, when going to and returning from the office, he had the impression that Ailsa in particular was growing colder toward him. Father remembered

her calling him "a wicked man" on that evening a year earlier when he had dismissed Miss Abernethy, and he suspected that Mother might still be poisoning our minds. Whenever he called at Forbes Street now, Mother invariably stood in the room while he was talking to us and intervened with scathing remarks. Father suffered these insults in the knowledge, as he understood it, that with the arrival of September 1 she would pack her bags and depart.

The appointed day arrived, and no such thing happened. Mother stayed put and a few days later refused to let Father see Ailsa when he called at the house. Father became obsessed with his fear that Ailsa and I might be kidnapped, so in order to be forewarned of any attempt, he installed four "watchmen" at Forbes Street, together with a lot of primitive listening devices. Mother countered by hiring her own men, with the result that Forbes Street was bristling with "watchmen," and everyone in Pittsburgh began to talk. This was particularly embarrassing for Ailsa, now ten, who was asked questions at school about what was going on. Of course, she didn't know what was going on, and that made it worse. Father's visits to Forbes Street were becoming unbearable. Not only was Mother extremely aggressive, but her "watchmen" were rude and offensive. On one occasion Father had to order one of them, a tough ex-policeman, out of the house.

Father's next move then was to file an application to the Orphan's Court to have us made wards of court under a guardian. The application was approved in December 1910, and Fräulein Bertha Meyer was appointed to the guardianship of Ailsa and me with the direction of the Court that she should live with us at Forbes Street. At the time Mother and Father had equal rights to see us, but this arrangement, even with Fräulein Meyer's presence, was clearly ineffective. Because Father couldn't tolerate Mother's abrasive influence, he put in another application within eight weeks that we should be removed from Forbes Street with our guardian and placed in a rented house.

CHAPTER 4

Their Divorce

——◆——

When the Himalayan peasant meets the he-bear in his pride,
He shouts to scare the monster, who will often turn aside,
But the she-bear thus accosted rends the peasant tooth and nail.
For the female of the species is more deadly than the male.

—Rudyard Kipling
"The Female of the Species"

In June 1911 Ailsa and I left Forbes Street with Fräulein Meyer, our toys, and other belongings and moved to a house in Sewickley Heights known as the Richard Quay residence. The house was rented only for the summer, and in October we were on the move again, this time to the William Abbott house on Morewood Avenue in East Liberty. Father and Mother were permitted to be with us on alternate weeks. I remember the Abbott house as a bare yellow-brick building close to the street, ugly, gloomy, and unhomelike. I was continuously nervous and sick all during that year and felt lonely and uprooted. I would have days of nausea and weakness. It was always called stomach-ache, and I would be put to bed. They would make me take citrate of magnesia, which I loathed, and milk of magnesia, which I loathed even more. If I had a headache, they would put me to bed in a dark room with a handkerchief dampened with eau de cologne around my head. Fräulein Meyer was a kindly woman, and cheerful, and I am sure she meant well, but there was something too kind, too friendly, and overly sentimental about her. I was naturally shy, and her impetuous gushing of pseudolove always disturbed and nauseated me. I remember her teaching me to sing "Ach, du lieber Augustin" and how I was

fascinated by the rhythm and the tune, but I couldn't understand and was somehow embarrassed by the words. It was she, too, who gave me one of those little monkey sets—"See no evil; hear no evil; speak no evil"—and I never liked the look of those monkeys. I didn't know what evil meant, and it worried me. In fact, there was something a little grotesque and ugly about Fräulein Meyer, about her appearance and about everything she said and did: her voice, her guttural German accent, her gray, stringy hair, and her overexcitement and enthusiasm about everything. Ailsa and I were both emotionally upset and confused, and Fräulein Meyer's efforts did not stand much of a chance.

Happily there were some lighter moments. I recall the Christmas of 1911, when there was a large tree in the front hall of the Abbott house (it was the first one that at the age of four I was really conscious of, perhaps the first I had ever seen), and I remember how fascinating all the objects suspended on it were to me: fairy sailboats, silver horns that really blew, angels with harps, icicles, snowballs, and golden stars. I think we still had real candles on the tree in those days instead of electric lights. I remember the blare and deep boom-boom of a German band with the players standing out in the street in their blue uniforms with silver buttons and their shiny brass instruments. They used to play on Sundays and at Christmas, standing in a circle in front of house after house on each street. I would take out a quarter and shyly give it to the leader.

Most of the time, however, I was left to play alone. I would pedal around the yard behind the house in my toy car, trying to have fun and imagining exciting things, but I was bored. Ailsa played with me occasionally, but she was going to school, and I didn't see her very much. She brought other girls home with her, but I was too shy and too small to play with them. They played hide-and-seek or charades or jumped down the stairway onto a pile of cushions. I liked Craigie McKay. She was very pretty, and I was used to seeing her. I always played with them if Ailsa brought Craigie home with her, but if anyone who was at all strange to me came, like her sister, Alberta McKay, I ran and hid in my room.

Ailsa and I had been witnesses to much unpleasantness at Forbes Street during my father's visits. The visits had lasted from the time of Mother's return to Forbes Street in June 1910 until my departure with Ailsa and Fräulein Meyer for the rented house in Sewickley Heights a year later. Mother had nearly always been in the room when Father was there with us and invariably made belittling remarks about him. It was only natural that Ailsa and I should wonder whether our father might not in some way be responsible for our present unhappiness. I remember a scene that occurred during this period. One morning, as Father was putting on his coat to go to town, he said or did something that irritated me. Perhaps it was nothing that he said or did really, but an unconscious, inner irritation in myself that had to find expression. He had recently injured his knee in a bad fall on some stairs, and with the startling suddenness with which only a child can act, I banged him on the knee with a stick I was carrying in my hand. I really hit him as hard as I could. I will never forget the expression of surprise and rage and pain that came over his face and the way he doubled over. He got very angry. I was roundly scolded and made to apologize, but I didn't know what I had done, and I didn't know why I had done it. I felt terribly sorry for him afterward.

Uncomprehending of what was happening to us, Father and Mother were overwrought and obsessed with their own problems. They each had a nagging worry that they could lose us. Beyond that they had been engaged in a battle involving Father's good name and Mother's virtue, and as long as adultery remained the stated cause for their divorce, it looked as if one or the other would have to suffer, and Ailsa and I as well. Mother was determined that it should not be herself.

Over the winter of 1910–11 Father, with his counsel, Judge Reed, had conceived the idea that he could use his undoubted political influence as a financial angel to the Republican party to get the divorce laws changed, so that the hearing of his case could be in private. By such a change, Father thought, his children would be protected from malicious gossip, Mother might

be spared the ensuing damage to her reputation, and he would avoid the publicity he so dreaded. Of course, he did not divulge these thoughts to Mother, and the truth is that if he had, it is unlikely that she would have listened. In April 1911 Father's political friends successfully got an amendment to the divorce law through the Pennsylvania legislature. It was voted without opposition. Mother, meanwhile, had already demanded a jury trial. She resolved that if Father wanted such a trial, she would see to it that his name would become a household word, synonymous with evil.

The main features of the new legislation were that (1) trial by jury became a matter in the discretion of the court, (2) trial by jury was forbidden when it "could not be had without prejudice to public morals," and (3) the court acquired the power to appoint a special master to take testimony of witnesses in the state of Pennsylvania, in other states, and in foreign countries and to render, with his report of the proceedings, an opinion of the case. The revised legislation was to apply to any cases pending. It was tailored to Father's requirements.

Suspecting that she might be denied her jury trial, Mother countered with a decision to make the public at large her jury. Suspecting, too, that Father could block her statements to the local press, she gave her version of the story for publication to a popular newspaper in Philadelphia. She bought large numbers of copies when the articles were published and made them available through a mailing and distribution agency to the inhabitants of Pittsburgh. Everyone from the mayor to the butcher could read Mother's account of how things stood. Her prepared statement, accompanied by photographs she had provided of herself and us, of Father, and even of Alfred Curphey, featured over three consecutive issues in May 1911 of the Philadelphia *North American* as front-page news. It read:

> The mothers of this state must realize that if they permit
> me to battle alone and unsupported against the combined
> money making and law-making powers of the state for pos-

session of my children, they will suffer with me. When they realize that ask me not what they can do. They know best then how they can fight, not with the mere courage of a man fighting for self-preservation, but with the joyous sacrifice of a mother fighting for the preservation of the child she has borne.

That is my fight now, and it is the fight of every mother in Pennsylvania, who by my fate may know if her motherhood hereafter shall be at the mercy of gold and politics. . . .

I am all alone in this country with my two children, my two babies. Were my sins as enormous and self-evident as my accusing husband claims, would the laws as they have been here for a hundred years not have been sufficient for my case? Is it fair, is it honorable, six months after suit has been instituted against me, to adjust the laws to fit my particular case? Is that justice? Is it honorable to go to such extremes against one lone mother?

And what have I done to bring all the powers of the Commonwealth against me? My sin is only that I have failed to realize the dream of a foolish young girl. At 20 I thought I should come here as the mistress and good angel of a wealthy and powerful husband's vast estate. I had the robust health of a girl who had spent her life out in the country, and the man of many millions and thousands upon thousands of servants suffered from a weak family constitution. He pleaded for my health for his children, for the heirs of his great fortune.

Was it foolish of me to accept with pride the call to give new life to a family of great wealth and power? I saw myself in the role of the mistress of the manor who lightens the burden of the peasant. I imagined myself as a link between the old and the new world. . . . All idle dreams.

But I was only 20 then, and I married into my dream, and so we came over here and he named a town after me, Donora. [Donora, a former company town about twenty miles outside Pittsburgh, received its name from the president of the Union Steel Company, a business associate of my father's called Donner, linked together with my mother's first name.] I was at last in my station as the human partner of my husband in his great financial empire. And I loved him, too; I admired him and looked up to him as a great man, a master mind.

My first great disillusion came when I learned that his people were not of his people at all. I had dreamed of another Hertfordshire, with Hertfordshire lads and lasses; I had arrived in a strange land with strange people. . . . They are foreigns [sic], Huns and Slavs and such as that, and you can't do anything with them. . . .

Then my baby boy was born, as fine a baby as any mother ever was blessed with. But my joy was saddened by the dread of the thought that this baby was to grow up to stand all alone as the master, not of a loyal set of workmen, devoted tenants and affectionate servants, with an intelligent appreciation of the master's trials, but as the master of an unreasoning hoarde [sic] of wage slaves. . . .

I took my baby boy to Hertfordshire. I wanted to nurse to life in him my own love for the green fields and for the open sky. I wanted him away from the gray-smoke and dust-filled air of my husband's gold and grim estate. . . .

Nights that I spent in my baby boy's bedroom, nursing these thoughts for his future, my husband, locked in his study, nursed his dollars, millions of dollars, maddening dollars, nursed larger and bigger at the cost of priceless sleep. . . .

In that way, each attracted by the pole of his own magnet, we drifted apart. . . .

It crept over me that perhaps I, too, a foreigner like his Huns and Slavs, had been weighed coldly, dispassionately on the scales of demand and supply, and as a wife ranked merely as a commodity in the great plans of this master financier's lifework. The babies were there; even the male heir was there. Was the wife to be laid off like other hired help when the steel mills shut down? . . .

He sought a divorce not on the grounds he had agreed to, but on absurd grounds of infidelity. He has followed charges with charges, attacks in the common pleas court with attacks in the orphans' court, and tried every means and artifice to get my babies away from me. . . .

But now they have changed the laws so that a jury may not hear my case. They have abrogated my right to a jury trial. Gold fighting against one lone woman is unscrupulous in its methods. Gold may crush me. Gold and politics may take my babies from me.

But if they do, it will be because the manhood of Pennsylvania has sunken so low that it is willing to surrender

the motherhood of the state to the pillage of gold and politics. I don't believe it. That's not American, and I don't believe it is Pennsylvanian.

In fact, Mother's manifesto, stripped of its overblown, ethnically offensive, and emotional rhetoric, was a very subtle and well-thought-out document, which could have been the envy of any minister of propaganda. During the last years of the nineteenth century and the early years of this century, Pittsburgh had witnessed a tremendous influx of immigrants from Central and Eastern Europe. Many were peasants of Croat and Polish origin who had left agricultural servitude to work in the coal mines and steel mills of Pennsylvania. They were coarse, simple people who spoke little or no English, and the native Pittsburghers looked down on them. The native residents, on the other hand, were comprised of early settlers from England and Ireland (mostly of Protestant stock), together with second- or third-generation Pennsylvania "Dutch" or rather "Deutsch," each category by that time united by language, religion, and general outlook. Mother appealed to these people: churchmen, city elders, and women prominent in the leagues. She appealed to their prejudices, their smug self-satisfaction, and their sensibilities toward a lady in distress. In a period when the dissemination of falsehood had not received the careful study to which it was later subjected, she was able to speak of having taken us back to the green fields of Hertfordshire and refer to her babies, one of whom was ten years old, and scoff at the "absurd" suggestion of her infidelity. The truth clearly didn't matter; the effect was all important.

The publicity campaign produced results. Bishop Cortlandt Whitehead of the Pittsburgh diocese of the Episcopal Church issued a statement deploring the amendments in the new divorce bill, with its loss of rights to jury trial. He claimed the legislation posed dangers to the marriage relationship on account of the establishment of private proceedings for the dissolution of marriage. Mrs. Schoff, the president of the National Congress of Mothers, described the amendments as "outrageous"; Mrs.

Mumford, the president of the Federation of Women's Clubs, thought they were "iniquitous"; and Mrs. Stevenson, the vice president of the South Side Women's Club, considered them "deplorable." Father was pilloried by the Philadelphia newspaper. In answer to a reporter's persistent questioning he could only reply in desperation, "What right have you to come here and ask me such questions about my private affairs? What business is it of yours, tell me that?" It seems a pity that he did not make his own statement to the effect that he had promoted the bill to protect his children, his wife, and himself from harmful publicity over a purely domestic issue that had caused his family enough unhappiness already. However, even if this had crossed his mind, considering Mother's unpredictability and the attitude of the press, it would have betrayed a certain naiveté on his part. Father was unable to silence all the Pittsburgh papers, although their comment was not directed at him personally. The *Pittsburgh Leader* used opposition to the bill as a platform on which to attack the state legislature and in particular the Speaker of the House of Representatives. Even in faraway England someone managed to ask a question in the House of Commons about this reported ill-treatment of an Englishwoman abroad. All this activity helped promote a feeling of uneasiness about the legislation. The reference to a special master seemed to have a very undemocratic ring about it, sounding more like the Star Chamber.

In June two new/old faces appeared in Pittsburgh. Alfred Curphey and Captain Kirkbride were there, ostensibly to help Mother with her defense. It was even rumored that Curphey had tried to see Father, perhaps with a view to suggesting another "settlement." Father's lawyers, when they heard of their presence, immediately had subpoenas served on both Curphey and Kirkbride. The pair promptly left for New York, where they were arrested. The Governor of Pennsylvania delivered a request for extradition to the Governor of New York, describing Curphey's and Kirkbride's offense as "contempt with intent to obstruct public justice." The two ex-Army officers, veterans of the Boer War, were highly indignant at the treatment they were receiving. The Governor of New York signed the extradition

order only to discover that they had jumped bail and boarded a ship bound for South Africa.

The legal machinery moved slowly, and on September 6, 1911, Mother's petition for a more specific bill of particulars came in oral argument before three judges. Her lawyers asked that Father's lawyers enumerate specific acts of adultery, stating the days, times, and locations of when and where they had taken place. Father hoped that it would be enough to name the corespondent and provide a general background on where misconduct had occurred. It became clear that Mother was going to fight him every inch of the way. Two months later, on November 11, the constitutional validity of the new divorce law was challenged on Mother's behalf before Judge Evans in the Court of Common Pleas. The Judge ruled that the law was retroactive and therefore applicable to this case. In the discretion, however, allowed it by the Act, the Court held that the request of the respondent for a jury trial should be granted.

In a sense the judgment was a compromise, and a wise one. Mother had won her fight for a jury trial, and Father had secured his wish to have the master render an opinion of the case. It must have become clear to Father that he was far from certain of winning his action before a jury. His main witness, Curphey, who might have crumbled under cross-examination, had apparently vanished to South Africa, and on past record it looked as if Mother would unblushingly commit perjury as far as her relationship with Curphey was concerned. Furthermore, in a little over six months' time, the requisite three-year period to establish desertion would have been completed, and the whole point of having a divorce based on adultery would have lapsed with it. Father therefore amended his libel with the charge of desertion. Mother, feeling she had vindicated her cause, reciprocated by dropping her demand for a jury trial. The hearing was held privately in the office of the master, John Hunter, on May 20, 1912. There was no cross-examination, and a decree was granted on July 3, 1912, so in spite of Mother's rhetoric and angry shouting, it all ended as in T. S. Eliot's phrase, "Not with a bang but a whimper."

CHAPTER 5

My Early Childhood: Life in Pittsburgh

————◆————

"Time was," the golden head
Irrevocably said:
But time, which none can bind,
While flowing fast away, leaves love behind.
> —ROBERT LOUIS STEVENSON
> *A Child's Garden of Verses*

June 11, 1851. Ah, that life that I
have known. How hard it is to remember
what is most memorable. We remember how
we itched, not how our hearts beat. I can
sometimes recall to mind the quality, the
immortality, of my youthful life, but
in memory is the only relation to it.
> —Thoreau's *Journal*

I have no way of knowing whether Curphey was ever heard from again. He might possibly have been in England in 1913, the year after the divorce; Mother was certainly there. Although it seems unlikely to me that either Mother or Curphey would have given up their romance, there is always the possibility that there was a cooling, or perhaps Curphey thought Mother's "settlement" inadequate.

Whatever the facts, within two years, as war clouds gathered over Europe early in 1914, Mother returned to the United States and arranged to buy a house in East Liberty. That summer, in Sewickley, I have a clear recollection of her arriving on the out-

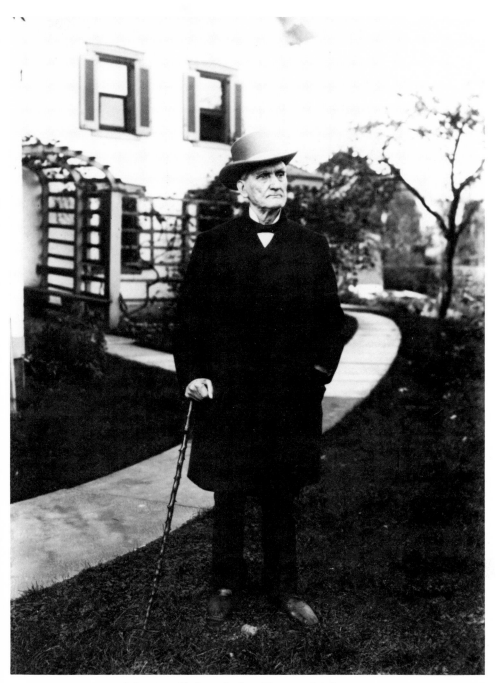

My grandfather, Judge Thomas Mellon

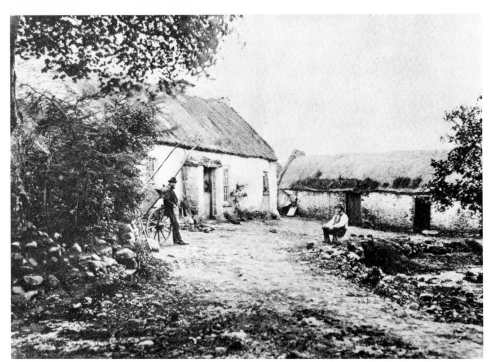

Camp Hill Cottage, Omagh, County Tyrone

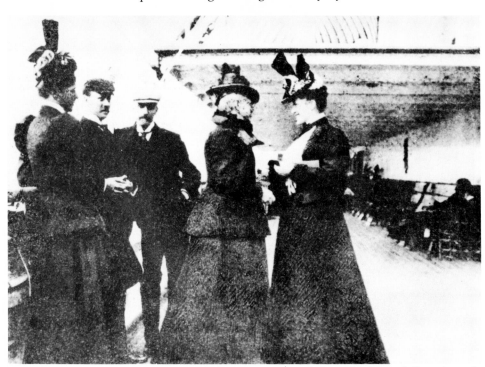

My mother-to-be, Nora McMullen (*far left*), and my father (*third from left*) on board the S.S. *Germanic* bound for Liverpool, June 30, 1898

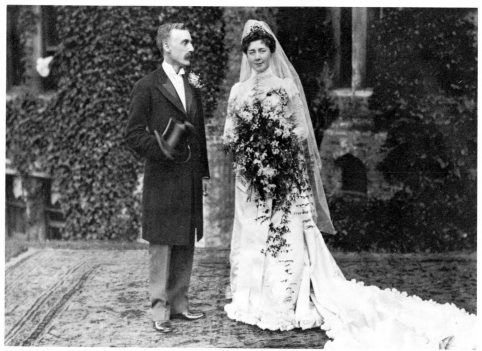

Father and Mother on their wedding day, September 12, 1900

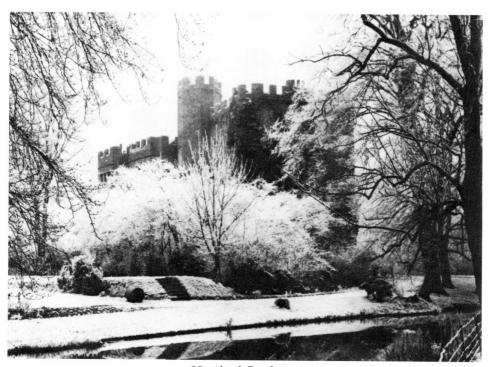

Hertford Castle

My father, Andrew W. Mellon

My mother, Nora Mary McMullen

Near Union Station, Pennsylvania Railroad, Pittsburgh, 1906

5052 Forbes Street

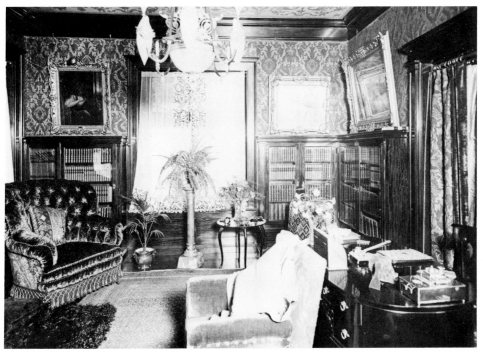

The library, Forbes Street

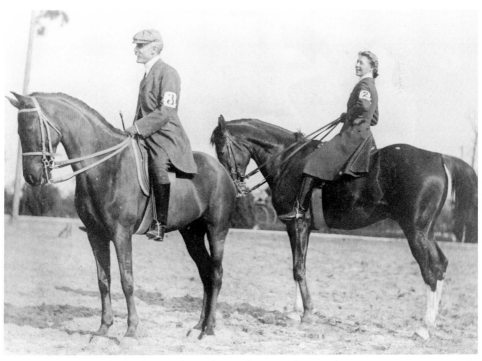

Father and Mother riding in a horse show

My uncle Dick and Father, the brothers who ran the Bank

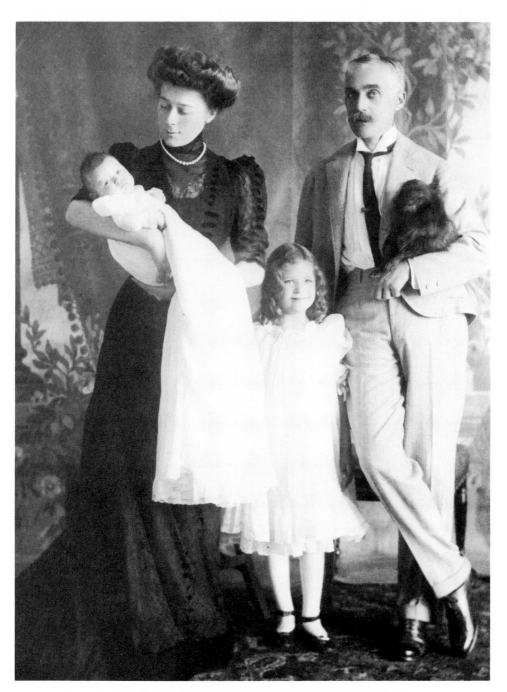

Father and Mother with Ailsa and me in 1907

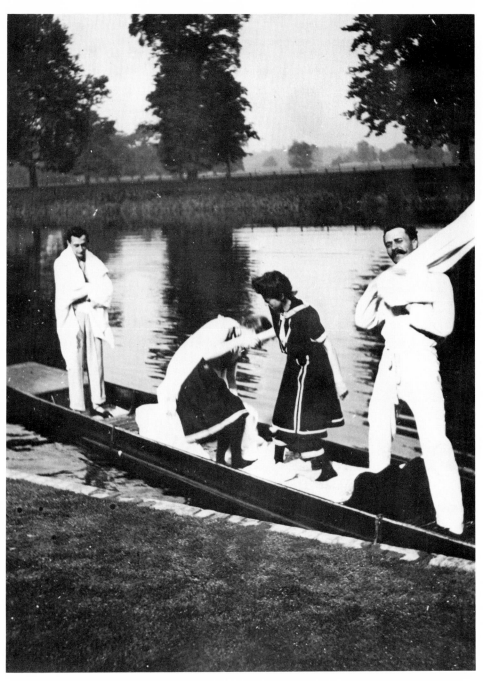

My uncle Percy (*left*) and Alfred Curphey (*right*) in a punt on the Thames

At Dartmouth in 1913, age six

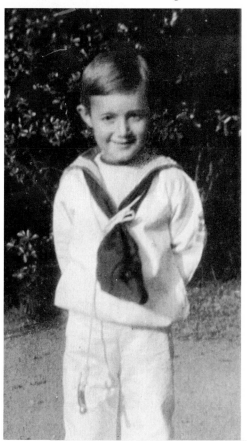

An early landscape, age seven

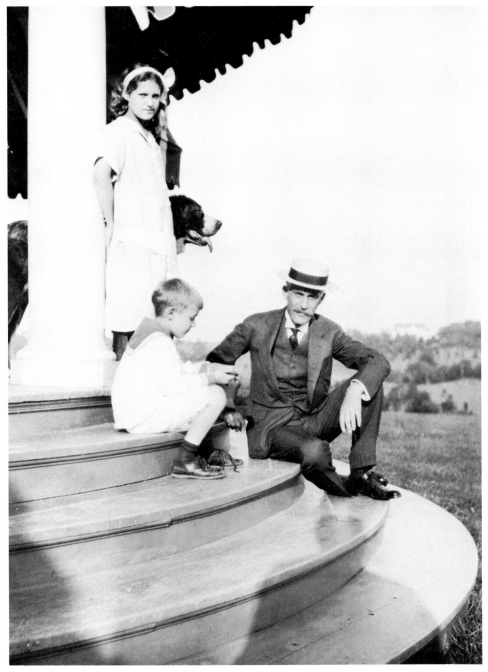

Father with Ailsa and me and our dog, Rover, at the Denny House, Sewickley, 1914

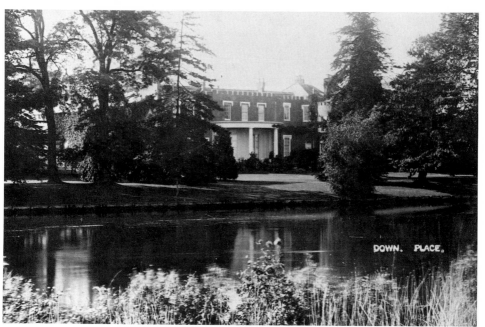

Down Place, on the Thames, 1913

The Minerva at Howe Street, Pittsburgh

Woodland Road, Pittsburgh

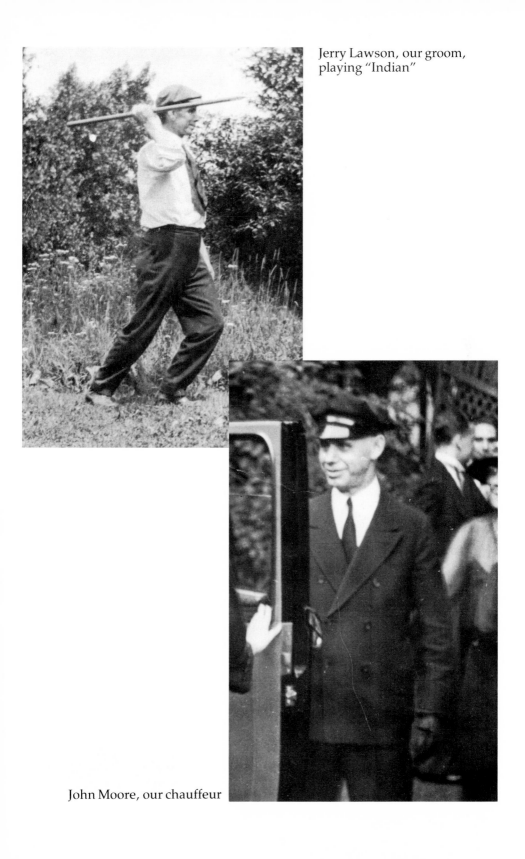

Jerry Lawson, our groom, playing "Indian"

John Moore, our chauffeur

Ailsa

skirts of the Quay property in a very sporty beige car, known in those days as a runabout. Ailsa and I were scooped up for a brief but fast drive down the road and back. I remember Mother at that time as being very young and very beautiful, with masses of golden hair crowning her head. I have another memory of that summer, of someone handing me the telephone and saying it was Mother. I recollect her voice and that I felt very warm and pleased to hear her. She said that she was coming home to Pittsburgh, would have a nice small house that Ailsa and I could come to, and wouldn't we like that?

It was not much fun to be a divorced person or to be the offspring of divorced parents in Pittsburgh in 1912. Divorcés were seldom to be met with and were subject to snide comment. Father accepted the situation stoically. He had the torture of uncertainty about his children behind him, now that a court order had stated as part of the settlement that Ailsa and I should spend eight months of the year with him and four months with Mother. These periods did not necessarily have to run concurrently for us both, and the order would terminate for each of us at age fourteen. After that time we could choose how long we wished to spend with either parent. Furthermore, Father was back in his own home, and he had the unfaltering support of Uncle Dick and Aunt Jennie. The whole matter had been settled fairly discreetly, and he was able to continue his business activities without further disruption. It is doubtful, however, whether his mind was at rest. He had loved Mother, and it was now blatantly obvious to him that his love had not been reciprocated and that she had loved another man. He must have been vaguely aware that he was someone who appeared not to need love and someone who, in his own turn, was incapable of communicating his love for others.

Grandfather relates in his memoir how Father became engaged, at the age of twenty-seven, to a young girl called Fannie Jones. Unhappily it became clear during the engagement that the girl was suffering from consumption and had not long to live. Father confided in the girl's mother, telling her that under the circum-

stances he would be unable to keep his promise to marry her
daughter. The foolish woman rushed to Fannie, not only con-
firming the girl's fear that she was suffering from an incurable
disease but adding that her fiancé was deserting her on account
of it. I have inherited a moving letter written by Father to Fannie
shortly after Christmas 1882, in which he tries to comfort her
and also to defend his honor:

> Dear Fannie,
>
> Before this [letter] I am afraid your mother will have made
> your heart sad as she has mine. I have been very wrong
> in not having confided all to you. It was only to save your
> feelings in your delicate condition that I did not. O! Fan-
> nie, I felt that I could not give you up and did not have
> the heart to say anything to you when you had so much
> to bear. It was for no want of sincerity in my professions
> of love that our marriage was deferred. If I had not been
> sincere I would not have gone to the Doctor or your parents
> about your health when I knew you would have broken
> it off any time at my request or without my request on
> the least show of insincerity. I thought it would be taken
> all in good part as an important family matter concerning
> us all but your mother has taken it otherwise and forbids
> me seeing you.
>
> I only write this note however to say that my love for
> you is and always has been true and sincere. Fannie forgive
> me for not confiding in you and believe me in all it has not
> been from want of sincerity. And the same feeling and es-
> teem for you will remain always even if from what she says
> to you you should hate me.
>
> This has been the saddest day of many to me.
>
> Yours ever Andy

Grandfather cites this tragedy to explain why Father had be-
come so withdrawn. I have to say I find his explanation singu-
larly unconvincing, and it would be interesting to know a little
more about Father's early relationship with *his* father.

Grandfather conducted his domestic affairs with the same rig-
orous and harsh discipline that he applied to his professional

and business life. His writings convey an engaging quality of self-examination mixed with fierce puritanism. "I had a high opinion," he says, "of the strict exercise of parental authority. I had heard so much about the necessity of coercion and chastisement in the proper training of children, when necessary for their future good, and my desire was so strong to bring them up in the right way, that at the outset I was in danger of overdoing the business in that line. . . ." He eased up on his younger children, as I said earlier, but was haunted with a bad conscience after Selwyn, his favorite son, died at the age of nine on September 24, 1862. ". . . for Selwyn I cannot be comforted," he writes. "The recollection of every little unkindness I subjected him to affects me with remorse. When I review in memory his short life in sickness or in health, I discover nothing to justify the slightest harshness of treatment." Of Father and Uncle Dick, he adds, "Kind treatment and enlightenment was all which was needed to lead them in the right direction; and the death of our dear Selwyn had softened me so much toward those who remained that a harsh word or action to any of them went against the grain."

This upbringing did not seem to do my hearty and extrovert uncle Dick any harm, but Father reached adulthood as a thin-voiced, thin-bodied, shy, and uncommunicative man. His brilliance as an investment banker provided him with his only real source of human contact, and that only with like-minded individuals. Were his early life better understood, it might provide clues to help explain his withdrawn character, but as things stand, his personality remains an enigma.

In looking back at the long lives of my paternal family—my grandfather was born in 1813 and lived to the age of ninety-five, dying in 1908—I'm reminded that my father was born before the Civil War and lived almost to the beginning of World War II. When he was about nine, during Lincoln's 1864 campaign, Father was taken to the East Liberty station to see and hear a speech by the great President. He told me that Lincoln was seated on the observation platform at the rear of the train, and when he got up to make his speech, "he seemed to unwind like

a long snake, and when he was standing, with his high black stove-pipe hat on his head, he seemed enormously tall." Father remembered nothing of the speech, but the tall, awkward man remained in his mind all his life.

Father and Mother never ceased to keep in touch with each other. Both had carefully observed the agreement to write weekly letters during those periods of their separation when they had custody of us children, and later Father would sometimes come to fetch us when one or the other was with Mother, to take us off for the weekend. Mother's earlier letters were plaintive, resentful in tone, and often about money. They launched into their message without any prefix, but gradually over the years some cordiality crept in. She found herself writing "Dear Andrew," and finally a degree of sisterly feeling replaced some of the old bitterness, and she felt able to recount to him in her bold, round hand the events in her everyday life.

When the divorce was made final in July 1912, Ailsa and I returned to the dreary surroundings of Forbes Street. I had been born at Forbes Street and had spent most of my five years there, so it was really the closest thing I knew to home.

The house itself had no comfortable, warm character but rather gave off a feeling of silence and gloominess. The hallways were carpeted in a ghastly deep red and pale green, with some circular designs at regular intervals. The curtains were mostly deep red or pale green, like the carpets, but with tassels and fringes around them. The library was dark, with only one window, and was a sort of passage into the sun parlor; it was paneled in black mahogany. The sun parlor itself was pleasant and cheerful, really a conservatory attached to the front of the house. It was full of potted palms and aspidistras, but there were swings, trapeze bars, and rings for us. It was a room we children used most of all, the only room in the house with any life in it. We had a Victrola there with a huge trumpet speaker. I can remember many of the tunes we used to play on it. There was the series of "funny" talking records: the one

called "The Three Trees" ("there, there, and there") and the one about the house burning down, which I think was called "The Dog Died." The first jazz tune I ever heard was on that Victrola, "Alexander's Ragtime Band." We often played Dvorak's "Humoresque," too, and it struck us as very sad. The living room was never lived in at all, and in fact, I remember going into it only occasionally for a piano lesson. One year I had my electric trains in there, and it came alive for the first time. Two Corots, one a lake scene with trees* and the other a depiction of naked cherubs dancing in a circle in a field, hung in that room together with a Cuyp landscape full of cows.† The furniture was a stiff Adam-style set, with wickerwork backs and seats and small medallions fancily painted. Father's den was a room we used a good deal. It was right next to the dining room, and we usually drifted in there after meals. It was hideously decorated, with bare gray walls and the inevitable drab green curtains and the green or red carpet. The couch was of green striped plush. There was a huge easy chair next to the fire, with a large greasy spot on the headrest where the oil from men's hair tonic had gradually soaked into the leather. There was usually a fire alight, with small gas jets coming out of artificial logs.

I spent many hours in that room with Father, but I don't remember his talking much. I would ask him to read me the funnies from the papers, and he would begin sometimes but soon give up, saying, "There's no use reading all that trash." I always felt overawed by him, afraid of him. All my life I had that feeling about Father, that he wanted me around out of pure possessiveness. The fact is that when Father was with me, he was inclined to be dry and censorious and negative, but in New York he would take time to visit the toy shops and return to Pittsburgh with attractive gifts, unwrapping them for me in the den. Two of the most exciting were a child's typewriter (with the letters on a round disk) and a red movie machine with a

*Now in the Nelson-Atkins Museum of Art in Kansas City.
†Now in the National Gallery of Art in Washington, D.C.

crank, the film being on a roll. It was thoughtful of him because that Christmas I had written to Santa Claus in a letter that is still in my possession. It reads:

Pittsburgh. Pa.

Dear Santa Claus.

Will you bring me a traveling bag with my initials on it in gold. Please bring me a watch in silver. Please put a little present on my bed. Will you bring me a typewriter and anything else you think I would like to have.

Yours truly, Paul Mellon

I was thrilled with Father's gifts, but the only trouble was that I always felt as if he wanted me to take them away and go and play by myself.

I passed my happiest days at this period with the servants. I loved the warmth and the rich smells of the kitchen at Forbes Street, smells of ground coffee, fudge being made, meat roasting. I loved the coarse red-faced cheeriness of Nora, the fat Irish cook, and watched her for hours at a time, fascinated at the sight of someone really *doing* something. She gave me tidbits, teased me, and let me play around the kitchen endlessly, but most important, she answered my questions. Like all children at that age, I had plenty of them. The quality that attracted me toward the servants was that they treated me seriously and talked to me as one human being to another. I felt I really meant something to them. There was Rose, the elderly Irish maid with glasses and gray hair. Then there was Veenie, another housemaid, whom I was a little soft about, even at my early age. There was Kate, my nurse, who had a nice open face, dark hair, and dark eyes. They all were Irish, and I felt at home with them. One day a poor man selling brushes came to the back door while I was with Nora, the cook. She sent him away because we didn't need any brushes, but he gave me a miniature broom. Nora said, "Sure, and you must give the poor man something for his broom. Didn't I see a nickel of yours on your father's desk?" I

went and got the nickel and gave it to the man and was glad to do it. It was a sacrifice, because it was my week's allowance, but I knew I was repaid by the feeling of having done something unselfish and helpful. It seemed that only in the back of the house did people have any humanity or any real sense of life. I never forgot the incident because I had never heard of beggars, poor people, or charity before.

The house on Forbes Street faced a large lawn that stretched down toward the street and was bounded by a low brick wall capped with gray stones. Small yellow trolleys came gliding by from time to time. Their procession was punctuated occasionally by the appearance of a much larger and longer green streetcar with a cowcatcher on its front, much like a locomotive, which came from the outer suburbs of Pittsburgh and bore the lettering "Monongahela Street Railway." There was something more romantic and mysterious about these visitors from what seemed far away, the sound of their motors evincing authority and power.

There were other visiting vehicles that came wheeling along the gravel driveway that wound up from Forbes Street. There was the iceman's wagon, all white but with its overlapping, gray, rounded top, and the iceman himself at the kitchen door with his gigantic tongs fixed into large crystal-clear blocks of ice. There was the pony cart with our groom, Jerry Lawson, holding the reins and guiding Topaz or Betty up the driveway. He would be bringing Ailsa from school or returning from an errand. There was the dark green Pierce-Arrow automobile with its brass lamps and brass radiator shining in the afternoon sun, with old John Moore at the wheel (looking like a coachman with a whip in his hand), bringing Father home from the Bank. There were Ailsa's friends from next door, Margaret Wolfe and her sister, who climbed over the low wall and arrived with laughter and in "bloomers," for an afternoon of pillow fights or sliding down the banisters.

There were also excitements to be found out in the street. Sometimes a fire engine came clattering by, drawn by a team of gray horses at the gallop and accompanied by a large Dalmatian

dog. Black smoke and fire came tumbling out of the stack of the pump wagon, and the whole scene was one of bright reds and flashing brass, galloping horses, the clatter of ironshod wheels, and sparks from steel-shod hooves. There were firemen with huge black hats and shiny black coats, hanging on to the running boards for dear life, and over all would be the clanging of the bells, the smell of smoke and steam, the excitement of speed, noise, urgency, and danger.

In the summer of 1913, when I was six, Father took us to England again. It was the first visit that I remember clearly. For me the journey had all the excitement of a voyage of discovery, from the moment we left on the liner *Hamburg*. I recall being scared, as I was held up to the railing, to see the sea move so fast and so far beneath us. Miss Askey, our new nurse, brought us cakes and candles and small flags from the gala dinner. I was taken down into steerage to look at the ship's rudder and the wake behind the stern, but my attention was drawn to a group of poor Italians traveling back home. I had never seen people as poor and as dirty as that before. They were huddled together, looking strangely at us.

When we arrived in London, we stayed at the Hyde Park Hotel in Knightsbridge. I had been given a booklet of old railway tickets and played trains, tearing off tickets and posting them through the letter box in the door of our suite. Miss Askey took us out into Hyde Park and Kensington Gardens, and I played with my toy sailboat in the Round Pond. There were nannies with prams and other children playing, and the whole park seemed an enchanted spot. One day—it was a Sunday—we ran to the edge of one of the roads that led through the park and found a large crowd of people. They were all cheering and waving their hats in the air. The nurse held me up so that I could see the carriage go by; it contained King George V and Queen Mary. I couldn't be sure whether or not I had seen them, as I was looking for ermine robes and crowns. There always seemed to be something exciting going on in London, parades of soldiers, groups of protesting suffragettes, bright uniforms, flags,

and music. Often we just walked through the park. Miss Askey finally sat on one of the benches, while Ailsa and I played under the huge trees or ran across the grass. I was timid, though, and not likely to run far or get lost.

Eventually we left for Down Place, on the Thames. A large touring car with a chauffeur arrived at the hotel and conveyed us over the dusty roads toward Windsor and the river. The twenty-five-mile journey was a long, tiring trip, but after several punctures we arrived. Down Place, near Windsor, was a beautiful low-built eighteenth-century country house. The close-cropped lawns sloped gently toward the river, and the house was surrounded by oak trees and elms with weeping willows near the water. The river, which is quite wide at that point, flowed gently, and there were usually swans and ducks swimming on its surface. It was really an idyllic place. The weather remained perfect, so we spent most of our time out of doors. We sat out on the lawn during the warm evenings. Ailsa, who saw herself as my mentor, taught me the words of the inscription engraved on a sundial on a low terrace at the end of the house. It read:

> One is nearer God's heart in a Garden
> Than anywhere else on earth.

For a six-year-old, these sentimental lines spoke the truth, and I remembered them. Ailsa and Miss Askey sometimes went swimming in the river. I had heard that there were dangerous weirs alongside the locks and large weeds that you could get entangled in, so I stayed out of the water.

The greatest excitement was an excursion on the river. Father would hire a motorboat, and we would take a picnic lunch with us. Having spent most of my childhood on my own, I had developed into a vivid daydreamer and could convert myself into a brawny sailor at a moment's notice. I would lie in the prow of the boat and watch the white swans glide past on the water and the great white clouds float past in the sky.

One day Father took us to see Mother and our grandmother

at Wimbledon. We went by train, and like many small boys, I was fascinated by English steam engines. Each railway company had its own distinctive colors: bright red, bright green, maroon, gray, and brown. The engine drivers and other staff took a tremendous pride in the appearance of their trains. The paint was always fresh, and the brass polished. I had a new panama hat with a wide brim, the kind with a ribbon and a narrow elastic under the chin. My eyes were glued to the countryside as we steamed along. The acrid smell of burned coal and steam wafted past the window as I looked out at farms and woods and horses standing in fields. We arrived and stepped out of the train, and as I watched it steam out of the station, I realized that my new straw hat had been left on the rack above my seat. If Miss Askey had been with us, she would have remembered it, but she wasn't, and Father was angry both with himself and with me. When we arrived at Grandmother's house, it didn't seem odd to see Mother meeting Father, even at that early stage after the divorce, but I hadn't the faintest idea where she had been over the past year.

Back at Down Place I sometimes went with the groom and our nurse in a small basket cart into Windsor Great Park for a drive, occasionally into the town itself. I loved the park and the round towers of the castle in the distance, and there were the great trees and herds of small brown deer. England had a stillness and deep serenity in those last few years before the First World War. It is impossible to describe the atmosphere and the feeling of that long-lost summer of 1913. It must have rivaled the next year's summer, so celebrated in memoirs and novels of World War I. To me it had the color and feeling of childhood itself, a most beautiful and peaceful interlude.

Toward the end of the summer we were passed over to Mother's care, and she took us to Dartmouth to spend a week with her brother my uncle Percy and his wife, Aunt Maud. Uncle Percy was a naval officer who was an instructor of science and mathematics at the Royal Naval College. Dartmouth at that time was a delightful town. It is situated on the west bank of the river Dart, just at the point where it opens into its estuary.

Beyond it a castle still stands at the river's mouth, and in the old days it was closed off in times of danger with a long iron chain. The Royal Naval College is up on the side of a hill that overlooks the town. Halfway up this hill was Uncle Percy's house. It was a charming small house with a pretty garden surrounded by a high, ivied wall.

Uncle Percy and Aunt Maud had two children. There was a boy my age called Tony and another boy, Alexander, who was then eight, two years older than I. Ailsa was twelve. I had hardly ever played with other boys before. My only companions had been Ailsa and Ailsa's girlfriends. Alexander was the ideal friend. He showed off like mad, and I thought he was absolutely great.

I had arrived wearing my sailor suit, which gave me confidence and made me feel nautical. The smock had a boatswain's whistle attached to a white cord, and the outfit was completed by long white bell-bottomed trousers. We all ate together in the nursery, and I thought that everything Alexander did was excruciatingly funny. His only tiresome habit consisted of pushing me into any nearby nettle bed. It stopped when I bellowed and he got roundly scolded.

Nearly all the time, however, we played happily together at being pirates and wandered around the rock pools by the sea, looking for shells and starfish. Alexander had picked up the word "bugger" from somewhere and taught it to me. Every time we would pass someone on the road, one of us would whisper "bugger" to the other, and we both would burst into peals of laughter. Neither of us had, of course, the least idea what it meant, but this was the first time in my life that I felt what it was like to be absolutely carefree. In the late afternoons we sat in the sweet-smelling garden while our parents had tea. In our corner we were given strawberries and thick Devonshire cream in little yellow bowls. After that it was back to Father, the hotels, the rented houses, and his seeming indifference.

That summer holiday in England was a singular event. Father usually took us to rented houses at Sewickley, a few miles

west of Pittsburgh, in the years just before and immediately after his divorce, until the outbreak of the First World War—that is, the years 1911, 1912, and 1914. The first of these, the Quay house, with its memories of exile and Fräulein Meyer, didn't have particularly agreeable associations. In 1914, however, Father rented the Denny house, another large rambling house situated on one of the highest hills. The main attraction of Sewickley for Father was that he could take a train from there and be at the office in town in well under an hour. He hated to be away from business all summer. In those days Sewickley was still really in the country, and the steel mills with their soot had not yet encroached on the green fields and lovely wooded hills that rolled down to the wide Ohio River. It was still a summer resort, rather than a suburb, and although wealthy Pittsburghers had built large houses that were scattered around the countryside, the overall impression was one of rolling farmland and meadows.

On the Fourth of July of that year Father held a large fireworks party, and many of his friends and neighbors came to watch the spectacle. I remember seeing a row of chairs on the front lawn and waiting with excitement for the display to start. I've always thought the fireworks then were more spectacular than those we see today, but perhaps it was just that they were being looked at through the eyes of a seven-year-old boy. There were fiery catherine wheels whizzing on their posts, rockets that burst into thousands of colors, and Roman candles, together with all the minor accessories of light and noise that we have now, including sparklers and multiple firecrackers. The sight that enchanted me most was that of huge paper animals that contained lighted wicks floating in little reservoirs of methylated spirit. There were luminous pigs and elephants and horses and lions, and as they filled with hot air, they rose slowly in a halo of wavering phosphorescence, to be carried away silently and mysteriously by a gentle wind, across the fields and over the woods into the night.

A month after the fireworks party everyone was talking about war in Europe. One evening Ailsa pressed Father to tell us about

it. He was very grave. He explained in great detail what had happened: the assassination of the Archduke and many other incidents leading up to the Germans' march into Belgium. I remember that evening very clearly. We were sitting on a couch in the small library, and Ailsa's childish face was upturned in the lamplight as she asked one question after another about the Germans, about the war, about everything. Perhaps it is because it was one of the few times that Father really talked to us as though we were grown-up and intelligent that the event stayed so firmly in my mind. He was with us so little. We had meals with him occasionally, and sometimes he rode with us, but there was seldom a shared feeling of naturalness and intimacy. On the other hand, during that summer he was probably less preoccupied and more considerate toward us than he had ever been before or than he ever was afterward.

I know that I felt very fond of Father that summer and loved to have him there. I used to go down to the station every evening with John Moore, the chauffeur, to meet his train. I treasure the photograph of Father, Ailsa, and me sitting on the steps of the Denny house porch. Ailsa has her hand on Rover, our St. Bernard, I am in my sailor suit, and Father has on a stiff collar and straw "boater."

Ailsa, who was six years older than I, was *in loco parentis*, sister and friend all wrapped into one. When I was very small, I truly worshiped her. I would curl up on the carpet outside her room like a dog, as though for her protection, and patiently wait for her to come out. If she said something nice to me, I was filled with happiness. If she scolded me, I felt utterly miserable. It was Ailsa who insisted that we have stockings on Christmas morning. I would go into her room before dawn and climb into her bed, waiting excitedly until she gave the signal at seven o'clock to open them. She would tell me some fairy tales or stories about Santa Claus, or we would find some small joke and laugh and giggle about it for hours. Ailsa liked poetry and often read to me. Long before I could understand the meaning of the words, I learned to feel their rhythm, to hear their music. The first words of poetry I ever knew, I learned from Ailsa. One

night, at dinner in the servants' dining room at Forbes Street, she recited the lines that she had just learned from Robert Louis Stevenson's "Requiem." They go:

> Under the wide and starry sky,
> Dig the grave and let me lie.
> Glad did I live and gladly die,
> And I laid me down with a will.
>
> This be the verse you grave for me:
> *Here he lies where he longed to be;*
> *Home is the sailor, home from the sea,*
> *And the hunter home from the hill.*

Later, after I had learned to read, I found myself one rainy afternoon looking through the books in a little bookcase in the living room at Forbes Street. I came across Stevenson's *A Child's Garden of Verses* and began to read it. Of course, I had often had it read to me and had often looked at the pictures, but somehow on that wet afternoon I understood it for the first time. "Up into the cherry tree, who should climb but little me"; "Little Indian, Sioux or Crow, Little frosty Eskimo"; "Dark brown is the river, golden is the sand," and then "Good-bye, good-bye to everything!" from the verse called "Farewell to the Farm," which had a special meaning, a special sadness for me. Stevenson struck a deep chord. The poet's quiet simplicity, pervaded by a note of inner melancholy, seemed to represent the essence of my childhood.

For Mother, the divorce was cathartic. She suddenly found herself a single woman whose lover had bolted. The family in England was annoyed with her, and although she had achieved a comfortable financial settlement, she really had nowhere to go. The result was that she transformed herself, almost overnight, from a superannuated adolescent into a thirty-two-year-old woman. She had left for England after the divorce, but the prospect of war imperiled the North Atlantic passage, so in 1914 Mother returned to the United States to be with us. She bought

a house in Pittsburgh, on Howe Street, and settled down there for several years. It was a curious mixture of English cottage and American suburban architecture. It was of white stucco (which had begun to get dirty before she moved in) and was trimmed with red brick. It had a roof of slate, looking vaguely like thatch.

The Howe Street house certainly looked out of place in a neighborhood where houses were fairly uniformly dull, turreted, frame, red-brick or yellow-brick affairs right on the street with no lawns, no gardens, and no garden walls. But ours had a wall, and a high one, enclosing a garden with a small lawn in front of the house and a vegetable garden behind it. The wall was about eight feet high, also of white stucco trimmed with brick. Americans generally just don't build walls around their houses, and Pittsburghers were no exception. Privacy seemed immoral to them; it was as though one wanted to close oneself in only for the sake of indulging in dissolute behavior!

In those days no one in Pittsburgh ever pulled his or her living-room or dining-room blinds down in the evening. As you walked along the street, you could look into each house, where the lights burned brightly and where you could see the families reading the newspapers, having dinner, or talking after dinner. They seemed to be mortally afraid of privacy. Not only did Mother's house have a high wall, but behind the wall she planted poplar trees at intervals of six feet. In a few years they grew to a tremendous height, gaunt sentinels of Mother's seclusion, and they gave the house even more the appearance of coming out of a storybook. There was a little white gate from the street into the garden and another, larger one for the driveway. They were always kept closed except for coming in and going out. As the years went by, the house became drearier and drearier and looked less and less like a whitewashed cottage in Devon.

In the beginning, however, when Mother first lived there, it was gay and cheerful, with a comfortable, old-fashioned air. The windows had diamond-shaped leads, and beneath them were flowers all around the house, and flower boxes in some of the windows, too. The garden itself was lovely. It was separated

from the driveway by a trellis of vines, which was always cov-
ered in the summer with wisteria or honeysuckle or rambling
roses. The beds were full of flowers of all colors—tulips and
hyacinths—and there were two squares of lawn on each side of
the path to the front door. There was a sundial in the middle
of one and a fountain in the middle of the other. It was a tiny
walled garden, and when you were in it, you forgot about the
drab streets and the inquisitive neighbors and the noise and soot
of Pittsburgh. On sunny days in spring it was a riot of colors
and sweet-smelling flowers and seemed miles away from town
and from reality. It was a bright little oasis in the center of an
American industrial city. The garden gave me an especially
peaceful and protected feeling. It seemed to keep out everything
that I feared: the dirt; the unknown terrors of the city; the eyes
of the public that I knew, subconsciously, were staring at us,
staring at that strange foreign woman, my mother.

We were aware that Mother was different from the mothers
of our friends. This would have been especially apparent to
Ailsa and was very obvious to me when I went to the Shadyside
Junior School at the age of eight, but perhaps also subcon-
sciously we admired her pride and her determination to lead
her own life and pursue her own interests in such alien sur-
roundings. When she left her little fortress and ventured into
other parts of town, she invariably wore garish colors, although
she was convinced in her own mind that she was being conser-
vative and retiring. Her car was a good example of this flam-
boyance. She wasn't satisfied to have an ordinary American car
of a neutral, unassuming color. She had a Belgian car, a Mi-
nerva, and what a Minerva! It was a town car, a brougham, very
large and a deep bright cobalt color. It is impossible to describe
that blue. You could see it for miles. It wasn't dark; it wasn't
light. It was just that bright, deep blue, like the Mediterranean.
Having a chauffeur in those days did not carry quite the same
connotation of riches that it does today, but a chauffeur without
a roof over his head while driving was a rare sight. This is the
car Mother went everywhere in, to East Liberty, to the movies,
downtown to shop, or to take me to school. Everybody in Pitts-

burgh must have recognized it and must have known the story behind the woman who owned it. I remember being vaguely uneasy about it at times, feeling that people were looking at us in a queer sort of way, laughing at us. I used to love the old car, of course, and I loved Camille, the French chauffeur, so it disturbed me that other people didn't like it, too, didn't understand its real magnificence, because I had no doubt that it was a paragon of mechanical perfection.

In later days, great care was always taken by everyone to give us the impression that there were no hard feelings between my parents, that they were sensible people, that bygones were bygones and it was as though nothing had ever happened. But in the early days after the divorce Ailsa would lead Mother on to talk about Father. Mother was only too ready to oblige, but I was not very happy about it. I never thought it fair and knew instinctively it was underhanded and bad sportsmanship. Mother often talked to us about Father, gradually letting her venomous feelings run away with her, becoming more and more biting and bitter or more and more sarcastic and insinuating. She complained continually about the divorce and his treatment of her. She would tell us that he had had her followed by detectives, for instance, and we, of course, thought that was terribly unfair. We didn't know in those days *why* he might have had her followed. She would tell us that the divorce was obtained dishonestly, that she had been maligned and treated shamefully.

Mother hated Father for his money as well, and I will never forget how she used to say with obvious disdain that he was a *"multi*millionaire." I gradually began to think that a millionaire was a hateful sort of worm. She had a way of laughing about him, too, a cheap way of getting back at him by belittling him in our eyes. She also made us feel that he was hated for his cold-bloodedness and for what she claimed was his questionable shrewdness in business. She told us stories about how he had been attacked by people who had lost money through him or on account of him and that he had almost been killed once by an unknown man who had pushed him into the path of an

oncoming streetcar. There was continual scorn and bitterness in
her voice when she talked about him. "Your father would prob-
ably say . . . ," and it would be something cruel and heartless.
But in reality the cruelty and bitterness were in her, and all the
unfairness. I never in all my life heard my father say an unkind
or malevolent word about her.

Mother often demonstrated great affection toward us, but in
spite of it all we both felt her to be of an independent and
detached nature. I remember that she played the piano well and
that she was a talented gardener, yet beyond arranging for me
to have a few piano lessons, she never encouraged me to play
the piano and she never talked to me about the flowers. She
would answer my questions but was too impatient to take mat-
ters further. In her own way she had as much difficulty com-
municating with us as did Father, though she was certainly not
as taciturn. She used to tell me about her brothers by the hour,
about their pranks as boys, how they teased her, how they all
used to dig for buried treasure at Guisnes Court, which, as I
have mentioned, was her family's seaside house in Essex, and
how they searched along the beaches for pirates' dens. She al-
ways talked of England in such nostalgic terms that I couldn't
have helped eventually coming to love it myself.

Mother's eccentricity lasted well into her old age. I recall that
she kept two weapons in the bathroom of her house in Green-
wich, Connecticut. There was an air gun and a .22 rifle leaning
against the wall, next to her fashionable negligee. She was very
fond and protective of the birds around her house, and it in-
furiated her when squirrels attacked them and their nests. So
Mother would lean out of the bathroom window, even as she
approached the age of ninety, and shoot the squirrels. She had
always been a good shot, and she told me that she often hit
them right in the head.

I only discovered the truth about the divorce twenty-five years
after the event, in 1937, following Father's death. Until then I
had been completely ignorant of the whole story, having always
been told that the sole cause was my parents' incompatibility

and Mother's disgust with Pittsburgh. When I read the divorce
papers (they had been left in a safe-deposit box), I found out
for myself what had happened. A few months after this discov-
ery I was going through my father's personal belongings at
Woodland Road in Pittsburgh with my first wife, Mary, when
we found a cardboard box full of old letters. Many were written
during World War I, when Father seemed to have been lending
money to several of Mother's seven extant brothers for various
purposes. One was for the purchase and equipment of a boat
for my uncle Norman so that he could get a commission in the
Royal Naval Volunteer Reserve doing coastal patrol work. More
loans went to the improvident uncle Leonard, who always
seemed to be on the point of bankruptcy as a result of ill-advised
financial adventures. There were a number of letters from Uncle
John, who corresponded with Father for many years about noth-
ing in particular, and many more from various people about
business matters. Since these latter ones were dull as ditchwa-
ter, Mary and I wrapped the whole lot up in a large package
and sent them, without any covering note, to Mother.

By then Mother had sold me the farm she owned in Upper-
ville, Virginia, and had moved to a smaller place in Stamford,
Connecticut, so Mary and I were living partly in Pittsburgh and
partly in Virginia. Several weeks after sending off the package,
we invited Mother to spend a weekend with us at the farm. At
the end of her short stay Mother walked into Mary's room,
looking flushed and excited, and asked Mary if we had read all
the letters we had recently sent her. Mary replied that we had
read a good many of them, but not all, and we had sent them
on because she and I thought they would be of more interest to
her than they were to us. Mother was very agitated and said
there was a letter in the package that we should not have read.
Mary and I had no idea which one she was referring to, but
Mother, having read all the correspondence, thought we must
have read the offending letter and that we had sent the package
on to her without comment in order to let her discover it for
herself.

About a week later I had a telephone call out of the blue from

Mother's former lawyer, Paul Ache, now living out west in re-
tirement. He had traveled to Washington at Mother's request
and said that he wanted to see me "about a very important
matter." Although I wasn't keen to see Ache again, I was anx-
ious to find out what it was that Mother was worried about, so
I went to his Washington hotel room to discover that he had
made the journey solely for the purpose of seeing me. When
the interview was over, Ache was going to check out of the
hotel, get on a train, and travel back more than two thousand
miles to his home. I noted that this fat, florid, and vulgar man
with a loud, unctuous voice had changed little in the twenty-
five years or so since, as a very small boy, I had last seen him.
First, Ache talked about the letter that Mother had spoken of to
Mary. It had been written by my uncle John and sent to Father
at the height of the divorce proceedings. Uncle John had been
on Father's side, and he sympathized with him over his prob-
lems concerning Mother. One passage in Uncle John's letter
contained words to the effect that every man certainly has the
right to know if he is the father of his children.

Ignoring the fact that it had clearly not been intended for my
eyes, Ache showed me the letter Mother had just written him.
She had obviously been in a rage. Mother told Ache in the letter
that it had been dreadful of her family to turn on her as they
had done at the time of the divorce and unspeakable of her
brother John to write such a letter. She accused Father of having
left these papers lying around on purpose to cause her embar-
rassment. She felt that it was a form of revenge and that he had
come back, even from the grave, to torment her. She made no
attempt to control her feelings, and the letter was couched in
extremely bitter language. Ache then turned to me and ex-
plained that his instructions were to tell me that the charges
implicit in my uncle John's letter were false and that my mother
had never had physical relations with anyone except my father.

I didn't tell Ache that I had read Father's account of the di-
vorce when I went through the papers in his deposit box. From
these I knew that Mother had been unfaithful, but I had also
been able to satisfy myself that I was indeed my father's son.

Of this I have always been certain. There is the description of the reconciliation spelled out in the legal deposition, a delineation of the time frame wherein I was conceived and born. Then there is the fact that my father, though often aloof and uninterested in my daily life, my thoughts, my aspirations, always looked on me with favor and with the love of a much older man for a son. He clearly had no worries on this score about me. Although I never shared his enthusiasm for business, I see in myself several characteristics that were also his: a habitual shyness and an almost obsessive attention to detail. My own son, Tim, by his physical similarity to Father as a young man and in his addiction to corporate pursuits, seems to me to be an obvious throwback to the appearance and business-oriented character of his grandfather. At the same time, Tim's expression and demeanor have always been a far cry from his grandfather's stern, forbidding manner.

As I sat with him in the hotel room, Ache proceeded to adopt the manner of the preacher and started mouthing platitudes about letting bygones be bygones. He suggested that I telephone Mother straightaway to tell her that I understood everything and that all was forgiven. I disliked Ache so much that I merely said, "Forget it," and walked out. On the way home I began to be fully aware of the conspiracy of silence that had followed the divorce proceedings over all these years. Judgments I had formed as a child, especially about Father, had been based on fallacies and innuendos. I remembered Ailsa's calling him "a wicked man" and my own feelings at the time of Father's visits to Forbes Street, when Mother was so scornful about him, leading me to believe that the separation and subsequent divorce were both his fault. Now that he was dead and now that I knew the truth, Mother's hypocrisy irritated me more than ever. I telephoned her when I got home and asked her to meet me in New York the following week.

When we met, I confronted her with my knowledge of the reasons for the divorce and angrily blamed her for never having taken Ailsa and me into her confidence. I implied that it had poisoned our relationship with her (a partial truth but a truth

at that) and that I thought her hypocritical and stupid. It shook her badly, but she had absolutely nothing to say, wept, and never mentioned the subject again.

One thing that has always struck me concerning my mother's wild gyrations and public diatribes against my father was her apparent lack of consideration for Ailsa and me as children. Whatever contemporary or later criticism was leveled at my father because of his implied suborning of the legislature to prevent salacious publicity, I personally have always felt grateful to him. Ailsa perhaps had already borne the brunt of questioning at school and of whispering among the servants in the house. But I knew little, only that there was bitterness, turmoil, sudden changes of plans. I was the innocent bystander. I perhaps prospered better because of my age and because of a sort of benign neglect.

My talk with Mother cleared the air and was a relief to me. We were friends after a while and remained on friendly terms until her death in 1974, just short of her ninety-fifth birthday; we were friends, with a certain amount of affection between us, although I would not have called it love.

CHAPTER 6

School Days:
Shadyside Academy
and Choate

———————•———————

Myself when young did eagerly frequent
Doctor and Saint, and heard great argument
About it and about: but evermore
Came out by the same door where in I went.

—EDWARD FITZGERALD
The Rubáiyát of Omar Khayyám

He, who would bring home the wealth of the Indies,
must carry the wealth of the Indies with him.

—Spanish proverb quoted in
Boswell's *Life of Johnson*

In 1912 I started attending a kindergarten at Miss Winchester's school, where Ailsa was in the sixth grade. We set out together in the morning in the carriage with old Jerry, our groom, or sometimes were driven by John Moore in the car. Father kept horses at Forbes Street for another three years and used them for driving to the railway station and for Sunday outings, but it was becoming increasingly difficult to do so in the city. As far as riding for recreation was concerned, he had probably wished to please Mother, derived no great pleasure from it, and was not particularly good at it. Mother, on the other hand, was an excellent horsewoman and as a young girl had done a lot of foxhunting in England, but she had no facilities for horses at Howe Street. She was driven about instead by Camille in the large Minerva.

As time passed, and automobiles steadily increased in number, Jerry, together with the horses and ponies, was sent off to Rolling Rock. Rolling Rock, a six-hundred-acre estate owned jointly by Father and Uncle Dick, was up in the mountains near Ligonier, about fifty miles east of Pittsburgh.

I was very attached to Jerry and thought he knew everything there was to know about horses and carriages. He taught me how to brush and curry and rub down the horses, how to paint their hooves with oil and clean them out with a pick. He also taught me how to clean tack and made me really work at it. I could saddle and bridle my pony Topaz and, when I got home, rub him down, clean his tack, and feed him. Jerry taught me to understand horses and to get the feel of them, and Topaz was a child's ideal first pony, just the right size and very quiet and sensible, as was his successor, Hotspur, a handsome liver-colored chestnut with a very smooth gait.

Jerry himself was a bad horseman with little patience, an Irish temper, and bad hands. Furthermore, we knew he drank and swore a lot, but I never saw this side of him. When he was with me, he was sobriety itself. It gave him a personal feeling of pride when I rode into the ring at a horse show and an even greater feeling of pride if I returned with a blue ribbon. He helped me be confident because he had confidence in me.

One summer, when we had been riding a lot out at Sewickley, Jerry suggested that I get the cook to make up a picnic luncheon sometime so that we could spend the whole day out and ride farther than usual. It was to be like a camping trip. That evening I asked Father if I could go the next day. Father said that he was sorry but he didn't think it was a good idea. He said that it was always a mistake to become too intimate with the servants and that it might be bad for my language and pronunciation. I couldn't see anything wrong with Jerry's way of talking and couldn't see that there was anything wrong with having a meal with him, and in a dim way I felt bad for Jerry's sake, knowing that he too would be disappointed.

With Jerry up at Rolling Rock, the field was left clear at home for John Moore, the chauffeur. John drove and looked after our

large Pierce-Arrow touring car. He let me sit in the driver's seat as the car stood under the porte cochere and talked to me in his friendly way, while I watched him oiling the car's valve springs, polishing its enormous brass exhaust pipe, or periodically painting the engine. What endeared him most to me was the Odd Fellow's watch fob that he wore. It was a very impressive sort of medal, which I remember as having a red cross and a white cross and a large gold medallion, like a gold coin, in the center. I was always asking him about it and trying to persuade him to give me one, but John told me it was only for members of the Lodge, and that impressed me even more. I wondered why Father didn't join the Lodge and get a medal like that. Jerry, the groom, and John, the chauffeur, had never got on very well, the former being a green Irish Catholic from the South and the latter a Protestant Orangeman from the North, but it was the end of an era, and John Moore with his motorcar had supplanted Jerry with his horses.

After that year at the kindergarten I went to the junior school of Shadyside Academy. The junior school was near the Oakland suburb of Pittsburgh, just a short distance from Forbes Street, and I was initially taken there in the carriage or the car, progressing to a bicycle during the course of my four-year stay. I didn't like the school very much, but I started reading more seriously. There were spelling bees, and I always did well in them. I especially enjoyed the reader with its excerpts of prose and poetry. I was particularly impressed with the passage from Coleridge's "Kubla Khan" that reads, "Where Alph, the sacred river, ran,/Through caverns measureless to man/Down to a sunless sea." It wasn't surprising that I didn't really understand the hallucinations and esoteric derivations of this poem. But I loved the sound of the words. I enjoyed Tennyson's "The Charge of the Light Brigade," too, all dash and bravura.

The eight-year-old boys were entering the aggressive stage and formed themselves into gangs, always picking on one another. Having been brought up among girls, I didn't know how to cope with their bullying but was fortunate that Craigie McKay's brother, Jimmy, who had come to the school after a

year in England, befriended me. For a long time Jimmy McKay
was known as English Jim. Jimmy's having a slight English ac-
cent and being the brother of a friend of Ailsa's made it natural
for us to get together. He was larger and more muscular than I
was and acted as a kind of bodyguard. When other boys asked
me where I lived, I found it embarrassing because I had two
addresses; sometimes I was living at one and sometimes at the
other. Jimmy understood this, though, and didn't ask questions.

On occasion Jimmy and I went out together on weekends to
Rolling Rock, where Jerry was now keeping the horses. Father
and Uncle Dick were building a clubhouse there for the future
use of their business and social friends. While this was being
built, they restored a log cabin nearby, so we stayed there. We
rode and drove pony carts over the dirt roads and through the
wooded countryside. Jimmy McKay was very much an entre-
preneur and always had the idea of making money in his mind,
so he and I used to drive in the pony cart to Rector, a nearby
village, and stock up with soft drinks like orangeade and Coca-
Cola. When we got back to Rolling Rock, we sold the drinks to
the workmen building the clubhouse. We made a 100 percent
profit, and this was the first and last successful commercial en-
terprise that I was ever involved in, except for my rather more
serious racing and breeding business.

With America's entrance into the First World War, we natu-
rally wanted to be soldiers, so Jimmy McKay organized an army
with himself as general, myself as a captain, and Ned Mellon,
a younger cousin, as a private. At that point Jimmy ceased to
be English Jim and became Big Mac. We used to go around the
countryside with air guns shooting at things, and I felt that
helped toughen me up a little.

What happened to Jimmy McKay? Either he got lazy, or he
wasn't as bright as he seemed. He didn't do very well when he
went to Choate with me, in spite of the fact that he was quite
popular. After school he attended the Columbia School of Jour-
nalism and later returned to Pittsburgh, where he became a
stockbroker. From then on he went gently downhill. He became
friends with two friends of mine, Chauncey Hubbard and

George Wyckoff, when they came out from Yale to Pittsburgh and, together with me, started what we hoped would become a hamburger chain, called the Ranch System. At least that was the intention, although we never got further than that first outlet. McKay was still the entrepreneur, and it sounded like a good idea, but none of us had had any experience in the restaurant business. We began by employing a crooked manager. Soon the whole thing collapsed, and we lost every cent we had put into it. McKay later lost more money in the stock market crash of 1929, and when the Second World War came, he was living out in California.

I always remember Jimmy with warmth, for he was my first real friend and on the whole, I would say, a positive influence at that age. He was precocious, a teenage man of the world. He bullied me into going to dancing school and later to teenage dances, and I was always envious of his easy way with girls, his ability to charm them with small talk, and his dancing. He was also a fair athlete, and he cajoled me into playing baseball. By the time he got to Choate, however, a certain lethargy had taken over, and I can't remember his being a star in any sport there. I was stationed at the Cavalry School at Fort Riley in 1942 when I received a telegram from Jimmy's widow saying that he had died of cirrhosis of the liver. He would have been about thirty-five.

Thinking back on that early, and disastrous, commercial adventure with the Ranch System, I recall one other bright business idea that I might have undertaken many years later in my life. Sitting on the cold, hard bottom of a bathtub one evening, I thought how wonderful it would be if I were sitting on foam rubber or some softer surface. Why weren't rubber bathtubs made, and wouldn't it be the answer to the thousands of injuries caused by falls in the normal porcelain bathtub?

We were remodeling little Oak Spring on our farm in Virginia at that time, and there were two air-conditioning engineers working with us in whom I had great confidence. They agreed to work on a life-size model of a foam rubber or plain rubber

tub or at least on a portable lining for standard-size tubs that could be inserted by plumbers. They finally had a prototype tub set up in a large storage building near Dulles Airport. On my way home from a day at the National Gallery in Washington, I stopped in to see their handiwork. The tub looked so inviting with its soft gray rubber lining that I took off my coat and trousers and stretched out in great comfort. There was no water in it, of course, and at that point my engineers explained to me that the catch in a working example was going to be the sealing of the faucet, the overflow hole, and the drain.

We put in for a patent, but because it hadn't really been thought through and there were other technical bugs, we never got it, and eventually I lost interest. What I did accomplish, however, was to get a certificate of incorporation for the Rub-a-Tub Corporation, which was filed with the State Corporation Commission of Virginia in 1956. I believe I still have the name reserved and would be glad to release it to some more recent entrepreneur—but at a price!

While I was still at Shadyside Academy, Mother became interested in Christian Science. The Christian Science church was just down the street from the school, and there she became interested in the organist, Charles Mustin. She was lonely, and they shared a love of music. She started taking organ lessons from him at the church and later at the organ that she had installed in her house on Howe Street. On one occasion a master at the school asked me if that wasn't my mother's Minerva parked outside the church, and I replied, "Yes, we go to that church." I was getting experienced at fending off that sort of question. Mother took me to the Christian Science church on several occasions, and I met Charles Mustin, who was an agreeable fellow and quite a good musician. Mustin supplemented his modest salary as an organist by playing the piano in the silent movie houses around town, and he was also a salesman of Chalmers cars when they first came out. In those days it was meant to be the car of the future, and I was very pleased when

Mustin turned up at Howe Street in one of these two-seaters to take me to school.

The same year that Mother met Mustin, 1915, Father took Ailsa and me for a summer holiday to East Hampton on Long Island, and again the following year. He had rented a typically vast shingle-type Long Island house called The Cottage. Lanes ran between the houses, each of which had a large lawn surrounded by a thick eight-foot-high hedge. Ailsa and I spent most of our time with the nurse on the beach, where we collected driftwood, built sand castles, and threw stones at enormous jellyfish. We had to be careful about swimming as there was a dangerous undertow and the waves were often tremendous.

It was at East Hampton when I was eight that I went to my first party. I didn't want to go, and a flood of shyness and embarrassment swept over me as, wearing my sailor suit, I was led through a little gate onto a wide, sunny lawn filled with children, all shouting, laughing, and playing. Nothing could induce me to join in a game, to talk to the other children, or even to have a lemonade or an ice cream. A group of boys and girls were playing a game in which they danced in a circle around a child left standing in the middle. There was something to do with kissing your partner at the end of each round. I thought some of the girls looked absolutely beautiful, but the idea of being expected to kiss one almost paralyzed me. I stood there frozen stiff with self-consciousness for the whole afternoon and wouldn't move from the side of my nurse. After threats and coaxing from the nurse and kind words from the hosts had failed to move me, to my intense relief we finally left.

An understanding master at Shadyside Academy named Orville Ott got in touch with my father around that time and explained diplomatically that in his view I needed a little beefing up, that I was too weak and unenterprising. He said he thought it would do me a lot of good if I went to camp. As a result, I, another Pittsburgh boy named Pat Keefer, and my friend Charlie Lockhart, all pupils at Shadyside Academy, were sent off to Camp Marienfeld in Chesham, New Hampshire. I was there for

two months in 1915 and returned for the same period during the following two years. At first I was very homesick, but this wore off after a week, and I began to enjoy it. In my last year, when I was ten years old and the United States had just entered the First World War, we formed a camp infantry troop. There were no uniforms, but we had wooden rifles, and Mr. Stacy, the headmaster of the camp, engaged a retired West Point officer to drill us on the parade ground. At this stage I was surprised to find I had a skill I could put to some use. I was able to play the bugle. My mother had earlier thought that I should play a musical instrument. First it was the violin, which was a disaster, and then the piano. I had also learned halfway to play the trumpet and could blow a few notes on it, so I was now made the troop bugler and promoted to the rank of corporal. I would blow a call to "fall in" and another to "fall out." I enjoyed this new authority.

One day the ex-regular Army officer was drilling us when he ordered, "Dress right." I raised my elbow and pushed and pushed, but no one moved fast enough, so I shouted at them to "get the hell to the right." The officer hauled me out and gave me a thorough dressing down, telling me the Army didn't allow bad language. He lectured me in front of the whole troop and told me to report to Mr. Stacy, who gave me a week's corrective punishment working on the tennis courts. Oddly enough, when I left, I realized that I had really enjoyed camp. Being shouted at by an Army officer was far preferable to receiving strictures from a nurse.

In 1917 Father moved to another house, on Squirrel Hill, in East Liberty. He sold or gave the Forbes Street house to what is now Carnegie Mellon University and bought a much larger one on Woodland Road from Thomas K. Laughlin of Jones & Laughlin, a Pittsburgh steel company. It isn't clear why Father, who appeared to have been relatively oblivious of his surroundings, should have wanted a different environment. Perhaps the Forbes Street house held unhappy memories for him; perhaps the University was expanding, needed the house, and this other house had come up for sale; but whatever the reason, it was a

good move as far as I was concerned. The Woodland Road house was in a relatively countrified setting on an uphill, winding private road. It had been built some twenty years earlier in the mock-Tudor/Jacobean style and looked not unlike the way I imagine the house at Windy Corner to have been in E. M. Forster's *Room with a View*. There was attractive oak paneling on the ground floor, and the doors were thick, with good-quality hardware. In contrast with Forbes Street, where streetcars rattled and clanged past the front door, Woodland Road was silent both inside and outside. It was spacious, and Father installed an indoor swimming pool and a bowling alley.

A year or so before Father moved to the Woodland Road house, he employed a governess to take care of me and to act as chaperone and confidante to Ailsa. Alice Sylvester, always Miss Sylvester to me, was a typical New England spinster who came from the Boston suburb of West Newton. I'm not able to say that I loved her, although I never resented her. I think she gave me confidence in myself, and I achieved a certain peace of mind from her consistently firm, but fair, discipline and her insistence on punctuality. The discipline would involve making me, and perhaps Ailsa, pick up our discarded clothes, eat slowly and with the right utensils, and write thank-you letters for Christmas and birthday presents. Where Father and Mother had left off, Miss Sylvester taught us good manners. She had a Boston accent and *looked* Bostonian, with a rather plain face, gray hair, and pince-nez glasses. Our closest approach to intimacy would occur at my bedtime, when she invariably read to me. She read well, although I cannot remember what tales and authors she chose. Then in 1919 I went away to Choate, and in 1921 Miss Sylvester followed Father and Ailsa to Washington, where Ailsa took up her duties as his social hostess. So our relationship as governess and child was fairly brief, but in spite of its brevity, her governance left its mark in a very positive way.

I *liked* Miss Sylvester, feared her a little, but respected her, and I was always glad to see her on my infrequent visits to our Washington apartment. She retired to Boston when Ailsa was

married in 1926. In later years, when I used to visit my son, Tim, at his schools near Boston, I would often have lunch with her and talk about old times. Then, when she died a few years ago, I went to her funeral, and that saddened me.

It is difficult to remember the exact sequence of years, or of the summer houses where Ailsa and I spent our holidays with Father. I can now see that none of them had any particular pattern, or reason for having priority at any given time. I remember that, very early, when I was about six, we had a house in Manchester, Massachusetts. I can recall picnics at the shore in Gloucester which were reminiscent of our visit to Uncle Percy in Dartmouth. In the years that followed, we spent one or two holidays each at Prides Crossing on the North Shore of Massachusetts and at Hot Springs in the mountains of Virginia. The latter was chosen because it was an easy overnight train journey from Washington for Father, who could spare only weekends away from the Treasury Department. These vacations were usually filled with golf and tennis lessons, with riding along wooded trails and competing in horse shows with Hotspur. Years later, when I became hooked on the Virginia Hundred Mile Ride in the mountains around Hot Springs, I found myself traveling over the same thickly forested mountain trails that I had ridden with Jerry, our groom, and remembering many of their landmarks and spectacular views. Each day we would pass The Pillars, the cool and commodious summer mansion so like its other summer counterparts. My childhood always seems to be repeating itself.

Intermittently, from 1917 onward, we had a large house in Southampton, Long Island, surrounded by wide lawns and with a pond that separated us from the Meadow Club. International lawn tennis was played at this club during "Tennis Week." As usual, the house had a stable where Jerry officiated, and from there we rode out to many of the outlying woods and fields (all gone now). Hotspur and I would go to compete in the Suffolk Hunt horse show, where we won several cups and ribbons. There were also paper chases on horses (my first taste of the excitement of the hunt), and I remember my consternation when

Betty Sharpe, a girl I was a little in love with, had a fall. I had visions of jumping off my horse to help her, but as usual I was too late and she was already surrounded by others.

In addition to tennis lessons at the Meadow Club, golf lessons at the Shinnecock Golf Club were another standard fare. I have never been any good at games where hitting a ball with accuracy was a requisite, not baseball, tennis, or golf. But being taught by the club professional, Charlie Thom, was always fun, and the inimitable aphorisms uttered in his Scottish brogue made my whiffs and slices more palatable. One particular saying that he invariably used, to counter any excuse on my part, went, "If the dog hadn't stopped to pee, he would have caught the rabbit." Shinnecock was a particularly lovely course, high in the barren hills between Shinnecock Bay and Peconic Bay. Covered with heather and bayberry, it was like a miniature Scotland in which Charlie Thom and his brogue seemed very much at home.

Rich kids in Southampton and other resorts in those days owned a species of small automobile called a Red Bug, a low-slung buckboard with two seats, an accelerator, a brake, and a lever that hoisted and lowered the rotary, bicycle-tired motor in the rear. I was no exception. Traffic then was minimal, so I suppose we weren't in any great danger as we beetled around the narrow roads and negotiated blind corners overshadowed by high, clipped privet hedges.

One day, I was swinging around our large lawn in my Red Bug. The lawn sloped gently down to the pond. Miss Sylvester came out of the house to watch me, so I showed off my skill in larger, then smaller turns. Suddenly an idea came to me. I asked her if she would like a ride, and to my surprise, she accepted. My original intention was altruistic and prompted by pride in my driving, but I'm afraid a darker motive soon took over and I decided to have another kind of fun. As we were approaching the pond I nimbly jumped out of the driver's seat and let the vehicle, and Miss Sylvester, go free. Never having driven, she had no idea how to steer or how to stop the motor, so there was a fascinating moment as the Red Bug and Miss Sylvester headed toward the pond. Fortunately it was all slow motion,

but into the shallow edge of the pond they slid, the motor churning up mud and finally stopping. Only her feet and lower skirt were wet, but her face would have frightened Frankenstein. I'm sure the unuttered words churning through her head would have shocked her Bostonian friends and relatives in West Newton. I can't recall the subsequent punishment, but I expect that I was not running around in my Red Bug for the rest of that summer.

When Father traveled from Pittsburgh to New York, he went by night train and arrived at Pennsylvania Station. He usually stayed at the old Holland House, but later he used the newly opened Biltmore Hotel. On one of these trips, in 1917, when I was with him, we both were invited to tea with Mr. Frick at his residence on Fifth Avenue. The celebrated mansion on 70th Street, designed by Thomas Hastings in 1913 and 1914, is in the style of eighteenth-century European domestic architecture and was later, after Frick's death, adapted as a museum by John Russell Pope. To start with, Mr. Frick had bought the then-fashionable Barbizon school pictures, but from the early 1890s on, his taste turned toward the Old Masters. The collection bears testimony to his superb taste and judgment. Apart from other masterpieces, Frick had, in 1913, acquired the wonderful series of paintings by Fragonard representing "The Progress of Love" from the estate of the recently deceased J. P. Morgan. The artist had painted them for Madame du Barry in 1770. When we arrived at the house, they were in place in the Fragonard Room, where we were served tea and where they may still be seen today. I, who was then ten, haven't much recollection of the conversation between Father and Frick during tea and remember Mr. Frick only as an old man with a big white beard. He died two years later in 1919.

About 1915 Ailsa had gone off to boarding school, first at the Low and Heywood School in Stamford, Connecticut, and later at Farmington. She was very unhappy at both places, and I am sure the dark and frightening days of the divorce and the evil rumors about Mother were more disturbing to her than anyone

at the time imagined. Although she had always had two or three close friends like Craigie McKay, who was the same age, and Margaret Wolfe, who lived next door, she seemed somehow to withdraw from all social contact and become more and more obsessed with her health. As a young child she had been quite a tomboy and very high-spirited. Even at the age of thirteen, when we spent part of the summer at Sewickley with Father, Ailsa was still active and outgoing. She read a lot and got involved in some absurd fads.

I walked into her room one morning when we were living at the Denny house in Sewickley Heights and found her sitting cross-legged before the fire, consuming an enormous meal of fruit, cereal, lamb chops, and potatoes, with piles of buttered thick toast on the side. She had just read in a magazine that it was important to start the day with a good breakfast. Another enthusiasm, connected this time with the expression of freedom, was to run across a field with her arms outstretched. I stretched my arms out and ran across the field below the house, knowing that Ailsa was watching me from a window. I wanted her to see how wild and free I, too, had become. All these happy antics stopped during the next year or two. Past experiences and the onset of adolescence seem to have conspired together to defeat Ailsa. She was gradually becoming more and more introspective and hypochondriacal. I often reminded her that she was always complaining about her health, saying that there was something wrong with her glands, something wrong with this, or something wrong with that. I didn't understand then what was the matter with her, and it upset me. I was losing a good companion.

By 1919 the time had arrived for me to leave Shadyside Academy. The fashionable prep school for Pittsburgh boys at that time was St. Paul's in Concord, New Hampshire. Charlie Lockhart's father took Charlie and me up to Concord to have a look at the school, but we didn't like it. For one thing, in the first year, maybe for the whole of our stay, we would have had to live in cubicles rather than in proper rooms. But apart from that, Charlie and I didn't care for the atmosphere of the place. One

of the counselors at Camp Marienfeld was, on the other hand, a master at Choate, and he took the opportunity to talk to Father and to Charlie Lockhart's father about their sons going to his school. We were given a brochure with photographs showing that the school had formed a uniformed cadet corps on account of the war. That sold it to us. Charlie Lockhart and I went to Choate and roomed together. Unfortunately we quarreled a lot, and because Charlie was stronger than I was, he usually managed to beat me up. We also discovered that the brochure we had been shown was out of date and that the cadet corps had been disbanded with the end of the war. No uniform, no marching, no bugle!

After I had left home, at the age of twelve, to go to Choate as a boarder, Mother moved from Pittsburgh to Hudson in Columbia County, New York. Father had bought her a small farm called Brookwood of some two hundred acres back in the country. She took Charles Mustin along with her, and he was able to run the farm with the help of a hired hand. This may seem a far cry from selling Chalmers cars and playing the organ, and Mustin must have found his sudden passage to the role of farm manager rather unusual. I liked Charles Mustin very much, and I loved going up there during my vacations. There was a large and very colorful garden that Mother looked after herself, and I enjoyed fishing in the creek, collecting eggs from the chickens, and shooting rats in the big barn. It seemed an idyllic existence until one tragic day.

After they had been on the farm for several years and while Mother was temporarily away in New York, Mustin was driving a maid into Hudson to catch a train. They had an old Ford car, and he had never been a good driver. He lost control of the car and ran head-on into a telephone pole. I remember Mother taking me to see him in the Lenox Hill Hospital in New York. As a result of the accident, he was, and remained, totally paralyzed.

In those days the boys at Choate spent their first two years in junior school; then they had four more years in the third, fourth, fifth, and sixth forms. I arrived when I was just twelve

and was eighteen when I graduated. At that period Choate was quite small and not very good scholastically. It had been founded some twenty years earlier with only about 180 pupils. The Headmaster, Dr. George St. John, was rather pompous and not greatly respected by the boys. His wife, Clara, was different. She was the sister of Charles Seymour, who later became President of Yale. She had a long, rather Burne-Jones–like face and wore lengthy, flowing Victorian-style dresses. She was a very intelligent woman and a very friendly one. When I was in the junior school, she read to us on Sunday evenings. She chose adventure stories such as Robert Louis Stevenson's *Treasure Island* and *The Master of Ballantrae* and Sir Walter Scott's *Ivanhoe*. I loved those evenings and still feel grateful to Clara St. John for giving a stimulus to my imagination and reading at this crucial stage. I didn't do very well at first in my studies but improved as time went by.

Old George St. John left a lot to be desired as a headmaster (e.g., why did Choate trail so badly scholastically and fail so dismally in having its students accepted in the better Ivy League colleges? And why did so many of those accepted fail to graduate?). When his son Seymour succeeded him, it was a different story. Seymour was a year or so below me in Choate, and one would have hardly seen him as a potential headmaster at that time. But beginning with his leadership, the school gradually pulled itself up scholastically and increased greatly in size, becoming one of the best boys' preparatory schools. Later, under the equally inspired leadership of Charles Dey, when Choate merged with Rosemary Hall, the Greenwich girls' school, the newly named Choate Rosemary Hall rose to equal the very best of the large coeducational preparatory schools in this country.

During my time there, however, while some of the masters were good, others were anything but satisfactory. I never did well in mathematics, although I managed geometry and algebra by learning the theorems and equations by heart. The underlying principles were beyond me, and both subjects just provided an exercise in memory training. Literature and poetry were another matter. I had already had my initiation in this field

with *A Child's Garden of Verses* and my reader at Shadyside Academy, and I now had the good fortune at Choate to be taught by a delightful and eccentric English teacher named Paul Griswold Huston. I wasn't sure whether this splendid character managed to instill into his pupils' minds any great knowledge of the subject he taught, but he was so humanly eccentric and so unusual in his approach that the boys listened to him. When giving out questions to answer for a written test, for instance, he would label them "toothbrush one, toothbrush two," etc. My other English teachers also helped stimulate my interest in poetry, plays, and novels.

My time at Choate coincided with the early days of Prohibition, and even in our fifth and sixth form years, on vacations, we were beginning to frequent bootleggers and drink gin and whiskey and applejack. I remember well sitting in a side room at a club dance in Pittsburgh with Jimmy McKay and some others, all drinking out of small silver hip flasks, straight. Every vacation from Choate we passed through New York on our way home to Pittsburgh and took in some musical show of the day: *Music Box Revue, Ziegfeld Follies,* or *Charlot's Revue.* I remember, to my horror today, piling onto the *Pittsburgher* in Pennsylvania Station with Jimmy and other young Pittsburghers, all of us ossified, and going home to meet Father at Woodland Road the next morning with a terrible hangover.

It was Jimmy's way with girls, however, that I remember most clearly. It was the source of much frustration on my part, for I could never hope to emulate him in that department. On the other hand, I no doubt absorbed a great deal indirectly and was more and more able to cope with my awkward shyness. His example was not only practical but always accompanied by a charming light humor.

One scene at Choate remains particularly vivid. One lazy Sunday morning we were discussing what we were going to do in life after college. All of a sudden Jimmy McKay said to me, "I know what you ought to be in the future . . . you must be a philanthropist." It would be stretching the imagination to say that this pronouncement was either encouraging or prophetic,

but looking back on my life, I can see that he didn't miss the mark by much.

During the last two years at Choate we took the inevitable College Board examinations. Choate boys did not usually do particularly well in the College Boards, and I was no exception. However, in those days it was much easier for boys in American prep schools to get into prestigious colleges like Yale, Harvard, and Princeton. So, after passing my exams during my last year at school, I was all set to go to Princeton. Like St. Paul's, Princeton was the popular choice among Pittsburghers. This was probably because it was originally a Presbyterian-based college, unlike Harvard and Yale, which had been Congregationalist. The time approached for me to go, yet I somehow felt uneasy. Several fellow students at Choate on whom I wasn't too keen, including a probable roommate, were heading for Princeton, but this was not the main reason I was beginning to change my mind.

During my years at Choate I had often visited New Haven for the dentist and for football games. It was not far away, and during my visits I had been particularly impressed with Harkness Quadrangle, later to house Branford College and Saybrook College, with its green lawns and intimate courts. More to the point, I had been told what fine English and History departments Yale had. Two weeks before I was due to leave for Princeton, in the autumn of 1925, the Princeton authorities sent me a freshman handbook. It was bound in black leather, like a prayer book, had extremely small print, and contained a plethora of depressing rules. "Only black shoes, socks, garters and ties may be worn. No fancy vests of any description," "Freshmen are always expected to carry wood for the bonfire celebration of important athletic victories," and many other rules couched in the same language focused my misgivings about Princeton, and that, coupled with my growing interest in Yale's department of English, made me decide to go to Yale instead.

Within a week I had summoned the courage to call my father, who asked why I wanted to make the change but put up no objections when told the reason. I had sent a telegram to the

head of admissions at Princeton explaining that I wanted my College Board credits sent to Yale because I had now decided to go there, and I had applied to and was admitted by Yale University, all within seven days. I hadn't expected Father to object to my changing my choice of college, but I had nevertheless consciously or otherwise made a statement to myself that *I* was going to make the decisions about my own future, and I have never regretted this one.

In November 1920, shortly after I had gone to Choate, Warren Harding was elected President. Father had provided substantial contributions to the Republican party over a number of years. As a result, he had acquired considerable influence within the party and was of course well known for his business acumen, but he had never made any attempt to obtain public office, nor had he wanted it. The Bank and his business interests had fulfilled all his ambitions.

Father had been for many years a client of Knox & Reed, the Pittsburgh firm of corporate lawyers. Judge Reed had represented him in his divorce suit, and his partner, Philander Knox, who was also an old friend, had earlier gone into politics with Father's support. Knox had been Attorney General in President McKinley's Cabinet at the beginning of the century, and Father, together with Frick, had had a lot to do with his last election to the Senate. Father had a high regard for Knox as a conservative and a man of integrity, and he urged him in 1920 to become a candidate for the presidential nomination. The feelings were evidently reciprocated. Early in 1921 Knox, who seems to have dropped any idea of running for President or of seeking a Cabinet post for himself, was pressing Father's candidacy for the post of Secretary of the Treasury with Warren G. Harding, the President-elect.

In an open letter to the Boston *Evening Transcript*, dated January 23, 1921, Knox says:

> I took upon myself, without Mr. Mellon's knowledge, the responsibility of strongly pressing upon Senator Harding

the wisdom of appointing him Secretary of the Treasury. I did this not with a view of serving Mr. Mellon but to help Senator Harding make good his promise to the American people that he would surround himself with the most capable advisers available. My appraisement of Mr. Mellon's character, aptitudes and attainments is predicated upon a personal intimacy covering his entire adult life and a thorough personal and professional knowledge of his aims and methods in his great undertakings. Mr. Mellon's entire life has been given to constructive work—to translating great capacity into great accomplishment. His is one of the few cases where his wealth is an accurate measure of his ability. He has never financially debauched any enterprise with which he has been concerned. He has never multiplied his fortune over and over again by resolutions to increase capital stock. He has never floated issues of stock upon the market in connection with any of his great works of industrial development. With marvelous vision and imagination he has spent his life in developing new fields for American energy and opportunity and in my deliberate judgment he is the greatest constructive economist of his generation.

All that Knox said about Father's business philosophy was true. Not one of the corporations that Father was interested in— the Aluminum Company of America, Carborundum, Gulf Oil Corporation, McClintic-Marshall Construction Company, Standard Steel Car Company, or Koppers Company—had their shares listed on the Stock Exchange. He liked to run businesses in an old-fashioned way. As it was often said, "to find a man who can run a business and needs capital to start or expand, furnish the capital and take shares in the business, leaving the other man to run it except when it is in trouble. When the business has grown sufficiently to pay back the money, take the money and find another man running a business and in need of money and lend it to him on the same basis." Father was pleased to let a business be taken over, as in the case of Union Steel, provided the price was right, rather than resort to a battle for control, but in fact, he liked, wherever possible, to keep the businesses within the family. In his eyes, the Stock Exchange

was for gamblers, and he thought gambling was a foolish occupation.

Harding, who knew Father only casually, accepted Knox's recommendation and invited him to come out to his house at Marion, Ohio, where he was considering the makeup of his Cabinet. During lunch, at which time the question of the secretaryship had not even been broached, Mrs. Harding turned to Father and said, "I am delighted we are to have you in Washington with us." Father looked at her anxiously and answered in his barely audible voice that he appreciated her feeling as she did about it but that there was little possibility of his going there.

Later he explained to Harding that he didn't wish to accept the appointment and believed that he would be a handicap to his administration by reason of his business and industrial connections, particularly his ownership of some stock in the Overholt distillery, because of the Eighteenth Amendment, which had been passed two years earlier and had ushered in Prohibition. Harding waved this objection aside, saying that he owned some stock in a brewery himself, that it was perfectly legal to do so, and that he would not take any such excuse from him not to take the Treasury post. As Father left, he said, "Senator Harding, I have just one personal favor to ask of you, and that is that you find someone else for the Treasury and relieve me from going to Washington." Realizing that he had a man with a reputedly brilliant financial mind and a man of integrity, Harding was resolved that he would not take no for an answer.

After a great deal of urging, from Ailsa, among others, and much soul-searching on Father's part, he turned his stocks over to Uncle Dick against notes, resigned from some sixty directorships in banks and corporations, packed his bags, and left in 1921 for Washington. He was sixty-five—an age when most men are considering retirement. He was to remain in Washington for the next eleven years, and apart from Albert Gallatin (who was Secretary of the Treasury from 1801 to 1813), he was the longest-serving incumbent of that office. He served under Harding, Coolidge, and Hoover, the three Republican Presidents of the 1920s, continuing in office until 1932, by which time he was

seventy-six. It was a long-standing joke in Washington that three Presidents had served under him!

In the spring of 1923, unknown to Ailsa and me, Father had asked Mother to remarry him. It happened that she was just then on the point of marrying an English antiques dealer in New York called Harry Lee when Father made his second proposal. It drew this (undated) letter of response from Mother:

> Dear Andy,
>
> ...I would have waited till I died. But the hope I had had, gradually died & it was then that I felt I could bear no longer that dreadful loneliness. This is not a reproach, dear Andy....
>
> ...even though I feel I have a mortal, inward bleeding wound, still I am so grateful not to have died without telling you how much I have loved & missed you all these years. As long as I live it will always be the same.
>
> I shall try very hard to be brave & regain some peace when I am once more among my flowers. Think kindly of me sometimes & if you can, write me.

Father replied on March 13, 1923, from his Washington apartment, and his answer demonstrates that Mother appeared to be the only person capable of breaking through his emotional armor. He writes:

> Dear Norchen,
>
> I have read your letter and it has grieved me deeply, while at the same time bringing solace and abiding comfort.
>
> I have been sadly wrong but must tell you how it was that I did not speak sooner. In the years of contention there was on your part a seeming animosity and bitterness which I did not believe could disappear. When suggestions were made of conciliation I believed you unfeeling and did not think you could really care for me. However wrongly I attributed to you motives of expediency and convenience....
>
> I did not believe that any love existed for me and so when I heard of your engagement to Mr. Lee it only gave me a

heavy heart. When I learned that the day was close at hand I had a twinge of pain and felt that I must see you. It was then the revelation and understanding came to me. It proved too late—your letter was so *final*.

The old love was in my heart even while I was so obtuse and blind, and it makes me heartsick to think of you in all this time suffering so sadly alone. The past can not be brought back and we must now look to the future. You have had more than your share of unhappiness and are entitled to brighter days.

I want to be helpful to you now and always. You must look forward and not allow anything of the past to distress you. Interest in the farm and garden will do much and your married life can become a happy and contented one.

For myself, aside from all else, the truth of our understanding remains and is an abiding comfort in my heart. I shall be interested in your life and pray for your happiness. . . .

I hope you are now feeling well and strong again. God bless you, dearest Norchen,

Your ever loving Andy

Father was sixty-eight; Mother, forty-three.

Mother married Harry Lee shortly afterward, and they remained together for six years, when she obtained a divorce and resumed the name of Mellon. I didn't care much for Harry Lee, and I didn't like Mother changing her name to Lee, then, after the second divorce, changing it back to Mellon. I wrote to her asking why she could not keep the name of Lee, as we all were used to it. By the time she received the letter she had already changed it, but it brought back too many memories for me, having to explain all these changes to everybody.

Father honored his promise to help Mother "now and always." Apart from buying her the house near Hudson, New York, he also funded the purchase of the house she moved into with Harry Lee in Litchfield, Connecticut, and, after her divorce, one in Stamford, Connecticut, making her at that time an unrestricted gift of securities sufficient to bring her a comfortable income. Finally he bought her Rokeby, Admiral Cary Grayson's four-hundred-acre farm in Upperville, Virginia.

CHAPTER 7

Universities:
Yale and Cambridge

———◆———

...not for knowledge so much as for arts and habits; for
the habit of attention, for the art of expression, for the art
of assuming at a moment's notice a new intellectual posture,
for the art of entering quickly into another person's
thoughts, ... for the habit of working out what is possible
in a given time, for taste, for discrimination, for mental
courage and mental soberness.

Above all, you go to a great school for self-knowledge.

—WILLIAM CORY, poet and master at Eton,
describing a liberal education

Leeze me on drink! it gi'es us mair
Than either school or college.

—ROBERT BURNS, "The Holy Fair"

I left Choate School in 1925, when I was eighteen. My father,
by then in his seventieth year, had been serving in the Treasury
for four years. He spent most of his time in Washington at his
elegant apartment on the top floor of a building designed by
Jules de Sibour and completed in 1916, at 1785 Massachusetts
Avenue. Ailsa had come to Washington with him and was act-
ing as his social hostess, although he had kept the house in
Woodland Road. The three of us a year or two earlier had made
a summer visit to England and to France, where Father had
taken us around the battlefields of the First World War, but apart
from spending that summer and parts of school vacations with
him, I saw very little of him during this period.

In the autumn of 1925 I went to Yale. There were no residential colleges at the University at that time, and I roomed with Fuller Leeds, a Choate friend, in a house on the corner of York Street and Elm Street. Leeds dropped out after his freshman year, but I made a number of other friends through working on the board of the *Yale Daily News*. "The Oldest College Daily" was founded in 1878 and saw its fiftieth anniversary during my spell on the staff. It provided daily information on sporting activities, university news, and some political coverage. It was well illustrated and also carried pictorial and literary supplements. There were plenty of advertisements promoting things like fountain pens and furniture, raccoon coats and cigarettes. I was one of ten applicants, or "heelers," for the five or six places available on the board.

Successful candidates were chosen from two competitions a year. Mine started shortly after the autumn term began and went on until the middle of February 1926. It was extremely time-consuming, and although I eventually became Vice-Chairman, I came to regret that I had ever undertaken it. We were reporters, assigned to cover various events and to interview people, preferably important people. I scored extra points because Father arranged audiences for me with President Coolidge, Admiral Ballard of the Coast Guard, General Billy Mitchell, and others. At my interview with the President he belied his reputation for taciturnity. He was very cordial and spent a long time with me discussing an upcoming naval conference.

I was elected to the board, but it didn't end there. I had to write editorials and act as editor for one or two nights a week up through my senior year. It was a way of meeting interesting people, as well as other students, but in retrospect I would have been far better off to have devoted more time to my English and History courses and to writing for the *Yale Literary Magazine*.

The approach to teaching during freshman year was disciplined and well suited for students coming straight from school. There were two kinds of courses. First you were set some reading for the next day, when the class of some twenty students had a session of questions and answers with the instructor. This

class partly involved lecturing by the instructor as well as questions about what had been read. In the second course you began with a ten-minute paper on a subject that had to do with the day's lesson. This would be followed by a full-scale lecture by the professor with perhaps a few questions afterward. It was a method that compelled study, but the drawback was that you needed to do only as much as you had to, day by day.

There were some wonderful lecturers at Yale during the years I spent there. William Lyon Phelps, known as Billy Phelps, delivered popular lectures, one of his courses being on Tennyson and Browning. He was very entertaining, and although his lectures were not as scholarly as those given by other professors, they were always well attended. Billy Phelps was a bit of a showman, and at one point he managed to persuade Gene Tunney, the heavyweight boxing champion, to deliver a lecture on Shakespeare. He had met Tunney while playing golf on a holiday in Florida and discovered that they shared an interest in the bard. I managed to squeeze into the lecture hall, which was absolutely packed, and heard Tunney speak without notes on *Troilus and Cressida*. It wasn't a bad lecture at all.

Chauncey Tinker was a fine scholar whose course "The Age of Johnson" was world-famous. Then there were John Allison, whose specialty was the Middle Ages, and Bob French, who lectured on the Age of Chaucer. I also took some rudimentary courses in art history. We pasted reproductions of paintings in notebooks and took notes on what the professors said about the artists and the paintings. Looking at the reproductions seemed a little pointless to me when I could see originals of similar quality at Woodland Road or in our apartment on Massachusetts Avenue, and the historical element did not at that time fire my imagination. You were required, in each of the freshman and sophomore years, to undertake one basic science. I elected to take chemistry in freshman year and biology the following year. Chemistry was almost a disaster, and although the professor of my particular class assigned a senior to give me extra tutoring in the subject, I barely scraped by with a passing grade. I was, however, producing good results in my main subjects.

In my sophomore year I joined Chi Psi, which was new on the campus and thus entitled for two or three years to "pack" or preempt sophomores. This meant I had a choice to join it with several of my friends and to find myself on familiar terms with a large group of upperclassmen as well. There were also friends from the *News*, so I found that I knew quite a lot of men in the fraternity. It was really an eating club. We had meetings once a week at which a lot of arcane mumbo jumbo was uttered, but it was having meals together that helped cement friendships and promote conversation.

I roomed with Lenny Mudge, an old friend from Pittsburgh, and Jack Douglas (both from St. Paul's) right on through our senior year. While a new Chi Psi fraternity house was being built, we were all welcome at the Psi Upsilon house, where I made many other friends, including George Wyckoff, Chauncey Hubbard, and Dick Goss. Chauncey Hubbard subsequently got a job in the Mellon Bank, and George Wyckoff started his business career in the Union Trust Company in Pittsburgh. George later became my personal business representative and sat on the boards of a number of the companies in which I had interests, such as Alcoa, Gulf Oil, and the Bank.

A separate book could be written about my long, deeply moving, and mutually reciprocated happy relationship with George Wyckoff. Beginning with our association at Yale and in Scroll and Key, continuing through our early carefree days as reluctant trainee-employees at the Mellon Bank and the Union Trust Company, and then learning to cooperate as employer and employee when we were just beginning to deal with our early education in financial and foundation affairs, we were always instinctively bound together by mutual trust and mutual understanding.

For years Wyck was my personal confidant, my eyes and ears in respect to what I wanted to know about my business and charitable relationships, and my warmest companion in hours of relaxation, glasses in hand. He was no sycophant and always stood in relation to me as a partner and an equal. His death in 1987, after a long illness, complicated by his lifelong

affliction of hemophilia, cast a shadow over me for many weeks. When he died, he was the last of my boon companions from Yale days.

Active participation in sport did not feature much in the lives of the ordinary student at Yale in the 1920s. There weren't any college or house teams or crews of the type that I was to know at Cambridge. If you hoped to row or play football, you needed to be a really good athlete in order to be included in the varsity or junior varsity teams. Jack Douglas occasionally played soccer, and Lenny Mudge managed the tennis team, but my only sporting activity took place when I signed up for a boat race between freshman, sophomore, junior, and senior class crews.

I had rowed a little at Choate, but only about half our crew had handled an oar. We trained for two weeks on the filthy Quinnipiac River, which runs into New Haven Harbor, shouting instructions to one another, oars moving in all directions. Naturally, when the appointed day for the race arrived, we were beaten. This was the only sport I took part in during the entire four years I spent at Yale, but I was more than going to make up for it when I went to Cambridge.

As a sophomore I was also elected to the editorial board of the *Yale Literary Magazine*. Two years earlier, in my last year at school, I had written a poem entitled "The Chapel," which was published in the *Choate Literary Magazine* and was subsequently adopted as the school hymn. At Yale, apart from acting in a purely editorial capacity, I pursued my own literary interest, publishing a short story and a few sonnets in the *Yale Lit*, including a poem that, whatever its limitations, accurately sums up my feeling of inadequacy at the time. It goes:

> I built a temple in my inmost mind
> Of pure white marble; its stern symmetry
> Became the symbol of tranquillity;
> For calm it was, and peaceful, and no wind
> Ever disturbed the stillness. Far behind
> Stretched a dim forest to a distant sea.
> To Peace, and Death, and Silence,—to these three
> I reared an altar, with my soul enshrined.

Despite my vows within the deep serene,
To offer rich libations, and return
After each dusty day, I find it now
Filled with dead rustling leaves. The shadowed green
Of lichen mars the whiteness of each urn—
And there are hoof-marks, where gay Pan has been.

In those days there always seemed to be an inner battle going on between a thoughtful scholar and a laughing hell-raiser. Sometimes, in reveries, I saw it as a conflict between classical perfection—the temple—and romantic flights of the imagination—"hoof-marks, where gay Pan has been." (I have to remind the reader that the word "gay" had an entirely different meaning in those days.)

During my time at Yale I enjoyed most of what I studied. My marks were never bad, except in chemistry, and even Latin poetry taught by a charming Professor Twitchell gave me considerable pleasure. Anthropology and science of society courses opened up exciting vistas. As I have said, Allison's "Middle Ages" gave me my first taste of the peculiar flavor of that time, and Tinker's "Dr. Johnson," Tucker Brooke's "Romantic Poets," and Bob French's "Chaucer" all continued to fill me with a hunger for English literature. Even Dr. Haggard's course in "Industrial Physiology" was stimulating since it opened my eyes to the wonder of the inner man, to what miracles take place every day in one's body.

It would not be correct to say that I spent all my time at Yale seated in my room studying or penning verse. When weekends came, my sporting side took over. There were plenty of "rich libations" being administered illegally in the precincts of the University both by me and by my friends. The Eighteenth Amendment, which, as I have noted, had been ratified just after the end of the First World War, remained in force until 1933.

College students drank far more than they might otherwise because drinking had the added allure of forbidden fruit. Perfectly "nice" people drank bootleg liquor. Good families drank, and there was no social stigma attached to it. Bootleggers turned up from time to time in New Haven, and my friends and I might

go down and buy a few bottles from a man in a car, or we would hear of some place out in the country that made absolutely lethal applejack.

On most weekends it was off to New York to some speakeasy or other. There was a famous one called Moriarty's at 216 East 58th Street. It became almost a Yale-Harvard-Princeton club, and you were bound to meet friends if you called in there on a weekend. It was situated in a gloomy basement room, no women were allowed, and you could only obtain virtually inedible sandwiches, which, for some inexplicable reason, were named Long Island Duckling. It was said that the handyman, Joe Morgan, was the illegitimate son of J. P. Morgan and a French maid, but I don't think there was any evidence to support this.

There were other speakeasies, where you could take a girl for drinks and dinner, and nightclubs, where you would either purchase drinks or bring your own in a hip flask and just order a setup of ginger ale or soda water. There was little likelihood of finding any of these places closed because they all paid protection money to the police. You could stay at these nightclubs and dance until dawn. I had a very special girlfriend, Jane Hepburn, for about three years, and we had high old times at Harry Richman's. Sometimes it was a journey from one speakeasy to another with Hubbard or Mudge or Douglas or any other Yale men, ending up at Harry Richman's brother's Dizzy Club at three in the morning.

I remember one night well, when we went on from the Dizzy Club to an even later one, where at the bar I was introduced to a Mr. Diamond. The introducer referred to Diamond as a car salesman, but I learned later that he was the infamous gangster Legs Diamond. I found him a very agreeable fellow! An irony some of us at the time thought amusing stemmed from the fact that my father, as Secretary of the Treasury, had overall responsibility for the enforcement of Prohibition. The enforcing arms—the Secret Service, Coast Guard, and United States Customs—all came under the Treasury Department. And there was the Secretary's son, lapping it up in speakeasies. Although my

father did everything he could to enforce the law, he soon came to realize that it was unenforceable and would eventually have to be repealed.

Back at Yale, at the start of the week, it was a different story. I was hung over, depressed, and angry with myself. That was when I longed for the blue skies of classical Greece, the peace of the temple of pure white marble. I studied hard and devoured lectures, but then toward Friday, gay Pan, as my classmate and friend Jimmy Brady paraphrased my poem, "got mud all over my floor."

There was a good psychiatric department within the Yale Department of Health in those days, and a very good psychiatrist by the name of Clements Fry. Years later I became friends with Clem Fry, but never a patient, and I gave him a good deal of financial help for his psychiatric department. I wish I had known about him while an undergraduate, for I am sure he would have helped me out of my occasional mild fits of depression and feelings of a lack of direction in my life. In later years we used to argue Freud vs. Jung from time to time, but gently.

Toward the end of my junior year I was well aware of the approach of Tap Day, when perhaps some three hundred hopefuls congregated under the elms on the Old Campus, many of them nervously hoping to be tapped for one of the so-called secret societies. In those days Yale was divided into two fairly autonomous parts, Yale College, or "Ac" (for academic), and the Sheffield Scientific School. As I remember it, there was not much socializing between the students of these two bodies, and they each had their fraternities and secret societies. In Yale College there were four of the latter: Skull and Bones, Scroll and Key, Wolf's Head, and Elihu.

These societies theoretically were looking for the elite of each junior class. The more visible and prominent juniors, such as the captain of the football team, the chairman of the *News*, the editor of the *Yale Record*, or the head of the religious organization Dwight Hall, were chosen by Skull and Bones. Scroll and Key, on the other hand, as well as Wolf's Head and Elihu, were likely to tap rather easygoing types and perhaps a more heteroge-

neous mixture of athletes, humorists, literary aspirants, and so-cialites.

I was tapped by both Skull and Bones and Scroll and Key (the first man to be tapped by each). I turned down the former and accepted the latter since I had a fair idea that several of my closest friends would be going that way, too. Sixty juniors had been chosen, fifteen for each of the four Yale College senior societies. In senior year these societies had evening meetings twice a week, on Thursdays and Saturdays. You were fined if you didn't turn up and looked down on if you missed too many meetings. There was supposed to be no drinking at the meetings. From time to time alumni would join us, and I remember one, a professor, who brought with him some homemade beer. It was dreadful, but normally the meetings were very orderly and usually on a pseudointellectual level. A group of seven of us among my circle in Scroll and Key formed close friendships during this last year at college, friendships that went on long into later life. There were Jimmy Brady and Fran Carmody, both of whom had been at Canterbury School and who roomed to-gether at Yale, Horace Moorehead and Harry Wilmerding, who were St. Paul's graduates, and Chauncey Hubbard and George Wyckoff from Hotchkiss.

In September 1928, just before returning to Yale for my senior year, I went to a coming-out dance on Long Island in my new La Salle phaeton. This was a small "touring car" with a con-vertible canvas top, and very smart-looking. I was staying with my sister Ailsa at her country house in Syosset.

The dance was an unusually good one, with beautiful music and, since it was during Prohibition, lots to drink. I honestly don't believe that when I left at about 4:00 A.M. I was drunk, but merely "having drink taken," as my friend Chunky Hatfield would later have described it, and very tired. I was headed down the Jericho Turnpike when I suddenly thought I saw some huge object in front of me, which made me instinctively jam hard on the brake. (I estimate I was doing about sixty miles an hour.) The car slewed off the road to the right into an open field. I had the sensation of being bowled over and over but

clung to the steering wheel with all my might. Suddenly I found myself right side up, with the canvas top draped all over me, the motor still running, and the gears in neutral. The windshield had disappeared, the steering wheel was like a pretzel, and I had a slight bump on my forehead.

I had skidded off into an empty field, the only field for miles along the Jericho Turnpike that had no boundary fence or wall, no trees, no telephone poles. Bewildered, I put the car in gear and slowly drove back to the road, my head sticking out from under the canvas. By now it was broad daylight. In that state I crept back to Ailsa's house along the turnpike, parked the car far back in the garage for secrecy's sake, and went to bed.

Later that day I returned to the field. The entire windshield (fortunately nonshatterable) was on the ground, shining in the sun. My raincoat from the backseat was nearby. Most miraculous of all, my gold cigarette case, which had been in my tuxedo breast pocket, was just a few feet away. It seemed that the car must have turned completely over sideways on hitting the edge of the field, pivoted on the strong left stanchion of the windshield, and come to rest right side up. As I stood there, the reaction set in, and I was shaking like a leaf.

It took many weeks of a very sober and reflective life at Yale for me to look back on the incident without flinching, and the shakes were for months never far below the surface.

By the time I was graduated in 1929, I was still somewhat shy, but Yale and drinking with friends had done much to break down my reserve. In my last year at Yale I began to suffer from stomach pains and had even worse days of languor and depression. I went to see a New York specialist, who took X rays and told me I had a stomach ulcer, brought on presumably by worry and drinking.

This doctor prescribed a rigid diet and told me that I must abstain from all alcohol. Then, to cheer me up, he reminded me of an old maxim, that in order to live to a ripe old age, one should develop a chronic illness and nurse it for the rest of one's life! This advice had exactly the opposite effect from that in-

tended, and I became even more depressed at the prospect of spending the remainder of my life as a teetotaler and semi-invalid. After two last gloomy, abstemious months at Yale, I entered a New York hospital on the strength of the doctor's diagnosis and had a couple of weeks of tests.

Another reason for my anxiety at this time was one shared by many young men of my age, a hidden worry about what we were going to do with the rest of our lives. Up to this period most of us had followed the usual routine of home, school, and then college. Some found they had a vocation or were prepared to slip into the family business, but for others, the future was a great uncharted map. I was in an unusual situation. I wanted to do something useful with my life but knew there would never be compelling financial reasons for me to have to take a regular job. I also knew that my father would dearly like me to make a career in the Mellon Bank and in overseeing investments in various industries. I didn't want to disappoint him but realized that I had no aptitude for banking and suspected that I would be everlastingly bored by the business world. So what else? One possibility was teaching. I talked to Chauncey Tinker, Clyde DeVane, and several other professors, who were quite encouraging, and I thought of embarking on postgraduate studies at Yale or Harvard and going on into college teaching as a way of life.

On the other hand, I had frequently visited my mother and Harry Lee over at Litchfield on weekends from Yale, and Mother, who was anxious that I should see more of England, urged me to spend a year or two at an English university. Her brother my uncle Percy was a friend of the head tutor at Clare College, Cambridge, and he offered to arrange for me to go there. I found the notion attractive. I liked England, and going to Cambridge would put off the decision about my future for a year or two, so I agreed. I had a good degree from Yale, and I had the summer before leaving for England to rest and nurse my alleged ulcer. I went back to Pittsburgh and spent most of the time out at Rolling Rock, riding and playing golf.

I arrived at Cambridge in some ignorance of what exactly I intended to do there. Unlike a Yale freshman, one was not taken in hand and put to work. I found I had been allocated attractive rooms in Clare College, looking out on one side at the Old Court, and on the other over the Fellows' garden, the Backs, and the charming seventeenth-century bridge that spans the river Cam.

At night, in winter, the mists rose off the river, enveloping the ancient stone building in a cold shroud. Everything, in particular the bed linen, became chilled and damp. I had the good fortune to find an antique brass warming pan with a wooden handle that I bought in the market square and took back to my rooms. I filled it with hot coals from the fireplace and ran it up and down between the sheets before I went to bed. I loved the gray walls of Cambridge, its grassy quadrangles, St. Mary's bells, the busy, narrow streets full of men in black gowns, King's College Chapel and Choir and candlelight, the coal fire smell, and walking across the quadrangle in a dressing gown in the rain to take a bath.

It was a romantic existence, but I was in a quandary about what course of study I should choose. I knew that if you had a degree from an American college, you could get a Cambridge B.A. honors degree in two years. Thinking it would be interesting to learn something more about English history, I settled for that but later came to regret my decision.

In the first place one inexplicably had to wait until the end of December for a meeting of the University Senate before getting permission to follow this course. Being fairly lazy and a not too ambitious student, I let most of the term go by without cracking a book. Second, when I started attending lectures in the new year on Ancient History and English Constitutional and Economic History, I found most of them pretty dull compared with the lecture courses I knew at Yale. The exceptions were those delivered by a renowned academic, John Harold Clapham, who was then a professor of economic history, but the overall result was that I didn't do very much studying. Perhaps this was not entirely my fault because I remember the relaxed approach to

teaching prompted a postcard from my tutor, a Mr. Gascoigne, just before Christmas vacation saying, "Dear Mr. Mellon, would you kindly let me know what you will be doing next term?" Later, when I would go to my weekly tutorial sessions with him, I would say, "Mr. Gascoigne, your tea is getting cold," and he, an incessant talker, would reply, "No matter—it's still wet."

I had a brief and muddily unsuccessful encounter with beagling, a sport in which, as you may know, pursuit takes place on foot. I went out one rainy day with the Trinity Foot Beagles, struggled through miles of thick Cambridgeshire clay, which stuck to one's feet like heavy concrete, never saw the beagles or the hare, and returned to Clare exhausted.

In the spring of 1930 I did a little reading, but I had already started rowing in the Clare boat during my first term, in 1929. I rowed most of that winter and again in the spring of 1931. It was a significant part of whatever extracurricular pleasures I had. I was glad to see my Yale classmate Appy Aiken in the boathouse on my first day. In a few weeks we both found ourselves in the first Clare boat, he rowing somewhere in the middle and I at bow. The Cam is a narrow and curving river, winding through lovely green countryside, and in those days it was fairly free of plastic bottles and other trash. We were still the first boat until about a fortnight before the Lent Races in February, when we were to row against the second Clare boat in a trial race. The river is too narrow for two boats to come up alongside and overtake each other, so the technique is to bump the boat in front, the coxswain turning the following boat into the stern of the boat ahead and just touching. We, the first boat, were bumped. Ignominiously we were demoted to second boat, and there we stayed all that winter.

However, in the Lent Races we were fortunate to make the desired four bumps in the four days against other boats, placing us nearer the ultimate, the "Head of the River." As a result, all of us were able to keep our oars as souvenirs and have them emblazoned with the Clare coat of arms and colors and with our names, positions in the boat, and weights in gold letters. I was lucky enough to be in the second Clare boat again the following

spring in the Mays (although they were held in June!) and, as a result, got a second oar to take home. Both oars have always hung above the shelves in my library in the Brick House, and among the other satisfactions I get in looking at them, I am pleased to see that my weight has changed hardly at all.

To the outsider, rowing may seem drudgery and very dull. But especially on that winding, peaceful river, the rhythmic sweep of the oars, the chock-chock of the oarlocks, and the synchronicity of the eight swaying bodies give one the feeling of participating in a kind of ritual dance. I remember one day as having a special magic. We were to row to the town of Ely, twenty miles away, pausing at two locks and gliding through a green countryside on both sides of the river. We arrived exhausted but somehow exhilarated by the knowledge of the great distance we had come and perhaps hypnotized by the long, rhythmic strokes we had taken. We went straight to a warm local pub and downed several tankards of cool English bitter. We returned home by road and to the sleep of the dead.

In one of my Clare photographs, Chunky Hatfield, an American friend, and the Sewell family from Philadelphia are watching our triumph in the Mays. At the time I was in love with Anna Belle, seated in the middle of the picture, who had come as my girl for the May Week festivities. Jock Leslie, later the Earl of Rothes, is on the far left.

In the spring of 1930, apart from rowing, I did a little reading of the prescribed books, but not very much, spending the Easter holiday in Spain with my mother and a friend from Yale. This showed up when the examinations came at the end of the first year, and although they were only trial runs, they pointed to where you were heading in the final analysis. My marks were unsurprisingly very poor.

One day I was walking along the Backs when I noticed a Clare man, a rowing friend, who was instructing a group of undergraduates in the manual of arms. All this was going on in a field near the college, so I asked him later what it was all about, and he explained that he was a Territorial Army candidate and that they had these drills once a week. "It's fun," he said, "and you

learn a lot of military things." I thought it sounded like a good idea, so I went along to the regular recruiting office in Cambridge and explained to the sergeant in charge that a friend of mine had suggested that I join the Territorials. He said that was fine and took my name and address. Of course, when I told him I lived in Pittsburgh, Pennsylvania, he said, "Well, that's a different story. We can't give the King's Shilling to a foreigner. What would happen if there were a war? There is no way in which we could call you up and we'd just be wasting our money training you. Sorry, but that's it." I realized he was right, but just the same I was disappointed.

During the spring term I found myself suffering from a return of the stomach pains that had been troubling me at Yale, and I asked a tutor if he could recommend a local doctor. The tutor suggested a famous surgeon of those days who lived out at the end of Trumpington Street. When I called him to make an appointment, he asked me to come out and see him at home, so I cycled over to his big old Victorian house for a consultation. I explained about the history of my ulcer, gave him a general background of what I had been doing, and said that I had been suffering from stomach spasms.

Having listened to me, he said, "I don't think you have ever had an ulcer," adding quickly, "In any case, do you drink soup?" I replied that I did drink soup once in a while, such as it was, from the Clare kitchen. "Ah, well," he said, "you probably drink it with a spoon." I replied that I did. "Then I think you should stop drinking soup," he said. "If you drink soup, you should drink it out of a cup because people who drink soup with a spoon are inclined to take in a lot of air with each spoonful. I think that is all that's the matter with you."

"Now," he said, getting up from his chair, "I have a beautiful garden here, and it's just in top form. I should like you to see it." I dutifully followed him out to admire the garden before being sent on my way. I cycled back to Clare, gave up having soup, and felt much better from then on. Years later the results of some other tests revealed that I had none of the inevitable scars that would have remained had I ever had an ulcer, so the

famous doctor's diagnosis was right—just nerves or soup!

Probably on the strength of my literary interests at Yale, I was selected as Editor of the *Lady Clare*, the college magazine. As at Yale, I wrote editorials and poetry for it, encouraged other students to submit articles, made up the dummy, read proof, and saw it through the Cambridge University Press.

Father was not enthusiastic about my spending a second year at Cambridge. It seemed to him that all this study might be detracting from my interest in business. It was clear that he would have liked me to come into the Bank, and it must have been equally evident to him that I wasn't cut out for it. Little, however, was said, and the issue was left open. Whenever the subject of my future came up, Father had an infuriating habit of repeating a cautionary tale about Henry Clay Frick's son, Childs. It always ended with "and you know what he finished up doing—taxidermy." I began to feel quite sympathetic toward Childs Frick and his interest in wildlife and natural history. At least I had a fellow feeling toward him as far as strong-willed fathers were concerned.

Partly to please my father and partly because I didn't have anything else to do, I returned to Pittsburgh for the summer holidays of 1930 and worked for a Mellon Bank subsidiary called the Mellbank Corporation. Mellbank owned a number of small banks in the vicinity of Pittsburgh, and I made the rounds of these banks in the company of Frank Denton and other senior officers of the corporation. I was bored to tears by the whole business and couldn't wait for the evenings, when I might get together with George Wyckoff, Chauncey Hubbard, or Lenny Mudge (who had all graduated from Yale with me and were now working in Pittsburgh) for music and dancing with some of the very attractive girls we knew around town. In any case, the Mellbank experience didn't sharpen my enthusiasm for business as a career.

In my first year at Cambridge I had discovered foxhunting. An American undergraduate at Corpus Christi College, who was known to his friends as Chunky Hatfield, pointed the way. Charles Alexander Hatfield looked rather like the cockney horse-

man Jorrocks, that unforgettable creation of the nineteenth-century hunting satirist Robert Surtees. He was short and very stocky, and like Jorrocks, he had become enamored of fox-hunting. He made me realize that I used to ride a lot and would probably enjoy hunting, too. Hatfield, ironically, hardly knew how to ride at all. He had read extensively about it, how-ever, and was sure that hunting was for him and, he hoped, for me, too.

We both found ourselves traveling back together to England from the United States after the Christmas holidays of 1929 on a North German Lloyd ship when we met Mrs. Plunkett Stew-art, the wife of the Master of the Cheshire hounds in Unionville, Pennsylvania. She was going over to join her husband, hunting with the Quorn and other Leicestershire packs of hounds. Learning of our enthusiasm and probably having no idea that we were complete novices, she invited us to stay with her and her husband at Craven Lodge in Melton Mowbray and to have a day or a weekend hunting.

Chunky Hatfield's record on horseback consisted of a few lessons at a Cambridge livery yard, and I hastened off to London to acquire a little more experience jumping over hay bales at an indoor riding school. We decided that we were ready now to take to the field, so Hatfield called Mrs. Stewart, and we were asked up for a day with the Cottesmore. We arrived properly dressed in our newly fitted top hats, black boots, white breeches, and black melton coats, all very correct, and set off for the meet. The hounds soon "found," and we had a run. Initially that was fairly safe because both Hatfield and I were well at the back of the field on the horses that Mrs. Stewart had hired for us. I was pleased to see a manageable jump, which I went for and got safely over, but halfway into the next field I heard a sound of thundering hooves and caught sight of a heavy, choleric-looking rider pulling up his horse and veering toward me. The angry horseman shouted at me, "How dare you, sir? How dare you cut me off? How *dare* you?" Somewhat taken aback by this spec-tacle of red-faced fury, I apologized and retired crestfallen even farther back in the field. We survived early mishaps like this and

returned to hunt there on quite a few occasions.

Then Ronald and Nancy Tree (he was an American sportsman) invited us to Kelmarsh to hunt with the famous Pytchley. Ronnie Tree was Joint Master, and they always showed good sport. Riding hired horses involved an element of risk. Some of these hirelings were slow but safe, but on others you were lucky to get through the day alive. Hatfield subsequently bought a huge half-bred with a docked tail named Badger. Hatfield always carried a sizable flask filled with brandy, which he referred to as "bottled courage." To see him tearing across the large grass fields and through the great bullfinch hedges, coattails flying and with no idea of danger and with very little of where he was going, was a sight to behold. For my part, I bought two horses, which I named, rather unimaginatively, Guardsman and Grenadier. They both carried me safely throughout my stay at Cambridge.

Hatfield and I hunted mostly with the Fitzwilliam hounds, chiefly because their meets were usually a shorter journey from Cambridge. It was there that I got to know my lifelong friend Tom Fitzwilliam, who succeeded his uncle Earl Fitzwilliam both to the earldom and as M. F. H. When we weren't hunting with the Fitzwilliam that first winter, we went up to Melton Mowbray by invitation of the Stewarts or to the Pytchley for a weekend with Ronnie and Nancy Tree. They were extraordinarily kind to us, and I remember vividly not only the excellent hunting (which we were beginning to comprehend, if not to master, and which we began to enjoy immensely) but the tremendous teas afterward of eggs and bacon and sausages, tea and toast, muffins and honey, and later the steaming hot baths in enormous tubs.

In those days there were thousands of miles of branch railway lines wandering over the length and breadth of England, and you could reach almost any destination on them. Many of the trains, especially those in the hunting districts, included small boxcars for transporting horses. You could ride your hunter to the railway station, hand him over to an experienced railway groom, who would feed him, water him, and, if necessary, rug him up on the journey to the station nearest to where hounds were meeting.

There were plenty of old agricultural workers used to handling horses who were glad for a job with the railway. There were platforms thoughtfully built up to the height of the rolling stock, so that the horses could be walked straight into the vans without a ramp. Some people used motorized horse vans or trailers, although it was far less common than it is today. Others were prepared to hack over long distances to the meet.

Chunky Hatfield and I often transported our hunters by rail. On one occasion, when I was on my own, I had to pick up my horse at Godmanchester Station, a few miles north of Cambridge. A fellow undergraduate had told me to be sure to get the pronunciation of Godmanchester right. Like Beaulieu or Glamis or Cholmondeley, he said, it wasn't pronounced as it was spelled but spoken of as "Gumster." As I drove into the town, looking for the station, I spotted one of the oldest inhabitants walking along the street and called out to him, "Excuse me, but can you tell me where Gumster Station is?"

The old man looked around, slightly bewildered, and said, "I don't rightly know, sir, but you will find Godmanchester Station just 'round the next corner."

Mother was in England at this time, and she used to ride while staying with a family in Sussex. The father of this family had quite a few racehorses as well as hunters, and for some reason he offered several of these to her—and to me, should I want any of them. In due course two were sent up to Cambridge, and I stabled them with Chunky's livery stable friend, where my two hunters were kept. One of the gift horses was a lovely chestnut mare that I named Lady Clare, and she turned out to be a great jumper and one of my best and favorite hunters. When I returned to the States, she came, too, and I kept her at Rokeby. She gave me many happy and *safe* days in the hunting field.

The other gift horse was another story. He was a large, rangy, and smart-looking chestnut named Fashion, a typical thoroughbred. Having been told he was an excellent hunter, I took him to a meet of the Fitzwilliam as soon as possible. Several young Cambridge enthusiasts out that day complimented him and sug-

gested I enter him in an upcoming Cambridge point-to-point race. Well, that idea had to be quickly abandoned. The hounds "found" very soon, and we all went off at a tremendous gallop. Suddenly I discovered that I had no control. Fashion was pulling my arms out of their sockets. I was standing up sawing and jerking the bit with no effect, and I looked through his ears with mounting terror. He crashed through two or three thick hedges without the slightest attempt to jump, and his speed was increasing. We were still behind a few of the field when, to my horror, I saw ahead of me two or three riders in the act of closing a farm gate. Right through the gap we tore, banging the closing gate open again and slightly brushing two of the riders, with a shout—"So sorry!"—before emerging, as luck would have it, into a large open field. There, the strategy was to hang desperately on to one rein and gradually wind him into smaller and smaller circles.

This took about twenty minutes, which seemed like an hour, and in the end he and I were furious and exhausted. Slowly we walked back to the railway station, both sweating profusely. That was my last ride on Fashion, and I returned him thankfully to the nice man in Sussex.

One of my best memories of Cambridge was the time when a Clare friend, Tommy Russell, introduced me to the bagpipes. Tommy was a Scot who was adept at the strange, mournful, wailing, eerie music of the pipes. We would bicycle out in the early evening to a remote wood near Madingley, where Tommy would assemble his unwieldy instrument and blow up the bag until it was full. The effect in that soft twilight and in the long shadows of the silent woods when he began to play a solemn march, a gay Scottish tune, or a sad funeral lay would make shivers run up and down my spine and sometimes bring tears to my eyes.

Tommy and I have kept up a regular correspondence over the years, mostly at Christmastime, and although I knew him well at Clare, because we rowed in the same boat and had mutual friends, I think it is the recollection of the sound of the

pipes in my mind over all these years that gives him a special place in my storeroom of Clare memories.

I led a sheltered life at Cambridge during my stay there from 1929 to 1931. You could get an *exeat*, permission to leave Cambridge, only if you had a good reason. You couldn't go out at night without wearing your gown, and you had to be in your college by ten o'clock. In that sense it was pretty much like boarding school. My isolation in the University allowed me to be completely unaware that there were unemployed farm workers living at subsistence level only a few miles away as the Great Depression took its grip.

I also had no contact with or knowledge of those young British left-wing elitist and rather arrogant intellectuals known as the Apostles, including Guy Burgess and Anthony Blunt, who were at that time being recruited by espionage agents from Stalin's Russia and were later to betray their country in such dramatic ways. I have never been strongly politically motivated and have trusted my judgment more in respect to individuals rather than with ideology. For me, Cambridge was an entirely personal, isolated, and enjoyable experience.

After graduating from Cambridge in June 1931, I spent a few days in Paris on my way to the south of France to stay with Ailsa and her husband, David Bruce, who had rented a villa at Cap Ferrat. One day I was asked to a luncheon at "The Travellers" club by Ted Rousseau, at that time head of the Paris Branch of the Morgan Guaranty Trust. The luncheon guests were mostly American literati and journalists, and included F. Scott Fitzgerald, as well as another well-known author and editor, Alexander Woollcott. The Editor of the Paris *Herald Tribune* was also there. We were having drinks at the bar before lunch, and the talk turned to the Depression of 1929. Several of the guests told sad stories of their financial experiences during the crash, but I remember Woollcott's especially. "When my broker phoned to tell me I had just lost two hundred and fifty thousand dollars, I was aghast. What worried me most was not the tre-

mendous loss—but how could I have ever been worth two hundred and fifty thousand dollars in the first place?"

I sat next to Scott Fitzgerald at lunch. He looked very young and was outgoing and charming, with the bright eyes and clean-cut features we associate with the expression "the all-American boy." We talked about Cambridge and my own writing, and to look at us you would have thought I was holding him spellbound. A few days later, however, I saw Ted Rousseau at the bank, and he told me a sad sequel. The drinks before and during lunch had been just enough to set Scott off on one of his serious binges.

Ted also told me that not long before, Scott had come to his office at the bank and asked for Miss Frickleton, Ted's secretary, to take dictation of a cable he was sending to his publishers in the States. (He had the shakes so badly that writing the cable himself was out of the question.) The message went something like this: "If you act quickly you might be able to secure the rights for a great novel called *The Sun Also Rises* by a young writer called Ernest Hemingway."

At the end of that summer I went to Saumur in the Loire Valley for a month to improve my almost nonexistent conversational French. David Bruce had recommended as a tutor an elderly French lady who lived there named Madame Labeille, with whom I conversed haltingly and ad nauseam every day. (I was told later by knowledgeable friends that I would have improved my French much more pleasantly and quickly if I had found a younger and prettier instructress in Paris, a tutorial arrangement known as a "bedside dictionary.") In any case, my dismal life in Saumur was greatly relieved when Madame Labeille introduced me to an officer cadet of the famous Saumur Cavalry School. He not only lent me his own well-schooled horse but, since it was vacation time, arranged permission for me to ride throughout the academy's fields and woods, including plenty of brush jumps and other obstacles that were part of their instructional courses. The horse's name was Flaneur, which perhaps helps to explain why my French language tutorials never really got off the ground.

As I have explained, I had a plethora of English uncles, originally eight in all, on my mother's side. They had been brought up at Hertford Castle believing that they would lead leisured lives, but unfortunately their father had been unable to leave them very much. Uncle Alan had a job with the Guinness brewery in Dublin, Uncle Percy was in the Royal Navy, and Uncle Leonard in the Stock Exchange. Although most of my uncles remained entirely self-reliant, Uncle Kenrick and Uncle Leonard were often quite a trial to Father when, in various stages of financial distress, they appealed to him for funds.

Uncle Leonard, who gambled on the stock market, was particularly brazen in this respect, and one of his letters to Mother begins with the mournful sentence "I know you don't like getting letters from me." Mother's brothers were, nevertheless, an engaging and attractive group, and I was very fond of those I knew. This was particularly the case with my uncle Percy, who taught science and mathematics at the Royal Naval College at Dartmouth up until World War I. For most of the war he was on that famous battleship HMS *Agincourt* and served on her in the Battle of Jutland. You will remember that I visited Uncle Percy and Aunt Maud as a small boy, in 1913. Uncle Percy's one interest in later life, beyond his naval duties, was betting on the horses, invariably to the detriment of his pocketbook. I once named a horse after him, who won quite a few races both in England and over here.

I also admired my uncle John, Mother's eldest living brother, who had been a construction engineer of railways in Africa in his early days. Uncle John was a very early aviation enthusiast and, in fact, had been flying for several years before World War I. By that time his age was such that he would not be able to fly combat, but he became a Royal Flying Corps instructor. This duty turned out to be almost as lethal as combat, since the early planes were highly unstable and the neophyte airmen sometimes much more dangerous than the planes. He had several bad crashes but survived to take up flying again in the late twenties.

When I knew him, he had a little trailer on stilts on the edge of the Heston Aerodrome. He was then aged sixty-eight and had just bought an autogiro, the latest thing in aviation. The machine looked a little like a helicopter in that it had four sails above the fuselage that were not powered and freely revolved with the wind, while the propeller and motor were placed conventionally at the front of the aircraft. The advantage of this machine was that it could take off on a very short runway, and if the engine failed, you hoped to glide gently down to the ground like a maple seed.

Uncle John was longing to demonstrate his machine, and he got in touch with me to invite me for a spin one day when I was staying with my father in London. This was shortly after I had come down from the University and at the time when Father had just taken up his appointment as American Ambassador to the Court of St. James's. I suggested to Uncle John that we fly to Cambridge. The outward flight was uneventful, and I sat in the open cockpit with my begoggled uncle seated behind me at the controls. We had a good nonalcoholic lunch at Clare College and then returned to the airfield.

With the plane standing on the grassy runway and the sails circling above us, a mechanic spun the propeller. Uncle John revved up, and the tail rose promptly into the air, burying the nose in the earth. There was a terrible noise as fragments of propeller flew in all directions, the sails splintered into large pieces, and the engine stalled. When silence finally returned, I could hear my uncle John shouting imprecations at the mechanics for not removing the wheel chocks, but I had seen them slip them away and I knew, as I realized Uncle John knew in his heart of hearts, that he had forgotten to release the hand brake.

Two of my English first cousins who, like my uncle Percy, were in the Royal Navy served with distinction in World War II. Captain Colin McMullen was the gunnery officer on the battleship HMS *Prince of Wales* when she was sunk by Japanese torpedo planes off Kuantan on December 10, 1941, shortly after venturing out from Singapore Harbor. Colin, still an intrepid small-boat sailor, has twice made the Atlantic crossing (to the

West Indies and to Gloucester, Massachusetts), with a friend as crew, and made the return voyages as well. His brother Rear Admiral Morrice McMullen rose to the post of Admiral of the Fleet, Far East, a short time after the war.

Colin's son Mike was a Captain in the Royal Marines. He, too, was a wildly enthusiastic small-boat sailor who took part for several years in the *Observer* single-handed race from Bristol to Newport, Rhode Island. I helped him buy a trimaran, named *Three Cheers,* in which he hoped eventually to win the race. Shortly after, he was married to a most attractive girl, Lizzie Goodenough, who shared his passion for sailing and who frequently went on summer cruises with him in the Shetlands and the Orkneys. As practice for the big transatlantic effort, he took part in a race around England in his trimaran with a friend as crew.

In 1976, a week before the *Observer* transatlantic race was to start, he and Lizzie and some friends were cleaning and polishing the trimaran's three hulls in a shipyard in Bristol. They were using electric buffers. Lizzie, who was standing knee deep in water, dropped hers. Before anyone could warn her, she stooped and tried to pick it up. She was electrocuted instantly.

This was a hideous blow to Mike, but he nonetheless elected to take part in the *Observer* race the following week. I'm sure his decision was based on a belief that that is what Lizzie would have wanted. In any case, he had a most competitive spirit.

Mike decided to take the northerly Atlantic route, in spite of the danger of icebergs, since he knew it to be the shortest and to contain the most favorable winds. After the first week he was never heard of again. It is known that the northern route turned out to be extremely treacherous that year, so the danger from the weather alone was great. There was also the chance of being run down by a freighter or hitting an iceberg in the dark. More than a year later the trimaran was found badly broken up on the shore of Iceland. Of Mike's fate, we will never know. Any suggestion that he might have been thinking of taking his own life has been fully discounted by his family and close friends, who have always respected his decision and admired his guts.

CHAPTER 8

Pittsburgh, High Life, and First Marriage

———•———

Friends I have had, the daemon-driven, the gay,
The girls like blossoms, the games and dancing done,
(Voices half-heard, and laughter far away)
You are my loneliness when night comes on. . . .

This is my loneliness, in the idle hours
When autumn and night lean in, and I am alone,
Remembering friends I have had, the girls like flowers,
Remembering the games and dancing done.

—GEORGE DILLON
"Autumn Movement" from *The Flowering Stone*

Father was appointed Ambassador to the Court of St. James's in April 1932 and served until March 1933, when Franklin Roosevelt was inaugurated. I spent a good deal of time at our embassy during this period, going about with a few of my Cambridge friends, attending weddings and garden parties, spending weekends at country houses (including one at Cliveden during Nancy Astor's reign there), and even managed to do some foxhunting and riding in point-to-points.

In London there were plenty of evening entertainments in town. The theaters were full of amusing plays and musicals, and there were nightclubs and late-night clubs, all of which featured several cabaret turns during the evening. One of the most popular was the Café de Paris, just off Leicester Square, the interior of which was designed in the style of the saloons of the great ocean liners, including a wide balcony surrounding

the whole room. I often went there with Delphina Burt, a very pretty girl I was soon to become engaged to, as well as with other very attractive girls including the actress Ann Todd (sister of a Clare College friend) and Victoria Titus, a popular debutante from Washington and Boston.

The cabaret turns at the Café de Paris were especially amusing and featured such popular entertainers of the thirties as Bea Lillie (Lady Peel), Douglas Byng the pianist, and Marian Harris, an American chanteuse. Bea Lillie always brought down the house with her song "There Are Fairies at the Bottom of My Garden," while Douglas Byng was constantly called on for encores of a risqué Scottish ballad that went:

> Flora MacDonald, Flora MacDonald,
> Heavy wi' haggis and dripping wi' dew,
> Many's the night she's been out in the heather,
> Bending the bracken with sweet Rhoderic Dhu

I only remember Marian Harris because of her song,

> Since making whoopie's become all the rage
> It's even got to the old birdcage—
> My canary's got circles under his eyes.

There were many ersatz nightclubs during World War II, but without any of the style or joie de vivre of those of the thirties.

The Café de Paris, alas, was demolished by a direct hit of a German bomb during the Blitz of 1941, killing and wounding scores of British servicemen and women on leave. It marked the end of an era, and for a long time clouded over my happy memories of those carefree hours and drowned out the golden echoes of dancing music, light songs, and laughter. In the early thirties, the Café de Paris had provided a touch of gaiety and humor against the general background of gloom and hardship that accompanied the Great Depression.

When I returned to the United States, I went back to Pittsburgh, by then a drab and depressed industrial city. Its wealth had been

based on heavy industry, mostly steel, which in turn had depended for energy on the soft coal that ran in rich seams through western Pennsylvania and West Virginia. The burning of this coal to fuel factories, power locomotives, and make coke for use in steel production had turned the city black with soot and grime. For much of the time a pall of smoke and fog hung in the air. It was so thick that it was frequently impossible to tell whether it was early morning or twilight. Everything was gray with soot, and to make things worse, the lower-lying parts of the city near the confluence of the Allegheny and the Monongahela rivers produced heavy smog and were prone to periodic flooding.

Apart from coal, the other source of energy had been manpower. The furious growth of industry during the second half of the nineteenth century had witnessed boom and slump, the wholesale importation of foreign labor to operate the mills, and an almost total disregard for the environment. By the 1930s the days were long past when young peasants were recruited from Central Europe and obliged to work intolerably long hours with the result that they were worn out by the time they were forty. The demand for materials created by the First World War and the ensuing boom in the twenties had gone, and now the whole area not only remained a cesspit of pollution but was also in the depths of a worldwide depression. You needed to be tough to survive in Pittsburgh, and the tribulations shared by the citizens bonded them in a fierce loyalty toward their grim city. It was a mark of their energy and sense of purpose that they were able to unite, dragging with them some recalcitrant commercial interests, to clean it all up so dramatically after World War II. There was a strange and sinister beauty about parts of the city on those earlier fogbound days. There was an eerie silence, while far-off sounds of whistles and factory horns penetrated the dense and sulfurous atmosphere.

I came back to Pittsburgh from Cambridge in the late summer of 1931. I had known the city from childhood, and despite long periods of absence at Choate, Yale, and Cambridge and on other visits to Europe, I felt very much at home there. I liked the house

on Woodland Road, and it took just over an hour to get out to
Rolling Rock on weekends. My old Yale friends Mudge and
Hubbard became members of the Rolling Rock Hunt. Together
with Adolph Schmidt, another friend, who had graduated from
Princeton and worked in the Mellon Bank, we took up foxhunt-
ing with exuberance. My father and my uncle Dick had bought
the land and built Rolling Rock Club and Golf Course, and my
cousin Dick (Uncle Dick's son, Richard K. Mellon) had formed
the hunt and was the master, so the whole enterprise was in
the nature of a family affair.

Adolph Schmidt, or Schmitty as we knew him, was subse-
quently preempted from the Mellon Bank by the A. W. Mellon
Educational and Charitable Trust at an early stage in its forma-
tion to be its president. Schmitty was married to my second
cousin Helen Mellon. Well known and well liked in Pittsburgh,
he ran the Trust for many years with enthusiasm and imagi-
nation, focusing its contributions mainly in the areas of the arts
and conservation. It was his imagination also that brought about
the establishment of the School of Public Health in the Univer-
sity of Pittsburgh, and he brought to bear his considerable di-
plomacy on the Carnegie Institute of Technology by persuading
its administration to form an amalgam of science, engineering,
and fine arts programs. Schmitty later became Ambassador to
Canada during Nixon's administration.

George Wyckoff, through his uncle Clinton, had been given
a job in the Union Trust Company, the umbrella organization
owning the Mellon Bank. Schmitty already had his job at the
Bank when I got back to Pittsburgh from Cambridge, and I per-
suaded Father and Uncle Dick to vouch for Chauncey Hubbard,
so he, too, got a job there. Hubbard's chances stood in jeopardy
for a moment when he went for his interview. While Father and
Uncle Dick were quizzing him, Father produced one of those
cheap little cigars that he was so fond of, "Grand Central Che-
roots," put it in his mouth, and fumbled for matches. Hubbard
was suffering from an appalling hangover but gallantly pro-
duced a match and leaned over the large desk to assist Father
with lighting his cigar. Father had rather prominent eyebrows

and was lucky not to lose one of them when Hubbard's shaking hand held the light directly beneath it.

Hubbard and Wyckoff had been together at Hotchkiss, and they had been friends for many years. When they came to Pittsburgh from Yale, they lived for a while with Schmidt, who was a year or two older, in a boardinghouse run by a Mrs. McManus. Later they rented a house of their own, and all of us had a very active social life. Prohibition was still in force during my first two years at home, so there was the pleasure of circumventing that, and there were plenty of debutante parties and a lot of pretty girls. But now it was time to think of work and a career. To please my father, I decided to try my hand at working in the Bank.

The Mellon Bank planned to give me overall experience of its banking operations by assigning me to its various departments. I spent some eighteen months moving from one department to another, but without any active role to perform and with everyone knowing that I was the boss's son. When Father returned from London in 1933, he realized this wasn't getting me anywhere and discussed the problem with his brother. They called me into my uncle's office and told me they thought I would be very interested to learn that they had decided to make me a director of the Pittsburgh Coal Company. They assured me that it would be a very rewarding job and that I would learn a lot. I tried desperately to evade the honor by replying that I was presently a trainee clerk and that it would be very embarrassing if I were to walk out of their office as a director. But I knew this was not a legitimate excuse because the American custom of the owner's son starting at the bottom and after a short time receiving sudden promotion was time-honored, so I agreed to their proposal. Soon afterward I found myself floating down the river on coal barges, donning a helmet to go down the mines, and attending the meetings of the directors.

The meetings were the worst part because I never knew what was going on and, what was more, didn't really care. I soon found myself on the board of the Bank and then on the boards of a number of little banks around Pittsburgh, one of them being

in Donora, the coal town Father had named after Mother and his friend Mr. Donner. I also ended up on the boards of the Farmers National Bank and the Gulf Oil Corporation. I thought it was no way to learn how these businesses functioned, but I admit that the real problem was that I fundamentally just didn't have any interest in their pursuits. I had tried, and it hadn't worked.

It isn't possible to write of my feelings toward and dealings with my father during the last years of his life without giving some brief account of the tax case that overshadowed this period. Even today the policies pursued during his term as Secretary of the Treasury before and after the Wall Street crash of 1929 give rise to very strong feelings. The tax case, which followed shortly after his retirement from public life, was, however, by general consensus, pursued as a political vendetta, and it is true to say that Father was hounded into his grave by his political enemies. I felt deeply sorry for him and still feel indignant about the injustices forced on him by the Roosevelt administration in the name of justice.

It is the custom for retiring ambassadors to hand in their credentials and at the same time to pay their respects to a new President, so in the spring of 1933, on his retirement as Ambassador to Great Britain, Father went to see Roosevelt. It happened that the Banking Act of 1933, which inaugurated federal insurance of bank deposits, had just been passed in Congress. Its purpose was to bolster confidence in financial circles and to try to forestall bank closures. Father's philosophy was that if you couldn't swim, you sank, that this was nature's way, and that to meddle with it could only bring trouble. His thinking about this bill amounted to the valid objection that if bankers knew they were going to be bailed out should they get into difficulties, it would make them careless in their lending policy and sloppy about investigating the creditworthiness of their customers, a viewpoint surely reinforced by the current Savings and Loan debacle.

The subject came up during Father's meeting with Roosevelt,

and Father put his views cogently. Roosevelt was very cordial, agreed with him 100 percent, and said that when the bill came through, he was going to veto it. He did just the opposite. The very next day Roosevelt signed the bill, praising it as a progressive piece of legislation. Roosevelt was entitled to his view about the bill, but the remarks he made to Father indicated that although he later may have proved himself to be a great statesman, his word was not entirely to be relied upon. Father should perhaps have taken this as a warning that there would be worse to come.

Within a month or two of Father's meeting with Roosevelt, Louis McFadden, a Republican Congressman from Pennsylvania and an old enemy of Father's, accused him under privilege on the floor of the House of Representatives of cheating on his 1931 income tax return and demanded that the Department of Justice investigate the claim. McFadden, himself a banker, who may have been slightly mentally deranged, had given his name to the McFadden-Pepper Act of 1927, a piece of legislation liberalizing certain banking functions that was probably partly responsible for the speculative boom that ended with the crash in 1929. He was noted for his aggressive tactics and political feuds, and in 1932, voicing his opposition to Hoover's moratorium on war debts, he proposed in the House that the President be impeached.

The story of Father's tax case is well described in David Burnham's *A Law unto Itself: The IRS and the Abuse of Power*. In an article in *The New York Times* on September 3, 1989, Burnham cites Father's case as follows:

> One of the most brazen instances of a political vendetta during a Presidency was the Roosevelt Administration's attack on Andrew Mellon. No historian has been able to determine why Mellon so enraged F.D.R., but there is speculation that the New Deal President saw the millionaire who served as Republican Treasury Secretary from 1921 to 1932—a time of Wall Street excesses followed by the Great Depression—as the symbolic enemy. Nor has a document

emerged that directly links Roosevelt with the decision to go after Mellon.

Elmer L. Irey, head of the criminal division of the Treasury's tax enforcement branch in Washington from 1919 to 1946, acknowledged in his 1948 autobiography that Treasury Secretary Henry Morgenthau Jr. ordered him to develop tax charges against Mellon even though he, Irey, knew that the former Treasury Secretary was innocent.

A Justice Department memo written about the case in early 1934 shared Irey's sentiment: the charges against Mellon were either invalid or could not be proved. Nonetheless, on March 11, 1934, the Roosevelt Administration announced it would seek criminal tax-evasion charges against Mellon. According to the Justice Department, he owed the Government additional taxes for 1931 of about $1.3 million, plus a 50 percent fraud penalty. The Bureau of Internal Revenue, as the tax agency was then known, subsequently upped Mellon's alleged tax debt to more than $3 million.

The Roosevelt Administration then suffered one rebuff after another.

In Pittsburgh, Mellon's hometown, a Federal grand jury (comprising five laborers, two mechanics, two farmers, two clerks, two engineers, a carpenter, plumber, writer, lumber dealer and one banker) refused to indict Mellon on any charge.

The case moved to a new battleground—the Board of Tax Appeals, in Washington. At the time, the tax board, theoretically an independent agency, was housed within the executive branch, and board members tended to side with the Government. But after weeks of hearings and after reading voluminous legal briefs, the board on Dec. 7, 1937, issued a ruling that rejected the most significant aspects of the charges. Mellon was found to owe $485,809—about one-sixth of the tax agency's claim—but the board dismissed all the criminal and civil fraud penalties.

It had been a cowardly and vindictive action on the part of the administration. Walter Lippmann wrote at the time: "The thing has the appearance of being a low and inept political maneuver. It looks like one of those stunts that politicians stoop to every now and then, thinking that they can gain some

advantage by it for their party." Hoover described it as "an ugly blot on the decencies of democracy." By the time the judgment arrived, however, Father had already been dead for several months.

There has been a persistent rumor that I would like to put a stop to here and now. People have sometimes told me, and I have even read in print, that Father did some sort of "deal" with the Roosevelt administration whereby the administration would stop hounding him if he built a gallery and gave his collection to the nation. This is untrue. First of all, Father formed the A. W. Mellon Educational and Charitable Trust in 1930 and made me a founder trustee. He transferred his whole collection to the Trust during the following year with a view to giving it to the nation. Quite apart from these facts, I can tell you that Father was not only discussing the possibility of a National Gallery with David Finley in 1927 but also hinting at the idea to Ailsa and me as early as that. Further, I have in my possession a letter which Father wrote to me while I was still an undergraduate at Cambridge. It reads:

> 1785 Massachusetts Avenue,
> Washington, D.C.
> April 15th 1931

Dear Paul,

Since writing you a few days ago I received your letter of 5th and am glad to learn that you are having a congenial time of study and recreation preliminary to your return to Cambridge.

I hope you are having some time to spend at the National Gallery as it will be useful to you to have some knowledge of the important pictures in the Gallery in view of the contact you will have with works of a similar character in the future here.

I have gone deeper into the Russian purchases—perhaps further than I should in view of the hard times and shrinkage in values, but as such an opportunity is not likely to again occur and I feel so interested in the ultimate purpose I have made quite large investment. However, I have confined myself entirely to examples of ultra quality.

The whole affair is being conducted privately and it is important that this be kept confidential. . . .

With much love
Father

I have always been quite clear about what he had in mind when he wrote of "the ultimate purpose" for the Russian purchase and, indeed, for the rest of his collection.

A few years earlier, when I was just out of Cambridge, aged twenty-five, I became engaged to an English girl, Delphina Burt, who was several years older than I was. I had met her at an informal and somewhat disorganized party at a minor embassy in London where, finding no one I knew, I followed my old Forbes Street custom and migrated to the kitchen, only to discover that she and some others had done the same thing. She and I met the next day for luncheon, we began many evenings of dancing at the Café de Paris, and finally I took her down to introduce her to my mother at Uncle Percy's house. Uncle Percy had left Dartmouth by then and was living at Tollshunt d'Arcy, in Essex. Mother was very enthusiastic about the idea of my getting married, but back in Pittsburgh Father and Ailsa were strongly opposed to the match on the grounds that my fiancée was older, a strict Catholic, and English. This was odd since Father was not particularly religious, but perhaps the fact that the girl was English conjured up memories for him of his own unhappy marriage and of the difficulties Mother had experienced in trying to adjust to American life.

I still have a memorandum that Father jotted down in pencil on Woodland Road writing paper, listing his reasons why I should not marry this particular girl. The first three clauses deal with differences in age, religion, and environment:

Women grow older faster than men, and differences of age which seem immaterial at thirty are accentuated after forty. . . .
Difference of religion is especially troublesome in the

event of there being children. If the girl is a devout Catholic,
even if she should suggest her willingness to have her chil-
dren not brought up in that Faith, she would be subjected
to the most tremendous pressure by the Priesthood, espe-
cially in view of the Mellon reputation for wealth.

It is difficult not to fear that a woman of thirty whose
habits are more or less formed would be happy if trans-
planted from England and set down in Pittsburgh where
she has no friends and acquaintances. . . .

For my part, I was passing through a trying period of uncer-
tainty in my own life, and I, too, had misgivings. I had com-
pleted my year's apprenticeship in the Bank's departments and,
at my request, had gone to work temporarily at the Bankers
Trust Company in New York City. It was a dreary routine, and
I cunningly persuaded my Bankers Trust bosses that I should
take a course in bookkeeping. My friend Jimmy Brady arranged
for a retired man who had worked for his family to come and
tutor us in his office, and Jimmy joined me for the course. That
got me out of the Bankers Trust building for at least two hours
a day.

I realized finally that I could not go through with the mar-
riage, so I took leave from the Bank to set sail for England and
to break the engagement as gently as possible. Though devas-
tated, Delphina was extremely calm about it, making me feel
even worse, although I knew it was the right decision. After our
meeting she traveled down with me to the Southampton docks
to see me off, and we said good-bye.

I found myself knowing no one on the ship except an English
couple whose daughter was a friend of Delphina's. I was feeling
depressed because nothing in my life seemed to be going right.
One morning, while I was taking a walk on deck, I noticed a
pleasant-looking man whom I had seen a few times before on
the ship. I was standing under the bridge, looking out to sea,
when the stranger introduced himself as Dr. So-and-So, and we
talked for a while. During the next day or two we came across
each other on several occasions, and he invited me to join him
and his friends for a game of cards. We started playing for

matchsticks and then progressed to money—just small change. The stakes rose, and a day or two later, when there was a very large pot, someone else won it, and they told me I owed twenty-five hundred dollars, a figure that could be multiplied by a factor of more than ten at today's values. Two of the party followed me down to my cabin and said the other players wanted my check right away. They became threatening when I protested that the whole thing was perfectly obvious and that the others must have known that the game had been fixed.

Knowing discretion from valor, in the end I gave them the check. Then I went directly to the ship's radio office and sent a wireless to my college friend Fran Carmody, who was working in a New York law firm, asking him to meet me at the dock when we landed. I sent another radio message to the Mellon Bank in Pittsburgh, instructing it not to cash my check. One of the gang muttered further threats to me as I disembarked from the boat, but Carmody was waiting there, and the next day we went to his law office, where photographs of various shady figures who specialized in confidence tricks were produced. I instantly recognized two of them.

The lawyers' representative, a detective named P. Toner McVey, paid the crooks a visit, telling them that the check was being canceled in Pittsburgh and that any attempt on their part to do something about it would result in police action. So the cardsharpers had to go back and study the passenger list on the next ship. I wonder how I could have been so naive, but I take some comfort in the knowledge that the success of confidence men depends on their plausibility and their ability to fool people. With my mind firmly elsewhere, I was certainly easy pickings.

I did meet the girl I was going to marry a little while later. It was in December 1933, and I had just returned to New York from Pittsburgh, where I had attended my uncle Dick's funeral. I knew Lucius Beebe, a very amusing and gregarious fellow who had been at Yale and had gone on to Harvard Graduate School, where he had written a thesis on Edwin Arlington Robinson.

Beebe was entertaining, although frequently drunk. He was working as a columnist for the New York *Herald Tribune* at the time. The first snow of winter was just coming down, and Beebe telephoned to remind me of the old pre-Prohibition custom whereby the passengers in the first sleigh to get to the Casino in Central Park were given a bottle of champagne. He said he had a luncheon engagement with a very nice girl called Mrs. Brown, and why didn't I come along and join them?

I thought it would be fun and met Lucius Beebe at the Madison Hotel. Beebe took me into the dining room, and there, seated at their table, was Mary Brown. By the time we left the hotel it was still snowing heavily. I sat up in the front of the hired horse-drawn Victoria sleigh with the coachman, while Beebe and Mary were in the back. As we passed the second-floor Wakefield Bookshop on Madison Avenue, I noticed two young ladies whom I knew very well peering down at us. Then a newspaper reporter came into view as if from nowhere, but probably tipped off by Beebe, and took a photograph. The picture appeared the next day in the New York *Herald Tribune* and caused me some uneasiness because I had been taking part in these high jinks so soon after my uncle's funeral. However, we were the first to arrive at the Casino and so won our bottle of champagne. Eddie Duchin was there playing the piano. We sat at a table for three; there were no other celebrants. Mary and I talked, and we went on to have a second bottle. Lucius Beebe left about four o'clock, and I took Mary out to dinner.

I was attracted to Mary from the moment I met her and within four or five months we were engaged to be married. Her face was very distinctive, with high cheekbones and large, intelligent eyes. She wasn't so much pretty in the conventional sense as striking in appearance. She was vivacious and impulsively enthusiastic, easy to talk to, and interested in all kinds of things. She was just three years older than I was and had been born Mary Elizabeth Conover in Kansas City. Her father, a local doctor, was a highly intelligent and very nice man. I found her mother pretty negative. From childhood Mary had suffered at-

tacks of asthma. As she grew older, she discovered that these attacks were more and more frequently brought on by proximity to horses and sometimes by the pressures of social occasions. Realizing that the complaint could have a psychosomatic element, Dr. Conover studied it and from time to time attempted to treat his daughter.

Dr. Conover was an internist, with only an intuitive feeling for psychiatry, and we were always fascinated by his stories about his early years of practice in Kansas City and his house visits to many poor farming families out in the Kansas countryside. His fee often was paid in eggs, butter, or vegetables. He was also the protégé of an older doctor in St. Luke's Hospital, where he did his internship. I believe the older doctor was an early psychiatrist or at least a specialist in nervous disorders. According to Dr. Conover, one of his mentor's patients was a young woman who had been bedridden in the hospital for many weeks and refused even to try to get up, claiming that her legs were paralyzed.

One day the older doctor went into her room and said to her, "It is time for you to get up and walk." She cowered and gave the usual excuse. With no further words, he slowly produced a box of matches from his pocket, struck one, leaned down to the side of the bed, and lit one of the sheets. According to Dr. Conover, the lady without more ado jumped out of the bed and ran down the corridor. Now *that* was an accomplished psychiatrist!

At the age of eighteen, in 1922, Mary had gone to Vassar, where she majored in French, but her main interest was music. She sang and played the piano with gusto. Everyone who knew her then stresses the fact that although she was bright, she was no intellectual. I find that curious, bearing in mind that later she was drawn so forcibly toward intellectual circles. After Vassar she spent a year at the Sorbonne and another year of graduate study in French at Columbia University.

Mary had married Karl Stanley Brown in 1929, the year that I graduated from Yale. Brown was in advertising and subsequently moved to Wall Street. Two years later the marriage was in difficulties. Mary went to Europe in 1932, looking up friends

in France and Scandinavia. She then took a job as girl of all work at the John Becker Gallery, a newly opened avant-garde art gallery on Madison Avenue. Her marriage came to an end, and she was divorced from Karl Brown in the summer of 1933.

The art gallery couldn't have been started at a worse time, with the stagnating effect of the Depression, so John Becker was obliged to close it in that same year. Mary had nevertheless mixed with a number of very interesting people in the world of art and literature. One in particular, John D. Barrett, Jr., who had invested in the Becker Gallery, later became a very close friend and associate of mine. He had graduated from Yale two years ahead of me.

Father had never really taken me into his confidence about his business life, and as a result, I had no proper understanding of it and certainly no understanding of his tax affairs. The government people who had been persecuting him so relentlessly didn't realize this, however, and imagined that I might have been kept in the background because I held information that could be useful to their purpose. Only a day or so before I was to leave for New York, where Mary and I were to be married in my sister's house, the government sent a court officer to the Bank with a subpoena requiring me to appear before the tax court to give evidence. This didn't fit in at all with my arrangements. Mary and I had made definite plans for a honeymoon trip to Egypt. When an assistant walked into my office on the top floor of the Bank and told me there was a man downstairs seeking to serve me with a subpoena, I promptly climbed out of a window that gave on to an inner courtyard roof, went back into the building through another window, rode down an elevator, and went home. There I packed my bags and took the night train to New York, where I was married two days later, February 2, 1935.

Mary and I embarked that same day on the liner *Rex* for Genoa and then went on to Egypt, where we chartered a small Thomas Cook houseboat that took us up the Nile as far as Abu Simbel. Our friend Jack Barrett had traveled extensively in

Egypt, and he arranged for Thomas Cook's chief dragoman, Mohamed Sayed, whom he knew from a previous tour, to conduct us. The honeymoon lasted several months, and we made a leisurely return home through Paris, where we met Barrett, then on his way home from a trip to the Aegean. From Paris we went on to Holland and to England, where I went hunting in Wiltshire, and then up to Scotland. Back in Pittsburgh, we settled down to live at Woodland Road. Father spent part of his time there as well as in his Washington apartment. Mary and Father got on very well together, and I had the feeling that he enjoyed having our young friends in the house and the occasional house parties we gave for our New York friends.

In the autumn of 1936 Father was in his eighty-first year. He had been busying himself for the last nine years with his art collection, rather like John Galsworthy's Soames Forsyte, the fictional character with whom Father had so much in common. Of necessity, much of his time had been consumed by the tax case. It was in this year that he offered his collection to the nation in Washington, together with a building to house it, as the basis for a National Gallery. Father had become very frail, and it was clear that his long life was drawing toward its close. He had suffered one or two temporary brain malfunctions, during which his words came out helter-skelter, with no meaning. These spasms passed within minutes, but he was clearly getting weaker.

I knew that it would only be right for me to clear up the matter of my own future with him before his death. The question had arisen of my buying my mother's farm, Rokeby, in Virginia, because she, too, was over fifty and was preparing to move to Connecticut and a smaller house. I brought the subject up one day as Father and I were being driven into Pittsburgh. Discussing any topic of importance with Father always made me feel uneasy. It wasn't just Rokeby I wanted to talk to him about. It was my feeling for the land, for country life, my repugnance at the thought of spending my life as a banker and all that would involve.

In any event, I just muttered that I thought it might be nice if Mary and I were to buy Rokeby from Mother. Father replied in his quiet voice that he considered that sort of real estate purchase a rather poor investment in the current economic climate. It might as well have been twenty years earlier, when I had asked him if I could have a dog, and the reply had been "Oh, you don't want a dog." There was a forbidding quality in Father's cold attitude that always unnerved me and made it very difficult for me to pursue a personal conversation with him.

I sincerely believe, however, that the problem of communication rested with him as much as with me. To cite an example, he had written me a Christmas letter in 1929 from his Massachusetts Avenue apartment. It read:

Dear Paul,

As a birthday gift to you on reaching your majority last year I transferred to you 1000 shares preferred stock of the Aluminum Co. of America, as an outright gift.

Lately I transferred to you 2000 shares of the Monongahela St. Railway Co. This Monongahela St. Ry. stock is a gift to you which I make in consideration of your having given up or relinquished to your mother your interest or share in the Trust fund designated as Trust No 3. of which The Union Trust Co. of Pittsburgh, Mr. McCrory and I were Trustees. As you gave this to your mother at my instance I have made it up to you by gift of this stock.

With much love—Father

I think Father was trying in his own way in this letter to express his affection for me.

I talked to Mary about how I should now approach Father, and then I put my thoughts on paper. Looking again at that piece of paper more than fifty years later, I can feel again the pent-up frustration. My memorandum to myself reads:

It was much better to talk to Mima [Mary's nickname] last night about what I am going to talk to Father about, and I

think it has cleared my mind considerably, or at least helped to accentuate the deeper and more important phases of the problem. The suggestion that it is easier and better to begin the whole matter by trying to get into his feeling in the matter, by asking direct and very important questions, and by trying to draw him out rather than have him put me on the defensive immediately by interrupting me, or ignoring the real meaning of what I am saying by passing over the subject. It is true that I have never asked him a direct personal question in my life, never really tried to discover what the feeling is behind his strange exterior, never tried to have him put his philosophy or religion or hopes or emotions into words.

. . . The years of habit have encased me in a lump of ice, like the people in my dreams, and when I get into any personal conversation with Father I become congealed and afraid to speak. It has gone on so long that it will be frightfully hard to thaw myself out and actually be able to feel my real emotions and actually say them to him. . . . But somehow I think I can do it at last, because I really think I finally realize that it is the most important thing in the world to me, and that if I put it off it may immediately become too late. . . .

These are the things I want to talk to him about, thoroughly:

Business: What does he really expect me to do, or to *be*? Does he want me to be a great financier, to enter into the real spirit of business, to accumulate more wealth in addition to protecting this great mass of interests that have fallen to me? Does he think that activity of that sort is the only real happiness? That wrestling with problems of finance and seeking new outlets for energy and capital are the end of life? What does he want me to do with everything that we have accumulated? What does he think will happen to our children, and what does he hope they will be? Does he want us all to be like him? Does he think that wealth and property are safe in the world today, and that by protecting it now personally we are setting up a protection for future generations?

The mass of accumulations, the complication of our holdings, the responsibility of great financial institutions appal me. My mind is not attuned to it. I would rather have most

of my own interest in the affairs taken care of by trusts or competent persons, the risks diversified, the responsibilities diminished by diversifying. I do not want to be harassed, in the course of my own life, by great problems of taxes or by the very dangers and hazards of business competition and natural changes. It is not a satisfying life to me, and I can't go on fighting it until I am old and worn out. I have some very important things to do still in my life, although I am not sure what they are. . . . Perhaps I am not meant to do anything very important or startling in the world, but I do know that I will have very engrossing interests if I am only able to grow into them myself. Perhaps I will only be a gentleman farmer or a sportsman, but I want to do in the end things that I enjoy and that are part of me. I am almost 30, and most of my late years have been spent in wondering how to get out of what I am doing. . . . which brings me to *Values*: What does he feel are the most important things in life? What does he think life is for? Where does he think the world is going, or what does he think the most important function of the individual is? Is it to make money, accumulate, eat, drink, and die? What does it really matter, in the end what you do, as long as you are true to yourself and feel that you are being yourself? Why is he so afraid of the country and country life? Why is business and the accumulation or protection of wealth more important than the acceptance and digestion of ideas? Than the academic life, say, or the artistic? . . . Is the man of action more happy than the man of reflection? Does he realize that there are definite types of human beings? . . .

. . . Whatever it is, there is no use beating around the bush by trying to identify my sense of values with his. . . . I am more like Mother in my instinctive nature, and near to the earth, as she is. . . . Which brings me to

Mother: . . . Having Mother and Father separated set up a dual standard of values in my own mind from the beginning. Although Mother hardly ever talked to me about anything personal any more than Father ever did, still proximity to her gave me instinctive feeling for beauty and natural things. From Father I received good judgement and sound natural sense and the sense of the importance of the outside world, a respect for logic and order and money, which I think is very important. But I think Father's denial of

Mother and his complete reaction to anything to do with feeling or the personal side of nature has always had a dampening effect on my energy and my natural emotions. ... I have always tried to do everything he has wanted me to do because I thought it was the right thing to do, and I have always loved and respected him. But I have always had these other emotions edging in and trying to burst out: love of the country, natural love for people, love of horses, gaiety etc. Which brings me to

Hunting, and love of the Country: What is his aversion to owning Land? He owns most of Bismarck which I have never seen and he hasn't seen for years, and paid a lot of money for it.* Why does he think it is foolish for me to own 400 more acres in Virginia, in a country that I love and where I have a definite interest, and a *home.* Why has he never agreed to have a house in the country, to actually own land which is valuable for its own sake, in a personal way, valuable to him and to his feeling for it? ... He had me buy the Singer-Massey property on Fifth Avenue, which has no value to me personally except for reselling and making a profit. ... Then why in God's name shouldn't I buy a small piece of property that I will always use, and that will protect the natural features of a country estate in a land where there is hardly any real country, in the English sense, left? Why haven't we, Ailsa and I, as children, ever had a permanent base, a real home with roots, in the country?

... I also feel that a great deal of my feeling for the country and horses comes from Mother. In the first place, she is English, and I am therefore partly instinctively English in my love of the country. I have lived in England and tasted English life pretty thoroughly, and it came to me naturally and strongly. It is really in my blood. ... It explains my addiction to English literature, to the English poets, to descriptions of English life, especially sporting and country life, and to the social and emotional aspects of English history. In poetry especially, because I seem to have a real and deep-seated feeling for and understanding of what they are saying to me, both in the sense of the poetry and through the musical and sensuous vibrations of English words and the

*Richard B. Mellon and George N. Mellon, both brothers of Andrew Mellon, set up a bank in Bismarck, where they also farmed and dealt in land.

cadence and harmony and innate force of rhymes and phrases. . . .

Hunting is another example of the reaction which has set up inside me against business, the city, modern industrial drabness, the suppression of the natural emotions and feelings. . . . It involves the use of the horse, that instinctive animal, and man's mastery of the horse. . . . It requires physical skill, good judgement, quick thinking, and the age-old thrill of the chase and the kill. . . . There is nothing mechanical about it. It is natural, as old as the hills, literally.

That is why I curl up in myself and feel resentful and can't talk when Father speaks of the danger of hunting and his dislike for it. . . .

Racing: Closely allied to the above, racing and race horses have always been a source of disagreement and irritation between Father and myself. Why does he misunderstand the subject so? Is it because he thinks the whole thing is connected with gambling, drinking, fast horses, fast women? Is he influenced by Uncle Percy's lamentable addiction to betting and losing? There are the same elements in racing that attract me as in hunting, although it is more its aesthetic quality. . . . It is the colour, the movement, the speed, the excitement, the competition, the skill of riding, the cleverness of the horses, and the primitive element of luck. . . . But it is mostly the love of the horse, the well-kept, well-trained, beautifully moving horse, the horse as an object of art.

. . . I have my horses and love to see them run, but I sometimes still feel guilty about it because it is a luxury and an economically useless hobby, and I know that he disapproves of it although he never says anything about it. Which brings me to

Paintings, and the Gallery: . . . Father had talked a long time about leaving his collection to a National Gallery, but Ailsa and I didn't realize to the full extent what he was going to do. Then we suddenly found that he had put *everything* into the [A. W. Mellon Educational and Charitable] Trust. . . .

. . . Father even put the Reynolds of Lady Caroline Howard, which I am sure he knew Ailsa loved, into the Trust.* He never asked me whether I would like one of them, or asked my advice about whether they all should go in or not.

*It hung for many years in her room in the apartment on Massachusetts Avenue.

One day he said to me "You and Ailsa don't seem to understand the significance of this Gallery. All of those pictures are so valuable and so rare that they ought to be kept for the public, and a gallery built for them. It is a fine thing to do for the Nation, and it is a fine thing for our name also. You and Ailsa are my children, and we all share in the kudos of this benefaction. We are all one, the family, and we are *all* doing it." Or words to that effect. Of course he should give the pictures to the Gallery, and I have never questioned that. But I would have expected some slight confidence on his part, some conference with us. And he was terribly surprised when we said that we would have liked just one picture, one favorite picture. But it was too late. And it isn't solely because we grew up with them and loved them for their own sakes: but we would have liked to have something as a sort of remembrance of the whole thing, as a part of Father and of something that he liked and that he had done himself, the only artistic or aesthetic thing that he has ever permitted himself. Perhaps we were grasping for some tangible evidence that there really was a feeling side, an aesthetic sense in Father.

He made David [Bruce]* and me Trustees of the Trust, but he has never really consulted us about any important matter to do with it, and has never encouraged me to take any interest in it whatever. Mary and I definitely offered to once, but were ignored. I offered to help him with it not more than a month ago, but since then he has sent Finley to see Duveen, has done all the negotiations with Duveen himself, and has never asked my advice about anything. He never even asked me if I had seen the plans, or if I would like to be there when Mr. Pope [John Russell Pope] came, or if I had any suggestions about it all. It is just the same as it has always been in business: he puts me into them and then ignores me, ignores my judgement or interest or actions. He has never encouraged me to do anything, never given me a word of advice or encouragement about business or my life. . . . The Gallery to him is just one more investment, one more tremendous Mellon Interest . . . one more prop for the scaffolding which holds up his gigantic, intensive, mysterious ego. . . .

*David K. E. Bruce was married at that time to my sister. He was later the head of OSS in London during the Second World War and, after the war, the United States Ambassador to the Court of St. James's, France, and West Germany.

I was twenty-nine years old when I wrote that and very dis-
couraged over a growing feeling of stagnation in my life. I had
been working myself up in my broadside in order to face Father
and have it out with him at last. My relationship with him was
always dogged by difficulties. To take an example, apart from
Ailsa's favorite Reynolds, there were a few pictures at Woodland
Road, two Corots and a Van de Velde seascape among them,
that were not destined for the National Gallery but that I had
known since early childhood in Forbes Street and that I thought
Father either would give me for sentimental reasons or would
leave in the house on his death. But no, he proposed that I pay
him for them. The sum wasn't particularly large, something like
twenty-five thousand dollars for each painting. I would be pay-
ing with money that Father had made over to me, and the in-
tention was probably that Father would not then have to pay
gift tax, but the action seemed at the time to be particularly
stingy.

The long-delayed meeting and conversation took place on No-
vember 29, 1936, just nine months before his death. To my sur-
prise, I found him very understanding and appreciative of the
fact that I broached these issues with him. He said he thought
it was not necessary for me to have any active part in any of the
businesses, that they were too complicated and varied for any-
one to have a real knowledge of them, and that I ought rather
to consider myself more in the position of an owner, who kept
vaguely in touch with everything through the head people. He
said the important thing was to know that the right people,
sound men with good judgment, were in charge of the com-
panies and that really in the end good management was the
only thing that mattered. I agreed with him but added that my
knowledge and judgment were so slight that I couldn't even tell
what was good management. Father smiled, as if I had a point
there, but said that he didn't think I should feel tied down.

He told me that when he was an active businessman, before
going into government service, he used to go away for long
stretches. He mentioned going off in the summers to England
and France for six months at a time with Frick, mainly as tourists

but also on the lookout for pictures, and he spoke of such adventures as their coaching tours and of the long summers he used to spend in England after he was married. He said that in those days he did not have to pay such close attention to business, that everything went all right, and that he felt perfectly free to go anywhere any time he liked. He said he didn't see why I couldn't do the same.

He went on to say that his objection to my being out in the countryside so much was the foxhunting part, and his objection to that was the danger, but he added that when you took into consideration all the danger there is in the world today from other things, such as cars and airplanes and speed generally, there wasn't much more danger in hunting than anything else. It was only that he had always felt that it was a needless risk. He was surprisingly receptive, much more so than he had ever been before. In fact, there was a reasonableness and a softness and understanding in him that took me back a little because I had always thought of him as being so different.

I then sat down to write him a letter summarizing our talk. It read:

Dear Father,

Before I go I want to put in writing a few of the ideas that I tried to express today, partly to clarify my own mind, and partly to be sure that you understand me thoroughly. Somehow I am much better able to express myself on paper, and it gives both the other person and myself a more thorough understanding and a clearer picture of my ideas and feelings. . . .

I have always been afraid to talk about these things with you because I felt for some strange reason that you might think the less of me or feel that I was being unreasonable or disloyal. I now realize that it would always have been much better to have you know what I was thinking or feeling, and that that is the only basis of a real understanding between us. I have always had the feeling that you would judge me and think about me in terms of business and of your own active, fruitful, and energetic life: but I now realize that even if that had been so it would not be worth

the price to compromise with that feeling in me and to keep on in silence and mental compromise. In other words, I found that I would much rather have you disappointed in my attitude toward business and our material interests than in myself as a person, and that I would much rather have you respect me for my honesty and frankness than accept me as an inadequate replica of yourself, a counterfeit. And there is no doubt about it, from your attitude, your chance questions, you have wondered what my position is and what I have been thinking about for a long time. I want you to have confidence in me and an understanding of me as I am, just as my feeling and respect for you is for you as a man and my father, and not the same sort of respect and love and deference as the rest of the world has for you. It is much closer and more real.

My father grew progressively weaker and more frail at this period, and nine months later, on August 26, 1937, he died.

C. G. Jung, Zurich, and Bollingen Foundation

———◆———

If I were as wise as they
I would stray apart and brood,
I would beat a hidden way
Through the quiet heather spray
To a sunny solitude ...

I would think until I found
Something I can never find,
Something lying on the ground,
In the bottom of my mind.

—JAMES STEPHENS
"The Goat Paths"

Macbeth:

Canst thou not minister to a mind diseas'd,
Pluck from the memory a rooted sorrow,
Raze out the written troubles of the brain,
And with some sweet oblivious antidote
Cleanse the stuff'd bosom of that perilous stuff
Which weighs upon the heart?

Doctor:

Therein the patient
Must minister to himself.

—WILLIAM SHAKESPEARE
The Tragedy of Macbeth, Act v, scene 3

Mary's asthma was not a serious problem when she and I were first married. She had suffered from it since childhood, but there had been quite long periods when it seemed to present no great

157

difficulty, maybe just a little attack every two months or so, and she could obtain relief from a spray that she carried about with her. She had one really bad attack during our engagement when we had gone together to the Meadowbrook races on Long Island. It was alarming and pitiful to witness her suffering as she struggled to inhale and release her breath.

As a result of reading Jung, Mary suspected that there could be a psychological problem aggravating her illness, and she was considering therapy for it. Shortly after we met, she started having analytical interviews in New York with Ann Moyer, who we were told was a Jungian analyst.

Apart from wanting to find a cure for Mary's complaint, my own interest and curiosity led me to believe that analysis would benefit me as well. It was a period in which I was still wrestling with my father's influence (or perhaps I should say the *idea* of what my father had wished me to be), and I was torn between appeasing him with the promise of a business career and deciding what else I could do. I daydreamed at that time about entering the publishing business or something connected with books, having long ago given up the idea of an academic career.

I can only say that, for both of us, this first period spent in analysis with Ann Moyer was a complete waste of time. One unfortunate feature of Jung's system in those days, and, indeed, probably throughout his career, was that there was no way of knowing which analysts were approved by him, or had been trained by him, or trained at all in any professional sense of the word. When, later, I got to know him personally, I always found his attitude toward his pupils and analysands puzzling. It was sometimes hard to distinguish between his elderly lady patients and those other ladies who claimed to be analysts.

At one point Moyer married a young Dutchman named Erlo van Waveren, and I was shifted temporarily over to him. Suffice it to say that although Mary suffered under Moyer's hazy and mystical advice for longer than I did under van Waveren's, we both ended up with a feeling of having been hoodwinked by this pair, whose understanding of Jung seemed to be warped by their own misinterpretations and wishful thinking. In the end

we parted from them on fairly friendly terms.

In 1934 Mary and I read Jung's *Modern Man in Search of a Soul*, first published in English a year earlier, and we were deeply impressed by it. We subsequently met and became close friends with Cary F. Baynes, who, with W. S. Dell, had made the translation. The book comprised a collection of essays that outlined the directions of Jung's thought. In October 1937 Jung delivered the Terry Lectures in English at Yale on "Religion in the Light of Science and Philosophy." He then went on to New York and, under the auspices of the Analytical Psychology Club, gave a five-part seminar on the subject of "Dream Symbols and the Individuation Process." We were most eager to hear him and arranged to attend at least one of the seminars.

In Pittsburgh, a few nights before we left for New York, I had an extremely moving dream. I was reading a book, the story of which involved "The City that never Changes" or "The City that always Sleeps." It included a symbol which was like this:

The S in the middle represented the river which ran through the sleeping city. The passage I was reading went:

> The sacred river that curves through
> the sleeping City, where the sun remains
> fixed and glowing on the further cliffs
> and palaces, aslant and in the same position
> all day: where every house is the same,
> and in every house in a white room there is
> a cool bed, and in every bed a still protector
> of a small leaden box, and a hand laid gently
> on the small leaden box in which lies the heart
> of the City that always Sleeps.

It gave me a feeling of immense stillness, a picture permeated with sunlight and lovely late afternoon colors. Simple, small white rooms, small plain beds, very white sheets, and red or blue wool coverlets. I had no idea of the meaning of all this, but the emotion inspired by the dream, a sort of quiet euphoria, stayed with me for many days.

A poem that I had written as a schoolboy, and that was published in 1925 in the *Choate Literary Magazine*, seemed to have the same feeling. It goes:

> There is a gay city
> I see in my sleep,
> I hear its sweet laughter
> From over the deep,
> Its gay songs and laughter
> From over the deep.
>
> Its bright colored minarets
> Shine in blue skies,
> With gold streets and silver
> It dreamily lies.
> Beset with white mountains
> It dreamily lies.

You can imagine how great was my surprise when I entered the lecture room for the seminar and saw on the blackboard, drawn by Jung himself in chalk, the very same symbol, the symbol, as I then learned, of psychological integration.

Years later, reading poems in an anthology assembled by Field Marshal Viscount Wavell entitled *Other Men's Flowers*, published in America immediately after World War II, I came upon the following anonymous poem:

> This is the Key of the Kingdom:
> In that Kingdom there is a city;
> In that city is a town;
> In that town there is a street;
> In that street there winds a lane;
> In that lane there is a yard;

In that yard there is a house;
In that house there waits a room;
In that room an empty bed;
And on that bed a basket—
A Basket of Sweet Flowers:
> Of Flowers, of Flowers;
> A Basket of Sweet Flowers.

Flowers in a Basket;
Basket on the bed;
Bed in the chamber;
Chamber in the house;
House in the weedy yard;
Yard in the winding lane;
Lane in the broad street;
Street in the high town;
Town in the city;
City in the Kingdom—
This is the Key of the Kingdom.
> Of the Kingdom this is the Key.

A shiver ran down my spine when I read it. The whole sense of the poem was so much in keeping with both the visual impact and the deep emotion of my dream that once again I marveled at the correlation between the dream, my boyhood poem, and the symbol portrayed by Jung at the lecture.*

We attended the seminar, but the subject matter was very abstruse, and I found the lecture way above my head, as indeed did Mary. She, however, was deeply affected by the force of Jung's intellect and the sheer power of his mind, whereas I was delighted with his naturalness and modesty. When we sat down together for supper after that lecture, Jung saw a bottle of Chianti on the table waiting to be served with the meal. Not standing on ceremony, he produced a huge Swiss hunting knife from his pocket, levered out the corkscrew, drew the cork, and poured some wine. I couldn't help admiring such an intellectual giant for being so down-to-earth.

*I also came across the following epigraph preceding a poem in *The New Yorker*: Far, far away in a lake lies an island; on that island stands a church; in that church is a well; in that well swims a duck; in that duck there is an egg; and in that egg there lies my heart.

I wrote a letter to Jung two months later, in December 1937, saying:

> Dear Dr. Jung:
>
> Mrs. Mellon and I have been working with Mrs. Ann Moyer van Waveren in New York over a period of three years. It was through her that we were able to attend the seminar which you gave in New York in October of this year.
> We are both very eager to attend your seminar in Zürich during next May and June, and are writing to ask if it would be possible. Also, each of us would be grateful for as little, or for as much time as you could possibly give us individually.
> Since we would like to make our plans for living in Zürich soon, we would appreciate very much hearing whatever answer you are able to give us at your earliest opportunity.

Jung's secretary replied to say that we could come to the seminar, although it would probably be impossible for us to see Jung personally.

Our daughter, Cathy, had been born on December 30, 1936. A little while after Father's death in August of the following year, we left Pittsburgh for good, giving the house in Woodland Road to neighboring Chatham College (then the Pennsylvania College for Women) and moving permanently to the farm in Virginia. Early in 1938 we set off with Cathy for Europe, accompanied by a nurse. While staying in London, en route to Zurich, I arranged for Gerald Brockhurst to paint portraits of Mary and thirteen-month-old Cathy. Mary sat wearing a dark green cape, designed for her by Jack Barrett's great friend the couturiere Valentina. The resulting portrait, which now belongs to Cathy, makes her look rather too severe, but it is an excellent likeness. On May 6, 1938, we left for Zurich and remained in Switzerland for eight weeks. During our stay we attended Jung's seminar in English on the subject of Nietzsche's *Thus Spake Zarathustra*. After the *Zarathustra* lectures and toward the end of our visit, we drove down to Ascona, where we stayed at the legendary

Hotel Monte Verità, high above Lake Maggiore. There we met someone who was to play a significant role in our lives, Olga Froebe-Kapteyn, who lived nearby on the lake in a house called Casa Gabriella.

Olga was a very powerful, mysterious sort of woman, brimful of all kinds of mystical learning. What made her even more unusual to me was the knowledge that early in her career she had been a circus rider in Holland. She was given the Lake Maggiore house in about 1920, together with a patrimony, by her father, a former director of the London office of the Westinghouse Brake and Signal Company. At that time I was unaware of Olga's family's connection with the company, whose main office was in Pittsburgh. The house was in a beautiful location near Ascona, and the terrace afforded a fine view over the lake.

In the early thirties Frau Froebe-Kapteyn had started organizing lecture programs on esoteric subjects, mostly with Jungian overtones. At the suggestion of a German scholar, she called her undertaking Eranos, a Greek word meaning "shared feast." The conferences invariably took place in August for about two weeks. The first was in 1933, when the subject was "Yoga and Meditation in East and West." Jung inevitably became a focal center at the conferences, and in 1935 Frau Froebe-Kapteyn began creating a photographic archive of documents and works of art that exemplified Jung's archetypes of the "collective unconscious." Following our departure from this, our first visit, in May and June 1938, the theme of the conference, scheduled to take place in August, was "The Great Mother," and the lectures were to be illustrated by blown-up photographs from the archive.

As soon as they met, Mary and Olga Froebe-Kapteyn discovered a strong rapport. Olga found she had spent nearly all her patrimony on Eranos and its archive, and Mary at once offered financial help on our behalf. Mary had made a careful study of Dante's *Divine Comedy* while at Vassar (I still have her copy of the book with her assiduous penciled annotations on nearly every page). She now asked Olga to order photographs for her

of an illuminated manuscript of Dante's epic poem that was in the Apostolic Library of the Vatican. Although she wasn't a natural scholar, Mary was always watching for outlets for her terrific energies.

Jung happened to be taking a holiday in Ascona during our stay there, and he consented to see Mary and me on our last day. We each had an appointment lasting some fifteen minutes. During my interview Jung explained that Mary had a tremendous animus, which was the real problem. The reader will recall that in Jungian terminology, the word implies the personification of the masculine nature of a woman's unconscious, rather than just meaning a display of ill feeling. He said that it was the horse in *her* that was on the rampage and that she should be given more freedom to kick out. He thought that her parents (perhaps her mother in particular) had caused her to feel mentally and morally constricted and that I might be able to help her break out from this confinement. With these thoughts in mind Mary and I left, to sail two days later from Bremerhaven on the *Europa*.

We planned to return later in the summer of the following year so that we could attend the 1939 Eranos conference. The theme that year was to be "The Symbolism of Rebirth." We again took Cathy with us and sailed direct from New York to Genoa on the *Rex*. From there we drove up into the mountains to Ascona in our little blue Plymouth convertible, arriving on July 31. The conference started a week later on August 7.

It was Olga Froebe-Kapteyn's practice to hold the lectures before noon, and when they had concluded, the audience left, except for the houseguests and those whom she decided to invite to stay for luncheon. On most days we found ourselves numbered in a group that took luncheon at a large round table on the terrace. Very shortly after the start of the conference, on August 9 and 11, we each had a second appointment with Jung, and at that time it was arranged that each would work with him independently over the coming winter.

After the conference finished on August 28, we motored up to Zurich and stayed initially at the Dolder Grand Hotel in the

hills above the city. Hitler invaded Poland on September 1, 1939. As a result, France and Great Britain declared war on Germany, but Switzerland remained neutral, and these developments didn't affect us immediately. During our visits to Olga Froebe-Kapteyn at Casa Gabriella we had made friends, among others, with an elderly American lady, Mary Foote, who had arrived in Switzerland in 1928 but who had become so wrapped up in Jung's world that she eventually stayed on for thirty years. Mary Foote now found us an apartment at 68 Plattenstrasse, in a quiet suburban area of Zurich. It was near the Psychological Club where Jung held his seminars. Both Mary and I started working separately with Jung at the end of September.

Jung lived in Küsnacht, a suburb some miles away from the center of Zurich, on the lake, and we each drove over for about three or four sessions a week. During one of my first appointments with Jung I told him of a dream I had the night before. I was with him in the hayloft of a barn and saw that he was about to smoke a pipe. I struck a match to light it for him, but suddenly the hay caught fire. I can remember that Jung said, "Well, perhaps that is a warning dream that shows we must proceed very carefully with your psyche!" Looking back over the years, I would interpret the dream now as saying to me, "Jung's theories and teachings will only confuse you more. Get out of his barn while you can." His was not a probing analysis. He often criticized the Freudian method for paying attention only to the personal unconscious (i.e., the individual's childhood memories and traumas), instead of what he termed the collective unconscious (mankind's unconscious memories, the archetypes). The latter is the theory that I take to be *his* main contribution and magnum opus.

Jung was sixty-four when I first came to know him. He had been born the son of a pastor of the Swiss Reformed Church and had trained as a medical doctor before specializing in psychiatry. He worked for ten years in a psychiatric clinic in Zurich, leaving in 1910 to concentrate on his growing private practice. He was becoming interested in myths and legends and the light they throw on mental disorders, as well as in treating mental

disorders by psychic influences, such as hypnotism.

Jung's interests led him to study Indian philosophy, and he also went to Africa to observe tribal myths and customs. He believed that Western man had deserted his roots and that this was the source of a lot of mental disorders. Jung met Freud in 1907, and they collaborated closely for the next five years. Fundamental differences in their thinking caused a break, and after a period of inner doubting, Jung went on to form his theories of the collective unconscious and its manifestation in the archetypal images. Jung was particularly interested in the individuation process, which to him meant the attainment of the integration of the personality. He had lectured on the subject at his New York seminar in 1937, explaining that some people, who have achieved independence from their parents and who have grown up sexually and led a fulfilling working life, could still experience a mid-life crisis because they were not yet whole. Although Jung was such an intelligent and learned man, he was quite easy to talk to. There was a good deal of the peasant about him, and he was very direct. He also had a very good sense of humor.

Jung urged me to record dreams, and I found, as time passed, my dreams became more and more complicated and unfathomable and very long. There were no more symbolic and emotionally moving dreams, such as I had experienced of the mandala of the city with its winding river and the final reduction to a small lead box in a room. He also encouraged me to write a psychological autobiography, a project on which I spent many hours during those gloomy winter Zurich afternoons in our little apartment. But that, too, became depressing, an exercise in remembering and recording more and more about less and less. As the winter wore on, I felt that I was not getting anywhere and that Mary was not making any headway against her enemy, asthma.

With the outbreak of hostilities in Europe, since none of the combatants was fully prepared, nothing very much happened for a while, and that autumn and winter were a phase known as the "phony war." Switzerland, retaining its neutrality, was

almost unaffected. There was rationing of food and gasoline, but otherwise life went on as usual. I had friends with the British forces in France, like John Stansfeld, who was stationed at or near the Maginot Line. He was the father of the two young boys, Jonathan and Martin, who later came to us in Virginia for most of the war years. We sent him food packages and a radio, and at the back of my mind there was a vague feeling that I should join *his* army. By the summer of 1940, however, things had changed radically. Hitler had swept over Norway, Denmark, Holland, Belgium, and France, and we were concerned that sooner or later the United States would become involved.

I felt a growing sensation of being constricted by the family, Mary and Cathy, the stigma of too much money, the burden of everyday responsibilities, the knowledge that I would be returning home to the unstimulating use of money for conventional educational and charitable purposes. Living in tight little Switzerland exacerbated these feelings, and my thoughts turned more and more toward the lure of another constriction, the Army. I saw the Army as a place where my identity as a wealthy, married "society" individual could be assimilated into a group with a historical and collective purpose. It could also have been that I yearned for a more masculine and carefree world, such as I had enjoyed at Yale and Cambridge.

Mary's enthusiasm for Jung, meanwhile, seemed unbounded. She even went to his lectures in German. Although she had taken a few lessons in elementary German, Jung's abstruse thinking was difficult enough to follow in English, let alone in German, and furthermore, he spoke English fluently. It was a curious obsession that made her go to such lengths. As winter drew on, I found Zurich cold and rainy and, hemmed in as it is by mountains, a dank and gloomy place. However, I conscientiously made my visits to Jung, enjoying his warm company and the pleasure of listening to him.

Shortly after Christmas 1939 Mary, Cathy, and I took a trip to Arosa, near Davos and the Austrian border, for a skiing holiday. It was extremely cold. Mary had a severe attack of asthma, and we were back in Zurich within four days. We had come to

Switzerland seeking a cure, but it clearly wasn't working. Within two years of our getting married, the little spray she used during attacks had to be replaced by a heavy oxygen cylinder, which we now carried about with us wherever we went. Eventually that large cylinder became a growing irritation to me; it seemed as if it had become a rival for Mary's affection, a silent lover.

In early spring Mary had appendicitis and had to undergo an emergency operation in Zurich. While she was convalescing, I joined Jung, his wife, Emma, and their daughter on a walking holiday in the mountains outside Locarno.

I started my two weeks of walking in the mountains on April 2. We walked and talked, and in the evenings I jotted down where we had been and what had been said. On April 6 I wrote:

> Walked with Dr. and Mrs. Jung to Intragna over the hills from Losone. Took a train to the church at Losone, then up into the woods, quite high up past a small lake. A place for a witches' sabbath—a meadow up there. Jung said that when he first went there, there was a circle of stones in the middle, as if for some rite. We found it, still there, in the grass. On the way, we talked about drinking mountain water, then on to typhoid, infection and asthma. I told him about Mary's injections. He said they [the medical profession] had no idea—that it was not an organic thing at all. I told him that many children seem to be getting it in America. He said it was no wonder, they were all stifled; that they had no clean psychic air to breathe.
>
> We had lunch under the bridge at Intragna. Quiet and warm. Green bush coming out from middle of bridge. I told Jung about Thoreau mentioning Indian custom of burning everything they own every year. Also that he used the word unconscious seemingly in the proper sense. Jung said, "Anyone who has lived in a primitive way and who *thinks* will naturally come to know about the unconscious. It only goes to show how many silly asses have done it who don't think."
>
> We walked from Intragna to Ponte Brolla, where we stopped at the Jungs' favorite ristorante. The proprietor was fat and hearty with a moustache, and his wife came out and sat with us. We had orangeade, then coffee and

kirsch. I was tired and sleepy by then, but Jung was much interested in the fortifications the Swiss army had been building back in the mountainside, and so we went to see them.

I tried to talk to Jung about my dreams and told him of a series about soldiers. First he said, "Why are you dreaming of soldiers, I wonder?" later adding that it was a question of me getting into my true masculine role; that I must get away from the influence of women—Mother, Mary, family etc., etc., and do a man's job. He spoke of what a good thing military service was for young people. He had seen enormous benefits to the youth of Switzerland, such as manliness, self-reliance, training, discipline and the rugged life.

Mary and Cathy came to join me at Locarno on April 15, 1940. Hitler had massed his forces in the west and was about to overrun much of Europe, so I immediately made arrangements to get Mary and Cathy back to the United States. They sailed on May 3 from Genoa on the *Manhattan* with the nurse and with Ernest Ridsdale, the butler who had run our house in Pittsburgh. Ernest, who had remained after Father died, had come over to help us shortly after Mary and I arrived in Switzerland. I followed two weeks later.

It was with a sense of relief that I closed up our apartment on Plattenstrasse, took a train through the customs frontier at Chiasso into Italy, and embarked for the United States on the *Washington* from Genoa. By then it was no longer easy to get passage out of Europe, and I had to share my cabin with another passenger. This fellow traveler turned out to be Armand Hammer's younger brother, Victor. Victor Hammer had a guitar with him, and he entertained me on the voyage with sad Russian songs and fascinating stories about his and his brother's adventures in Russia.

I certainly don't want to leave the impression that my experience with Jung was totally unproductive or that I regretted the many hours I spent in his company. I always had a strong sense of his greatness, of his compassion and humanity, of his immense learning. His aura of mysticism was deceptive, for it was

tempered with common sense and a keenly analytical mind. Reading his books and being able to talk with him about the many facets of his work—his analysis of alchemy, of primitive customs—were intriguing, and he was always bringing them to life by showing how they appear in the unconscious mind of modern man. He made "projection" very clear. His theory of types fascinated me. I came to the conclusion that mine was *sensation*, with my second and less usable function being *thinking*.

Two memories of Jung stand out with special clarity. As he discussed the advance of the German Army southward during one analytical session, his thoughts were diverted to a letter he had received just before the war. It was from a prominent American woman, an unidentified intellectual, who pleaded with him to "call together a hundred of the most intelligent people in the world to discuss ways of preventing the coming conflict in Europe." Jung said: "I wrote to her and told her that, if you assembled a hundred highly intelligent people into one room, all you would have would be one big idiot."

The second memory is of Jung shortly after the end of World War II, when I talked with him for a few minutes in his home in Küsnacht. He was obviously immensely concerned with the dropping of the atomic bombs on Hiroshima and Nagasaki and depressed by what he foresaw as the threat of a proliferation of this weapon, but what he then went on to say struck me as an amazing psychological insight in regard to the power of what he called the collective unconscious. "Perhaps," he said, "the invention of the bomb and the actual use of it in war proceed from a worldwide unconscious impulse to limit the surge of and growth of populations throughout the world." This analysis seemed to me to be a graphic illustration of one of Jung's most important, if also one of his most disputed, theories.

My final impression of Jungian analysis (analytical psychology) is that it is generally of slight assistance to the neurotic personality and perhaps only helpful to those with personalities of a deeply religious nature or with mystic feelings and intuitions, or it may even be appealing to, and effective with, those

who are highly intellectual. I feel, however, that I have never fallen into any one of these categories. Curiously it was only after the war, some fifteen years later, that I found the answer to my search for psychiatric help when I underwent psychoanalysis with a Freudian analyst. I think I must be unique or at least one of very few who have experienced both Jungian *and* Freudian analysis.

Perhaps the most significant result of Mary's and my association with C. G. Jung and the time we spent with him in Switzerland was the establishment after the war, in December 1945, of Bollingen Foundation. The Foundation, named after the little village where Jung had built a house for himself on the shore of Lake Zurich, was a most unusual and also, for me, a very rewarding scholarly adventure. Jack Barrett, whom I had first met through Mary, together with his loyal colleague Vaun Gillmor, formed the crucial spirit of the enterprise. Mary and I established the Foundation with the primary objective of having C. G. Jung's works properly translated and published in English.

In fact, it accomplished that and a great deal more. Bill McGuire, who first became involved with the Foundation in 1948 as a free-lance editor, went on to become more closely connected over the next twenty-one years with the Foundation's activities, both as the managing editor of Bollingen Series, a program of book publishing sponsored by the Foundation, and as the house editor, subsequently executive editor, of Jung's *Collected Works*. He wrote the delightful and authoritative history of the Foundation entitled *Bollingen, an Adventure in Collecting the Past*. From 1949 Bollingen shared its headquarters with Old Dominion in what was originally one, but eventually became three conjoined old brownstones on East 62nd Street in New York, the buildings that today house The Andrew W. Mellon Foundation. Jack and Vaun worked devotedly at Bollingen Foundation for twenty-three years from 1946 until their retirement in 1969.

Partly as a result of my admiration of Mary's enterprise and of my friendship with Jack, I found myself taking a more active

interest in the Foundation's affairs. Mary had initially been the driving force behind the project of translating Jung's work into English, and she had tried to lay the groundwork in the face of considerable difficulties during the war. At the outset Mary was elected President of the Foundation and first editor of the Series. The Series was initially published by Pantheon Books under the aegis of Kurt and Helen Wolff. After 1960 it was published by the Foundation itself. The Foundation was established to embrace English translations of foreign works and new editions of classics, as well as books devoted to subjects relating to art, aesthetics, anthropology, archaeology, psychology, philosophy, symbolism, and comparative religion. The source of Mary's interest in these subjects was, of course, the visits to Olga Froebe-Kapteyn's villa near Ascona shortly before the war and her contacts with C. G. Jung. We also planned to use Bollingen as a source of funds for fellowships and grants-in-aid to scholars in a variety of humanistic and scientific fields.

Following Mary's death in 1946, Jack, who had joined the staff as an assistant editor in May of the previous year and had replaced Stanley Young as editor of the Series at the end of 1945, was elected a trustee, and I became President. I had met Jack back in the mid-thirties, when he had been one of the backers of John Becker's ill-fated art gallery in New York on Madison Avenue, where he had become one of Mary's circle of friends.

Jack Barrett was a remarkable man, whose aura I feel to be still pervasive. Although he died in 1981, it takes little effort on the part of my imagination to picture his shade back in the room, seated comfortably in the corner, martini in one hand, cigarette in the other, talking informally on some serious matter with his inimitable droll delivery. He was modest and humorous, had great natural charm and courtesy, and bore his learning lightly. One of his favorite historical subjects was Eleanor of Aquitaine, wife of Louis VII of France and later of Henry II of England, and he would sit at dinner talking of *dear* Eleanor as if she were also seated at the table.

Jack, who was four years older than I, had graduated from

Yale in 1926. He had traveled extensively, in the Mediterranean, the Levant, and Europe, and spoke fluent French as well as being widely read in French literature. With the advent of the Second World War he became a volunteer in the Co-ordinating Committee of French Relief Societies. It was only in 1945, at the age of forty-three, that he took the first paid employment of his life as assistant editor of Bollingen Series. He transformed himself, in a very short time, from a well-read and well-traveled amateur into a highly competent foundation executive and professional editor. The Bollingen Foundation and Bollingen Series became his burning interest and his true life's work.

Two of the most widely recognized publications in Bollingen Series are C. G. Jung's *Collected Works* in R.F.C. Hull's translation, and the *I Ching; or, Book of Changes*. The *Collected Works*, the translation of which was until his death supervised by Jung, includes his writings on psychology, psychoanalysis, religion, symbolism, and alchemy. It formed the central core of Bollingen Series. The *I Ching*, although originally planned by Mary as one of the first books to be published in Bollingen Series, came out finally in 1950. It was described at the time as "a common source of both Confucianist and Taoist philosophy . . . one of the first efforts of the human mind to place itself within the community." We had heard of it initially in 1938, when Mary and I met Cary F. Baynes, who, at Jung's recommendation, had been working for eight years on the English translation of Richard Wilhelm's 1924 German edition. As the "angel" of Bollingen Foundation I was naturally sent one of the first copies off the press. To my annoyance, something had gone wrong at the bindery, and this copy had many pages out of sequence and even some that were upside down. I was about to send it back to the Foundation with a sarcastic comment, when a revelation suddenly occurred to me. "This," I thought, "is the *I Ching* itself trying to tell me something. Maybe it means that the *I Ching* and its wisdom are not for me—leave it alone!" I have never tried, since then, to use it as a mental prognosticator. Jung himself had often said that for Western man, the East and Eastern philosophy posed

many difficulties and dangers, as though they created hidden currents and dangerous undertows lurking under the surface of our Western minds.

Somewhat to our surprise the *I Ching* was an enormous success, and today there are over half a million copies of the book in print. For a time, in the sixties and seventies, it was a sort of bible for hippies and flower children. One of the uses the *I Ching* may be put to is for the telling of fortunes, for asking important questions regarding one's life and one's future. On the other hand, it is not a game, nor is it to be taken lightly.

I'm not unduly superstitious or gullible, but under the tutelage of Cary Baynes, and years before I received my chaotically disarranged copy of the Bollingen edition, I ûñdertook to throw the yarrow stalks, the numerical pattern of which, in falling, leads one to the hexagram or hexagrams with their accompanying text. The text in turn seems to speak in general terms about the problem to which one is seeking an answer. What appears in the hexagram is a statement or parable that can be interpreted as one wants. As in all fortune-telling, one's unconscious wishes seem to sort out the answers that lurk there and to interpret them in one's own way.

The problem that troubled me in 1940, and that sent me to the *I Ching*, was whether, if this country entered the war, I should join the Army. Without going into detail about the complicated method of arriving at the hexagram, this is the text that turned up:

> Fellowship with men in the open.
> Success.
> It furthers one to cross the great water.
> The perseverance of the superior man furthers.

Since I already had a strong inclination to join the Army, it is not surprising that this dip into the well of Chinese philosophy strengthened my resolve. As it turned out, I entered the Army at the beginning of July 1941, five months before Pearl Harbor and the declaration of war.

My pony, Hotspur, 1920

Chauncey Hubbard

Fran Carmody

Chunky Hatfield

Father taking the oath on being appointed Ambassador to Great Britain. He is saying lightheartedly, on leaving the Treasury, "This is not a marriage ceremony; this is a divorce."

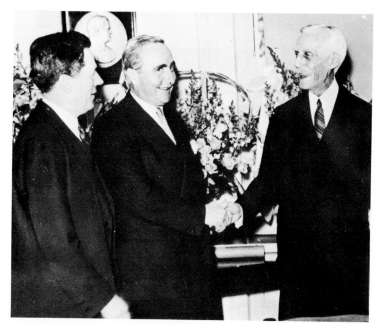

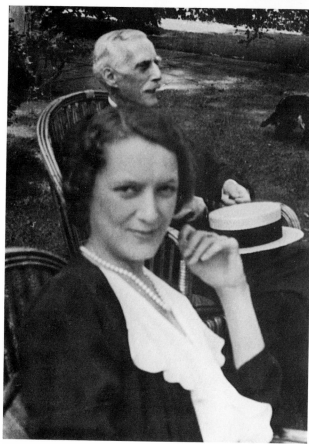

Ailsa and Father at her house at Syosset

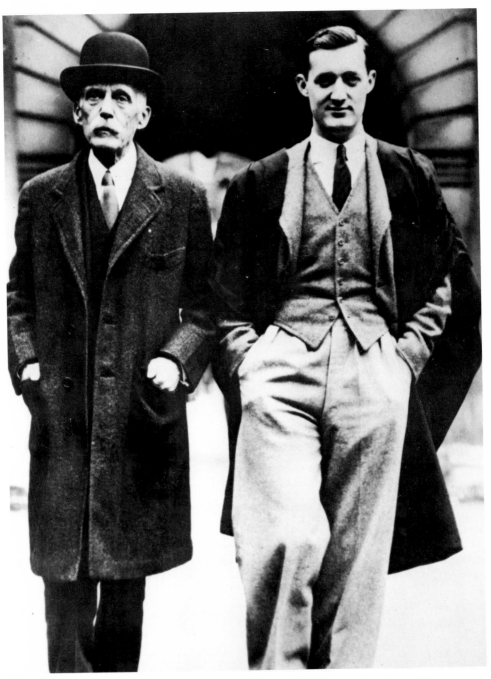

With Father at Clare College, Cambridge, for my graduation, 1931

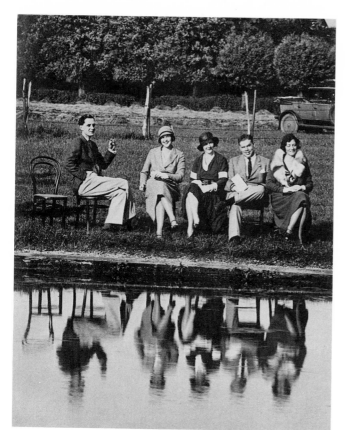

(*From left*) Hon. Jock Leslie, Ethel Sewell, Anna Belle Sewell, Chunky Hatfield, and Mrs. Sewell watching the May boat races on the river Cam

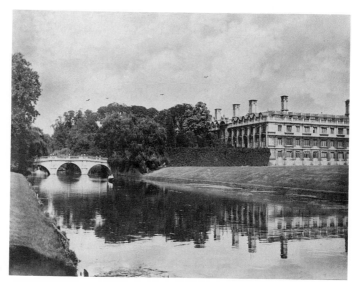

Clare College and bridge

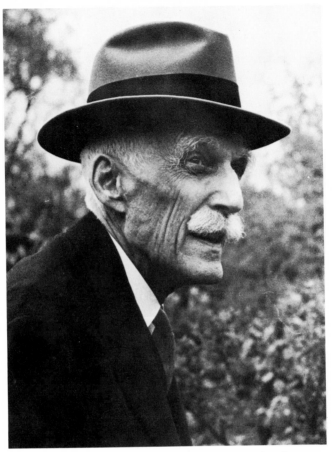

Photograph taken by me of Father, then aged eighty-two

Seated in a dark suit
with my fellow
directors of the
Pittsburgh Coal
Company on a barge on
the Monongahela River

The sleigh ride to the Casino in Central Park. Mary is in the back with Lucius Beebe.

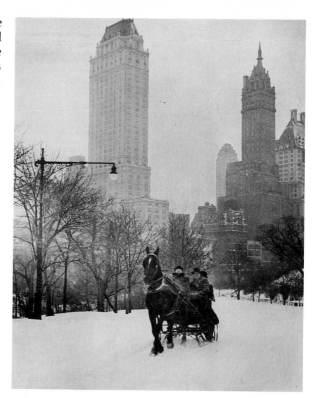

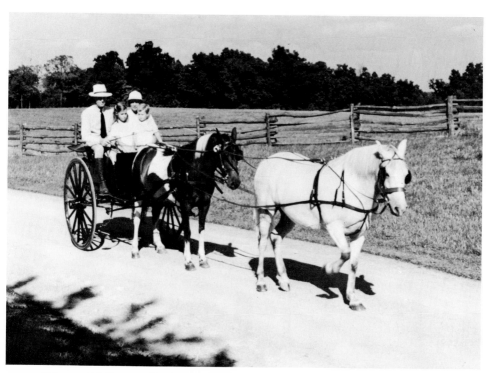

Mary with Forrest Dishman, Cathy, and Tim in a pony cart at Rokeby

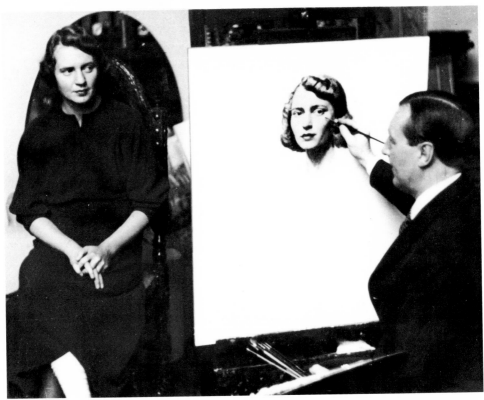

Mary being painted by Gerald Brockhurst, in London, 1937

Bollingen Series

C. G. Jung, taken by me
at Ascona, 1938

(*From left*) Harold Brooke, Ivor Anthony, Priscilla Hastings, Peter Hastings, Cathy Mellon, and the Hon. Mrs. Aubrey Hastings at Wroughton in 1947

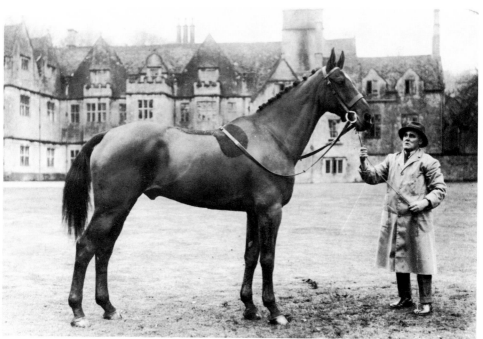

Dublin, at Bibury Court, 1936

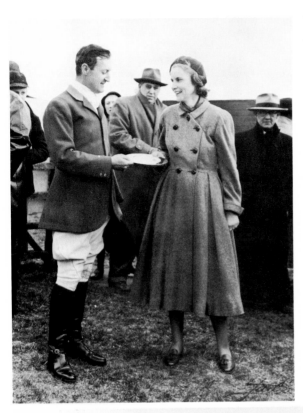

With Bunny, having won
a heavyweight race,
Piedmont point-to-point,
about 1949

Jack Skinner and jockey "Hold 'em"
Jones at the Greensburg Hunt
Races, 1946. Mary and I are
following on the right of the
picture.

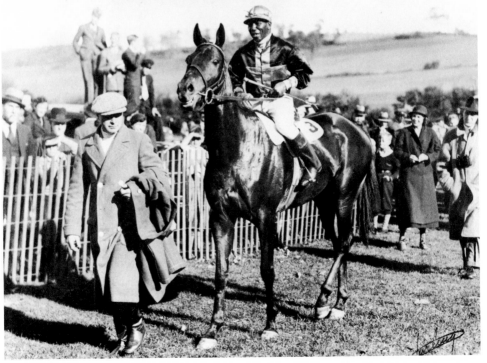

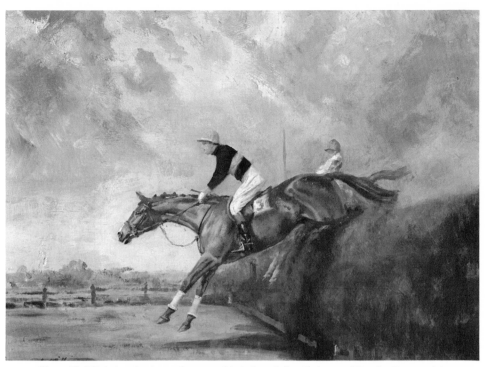

Raoul Millais' painting of me on Knight of the Galtees, North Cotswold
point-to-point, 1936

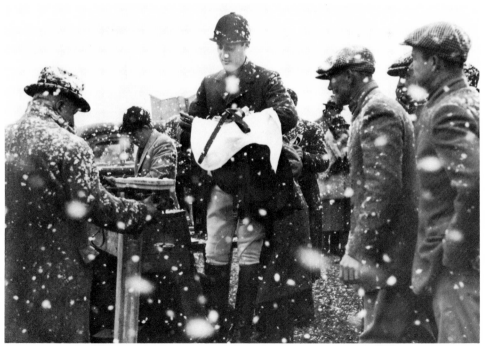

Weighing in at a Blue Ridge point-to-point, April 1949

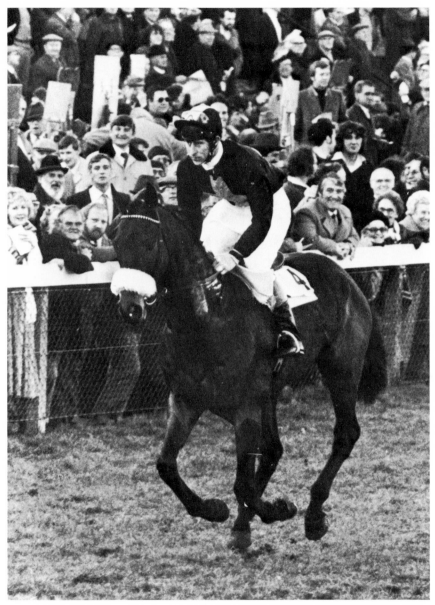

H.R.H. Prince Charles on my horse Long Wharf, finishing second in the Mad Hatter's Private Sweepstake, a charity race, at Plumpton on March 4, 1980. Inscribed "To the generous owner—from his grateful jockey. Charles. March 1980."

Jim Ryan

Ian Balding and John Hallum
with Mill Reef

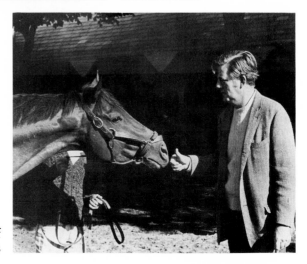

Elliott Burch with 1969 Horse of
the Year, Arts and Letters

MacKenzie Miller

Jack Skinner

Martha Tross

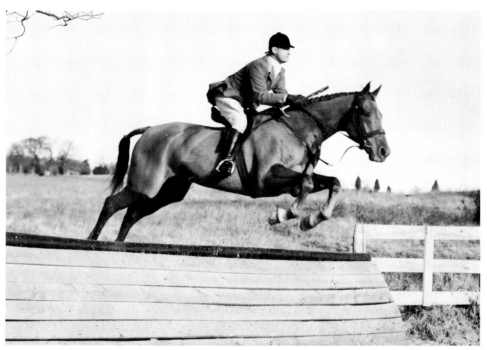

As M.F.H. on my hunter Enough Rope

Jackie Kennedy taking a spill. Inscribed "To the M.F.H. — I will get off to pick up your cigarette anytime, Paul. Piedmont, 1961. Jackie."

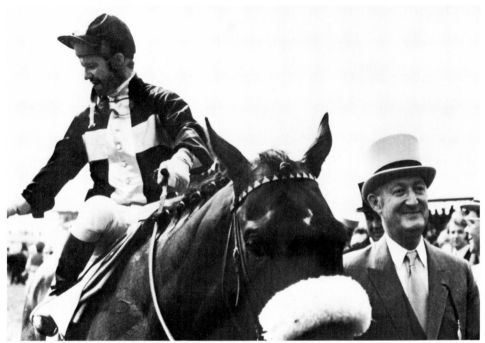

Leading Mill Reef with Geoff Lewis up into the winner's circle after the Epsom Derby, 1971

Bunny and I accepting Arc de Triomphe trophies presented by the French President, M. Pompidou, 1971

Since 1952 Bollingen Series has been responsible for publishing all *The A. W. Mellon Lectures in the Fine Arts,* which have been delivered annually at the National Gallery of Art by such eminent art historians as Kenneth Clark, John Pope-Hennessy, and John Rewald. Another of the monumental projects for Bollingen was the publication of *The Collected Works of Samuel Taylor Coleridge* in close to thirty volumes. Other books in the Series include writings of the late Joseph Campbell. Joe Campbell's association with Bollingen Foundation went back to the early 1940s, when he was asked to write a mythological commentary on the Series' first publication, *Where the Two Came to Their Father,* a study of a Navajo Indian ceremonial ritual, recorded by Maud Oakes and published along with her copies of sand paintings. He also edited several volumes of the writings of Heinrich Zimmer, a German scholar of Indian mythology, as well as the papers from the *Eranos Papers* yearbooks, a collection of lectures that had been presented over a number of years in conferences at Olga Froebe-Kapteyn's villa. Campbell is perhaps best known for *The Hero with a Thousand Faces,* which was published in the Series, and *The Masks of God* in four volumes, which were not. His intriguing and copiously illustrated study of mythology the world over, entitled *The Mythic Image,* was the hundredth numbered publication in the original Bollingen Series.

Apart from publishing, Bollingen Foundation made fellowships and grants to scholars, shrewdly selected by Jack and, before she died, by Mary as well. Other programs included funding the Bollingen Prize in Poetry and the Bollingen Prize in Translation. There was a great flutter in literary circles when the first poetry prize was awarded to Ezra Pound in 1949. The idea for a poetry prize came from Allen Tate, who had been the consultant in poetry at the Library of Congress. The Bollingen Foundation agreed in 1948 to finance it. The judges were to be the Fellows in American Letters, a body then comprised of Tate, Robert Penn Warren, Louise Bogan, Karl Shapiro, Robert Lowell, Conrad Aiken, W. H. Auden, Katherine Garrison Chapin, T. S. Eliot, Paul Green, Katherine Anne Porter, Theodore Spencer, and Willard Thorp. The Fellows chose Pound's *Pisan Cantos*

as the best book of verse published the previous year. The choice was virtually unanimous, with Shapiro voting against Pound and Green abstaining. The award aroused a storm of controversy. Pound had been an admirer of Benito Mussolini. He had remained in Italy during World War II and made radio broadcasts for the Fascist government. Captured by the American Army, he was imprisoned near Pisa, where he wrote the first draft of the *Pisan Cantos*. The American government initially wanted to try him for treason, but he was judged insane and committed to St. Elizabeths Hospital in Washington, where he remained until 1958.

There was naturally a great deal of opposition to the award, with all sorts of wild charges made about Bollingen Foundation's Fascist sympathies, etc. There was even a congressional investigation, with the result that the Library of Congress was forbidden to award any more prizes, for anything! The poetry and translation awards were therefore turned over to Yale to be administered by the University Library (still financed by Bollingen Foundation and later by The Andrew W. Mellon Foundation), which has continued to underwrite the poetry award. Recently Congress relented and allowed the Library of Congress to initiate a new poetry prize.

In the late sixties the trustees thought the time was approaching to dissolve the Foundation, and when Jack Barrett retired in 1969, they put this resolve into effect. It had always been Mary's and my intention that after our deaths the Foundation should be disbanded, rather than pass into the hands of others who might not have the same personal vision or careful policies as ourselves and our trustees and staff. All of Bollingen's funds for administration, publication, fellowships, and other grants were advanced by me personally. Extra funds were added by me when necessary, so that at no time did Bollingen have a large endowment on which to draw or any income from an endowment. Therefore, when Bollingen wound up its activities, there was a sum of roughly two million dollars in its coffers. Bollingen Series could not be brought to an end because there were pub-

lishing contracts and other commitments, and furthermore, only a not-for-profit publisher could carry it on. The choice for publisher was the Princeton University Press, and the aforementioned funds having been transferred there, the Series followed. The Press has continued to publish the roster of books that had been in the assembly line or had long been planned. The Bollingen enterprise was very rewarding. It was intelligently run and provided a number of scholars with the opportunity to publish books on a wide range of subjects, from a study of prehistoric cave paintings to a translation by Vladimir Nabokov of Pushkin's *Eugene Onegin.*

During the summer of 1940 I read an article by Walter Lippmann in praise of St. John's College at Annapolis. There was also an enthusiastic article about it in *Life* magazine, with illustrations of its attractive campus and eighteenth-century brick buildings. St. John's was founded in 1696 as King William's School and chartered as St. John's College in 1784, thus making it one of America's oldest educational establishments. It had, years before, fallen on hard times, but its direction had recently been taken over by two educational reformers, Stringfellow Barr and Scott Buchanan, both of whom came from the University of Virginia. They planned a curriculum, designated the "New Program" (although it was hardly new), that was to revive the traditional classical education. In freshman year Greek was studied, and Euclid in mathematics. In the laboratory the students would carry out Archimedes' experiments and so forth. The set reading for the first year was to be Greek history, plays, and poetry in translation. The program started out with Herodotus and Tacitus, and at a two-hour seminar each week the students and the instructor discussed what they had read.

I drove to Annapolis, which is some seventy miles from the farm at Rokeby, to see Stringfellow Barr. The purpose of my visit was to offer financial assistance for the project, but I got so interested in it—this curriculum rooted in the medieval system of the trivium and the quadrivium—that I decided to sign on as

a student. Although I had studied Latin at Choate and Yale, I had no knowledge of Greek and believed this to be an unfortunate gap in my education. I have a letter I wrote from the farm, to my friend and business assistant George Wyckoff, saying:

> In order that you and Schmitty [Adolph Schmidt] have some definite answers for the newspaper boys, as well as for whatever friends and acquaintances in Pittsburgh are interested in my educational venture, you may quote any part or parts of the following:
>
> I have been interested in many general aspects of education ever since my own undergraduate days at Yale and at Cambridge. About a year ago I learned of the St. John's College program, and was immediately impressed by its soundness. I felt that it might be the answer as a much-needed departure from the usual higher educational forms and methods in this country.
>
> In the meantime, after several visits to the College in Annapolis and several interesting conversations with the men responsible for the new program in the College, plus a thorough study of the curriculum itself, I decided that I would like to see the experiment actually in operation, from day to day. I believe in it enough to want to become a part of it, rather than read about it or hear about it, second hand. . . .
>
> Anyone interested in the St. John's experiment, or rather, the St. John's program, can get a brief but clear idea of the plan from the article on the College in the February 5, 1940 issue of *Life*.
>
> I expect to live in Annapolis, but to return to the farm in Virginia every weekend, and for the regular vacations.

I started in the autumn of 1940 as a mature student, being about fourteen years older than my fellow freshmen. I bought a little house in Annapolis, going home on the weekends for some foxhunting, then returned by car early on Sunday evenings to catch up with my reading. The whole program was very hectic, and as at school, mathematics proved a big problem. Purely by memorizing theorems at Choate, I had done well in

plane geometry and had got a perfect score on my College Board examination, but at St. John's the students were assigned some ten theorems a day. We were supposed to work them out to their QED solely by logic. When asked to prove one at the blackboard early in my first term, I was flabbergasted and unable to go beyond the first segment. This was highly embarrassing for a Yale and Cambridge graduate!

As the term progressed, it became more hopeless. I noticed, however, that those students who did well in their Greek language class were almost as much at sea as myself in Euclid, and vice versa, the brilliant math students being far from competent in Greek grammar. This seemed to me to present some kind of law of learning. I wrote to Dr. Jung explaining the situation (I had already complained to the math instructor and to Stringfellow Barr as well).

A couple of weeks later I received the following letter from Jung:

Prof. Dr. C. G. Jung Küsnacht-Zürich
 Seestrasse 228
 December 16th, 1940

My dear Mellon,

Thank you very much for your long letter. I was really glad that it was so long, because it gave me precious insight into your actual life. Your pensum is really amazing, but such reading should be very useful. How one can digest such a course in a year's time is a question to me, but mental digestion in America may be much quicker than with us.

It is an assinine [sic] prejudice that mathematics has anything to do with the training of the mind. It has as little to do with the mind as music, which also doesn't train the mind in the case of one who isn't just musical. Mathematics is not a function of intelligence or logic. It is a particular gift like music. You find it therefore very often in families alternating with the inheritance of musical talent. (For instance the famous mathematical family of the Bernoulli's of which I know a number of species.) You also find a mathematical talent with individuals that are idiotic in every other respect. When I was at school I never understood

higher mathematics. It just didn't enter my head. So I think you waste your time absolutely when you try to study mathematics. Mathematics is a hellish and perfectly useless torture for somebody who hasn't a gift in that way, as it is the most boring nonsense to be forced to learn to play an instrument when one isn't musical. Tell your professors that their psychological knowledge is a bit weak. They should examine their students first before they make such mistakes as to cramm [sic] mathematics into a head that isn't made for that particular art.

I hope you will be able to finish the building of your house [the Brick House at Oak Spring]. Please tell Mrs. Mellon that I soon shall write to her too. I got her letter of October 9th, but in the last month I've been very busy and I had little time to write letters.

Don't overwork and don't forget to have a time for yourself in between your studies.

Nothing has happened yet over here, except that we are a bit short of fuel, but we easily can stand that. Certainly the sky is dark and nobody knows what the future will bring. But one lives from day to day and one gets accustomed to such a kind of life. Things will become painful when we get entirely severed from America. I'm afraid it will happen when Germany beats down France altogether.

Hoping you are always in good health

<div align="right">

I remain
yours cordially
C. G. Jung

</div>

While this encouraging letter pleased me, it did little to assuage my embarrassment in class. I showed it to Barr and others, but they brushed it aside as an interesting generality of no meaning for the St. John's curriculum. I thought, when I was at Yale and always since then, that there must be some way of interesting unmathematically and unscientifically minded students in math and in science and explaining it to them. Similarly that there must be a way of easing the distress of those students who have little sense of the beauties of language or the rewarding benefits of the rest of the humanities and letting each soar to the height of his or her ability.

A third part of the curriculum of each year at St. John's, in

addition to reading and discussing the great books and to the daily language class, was attendance at a scientific "workshop," a two-hour session in a rather primitive laboratory, where early scientific experiments and problems were carried out and discussed. Although we didn't actually sit in a tub of water, like Archimedes, the general idea was to carry out the original experiments and tests that had intrigued the ancients. Because of my mathematical limitations, as well as my clumsy drawings, these sessions were also the source of a good deal of anxiety on my part. But as usual, I excused my lack of adroitness by unconsciously appealing to Jung's strictures about the educational usefulness of mathematics.

Looking back, I recollect that I enjoyed my study of Greek language and literature, but I was very conscious of being nearer in age to the instructors than to the students, so after about six months I gave it up for the life of a soldier.

At that time one couldn't escape the feeling that war was at hand. I registered for the draft at the courthouse in Annapolis. One of my strongest recollections was of hearing sounds of marching and a military band coming from the nearby Naval Academy. I was beginning to realize that I was not cut out to be an academic or an intellectual, and I was longing for a more active life, especially in uniform.

One of the curious things about my early daydreams involved a fascination with things military. Perhaps it had its origin in my toy soldiers or my introduction to the bright scarlet uniforms of the guards' regiments during my early childhood visits to England, augmented by pervasive patriotic emotions during World War I, when Pittsburgh schoolboys had their own armies and uniforms.

This feeling for the military is the only inclination that I can possibly trace as a parallel interest with my cousin Dick. Perhaps his interest began as a Naval aviation cadet toward the end of World War I. Luckily Dick never saw action, but before the war, he had organized at Rolling Rock a troop of cavalry, consisting of friends of his from Pittsburgh, and they were complete with khaki uniforms and wide-brimmed cavalry campaign hats.

Dick's time came later with appointments in the Pennsylvania National Guard, and during World War II he held various commissions in the Finance Department and other areas of the Army of the United States. Eventually, after the war, he ended up as a Lieutenant General.

While still at St. John's, I read a lot about the U.S. Cavalry in magazines like *Life*, about Fort Riley in Kansas and Fort Bliss in Texas, and it appealed to me tremendously. The combination of riding horses and wearing the uniform was too much for me, and I volunteered under a Selective Service regulation that gave me a choice of branch of service. I looked forward to the uniform, the still-favored officers' Sam Browne belt, the bright brass insignia (the letters U.S., the crossed sabers, and the eagle cap insignia). Bobby Davis (an old friend at Fort Riley whom we meet later on) always said jokingly that we were strictly Abercrombie & Fitch soldiers, in view of our Sam Browne belts, our custom-made English boots, and our extra-warm sleeping bags.

Later, without having seen any actual fighting close up, I was near enough to war and witnessed enough of its consequences to become disgusted with the idea and not a little ashamed of these romantic thoughts. By then I was able to distinguish between the glamour of scarlet and gold and the reality of blood and guts. Kendrick Murphy, my great friend, the regular Army sergeant in our barracks at the Cavalry School, used to laugh at the idea of patriotism, and when the Army appealed to the soldier's sense of duty, he would laugh and say, "That's right, beat the drum, wave the flag!"

The Army and Fort Riley

———◆———

The street sounds to the soldier's tread
And out we troop to see:
A single redcoat turns his head,
He turns and looks at me. . . .

What thoughts at heart have you and I
We cannot stop to tell:
But dead or living, drunk or dry,
Soldier, I wish you well.

—A. E. HOUSMAN
A Shropshire Lad

By the summer of 1941, perhaps unconsciously spurred on by Jung's remarks, I had registered for the draft and was being carried along by my compulsion to join the Cavalry. Because I wasn't sure how to go about it, I got in touch with General George S. Patton, uncle of my neighbor Mrs. A. C. Randolph, Jr., and the only officer in the U.S. Army I knew personally. I had talked with him in the hunting field in Virginia, and a few months earlier the General had sent me a cordial letter complimenting Mary and me on the sportsmanlike conditions of the Rokeby Bowl, a point-to-point race we had organized at the farm, and regretting that his duties as Commanding Officer of the 3d Cavalry at Fort Myer did not permit him to compete.

I wrote to Patton and later called him during our winter holiday in Hobe Sound, Florida. He invited me to lunch at Fort Benning, Georgia, where he was the CO. Not liking the idea of

sitting in a bus for twelve hours, I chartered a small single-engine plane to take me to Fort Benning from Palm Beach. The pilot, a breezy character, was still wearing his pajamas when I found him at the airport at 7:00 A.M., and I wasn't particularly reassured to be told that everything was ready. He changed his outfit, warmed up the engine, and we took off. We had been flying north along the Florida coast for about an hour when I asked why we weren't heading in a westerly direction toward Fort Benning. The pilot replied that it was a brand-new plane with a new engine and that he was sticking to the beaches as long as he could. A little later we swung inland, and I anxiously looked down on the alligator-inhabited swampland stretching endlessly before us.

Later, having landed for fuel at an Air Corps training field, where cadets were shakily taking off and landing while we descended among them, we resumed our flight west into rapidly deteriorating weather. Staying underneath the low cloud ceiling, the pilot was following a railway line until, looking at the map, I pointed out that the line that led toward Fort Benning had power cables alongside it, while this one didn't. The pilot exclaimed, "My God, you're right, we're on the wrong railroad," and banked over sharply to look for another. When we found what the pilot thought might be the right one, he leaned over and said to me, "When we get to a station on this line, I'm going to come down low; see if you can read the name on the platform." This he did, and I was able to identify the station.

We arrived two hours late for my luncheon engagement to find General Patton beribboned and jumpy but not angry. Before I left the airfield, the pilot offered to fly me on to Columbus later that afternoon so that I could catch a night train north. The General telephoned Benning airfield during lunch and was told that the highest cloud ceiling that day was expected to be twelve hundred feet. Patton pointed out that there was a thirteen-hundred-foot mountain between Benning and Columbus and advised me to go by land.

I spoke to the General of my Cavalry ambitions, and Patton

told me he would write a letter of recommendation to General Herr, then Chief of Cavalry in Washington, and suggested that I should go and see him. He said that he would also write to the Chief of the Remount Service and to the Adjutant General but that the quickest and safest way to make sure of joining the Cavalry was to volunteer under Selective Service, which allowed one to choose one's branch of the service. A young Army doctor was among the guests at the luncheon table. After the meal had ended, I heard him suggesting to Patton that he should not exert himself too much and trying to tell him diplomatically not to get overexcited. The General nodded and then told me that he planned to spend the afternoon inspecting a new installation of barracks, parade grounds, tank depots, etc., and insisted that I join him.

Patton seated himself behind the steering wheel of his maroon Packard convertible with me beside him, while the back of the car was occupied by his large and evil-looking Alsatian. Patton gripped the wheel, staring in front of him intently and not uttering a word as we set off on the well-paved state road. I watched the speedometer rise to over eighty miles an hour, and within a few minutes I heard a siren wailing. I glanced over my shoulder to catch sight of an MP in a shining white helmet tearing after us on a motorcycle. The General appeared to be oblivious of the fact that we were being chased and drove, if anything, a little faster. After several minutes of this pursuit I ventured to mention that I thought we were being followed. Patton broke his silence to growl, "I know it."

Finally he slowed down sufficiently to negotiate a right-hand turn into a dirt road and up a short hill, where some building operations were going on, and there he stopped the car. The MP drew up a few yards behind us. I sat still, but the General leaped out of his side of the car and shouted, "What do you want?"

The MP, who didn't look up as he slowly adjusted the stand on his motorcycle, replied, "There's no hurry."

This remark seemed to infuriate Patton, whose face grew red-

der as it assumed a more and more ferocious expression, and he yelled at the man, "The hell there isn't. Come over here immediately."

The MP looked up to see the two stars on Patton's cap and shoulders. A swift change came over him as he jumped to attention and saluted. He then walked up to the General with a desperate expression on his face, saluted again, and said, "I'm sorry, sir, I had no idea it was the General."

"Why not?" shrieked Patton.

The MP, terrified, replied, "Well, sir, you were going over eighty miles an hour. I don't know the General's car, and there's no insignia on it."

Suddenly Patton changed. I have never witnessed such a lightning transformation from violent emotion to a state of calm. His face lost its fieriness, the shrillness went out of his voice, and he said, "Of course, you did the right thing. You were only doing your duty. Forget it. Carry on. Dismissed."

The MP saluted; the General saluted, got back into the car, and drove slowly on toward the construction work.

General Patton, with myself following a few paces behind, inspected the new installations. They were mostly barracks being erected on the scarred red earth of a small plateau surrounded by scrub pines. The afternoon wore on, and I looked anxiously at my watch, thinking about my train to Washington. I asked him if he would very kindly take me to a taxi or a car rental, if there were any such thing on the post, while realizing it was highly unlikely that such facilities existed in the middle of Fort Benning.

As I was wondering what would be the best way to get home, I saw a long column of tanks crawling and clanking up a dusty road toward us. The General dismissed my request about renting transport, saying, "I will send you into Columbus." With that, he stepped out into the middle of the road and held up his hand as the column approached. A young red-haired sergeant standing in the cockpit of the first tank saluted smartly. Patton shouted to him, "Get out of that tank, go over to the officers' parking lot over there, take the first car you see with

keys in it and enough gas, and bring it here. Then take Mr. Mellon to the station in Columbus."

I was embarrassed and slightly stunned. I told Patton there was no need to go to all that trouble for me. He turned around, grinning, and said, "I'm *ordering* you to go with him."

I caught a slow train from Columbus to Atlanta and made my night train north to Washington. Sitting in the train, I looked back in near disbelief on Patton's odd behavior. Why had he done these things? Was the first explosion a spontaneous surge of deep anger (perhaps touched off by some unconscious aggressive force that had nothing to do with the incident)? I wondered whether the whole charade had been enacted to impress me. Perhaps, on the other hand, they were routine "acts" for the inculcation of discipline at Fort Benning, because he knew that the tales of both encounters would be bound to make it throughout the post. Maybe they were just two more stones in the edifice of his reputation for swagger, flamboyance, eccentricity, and violence of temper.

Shortly after my visit to Fort Benning, in June 1941, I volunteered under Selective Service. I had already resigned from the presidency of the National Gallery in 1939. David Bruce was elected in my place. I also resigned, with a great sense of relief, from all those boards of directors in Pittsburgh, including Gulf Oil and the Mellon Bank. Donald Shepard, my father's former lawyer, had a wide acquaintanceship in Washington, including a Colonel connected with Selective Service. Under his aegis, it was arranged that I should report to Warrenton, near my Virginia home, and volunteer for the Cavalry. Together with a group of other draftees, I was taken by bus to Richmond, Virginia, where we all were put through physical examinations. Having passed that, I went on to Camp Lee at Petersburg for about a week before being shipped out to the Cavalry Replacement Training Center at Fort Riley for basic training.

While I was not exactly an exemplar of the bellicose as I set off for Fort Riley, I was at least not following in the pattern of my great-great-uncle Thomas, whose evasion of the military was

described in Grandfather's memoir. Thomas, like Grandfather, emigrated from Ireland to the United States in the early years of the nineteenth century. He made his passage, before the War of 1812 between Great Britain and the United States, when the Royal Navy was exercising the detested right of search. This process involved press gangs boarding emigrant ships to take off single men for service in the British Army, whose numbers had been depleted by the War of Independence and the Napoleonic Wars. A cruiser bore down on the ship on which young Thomas and his sister-in-law were sailing for Philadelphia. Grandfather tells how Thomas "dressed in a suit of her clothes, and in a jaunty cap presented to the press gang of the cruiser the tableau of a fresh young Irish girl engaged at her knitting. His slight form, smooth face and florid complexion favored the deception."

Junction City, Kansas, is right in the center of the map of the United States. The Cavalry Replacement Training Center was situated on the open flats of the Republican River, some 140 miles due west of Kansas City and near Junction City. To get there, we were sent in an overnight train to St. Louis, with a change to another train for Kansas City. There was a delay of several hours before the train for Junction City was to leave from Kansas City, and I used it to make a hurried visit to see Mary's parents and her sister. When we finally arrived at Junction City, early the next morning, transportation was waiting to take us to the CRTC. On the day I arrived, the temperature was 114 degrees, and the camp was simmering under the dusty heat of a July sun.

I spent the next nine months from July 1941 as a private, following the universal routine of Cavalry basic training; horsemanship, inspections, marches, close order drill, rifle practice, etc., interspersed with lectures on map reading and fieldcraft. I experienced the pleasure, shared by many when they join the Army, of shedding all civilian worries and responsibilities.

One could be excused for wondering whether the Army, as I knew it at Fort Riley at that time, was training for the Civil War or even for the Indian wars. One of the Cavalry training

exercises involved galloping on horseback past silhouetted cut-out targets and shooting at them with the always erratic Colt .45, a risky operation for anyone who did not have perfect control of his horse, as well as for the trooper riding in front of him or behind him, and I can promise you very few of them had control of their horses or of their .45's. We were also taught how to handle pack mules, the idea being that we might someday find ourselves conducting reconnaissance through rough mountainous terrain. In January 1942 there were twenty horse classes and one mechanized at Fort Riley. By the time I finally left, in February 1943, there were only two horse classes; the rest were mechanized.

When Pearl Harbor blasted America into the war in December 1941, I had completed my basic training and was in a special troop awaiting orders to report to the Cavalry School at Fort Riley proper for an officer candidate class in January 1942. I was selected, along with about twenty others. I then had ten days' furlough before returning to go to OCS on January 1. Fort Riley was as cold in winter as it was hot in summer. The temperature could reach twenty degrees below zero. I was moved into an old stone barracks with about forty other men, but at thirty-four I still felt young, and basic training had made me pretty fit. Mary remarked how well I looked and how the life seemed to suit me.

I now had the good fortune to have two congenial companions who had beds on either side of me in the barracks. On the left was Bobby Davis, a well-known amateur steeplechase rider whom I had often met on the circuit of hunt meeting races. Davis had been a sergeant in the famous, albeit rarefied 1st City Troop in Philadelphia, so he had some knowledge of how the Army operated. He was there during the whole time I was at the Cavalry School and was, like me, first an officer candidate and later, after receiving his commission, an instructor in horsemanship. When the Army finally discovered that horses really weren't going to be very useful in the war, the officers were assigned to other outfits.

Bobby ended up in the infantry, and with very little infantry

training he was shipped off on a troop transport to Burma with the Mars Brigade to fight the Japanese. By the time he arrived, he was very much out of shape, but he was issued a backpack and a rifle and sent off on a two-hundred-mile trek on the Burma Road up to the front line in the jungle. On arrival he found himself in charge of evacuating the wounded, having replaced the regimental Adjutant, who had also been wounded. Very soon after, Bobby, too, was badly wounded by Japanese machine-gun fire in both an arm and his abdomen and was himself evacuated, being sent by stages all the way home. Fortunately the arm and abdomen wounds eventually healed well, and he went on to a career as a successful steeplechase trainer in Camden, South Carolina.

Another, much more experienced soldier, a regular Army sergeant, was Kendrick Murphy, who had the bed on my right. "Murph" knew exactly how the military mind worked. He had won the Soldier's Medal, the highest award granted in peacetime for heroism. It seems that while staggering home after drinking one night in Montgomery, Alabama, Murph was crossing a bridge and heard a man drowning in the river. Without further ado, he leaped off the bridge and hauled the man to safety, but he added that he would never have dreamed of doing it if he hadn't been blind drunk.

When we were commissioned, in March 1942, Colonel Thornburgh, who was in charge of routing new officers to other assignments, told a small group of us, including Bobby Davis and me, that we were picked to remain at the Cavalry School as horsemanship instructors. In a formal questionnaire that we were given to fill in, we were advised to apply for the Cavalry School as first choice for our next posting and then to name an alternative, such as the First Army at Fort Bliss, as our second. After graduation we went to our mailboxes, and Davis and I found notes in ours telling us to report immediately to General Ramey, the Commanding Officer. We were delighted that things were moving so quickly and hurried over to knock on the General's door. Finding him seated behind a desk at the

end of his large office, we marched up and saluted smartly, say-
ing, "Lieutenants Davis and Mellon reporting to the Com-
manding Officer."

General Ramey looked up slowly with a glowering face and
remarked that "when the Cavalry School wants instructors, it
will say so." The Cavalry School was not going to be told whom
to take.

Davis and I were taken aback, and Davis said, "General Ra-
mey, sir, we were told by Colonel Thornburgh to apply on forms
that we were given. He *advised* us to apply."

Ramey replied sourly, "Well, he gave you very bad advice.
Dismissed."

A short while later we had orders to go on leave and then,
at the termination of the leave, to report back to the Cavalry
School. It needed a man like Murphy to comprehend the strange
logic behind Army thinking, for when Davis and I returned from
our leave, it appeared that General Ramey and Colonel Thorn-
burgh had made up their differences. Without any further ex-
planation, we discovered that we both had orders to report as
instructors in the Department of Horsemanship. I was required
to spend a lot of time in two enormous indoor riding rings, so
large that they could accommodate polo games and horse
shows, where I taught the military seat and elementary jump-
ing. Davis, on the other hand, was lucky enough to be assigned
cross-country work in the prairielike Kansas countryside sur-
rounding us.

It happened that two of the officer candidates, in one of the
platoons that I was busy instructing in the military seat, were
Pete Bostwick and Louis Stoddard. Pete was an old friend from
English hunting and racing days and from the hunt meeting
steeplechase scene in this country, as was Louis. At one time in
the thirties Pete was one of the leading steeplechase riders in
England, and he and Louis both had competed several times
in the Liverpool Grand National, where there were to be found
the stiffest, largest fences in the world and the most dangerous
jumping course. They rode horses out of the famous steeple-

chase trainer Ivor Anthony's yard and were very popular in England and America in the racing world as well as on the polo field, both being top polo players. It was with some hesitancy that I undertook to bark at them for their mistakes.

As with many polo players and race riders, they had very bad "hands" and were prone to hang on to a horse's mouth as well as to sit back in the saddle. Pete was bright, but Louis was not an intellectual marvel, so we had to nurse him along by carefully doctoring his horsemanship marks, as well as his paper work in other subjects. I found it impossible to get them to learn the military or forward seat: short stirrup leathers, upper body well forward, and buttocks sticking out behind. They had an utter contempt for this posture in the saddle. One jump over an English Grand National fence with the military seat would have found them immediately on the ground on the other side.

Many a day Colonel Corbett, the Chief of Horsemanship, came into the riding hall to check on the class and to monitor me. He was constantly pointing things out, saying, "Look at Mr. Bostwick, Mr. Mellon. He's all bunched up," or, "Why don't you make Mr. Stoddard sit right?" It was a hopeless task, which Pete and Louis and I knew all too well, but in the end they pulled through and got their commissions.

I don't know what their careers turned out to be during the war, although the last I heard of Louis Stoddard was that he was parachuting in the Far East. Pete Bostwick died only a few years ago of a heart attack in the middle of a polo game. What a great way to go!

I enjoyed instructing, and although it hadn't much to do with war, it had a lot to do with horses. I was allowed to bring four horses of my own out from Virginia, one of which I lent to Davis. The instructorship lasted a little under a year, from April 1942 until February 1943. Riding around the vicinity of the school in spring and autumn over rolling hills covered with buffalo grass and under a wide open sky was a memorable experience. You could cover miles with not a tree in sight and

nothing before you but vast plains and little bushy ravines. There were horse shows and point-to-points, and every now and then Davis and I hunted with the Cavalry School pack of hounds, which chased coyotes.

Fort Riley and its environment, Junction City and the Republican River, have always held a warm place among my wartime memories. There was an incident years later that I recall very well. It was during the time when we were trying to find an architect for the National Gallery's new addition (the East Building), and traveling throughout the country to look at different buildings was part of the decision-making process. Several of us who were involved in this project flew to California in my plane. When we were flying east on our return journey, I had been asleep for about an hour or so when suddenly I woke up with a strong premonition that we were in the middle of Kansas and near Fort Riley. I was looking out the window for familiar landmarks when our pilot's voice came over the intercom saying, "Mr. Mellon, if you look under the left wing we are just about to pass over Fort Riley." John Walker, the Director of the Gallery, was with us, and he always claimed afterward that the aroma of the stables was so pungent that it arose to the plane and woke me up. I prefer to think that the spirit of Sergeant Murphy was still vibrant enough to reach ten thousand feet.

Mary had made the journey to watch my final parade at the Replacement Center following basic training, and I had gone home to Upperville for Christmas leave and again after completing officer training. Mary came out with our daughter, Cathy, in the autumn of 1941 and stayed for about three months with her family in Kansas City. Our son, Timothy, was born in July 1942, three months after I had returned to Fort Riley as an instructor. Later, in the fall of 1942, Mary came out again with the children to a small house I had rented in Junction City. It was quite an agreeable, if slightly boring, life, but I began to feel pretty foolish doing what I was doing, and it finally dawned on me that perhaps this was not, after all, going to be a war in which the horse would be of prime importance.

On my latest leave I had been to Washington and had seen Donald Shepard, the family lawyer who had advised me about enlisting, and asked him whether there was any chance of my getting a posting abroad, especially to England. Shepard fixed up orders for me to be sent to England, perhaps as aide to a general, although I never found out what had been arranged. I had been promoted to First Lieutenant at Fort Riley, and in March 1943 I received my orders marked "secret." I was instructed to go to the quartermaster stores and draw equipment, which surprisingly included mosquito netting. Murphy would have smelled a rat. I was then given leave, after which I was to report to Fort Hamilton in Brooklyn, New York. That was good news, for this camp was the holding point for embarkation to Britain, and it meant that I could throw the mosquito netting away.

Fort Hamilton was situated near Coney Island in that wide part of the bay opposite Staten Island as you now approach the Verrazano Bridge from the east. For the first five days I was there, we were confined to camp on account of an alert. These alerts were usually called when a ship was leaving New York Harbor for Britain. There was virtually nothing to do, and the only requirement was to report at eight o'clock in the morning and again at five o'clock in the afternoon for roll call. When the alert was over, some of us established a routine that worked well enough. After the afternoon roll call I would take the subway to Times Square. Mary and I had rented a house in New York on the site of my present house on East 70th Street. Before the war we had used it only once or twice a month when we were in town. It was handy, now that I was stationed nearby, and I would take a taxi to the house from the subway, meet up with Mary, then call our friends and go out to dinner. Jimmy Brady, Fran Carmody, and Chauncey Hubbard were all in the Navy, stationed temporarily in New York, so they would join us for dinner at "21" and go on to Jack White's, La Rue, or some other nightclub. Mary and I usually arrived back at East 70th Street in the early hours. I would then leave, bleary-eyed, in a

taxi at about six-thirty in the morning, get the subway from Times Square back to Fort Hamilton, report at eight o'clock for roll call, rush to the mess hall for breakfast, and then fall into the sack at the barracks. Others had adopted the same formula, and it didn't take long to get into the groove. Around midday we would begin to get up and prepare ourselves for a walk to Coney Island and back and finally the five o'clock roll call. After that it was straight back into town.

This went on for about three weeks while I became increasingly restless. Occasionally there were lectures (map reading, tactics, pistol practice, etc.), which were semivoluntary. I kept inquiring from an administrative officer, a Captain, whether my orders had come through, and the Captain explained that there was nothing he could do to expedite the matter and that I would have to be patient.

Such are the circumstances in life that over forty years later I met up again with this Captain. The National Gallery of Art was planning to offer the post of Chief Curator to the distinguished scholar Sydney Freedberg. The Gallery asked me if I would like to have a talk with him, and it was arranged that Freedberg would come to lunch at our house on East 70th Street. While talking over a drink before lunch, Sydney mentioned something about our having met before, but being a little deaf, I didn't take it in. During luncheon the conversation turned to the Army, and Fort Hamilton was mentioned. Sydney then explained that it was he who had been the administrative officer dealing with my orders and that when they finally came through for me to go to Boston and to sail from there to England on a freighter as security officer, it was he who had processed them.

A few days after my orders came through, I discovered that Chauncey Hubbard was also being sent to Boston by the Navy. This was fortunate because a sycophantic and parasitic Captain from the Inspector General's office had latched on to me, and I wasn't able to shake him off. This individual was obviously impressed by me, his unwilling companion, and I found myself having to sit through boring dinners listening to his dull conversation. The Captain, when he learned that I was going to

Boston, suggested that we both stay at the Parker House. Hubbard had no intention of establishing himself anywhere but the Ritz, where he took a suite, so I moved there, too, knowing that the Captain would not want to frequent such an expensive and fashionable hotel. Hubbard was on Navy watches, sleeping either at night or during the day according to his duty roster, but I found that all I was required to do was to telephone a Lieutenant at the port every morning to find out whether my ship had arrived. Each time I uttered the code words "What's for lunch?" the answer came back, "Don't know yet."

Hubbard, meantime, was living around the clock, giving cocktail parties in his suite, then going off with me to the Latin Quarter and having more drinks. It was a grueling existence and perhaps too much of a good thing, and I began to weary of it. I thought it would be nice to have Mary join me, especially since my request for leave had been refused on the ground that the ship might be in any day. Because I didn't consider the ambience of Hubbard and our cocktail friends (including some extra-pretty girls from the Latin Quarter) to be right for Mary, I took a suite at the Copley Plaza. It was quite large, and I thought it would be just fine, but when Mary arrived, she looked sharply at me, sensing at once in her intuitive way that something was up. "Why are we staying at the Copley Plaza?" she asked. "Why aren't we at the Ritz?"

I explained that Hubbard was over there, and I thought it would be quieter where we were. "I believe the Ritz is pretty full," I added evasively.

"Let's find out," she said, lifting the telephone receiver. So we moved to a large penthouse suite at the Ritz, so large that it even had a piano in it. For some days after that there were fewer visits to the Latin Quarter, and things were a little quieter.

Finally, after about ten days, my ship came in. She was a 4,999-ton freighter, the last ship to be built at the Hog Island shipyard at the end of the First World War. Her name, which was now painted out, had been the *Exchester*, and in peacetime she had been operated by the American Export Line. As a security officer I had to watch the ship being loaded and to guard

against theft of Army supplies. I was assigned GIs to guard the holds, but since there were two holds, I couldn't personally watch both. We were on duty for twelve hours a day from seven in the morning until seven in the evening during the four days it took to load the ship. I did catch one of the soldiers asleep and threatened him with court-martial. I carefully checked the manifest and watched huge bulldozers and other earth-moving equipment being hoisted aboard by crane. More heavy equipment followed, including wire mesh for temporary airstrips and a large consignment of ammunition. Then, when it looked as if the ship could take no more, PX supplies were brought aboard: cases of beer and candy and all the things that made the U.S. forces so envied among the British military and civilian populations. I tried my best to make sure there was no pilfering. It was these supplies that made the presence of a security officer all the more urgent and all the more difficult.

We sailed out of Boston Harbor on the former *Exchester* on May 1, 1943. I had equipped myself with some bottles of gin and a case of about twenty books and hoped the martinis and the reading matter would look after me over the North Atlantic crossing. I had spent over a month wasting time at Fort Hamilton and in Boston and was glad to be under way. That damned Captain from the Inspector General's office had somehow got onto my ship. He just had a fixation that I was great stuff. Anyway, I didn't have to room with him but found an extra bunk in the infirmary. I sought out the Chief Engineer, a sort of droll Ancient Mariner, and we had drinks together every night before dinner. The ship's Captain, C. L. Evans, usually joined us, but he made a point of never drinking. This rule did not appear to apply to the Chief, who drank large quantities of liquor, as did the Army Captain from the Inspector General's office. The gin soon ran out, but when we arrived at Halifax, Nova Scotia, we replenished supplies with a case of whiskey.

The Chief Engineer, Fred Bennett, was insistent that I should come down and pay him a visit in the engine room. I wasn't enthusiastic about going belowdecks in U-boat–infested waters, but I did go down one day as a matter of courtesy and, looking

around me in the hot, oily atmosphere, saw that many of the pipes were bound with tape and that the whole thing seemed to be held together by the Chief's flair for make do and mend. The weather was fine for the first few days of the voyage, and I suggested to Lieutenant Ludwig, who was in command of the twenty-man Navy gun crew, that we should have some daily exercises. He, if not his gun crew, responded enthusiastically, and on deck I taught the calisthenics I had often practiced at Fort Riley to a bemused group of sailors. They may have enjoyed it over the few good days it lasted, but then the weather turned foul, they had long hours of duty, and the push-ups and knee bends had to come to an end.

For my part, I retired to my cabin and started reading from my small library. The ship, having stopped off at Halifax, sailed by the northernmost route in an enormous convoy of some 150 ships. These varied in size from huge tankers to a little Norwegian vessel of seven hundred tons, all traveling together at a uniform speed of seven and a half knots. By the spring of 1943 the Allies were able for the first time to provide air cover over the whole North Atlantic route, but because the weather was so bad on this voyage, all aircraft were grounded. The main protection from submarines was icebergs. The passage was sufficiently northerly that for a good many days we were actually sailing through icefields. The ice was reckoned a lesser hazard than the submarines and was identifiable on the radar and sonar recently in service, but I still find it difficult to understand how we got through unscathed. By the time we sailed down through the North Channel into Belfast Lough, I had been at sea for three weeks. I had read most of my books, popular books like Louis Bromfield's *Mrs. Parkington* and *The Green Bay Tree*, Willa Cather's *Sapphira and the Slave Girl*, and Daphne du Maurier's *Hungry Hill*, and I had swallowed a great deal of coffee. Some of the ships berthed at Belfast while the rest of us sailed on to Cardiff, where we disembarked.

CHAPTER 11

Service Abroad and Second Marriage

———◆———

Oh the wife she tried to tell me that 'twas nothing but the
thrumming
Of a wood-pecker a-rapping on the hollow of a tree;
And she thought that I was fooling when I said it was the
drumming
Of the mustering of legions, and 'twas calling unto me;
'Twas calling me to pull my freight and hop across the sea.

<div style="text-align: right">

—Robert Service
"The Man from Athabaska"

</div>

American soldiers—overdressed, overpaid, oversexed and
over here!

<div style="text-align: right">

—British World War II adage

</div>

Although I didn't know it at the time, my orders supposedly to
report as aide to an American general had been lost, so as a
"casual officer," without a unit to go to, I was sent off to the
Replacement Depot at Lichfield for reassignment. Lichfield, hav-
ing been the native town of Samuel Johnson, stirred memories
of Yale and Chauncey Tinker. Before the war, I understand, the
camp had been a British Territorial Army depot. It was a large
red-brick quadrangle of barracks and offices enclosing an im-
mense drill field that had been adapted to form a transit camp
for American troops. For want of anything better to do, they
had me drilling Army prisoners who were in the stockade for
serious offenses such as absence without leave, theft, man-
slaughter, etc. Finally the CO of the camp noticed on my ser-

vice file that I had a degree from Yale and planned to assign me to his office to handle correspondence. The file, showing my service record and civilian occupation, also noted that I owned a farm in Virginia. The upshot of it all was that after three weeks at Lichfield I was sent to Cheltenham in southwestern England, where I was assigned to the Service of Supply (SOS). I had been made assistant to the Colonel in charge of the victory gardens around all the American camps. It was a little like the music hall song "Oh, mister porter, what shall I do? I wanted to go to Birmingham, but they've carried me on to Crewe."

I thought back sadly on the encouragement I had received from General Patton and how I had trained for the Cavalry and for life in the field. Was it all to end up with my raising cabbages or arranging shrubs in flower beds? Fortunately the assignment lasted for only two days. On the second day, while the Colonel was away, I received a telephone call from an officer stationed on the east coast of England inquiring where he could get a power lawn mower. He explained that the grass around his camp was getting high and that soon it would present a fire hazard. I told him that I was very sorry but that I was the new boy and I just hadn't any idea where he would be able to obtain a power lawn mower. I told him I would find out and get back to him the following day. I never did get back to him because that day orders came sending me to London. I felt I had escaped a fate much worse than combat. I hope he got his lawn mower.

My first London duty was at the headquarters of the SOS in Grosvenor Square, and there I found myself assistant to Colonel Meachum. I was let loose in the War Room, which contained a great deal of top secret material, but since I had no real assignment yet, the information meant little to me. I sat opposite Meachum at his desk, and he urged me to familiarize myself with his files. These were interesting enough, but I still wondered what I was supposed to do.

After the first two weeks I was thoroughly fed up with office work (shades of the Mellon Bank) and was looking for greener, and, I hoped, more active, fields. The routine in this office was not very different from looking after the victory gardens down

at Cheltenham, and although I have always been hesitant to pull strings, the moment had arrived. On getting to London, I had looked up my brother-in-law, Colonel David Bruce, by then head of the European Office of Strategic Services (OSS), the newly formed American intelligence organization, which later became the nucleus of the Central Intelligence Agency. I also went to see Stacy Lloyd, an old foxhunting friend whom Mary and I had known in Virginia. Stacy was working in the Special Intelligence (SI) branch of the OSS, with the rank of Captain. I stayed for a few days with David before renting an apartment with Stacy at Sussex Gardens Terrace, in Paddington.

David was nine years older than I and had married my sister, Ailsa, in 1926. He was trained as a lawyer and had spent some time in the Foreign Service before entering the business world, in which he was encouraged by my father and joined by his great friend Averell Harriman. He came over to England early in the war, ostensibly to work for the American Red Cross. It later transpired that even before Pearl Harbor David had been recruited by Major General William "Wild Bill" Donovan to be the General's right-hand man in London with the task of setting up an intelligence network. Harriman had also been in London, organizing lend-lease. While Donovan spent most of the war in the United States as head of the Office of Strategic Services, David ran the London office, as Chief of the organization's European Theater of Operations. By the time I arrived, David had been in his new post for several months.

Stacy Lloyd was at that time married to my present wife, Bunny. He and I stayed at Sussex Gardens Terrace for about six months before moving into a house that we rented on Chapel Street, Belgravia. It was a convenient arrangement since we had a housekeeper who looked after things and who could cook dinner if either or both of us were in. If she was off duty, she left something for us to heat up. On one of the first nights that we both decided to stay home for dinner, we discovered a saucepan on the stove with large lumps of meat and some rice in it. We couldn't make up our minds whether it was some sort of soup, to which we were meant to add water before heating, or

a stew. Being inexperienced cooks, we filled the saucepan with
sufficient water to cover the meat and then heated it over the
gas ring until it had boiled for a little while before serving it up.
It had a disgusting taste, and we found we couldn't eat very
much, so we thought we had better go straight on to the dessert.
While searching for that, we opened the oven door and found
a very nice-looking casserole, which was obviously intended as
the main course. The following day the housekeeper looked at
us resentfully and said, "You absolutely ruined my cat's din-
ner."

Stacy arranged an interview for me with his colleagues in SI,
but my French wasn't really fluent enough, so it was settled
instead that I would see an OSS Special Operations (SO) officer
by the name of Colonel Vanderblue. I was walking down Gros-
venor Street for this appointment when the Colonel, who had
presumably been waiting for me, stepped out of the OSS office
building onto the sidewalk. Not knowing who he was, I saluted
as I walked past. He turned around, then, looking to left and
right to be sure that no one could hear, and said in a subdued
voice, "Are you Lieutenant Mellon?" I replied that I was. The
Colonel said he thought it best if we talked where we were, out
in the street, because the whole thing was highly secret. He
leaned forward and asked me if I liked spy stories. I said that I
did and that I read them occasionally. "Well," he said, "I think
maybe you'd like it in OSS because it's a highly secret business.
Come to the office tomorrow." I never saw the Colonel again,
but I reported to Special Operations the following day, where I
was checked out by the security department, and the next thing
I knew I was in the OSS and had said good-bye to the SOS. By
then it was late July 1943, almost two months after my arrival
in England.

Most of the French agents, or French-speaking recruits who
were going to be dropped by the OSS into occupied France to
help the Resistance, were trained by the British Special Opera-
tions Executive (SOE), whose headquarters were in Baker Street.
The British had great expertise in such matters as sabotage and

operating behind enemy lines. The OSS, the American counterpart of the SOE, sought its trainee agents almost entirely among French-speaking soldiers or civilians in the United States. A lot of us in the OSS had known one another before the war, and the buzzword was that OSS stood for "Oh, so social." Similarly, the SOE, which had requisitioned a great many country houses for its training installations, was known as "Stately 'Omes of England."

I knew sufficient French to translate the pledge of allegiance to the flag orally, which enabled those recruits from America who were not United States citizens to join the U.S. Army, but I didn't know enough to teach them what they would be required to do in the field. For the most part, these French-speaking American recruits were sent to various SOE screening and training Centers, while their American security clearance and pay scales were being processed at Grosvenor Street HQ. The British then trained them, briefed them, and gave them their cover stories.

When I joined the OSS, Paul van der Stricht, a New York lawyer who had the rank of Colonel, arrived in London to run the Special Operations section. I spent quite a lot of time during these early autumn months of 1943 with Steve Millett, another Lieutenant, working in Colonel van der Stricht's office at Grosvenor Street. As two junior officers, we were assessing fair compensation for the American recruits, using Army pay scales as a guideline. Neither of us really had enough to do, and every morning we made coffee in our little office. Van der Stricht would poke his head around the door and say, "Coo-king again?"

Millett and I thought it was about time we were promoted to Captain, and we kept explaining to van der Stricht that it was difficult for us, as Lieutenants, to talk to British Colonels and Majors over in SOE or to Free French officers and expect to be taken seriously. After some badgering and after van der Stricht had sent cables to headquarters, he told us to word our own cables and send them. We composed messages recommending

ourselves warmly and sent them off under van der Stricht's signature. In due course the order came through promoting each of us to the rank of Captain.

At that time one of the lawyer-officers was returning home to the United States to recruit for the OSS, especially for our unit, SO. He asked me whether I could think of anyone at home who might be suitable. I said that I knew several possible candidates who were intelligent and college graduates, men I had known in civilian life and men I had met at Fort Riley, but that to my knowledge none of them had a particularly strong grasp of the French language or any other foreign language. I put forward several names, including those of Reeve Schley and James Vaughan, both Cavalry School graduates from Fort Riley. Not long afterward, in November, Schley and Vaughan arrived to swell the contingent of my friends in London.

SOE had requisitioned a large old house down at Liphook, Hampshire, and was running training courses there on all sorts of cloak-and-dagger activities, including sabotage, communications, and personal combat training. I heard that SOE had taken several Americans from SO, so I applied to attend a month's course, which was to run during September 1943. I was accepted and was the only American officer in the course. It consisted mainly of training in the use of explosives for sabotage, silent killing, crossing streams by cable hand over hand with a Sten gun hanging below one, forming organization charts, entering houses unheard and unseen at night, night ambushes, etc. After crossing a stream on one exercise, I blasted away with my Sten gun at a suddenly appearing silhouette target. It malfunctioned and discharged *all* its bullets within two or three seconds. As a result, I was given 100 percent for the exercise and ended up getting the highest marks of the week!

At the end of the course I went with a few of the group to Ringway for a parachute training course involving five jumps. The jumps were made through a hole in the floor of a Halifax bomber. My first jump was unfortunately a disaster. The instructions were to pull down on the front straps of the harness to guide your descent in a forward direction. This also had the

effect of making you fall much faster, so I struck hard on the ground with the parachute pulling me forward in a brisk wind. The result was that I banged one of my knees. During the night it became swollen and had to be bandaged and immobilized, so that meant postponing the remaining four jumps of the course in order to qualify. I returned there and finished the course later.

In January 1944 I was sent to Baker Street as liaison officer with the British SOE. The plate on the outside of the building stated that it was the office of the "Inter-Services Research Bureau," but that didn't fool anyone, least of all the Germans. At one point I was assigned to assist Colonel Barcroft, attached to the Ministry of Home Security, who was in charge of the preparation of a deep tunnel shelter at Chancery Lane. The Allies were fully aware that the Germans had been working to develop an atomic bomb and that the possession of such a weapon in their hands, delivered by a V–2 rocket, would have meant the destruction of much of London. SOE was therefore fitting up offices in a very deep disused underground station at Chancery Lane to accommodate top government officials, and I was involved in the logistics of this highly secret project.

One of the odd jobs that I had to do in the OSS was to demonstrate a brand-new weapon, the bazooka, to the Free French and SOE, the idea being that the weapon could be dropped to agents in occupied France for use against tanks. I had had some training with the bazooka at Fort Riley. It looked like a five-inch-diameter pipe and was about four to five feet in length. One man would raise it to his shoulder and take aim while the other slid the projectile into the muzzle, making sure that it was the right way up or the whole thing would blow up. Colonel van der Stricht asked me to take one of these weapons to a high-level meeting of the Free French to inquire whether they would like to have some for their agents. I walked off down the street in London's West End with this thing under my arm and tried to explain to those at the meeting, speaking half in English and half in French, how it worked. Later we were requested by the British to give them a live demonstration, and Reeve Schley and I set off for an Army range, accompanied by a group of British

officers. Like me, Schley had had a minimum amount of training on the bazooka at Fort Riley, so when we arrived, we got it ready, and Schley raised it to his shoulder, like a rifle, while I dropped the projectile in. There was quite a recoil, a tremendous bang, and then a lot of gunpowder blew back into Schley's face, something he hadn't expected. Of course, the missile didn't go anywhere near the target we were trying to hit. I suppose we weren't very good salesmen for it, but on the other hand, it was intended for use at close range, and the results on the landscape were really quite impressive. I imagine that today the bazooka is as outmoded as the longbow. Presumably these unwieldy tubes were used to good effect by the French Resistance.

Reeve Schley, apart from having been a graduate of the Fort Riley Cavalry School, was an old friend of mine from Yale and New Jersey. Not long after our amateurish exhibition of the uses of the bazooka, we heard through the grapevine that General Donovan would be in London shortly. There was also a rumor that a resistance team of OSS/SO agents would soon be dropped into the mountains of Greece and Albania. The agents would form mule pack teams to harass the enemy behind the lines by the demolition of railways, highways, and enemy installations.

At the Cavalry School we had been taught to harness horses and mules and to hitch large and heavy packs onto their backs. Whether Reeve and I remembered all the knots and hitches would have been somewhat doubtful, but we convinced ourselves that we could learn quickly. We were totally fed up with our inaction in London ("Coo-king again?") and bored with the daily routine of such civilianlike tasks as adjusting the pay of agents being dropped into France, Belgium, and Holland. So we decided to seek an interview with Donovan, the great man himself, in order to volunteer for service in Greece.

We knew one of Donovan's aides, and through him we were finally granted an interview one evening in the General's suite at Claridge's. Dressed to the nines in our best pressed uniforms, brightly shined Sam Browne belts, and Cavalry boots with spurs, we waited in the lobby of Claridge's. After about an hour the General arrived, and we saw him go up in the elevator. We

followed shortly after, knocked on the door of his suite, and, to our surprise, were met by Donovan himself, in his shirt sleeves. He ushered us into the living room.

Reeve and I told the General of our ambition to join the newly formed pack unit, stressing our Cavalry training and our intimate knowledge of mules and packing. He asked us to join him for a drink, which we readily accepted. After complimenting us on our initiative and patriotism, he said, "I know what you boys are thinking. You want to be a part of the action. Don't worry, when D day comes, *everyone* in OSS in London is going to see plenty of action. I can't just write an order to transfer you out of your present jobs and send you somewhere else; these things are arranged well in advance, so just make up your minds to wait until D day, when everyone in OSS will be on the beaches."

Somewhat disappointed, although perhaps somewhat relieved as well, we rose, saluted smartly, thanked him, and left. Going down in the elevator, Reeve voiced what I had been thinking—i.e., that we were not too happy at the thought of fighting under the command of Colonel van der Stricht. In any case, things turned out differently. Van der Stricht, by the way, later became American Chief of Staff under General de Gaulle of a staff with the glorious title of *État-Major des Forces Françaises de l'Intérieur.*

On another occasion Raymond Guest, an old Virginia friend in the Naval department of OSS, asked me to come to his office, where he explained that they had just received some frogmen's equipment from the United States and that a team of underwater divers out at Staines Reservoir (near present-day Heathrow Airport) could demonstrate how it worked. I managed to get some top people in SOE interested, including section heads and liaison officers from the French and Dutch as well as the British, and it was arranged that I would take them out to the reservoir to see the equipment in action. When we arrived, for some reason or other Guest wasn't there.

The frogmen seemed very nervous, and it transpired that one of their party had been drowned just a few days earlier using the same equipment. Two of them, however, agreed to give a

demonstration. As things turned out, it was very embarrassing. Instead of disappearing underwater as you would expect in a clandestine operation, neither frogman fully submerged, and you could clearly see them moving about on the surface of the water. The visitors were not at all impressed.

About a week after D day, in June 1944, I was sent with about ten other officers from Special Operations to an OSS unit under Colonel R.I.P. "Rip" Powell at a large house in the South Midlands. In some respects the setting was not unlike that in the opening episode of Evelyn Waugh's *Brideshead Revisited*. The country house in the Midlands was just a holding station, and after an overnight stay we went on to Patton's Third Army headquarters in the same part of the country. Within two or three weeks the various units had left separately for their embarkation points for France. Ten of us, officers and enlisted men, from our OSS detachment set off by a circuitous route in five Jeeps and a command car for Southampton. We all spoke enough French, some better than others, to be able to communicate reasonably with members of the Resistance and were to be sent over to France to organize radio linkage with them. The idea was that when the big push came, we would join up behind enemy lines with the French Resistance and other SOE and OSS agents, who would then harass the enemy by blowing up bridges and ambushing the Germans' armored divisions with mines and bazookas. We wound our way through the countryside, passing through the Meynell hunt country and the house to which my old hunting acquaintance Maurice Kingscote had moved when he left the Vale of the White Horse and became Master and Huntsman of the Meynell. As we drove south, we went past Swindon and then through Wroughton, where Ivor Anthony my former steeplechase trainer lived, and where he had trained Drinmore Lad. The family of Peter Hastings-Bass, who was to train for me after the war, was there, too, and I wanted to make a brief detour to go see them. This was unfortunately out of the question, and we arrived at Southampton to be put aboard an LCT (landing craft, tanks) the next morning.

In convoy with a lot of other troops, we crossed the Channel

and landed at Omaha Beach on the coast of Brittany near Bayeux about three weeks after D day. The crossing was uneventful, the day was sunny and cool, there was no air activity, and the presence of many destroyers and corvettes gave us a feeling of security. We finally made camp near Ste. Mère-Église, a little town in the Cherbourg peninsula, some forty miles from Caen, and there began working out strategies of how to get in touch with the French Resistance once the push had started. After a few days, together with two or three others, I was sent over as liaison with a First Army OSS unit in Normandy. This unit was only two hours away, but on the way there in a Jeep I began to feel extremely ill.

On arrival I reported to the Major in charge of the nearest medical unit, who gave me some pills and asked me if I had anywhere to sleep. I said I had a sleeping bag and was sleeping in a hayloft. As days passed, my temperature climbed higher and higher. I had caught pneumonia and just lay there in the hayloft in my Abercrombie & Fitch sleeping bag, becoming hotter and more feverish and sweating gallons. Each day I had to be sent over to the medical unit, and I also had to leave my sickbed from time to time for meals and to use the latrines. On the fourth day the Army doctor looked at me and said, "I guess I should have put you into the hospital when you first came in." By then I had a temperature of 105 degrees.

I was sent to a field hospital, and there my friend Jim Gallatin came over a few days later to see me with a gift of some books and the rest of my equipment. Gallatin was a descendant of the Albert Gallatin who served as Secretary of the Treasury from 1801 to 1813, the only Treasury Secretary to have served longer than my father. I was lying in a canvas cot on sloping ground, and by then I had become semidelirious and couldn't even talk sensibly. A nurse from the Red Cross asked whether she could write a letter to my family. Mary had not heard from me for a month, but the fever had put me into a state of total apathy so that I had no interest in anything. The nurses and the medics were kind and efficient, but this particular type of pneumonia (atypical lumbar pneumonia in both lower lobes) was imper-

vious to whatever drugs were available at the time. Later I was sent to a base hospital at Isigny, where the staff treated the constant cough I had developed, giving me codeine every night and getting a little strength back into me. After two more weeks I was put on a hospital plane back to England and sent to a brand-new Army hospital near Newbury.

The hospital was nearly empty, and my spirits were beginning to return. I took my first shower in a month, ate some bacon and eggs, then sat on the edge of my bed and reflected that life wasn't really so bad. London was only an hour away by train, the Hastings family and Ivor Anthony were nearby, and I thought that maybe I could get over to see them and some of the horses. It was not to be. The following day I was put on a stretcher train and sent off some two hundred miles northwest into the wilds of Shropshire, near the town of Whitchurch. When the train arrived, I was carried by ambulance to another Army hospital and put in a bed curtained off by long sheets hanging from the ceiling. I was still coughing badly, so I was taken to have my chest X-rayed. I stood against the machine with my arms raised, and the orderly walked behind the screen into the next room to press the button. Nothing more happened, and I remained there in the same position for what seemed like hours. Finally the orderly reappeared, and I asked him what was going on. Finishing a cigarette, he said sheepishly that he had forgotten that I was there. I told him I very much hoped the X-ray machine had not been on all that time.

I returned to my bed and was later visited by a medic Major. He looked at my chart and examined the X rays, then asked me if I had a venereal disease. I replied that I did not have a venereal disease, nor had I ever had one. I had double pneumonia. The doctor held the X rays that came with me up to the light and looked at them again, saying, "Why, then, are you in the VD ward?" I said I hadn't the slightest idea, so he promised to get me moved at once, and in the meantime, he put me into an empty conference room in the same ward.

I had throughout much of my tour of duty in England been friends with an English girl, Valerie Churchill-Longman, who

worked for the American Red Cross in London. I sent her a telegram asking her to come and see me and to bring some money with her because I was absolutely broke. Valerie made the long journey up to Shropshire with another Red Cross girl. She was a little puzzled to find me in the VD ward, but I managed to put her mind at rest!

Valerie never married. She left England after the war, came to the United States, and got a job in Boston. Forty-three years later, I was contacted by her lawyer. He told me that she was terminally ill with cancer in the Massachusetts General Hospital and that she had asked whether I might like to visit her. I flew up to Boston right away, and we talked happily about old times. She died two days later.

After a weekend leave in London I was feeling much better and was ready to be discharged. The OSS sent a car to pick me up, and I was on the point of checking out of the hospital office when a clerk asked me where I was going. I explained that a car had come to collect me and take me back to OSS headquarters in London. The clerk who had queried my departure told me there was no question of my going to London as he had me down in his book to return to the Replacement Center at Lichfield. It was another three weeks before the OSS could spring me from there, but I was back at headquarters in London, feeling fully recovered, in early October 1944.

I was given a choice by the OSS. I could either stay in Europe or rejoin my old unit at Third Army headquarters, which was being trained at home to go to the Far East. I had missed the big push across France. While I was incapacitated by pneumonia, several of my colleagues had seen a good deal of action during Patton's campaign, and at least one had been decorated. Although the prospect of a month's leave in Virginia appealed greatly after eighteen months away from home, I opted to stay in Europe, being pretty well convinced that the war would be over there much sooner than in the Far East. I was assigned to the Morale Operations (MO) unit in Belgium, by then under the command of Stacy Lloyd. The idea behind Morale Operations, and a highly impractical one it proved to be, was to distribute

"black propaganda" behind the German lines by what was sup-
posed to look like the work of a German underground. Dis-
placed persons or German-speaking agents were to be infiltrated
through our own and enemy lines to distribute leaflets and post-
ers. The only time when it might have worked was during the
German counteroffensive in the Ardennes in December and Jan-
uary 1944–45, the so-called Battle of the Bulge, but at that stage
things were moving so quickly that there was no time for in-
genious morale-sapping schemes. Even when the lines were sta-
ble, it was difficult to persuade American combat officers and
their men to risk their lives taking unknown civilians along with
their patrols into enemy territory at night.

By October 1944 OSS headquarters had moved to Paris, and
in line with my frequent trips to and from the Continent, I had
orders to fly there. I always seemed to have problems getting
anywhere in the Army, and when I arrived at Croyden Airport
with some others to board a DC–3, the weather was so bad that
we were all sent back to central London and put on a train for
Southampton. There we stood on an open dock for two or three
hours in the rain waiting for an LCI (landing craft, infantry).
Once we were aboard, the weather deteriorated still further, so
we were unable to sail for France.

We lay at anchor behind the Isle of Wight in the Solent for
three days while the sea raged in the English Channel. We sat
belowdecks by day, and at night we lay in hammocks, three
deep. Meals consisted of K rations, which were pooled for one
of our group to cook. Three times a day the Navy crew appeared
and turned us out of the kitchen and mess area in order to enjoy
their own meals. We Army folk looked on like poor relations,
while the Navy men ate pork chops and fresh green salad, fol-
lowed by canned peaches and ice cream. As the storm abated,
the LCI returned from the Solent to Southampton to collect
water and more passengers.

I had meanwhile run into our OSS Adjutant on board. He
said that he no longer saw any point in going to Paris because
everything he was going over there for was already obsolete,
and he had decided to return to London. Although my orders

did not say anything about going back to London, I thought no harm could result from accompanying the Adjutant, so the two of us, together with two GIs from OSS, stepped on a London-bound train.

As the train passed through the Hampshire countryside, the conversation in our otherwise empty compartment turned to weapons. The Adjutant produced his Colt .45 automatic, and I, who, blindfolded, had been able to strip down and reassemble one in three minutes at Fort Riley, confidently unholstered my own. I pulled back the slide and slipped a round into the chamber. I had since forgotten that this action locked the clip containing the rest of the ammunition and that the shell couldn't be ejected, so I found myself wielding a dangerous weapon that could at any moment shoot somebody's foot off, including my own. The two GIs were vastly amused at an officer's embarrassment as they explained to me how to clear the gun.

Afterward, when I returned to our house in London, I regained some of my confidence and savoir-faire by completely stripping the .45 down to its smallest component, cleaning and oiling each one, and successfully reassembling it into perfect working order as I had been trained to do at Fort Riley. But not with the blindfold, however.

On my second attempt to fly to Paris I was able to board a DC-3 and landed at Orly Airport. I spent two or three days there before joining our unit in Nessonvaux, Belgium, just in time for the Battle of the Bulge. We found ourselves retreating with other rear-echelon units of the Army. By then the German advance had collapsed as abruptly as it had started. The Germans had overrun and destroyed small towns like Houffalize but failed to reach Liège. Nevertheless, our unit was ordered to withdraw from its commandeered house at Nessonvaux, southeast of Liège, to a town called Hainaut, about thirty miles to the west. As we moved back, we saw quite a few buzz bombs (V-1's) moving overhead, and a few fell on Liège as we were passing through. The limited range of these weapons was making it increasingly difficult for the retreating Germans to hit London, and they were targeting them more and more onto Belgian

towns. Earlier one had fallen and exploded on a house next door to where we had been living. With the exception of Captain John Michel, one of our group, we all were away on a mission at the time.

Michel was a very intelligent, excellent linguist from Chicago. He was also, unfortunately, given to telling filthy stories and jokes but was amusing enough that the others couldn't help liking him. He had bought a pair of riding boots in Nessonvaux, and because everybody was away and he had nothing to do, he decided to try them on. Then he found that he couldn't get them off. There were two young French boys who acted as orderlies and cooks for the unit, so he summoned them and told them each to take hold of a boot and to pull, while he lay on the bed, grasping the bed rail. At that moment the buzz bomb exploded on the house next door with a deafening roar and blew out all the windows in our house. Luckily none of them was injured, but Michel was less concerned with his fright and survival than with what people might have thought if they had found him dead, in his underwear, wearing leather boots, and with a boy lying on either side.

While my unit was still in Nessonvaux, some of my colleagues and I went to a meeting in Paris, and on the way back, after a miserable night train journey, we arrived in Brussels tired and dirty. With us was our supply sergeant and general factotum, Sergeant Switgall, a native of Chicago, who had an uncanny ability to scrounge. He spoke very passable French and several other languages, and among his accomplishments was the knack of taking advantage of the black market in food as well as in currency.

While we ate a dismal breakfast in the station, Switgall was sent to find accommodation for that night. He returned after a while and told me he had found a suitable hotel not far from the station, so we all picked up our duffel bags and knapsacks and followed him. The house turned out to be sunny and clean, and we were ushered into a cozy bar. Having ordered drinks all around, we were marveling at the luck of finding such a nice *pension*, when surprise, surprise, in came the girls, who sat

down among us, and they weren't at all bad-looking.

As the CO of the unit I had qualms about the propriety of letting us settle down there for the afternoon and for the night, partly because I had never heard of an Army unit bivouacking in a brothel. However, it was too late to change without paying the *patron*, and we were warm for the first time in days. When I was shown up to my room, I was touched to see, perched on top of the pillows of my bed, a small round rubber souvenir. Celibacy is not one of my favorite virtues, but my bed that night, welcome as it was, was not shared with any of the angels of mercy who came with the establishment. I have always been curious about my companions spread around the rest of the house, but I never inquired.

Switgall was a marvel. When we formed a convoy in Luxembourg to go to Nessonvaux, I, as the new Executive Officer, made sure that it was made up according to Cavalry regulation, the right vehicles in the right places, spaced properly, adequately fueled, etc. I did *not* see that just inside the tailgate of one of the trucks loaded with provisions for the unit there was a crate full of live chickens. I was following in the rear of the convoy in a Jeep and was not at all surprised when at one point we made an unauthorized stop. Before I could investigate, the convoy moved again.

Two days after we arrived in Nessonvaux, we were treated by Switgall to a delicious chicken dinner. "Where, Switgall, did you come upon these lovely fowl?"

"*Victimes de voyage*," he answered. The tailgate had dropped open, and out had fallen the crate of chickens.

In January 1945 Stacy returned to the United States, and I became the CO of this Morale Operations unit. Shortly thereafter I was promoted to Major. I never had much confidence in the idea of black propaganda, and now that the Allied armies' advances were so rapid, I thought the whole idea of trying to infiltrate agents behind enemy lines was getting a little ridiculous. We held futile meetings at Twelfth Army Group HQ, at one of which it was suggested that night fighters be employed to drop leaflets behind the lines and that explosives and am-

munition for agents be lowered in canisters by means of fishing reels and lines! Needless to say, none of the proposed schemes was implemented. By April even OSS headquarters in Paris accepted the fact that there was nothing more for our unit to do, so we were ordered back to London.

There was a little matter that I wanted to settle before the war ended. I had not completed my parachute course at Ringway, having, on my first attempt the year before, banged my knee seriously on landing. I therefore had four more jumps to make in order to qualify. I persuaded OSS headquarters to cut me orders to act as a conducting officer for five young girls who were being trained to drop behind the lines in Germany. Two were French, and three were Dutch. One or two English officers were on the course as well.

This time my first jump was also out of a Halifax bomber, and as I dropped through the narrow hole, my chin hit its edge, jamming my jaw upward and splitting one of my front teeth. That evening I bound the tooth up with dental floss until I could get to a dentist to have the tooth removed, and the remedy worked very well. The second jump was also by day and involved the use of a "leg bag," which was filled with simulated small arms and ammunition and attached to one leg, with a rope at your waist to lower it while descending. A few feet before the ground came up you released a cotter pin holding the bag, detached the rope, and let down the bag so that it hit the ground seconds before you did. This made you suddenly lighter, with the result that you hit the ground more softly.

The weather became too windy for the last two jumps, so they were made from a tethered balloon at night, the wind usually abating after dark. I have neglected to say that you didn't have to pull a ripcord by hand to open the chute. A static line, hooked to a bar inside the plane or to the platform of the balloon, opened the chute automatically as you exited one or the other. The balloon jump was easier in one way: since you couldn't see the ground coming up, you were automatically more relaxed and ready. Also, the air was cooler, and the drop slightly slower. However, with no slipstream from the plane,

the chute took much longer to open, more than thirty seconds, a lacuna that seemed more like an hour.

The five girls were on the same flights, and one of them, a very pretty young Alsatian, couldn't wait for the next jump. I've never seen anyone more eager or more brave, and she had a wonderful sense of humor. But one of the Dutch girls was a very different story. On her first flight she froze and wouldn't jump through the hole. I believe this happened twice. Finally, at night, on the platform under the balloon, she balked again. Strong British arms grasped her and threw her out through the hole. I don't know what happened to her career as an agent after that. In any case, I had completed my five jumps, had qualified, and was entitled to wear the silver parachutist's badge. I have to admit that it boosted my ego quite a lot, but when I thought of all those others who were descending into enemy or occupied territory, probably being shot at from below, my mood was a good deal more humble.

The war was drawing to its close, and the U.S. Army was fast pushing east through Aachen and Cologne toward Berlin. As CO of our MO unit I packed my bags and, together with my Exec and good friend David Yerkes, John Michel of riding boots fame, and Walter Kerr of the New York *Herald Tribune*, started wending my way back to England by way of Paris.

While waiting in Paris for transportation to London, I had an idea that there might still be some black propaganda opportunities in the ports of Le Havre and Bordeaux. There were still sizable German forces holed up within the gigantic reinforced concrete structures housing what was left of their submarine fleet. These German soldiers and sailors, for nothing better to do, were coming out in small groups at night, and even in the daytime, to molest the patrolling Free French, to cut themselves wheat and barley for food, and to plant booby traps at random. I thought it possible, and the CO in Paris agreed, that some propaganda leaflets might be infiltrated into these maritime forts, perhaps to look like the work of an army underground or of disgruntled German soldiers and sailors.

We had in our unit two ex–U.S. Air Force officers who had

completed their bombing missions. There were Lieutenant James, whose first name I have forgotten, and Malcolm de Sieyes, a Captain. Both spoke excellent French. I got them to come with me, to buttress my inadequate French.

We were issued a Jeep with a trailer full of five-gallon jerry cans of gasoline. Of the trip south through the Loire country, my main recollections are of a delicious black-market lunch at a little restaurant in Châteaudun and a halt for the night at a small hotel in a village farther south. When we reached that hotel, the problem was what to do with the remaining, perhaps twenty-three, jerry cans. They couldn't be left out in the street for any passing Frenchman to walk off with. To add to the problem, the only rooms available at the hotel were on the fifth floor. Fortunately we had been able to rent an extra room for the gas, but even for three able-bodied men, carrying a large number of full jerry cans up five steep flights of stairs was exhausting and not what we had planned. Still, we got it done. It was a fairly uneasy sleep for the three of us that night, with thoughts of fire and what a fine explosion the hoard of gasoline would make.

We eventually reached Saintes, which was to be our headquarters. The Free French officers whom we contacted were friendly and cooperative, although I suspect, when they heard of our plans, they thought they were dealing with American lunatics. After they had entertained us well at dinner on our first night, they suggested that we go out with two of their soldiers for a reconnaissance of the areas where the Germans were in the habit of foraging. We were warned about booby traps and with our two guides walked about five miles down a narrow tarmac road toward a sizable vineyard. The guides took us to a large house owned by the *propriétaire,* where we were given some delicious white wine and were briefed about the habits of the marauding Germans. While we were talking, we could hear bursts of machine-gun fire a mile or so away. Our hosts explained that these were warning signals, just as though to say, "Don't disturb us at our farm work." All this persuaded us that getting black propaganda to the German troops was a

little naive, and we had no intention of approaching the machine gunners to sound them out!

On the way to the vineyard I had spotted a long wire leading from the ground and reaching up to the top of a telegraph pole, just off the road we were walking along. On the way back I noticed that the wire was gone and the pole had a lean to it. Just then we saw blood all over the road, bits of bone and pieces of flesh. The reaction of our guides, who were seething with anger, was to mutter, *"sales boches."* Some unfortunate soldier following us up the road had fallen for the booby trap and tripped the wire. It wasn't our fault, and it was stupid of the Free French soldier, but it put a great cloud over our minds, and I suddenly realized that our playing at war, playing at being propaganda artists, was thoughtless and foolish. We packed up the next morning and, having saved enough of our precious gasoline, drove back to Paris, sadder and wiser.

I had not entirely given up hope of contributing to the war effort through propaganda. Sometime in the spring of 1945, after I had returned to London, I conceived the notion that I might, by a visit to Dr. Jung in Zurich, assemble some ideas about German psychology and morale that could be helpful in distributing propaganda. The Commanding Officer in London at that time thought it was a good idea and had orders cut for me to fly to Zurich. He had consulted Allen Dulles, head of OSS in Switzerland, who had also consulted Jung, and they both gave the green light. I was to go in civilian clothes, had been given enough clothing coupons, and went to a fashionable haberdashery in Piccadilly to be outfitted. Alas, before I was able to get transportation, Germany surrendered, and I was left holding some useless shirts and a gray suit. The haberdashers were not amused when I went back to return them, because I had to ask for the return of the clothing ration coupons I had used for the purchase, so that I could in turn hand the coupons back to the OSS.

German resistance collapsed very shortly after I completed my parachute course, and I found myself back in London for

V-E Day. I remember walking with some Army friends down Pall Mall that evening and being surprised to see so many bright lights after years of blackout. I chanced across Alan Houseman, an old Clare friend who had rowed with me at Cambridge, together with several other Cambridge contemporaries whom I had not seen since the early thirties. The whole atmosphere seemed unreal. Soon after, I received a cable from David Finley, saying that David Bruce had resigned as trustee of our National Gallery and asking whether I would agree to succeed him. David and Ailsa were getting divorced, and David obviously felt it inappropriate for him to stay on the Gallery board. I became a trustee again and was to give a great deal of my time in the future to the Gallery's affairs.

A few days later I received orders to return to the United States, and on May 22 I sailed on the *Île de France* from Southampton. The luxury liner had been converted into a troopship. It was packed to the gunwales with GIs and zigzagged its way carefully across the Atlantic, just in case a German submarine out there had not had word that the war was over or, if it had, wasn't going to pay any attention. I disembarked at an Army depot in Brooklyn and with a few others was sent in an Army truck into Manhattan, where I was soon delivered to our house on 70th Street with my duffel bag and other equipment. I had to wait until August for my discharge from the Army but came home a very different man from the raw recruit who had left for Fort Riley four years earlier.

Much of Europe had been devastated by the war. There were shortages of food and a roving refugee population in the worst affected areas. By contrast, the United States had been physically untouched, and demand for war matériel had brought with it a boom resulting in widespread prosperity. Many returning servicemen felt uncomfortable. Attitudes at home seemed so materialistic and self-satisfied to men who only recently had been witness to a great deal of suffering and deprivation. Mary and I spent the early winter of 1946 at a house we had bought in Hobe Sound, Florida, and I found myself restless and irritated

by the life there. We had been leading separate lives for the last
four years, so it was hardly surprising that we had developed
separately and had inevitably grown somewhat apart.

Mary had enjoyed interludes of about two months during the
war when she had no attacks of asthma. She even reached the
point where she could ride a horse without suffering from any
of these symptoms. She had a theory that if she could regain
asthma-free comfort while riding, it might lessen the frequency
of her seizures overall. She had a nice sensible horse that our
head groom, Forrest Dishman, had found for her, and some-
times she went riding and got away with it. But on other days
she might be suddenly seized again. She loved the farm and
was determined to go foxhunting, although she usually stayed
at the back with Dishman and didn't try any jumping. In the
spring of 1946 she had a particularly bad attack and had to be
taken to the hospital in Winchester, Virginia, and placed in an
oxygen tent. Dr. Harold Kuehner, a Pittsburgh physician who
had been our family doctor and who had taken care of Mary in
the past, came down to evaluate her condition. He talked to me
and to George Wyckoff, who was staying with us at the time,
and said, "You know, this thing can't go on much longer. It's
a terrible strain on her heart."

The following autumn, on October 6, Mary and I were hack-
ing back from hunting when an attack began. She asked me to
go on ahead and fetch a car to get her to the house. Leaving
Dishman to stay with her, I galloped to the stables. By the time
she was collected and we all were back at the Brick House, she
was in really desperate shape and went straight to bed. While
I was out of her room, our children's nurse rushed up to me,
saying she was alarmed by Mary's condition and urging me to
come up at once. I went up to Mary's room and found her in a
dreadful state. She died right there.

She was buried in an old farm cemetery near our Oak Spring
house. The minister from our local church read the service, in-
cluding a text from the Gospel according to St. John, which was
a favorite of Jung's: "And as Moses lifted up the serpent in the
wilderness, even so must the Son of man be lifted up: That

whosoever believeth in him should not perish, but have eternal life."

Among the letters I received after Mary's death was one from Jung that read:

Dear Mr. Mellon,

Barrett's telegram, which informed me of Mrs. Mellon's sudden death, has caused such a shock to me that I can realize what a terrible experience it must have been to you. It is a loss the extent of which one can hardly imagine. Elle était une femme de grande envergure who had it in herself to play a great rôle in the world. And now she has gone from us in the zenith of her life, when she was at the threshold of her great realization. I share your grief and suffering.

Yours sincerely
C. G. Jung

My life with Mary, interrupted as it was by my four years in the Army, was a series of loving and friendly interludes punctuated by periods of misunderstanding and mutual aggravation. She had a very forceful, almost aggressive personality, but it was tempered with a sense of fairness and a mischievous sense of humor. She could be insufferably bossy at one moment, yet understanding and fair and equitable the next.

She was a person of considerable knowledge and much above average intelligence. Though certainly not a true intellectual, she thought very logically and with an all-encompassing and fundamental humanity and compassion. The set of her mind was such that when she encountered Jung, she became one of his most ardent and confirmed disciples. Jungian thought became her inner, deep philosophy, her religion.

Mary knew, even better than her family and friends, that her remarkable intuition was her worst enemy. She used to say, "I always see what wonderful things there are just beyond the mountains, but I am no good at finding my way through and over the mountains." The present was never as real to her as the future, and it was as though she always felt the present was holding her back.

She looked back on her years at Vassar with nostalgia. She enjoyed languages, she loved Dante, she loved poetry, she had many friends, and she was proud of being a member of the famous Vassar Daisy Chain. She spoke very fluent, if grammatically bad, French. She thought of herself as a feminist and began to write a life of Margaret Fuller. She would have other enthusiasms—at one time for gardening, at another for horseback riding and driving.

Mary was subject to sudden swings and surges of emotion and to occasional irrational, although not dangerous, behavior. She told me that during the war she was in a nightclub with a group of our friends, and they found themselves at a table with some sailors. She took a liking to one of the sailors and in an expansive moment took off a valuable emerald ring and gave it to him (whether it was returned or not I don't recall). She sometimes woke up our daughter, Cathy, in the middle of the night, called Forrest Dishman and had a pony cart readied, and took her for a moonlight drive around the farm. Once, on our honeymoon in Egypt, we were playing gin rummy on a table next to the window in a train taking us back to Cairo from Abu Simbel. The window was wide open, the day was hot, and I was winning consistently. Suddenly she picked up the whole pack of cards and hurled them out the window, to the astonishment of the Egyptian passengers in the compartment.

She drank a lot on occasions, her great ebullience getting the better of her, but I don't remember her ever being embarrassing or maudlin. She smoked like a chimney, a habit that she knew was the worst thing for her asthma, but again her nervous energy and her dislike of restriction always won out.

She loved the Virginia countryside and country people. One of our mainstays on the farm during the war was Forrest Dishman. Mary used to delight in his country stories and aphorisms, his Virginia accent, and his innate country honesty and sincerity. She loved riding in the early morning in the autumn when the leaves were gold and falling. She loved the nobility and the dignity and silence of trees.

When I returned from England after the war, we were often

at swords' points. The Army and the war and the long absence abroad had changed me, certainly not for the better at that time. For Mary, the responsibilities of caring for the children and our two little English evacuees, problems over the supply of labor, the day-by-day responsibility of running the farm, and the overwhelming sense that her intellectual interests and publishing projects with the Bollingen Foundation were withering on the vine all served to force her into a state of unrest and depression. And the depression often gave way to bouts of irritation and anger.

I often wonder how our relationship would have fared had she not died so suddenly, because there were periods of real understanding and tenderness in spite of our changed-by-war personalities. There was laughter, fun with the children, happy days with old friends, and a mutual reverence for the countryside, to say nothing of our shared love of reading and light music. I have a very strong feeling that eventually we would have stuck it out and found a calmer and sunnier common ground on which to continue our lives.

Although we had had many warning signals, the trauma of Mary's death overshadowed my life for some time. Cathy was nearly ten, and Tim just four. Jimmy Vaughan, my old Army friend, came up from Houston to stay and help with running the farm, so everything carried on, but I remained in a state of shock, drinking and smoking (I have long since given up the latter) more than was good for me and unable to concentrate.

Rachel Lloyd, or Bunny, as she is always called, my friend Stacy's wife, was very kind and understanding over my distress. The Lloyds both had long been intimate friends of Mary's and mine, and Mary had always admired Bunny, especially for her warmth and intelligence and for her expertise in gardening. The consequences of the war had left Bunny sad about her marriage. She was devoted to Stacy but bewildered, like so many other wartime wives, by the changes in his attitude toward her and toward their life in general, brought about by his long absence

overseas. It was clear that their marriage had effectively come to an end. Aware of this and having known each other so well for so long, we decided to marry. It was hard for her to change a life of seventeen years, but circumstances being what they were, we saw it through and were married on May 1, 1948.

We have been married now for more than forty years, and I must add that during that time Bunny has remained in contact with and devoted to Stacy, and he to her, each of them sympathetic to the ups and downs of the other's life. Over that period she has also provided my life with a stability and security it had not known before, and she and I have been careful to allow each other to develop our own interests. I was forty-one when I married Bunny. She brought with her her two children, Stacy, nicknamed Tuffy, and Eliza, together with a great flair and lifelong interest in gardening, building, decorating, and collecting. I continued to pursue my National Gallery work, my philanthropic activities, my foxhunting and thoroughbred breeding, but a new influence was at work. The little nineteenth-century farmhouse at Oak Spring was placed on rollers and transported over three fields to about half a mile away, where it was put down on the edge of a Rokeby field and where it has since been the home of our secretaries. One of them, Elizabeth Rye, has retired, but the other, Martha Tross, is still an invaluable help to me, taking care, among many other things, of the horse-breeding and racing records and accounts. We commissioned the late Page Cross, a New York architect and a personal friend, to design a replacement at Oak Spring, and the result is a complex of low-lying interconnecting whitewashed stone buildings with shingle roofs. The farmhouse, with its service buildings, guesthouse, and walled garden, lies nestled in gently rolling hills and is wholly in character with the surrounding countryside. The interior, under low ceilings, is full of light. The broad-planked wooden floors, for the most part painted, sometimes plain distressed white or in patterns of two colors, emulate a method Bunny admired in Sweden years ago.

The furnishings may be loosely described as French provincial. Bunny's touch is everywhere, and throughout the house

there are flowers, from tiny plants in little pots and jars to large informal arrangements. In fact, informality and lightness are the keynotes which may be seen in everything from the bright printed fabrics and colorful rugs to the softly painted walls and woodwork.

Bunny's enthusiasm has led to the building of vacation houses at Cape Cod and Antigua, as well as her Garden Library, a beautiful church in Upperville, a dairy, an apple storage house, and sundry smaller structures. One of the most engaging features in all our houses is their friendliness. Major works of art live side by side with small objects of art, children's drawings, and bronzes of favorite horses. Bunny's quest for comfort and informality has been nurtured with care; a little natural shabbiness in an old chair cover is sometimes purposely overlooked. The result, I think, is that the houses feel lived in and loved. More important to me than anything else, they are cheerful.

With the completion of Oak Spring, Bunny and I moved out of the Brick House. The Brick House had been designed by William Adams Delano for Mary and me, and it is an elegant building in the neo-Georgian style. Completed in 1941, it closely resembles the Hammond-Harwood House in Annapolis, which I admired during my stay at St. John's College. Aside from its unhappy association with Mary's death, it never was a convenient house to run and had the added drawback of noisiness, stemming in large part from a central hallway and circular staircase leading all the way up to a third-floor skylight. Children's laughter and shouts were heard everywhere, and the water running in a bathtub simulated Niagara Falls down the stairwell. We converted the Brick House twelve years later and used it to store and exhibit my growing collection of English paintings, drawings, and books. But at the time I write of, it was just left empty, the souvenir of another existence, destined in time for demolition. Our move from one house to the other was only a walk of about a quarter of a mile over a small hill, but to me, Oak Spring represented my new life with Bunny and our four children.

CHAPTER 12

Foxhunting, Point-to-Points, and Trail Riding

———◆———

Just enough danger to make sport delightful,
Just enough labour to make slumber sweet.
—GEORGE JOHN WHYTE-MELVILLE

It is very strange, and very melancholy, that the paucity
of human pleasures should persuade us ever to call
hunting one of them.

—SAMUEL JOHNSON
Mrs. Piozzi's Anecdotes

The literature of the hunting field—Robert Surtees' *Handley Cross* and *Mr. Sponge's Sporting Tour,* the work of Charles James Apperley (Nimrod), and Peter Beckford's treatise *Thoughts on Hunting*—was my preferred reading during the time I spent at Cambridge. I had been introduced to the pleasures of foxhunting there, and on my return to Pittsburgh in the late summer of 1931 I brought Guardsman and Grenadier back with me, stabling them out at Rolling Rock. As I mentioned earlier, my cousin Dick had established a hunt at Rolling Rock a few years before. He was himself Master at that time. I got together with several friends, among them Chauncey Hubbard, Adolph Schmidt, and Lenny Mudge, and we hunted there for several seasons. It was very hilly country and hard on the horses, but exhilarating, certainly a great relief from dreary days at the Bank.

Despite the fact that they had been divorced for nearly twenty years, Father bought Mother the farm of Rokeby, near Upperville, Virginia, in 1931. He knew Mother wished to be near David and Ailsa, at that time living in Washington, and Rokeby was only fifty miles away. Mother had not hunted since childhood. She was now fifty but didn't hesitate to take it up again with newly acquired horses. I sometimes went down on weekends to join her for days out with the Piedmont. Hunting with the Piedmont Foxhounds and the Middleburg Hunt is fast, with gently rolling hills intersected with stone walls and post-and-rail fences. Mother was happy that I shared her enthusiasm for hunting, a pleasure perhaps enhanced by the knowledge that Father thought the sport a quite unnecessary risk to life and limb.

To encourage me, she gave me a big Irish hunter called Dublin. Dublin remains my favorite among the many hunters I have owned. He pulled a bit and was strong as a locomotive, but although a so-called three-quarter-bred, he had enough foot and staying power not to disgrace me in several point-to-points. He could have jumped the Eiffel Tower. I think it was Dublin more than anything else who assured my lifelong addiction to hunting. He had huge quarters and a wonderful long front, and his eye had the "look of eagles."

I went back to England with Dublin in the spring of 1932, while Father was serving as Ambassador to the Court of St. James's. I was then twenty-five and realized that I had not really seen a great deal of him since I left Pittsburgh as a schoolboy for Choate, just before he had gone to Washington as Secretary of the Treasury. I was enjoying a two months' break from my apprenticeship at the Bank to be with Father and to hunt in England. I had a chance to talk with him during intermittent spells between gadding about London, visiting friends, and going off into the Cotswolds to hunt. I kept my newly acquired horse with a hunting farmer called Mr. Honour, whose farm was near Eastleach, in Gloucestershire. Mr. Honour was always known as "Squeaky" Honour because of the thin, piping voice that emanated from his rotund body. Ruth, sister of my Yale

friend Jimmy Brady, lived nearby with her husband, Michael Scott. The Scotts were great hunting enthusiasts, so I was able to go down frequently to stay with them, and we would set out together for a day with the VWH Bathurst, the VWH Cricklade, or the Duke of Beaufort's hounds.

During this visit to England I asked Alfred Munnings to paint a portrait of me on Dublin. We traveled down together from London to Mr. Honour's stables to take a look at the horse. I, who was still pretty reserved, said little on the journey, whereas Munnings, apart from being older, was a great extrovert and far from bashful. He was very amusing company. Looking back, I recall that I was probably a little overawed by my bohemian traveling companion and think that I could have taken greater advantage of the meeting if I had been more relaxed.

Munnings went back to Gloucestershire a couple of times to paint the horse, whom, as a knowledgeable foxhunter himself, he admired. He then painted me in his studio in Chelsea. I received a photograph of the finished picture before Munnings had it delivered. Looking at it, I thought the bushy willow tree on the left was a little disturbing and wrote to Munnings asking whether he could do something to make it slightly less prominent. Sometime later I got a blast back saying in the first place, the tree wasn't a willow, it was a pollarded oak, and second, he had no intention of changing anything whatsoever. So that was that.

Back at home, while I was working at the Mellon Bank, and Chunky Hatfield was studying at medical school in Philadelphia, we frequently traveled down to Virginia on weekends. We stayed either at Rokeby or at the North Wales Club, near Warrenton. The club itself was a large and beautiful old house later owned by Walter Chrysler. From there Hatfield and I hunted with the Warrenton, Piedmont, or Middleburg Hunt. The Piedmont is the oldest of these and one of the oldest in the United States, having been founded in 1840. Another hunt, the Orange County, was in one sense the most exclusive in that area, since it had a rule at that time that you could hunt with it only if you were a resident *and* owner of two hundred or more acres of land

there or if you were the guest of a resident. This last rule earned the Orange County Hunt the name of the "Toothbrush Hunt." I later bought a farm in Orange County territory specifically to enable me to hunt there. I eventually gave the farm to the Virginia Polytechnic Institute for use as an experimental cattle pasture farm; it has recently been restructured with my help as a horse pasture and nutrition experimental station.

Hatfield usually rode a wonderful old horse of mine called Stormy Weather, and I had several other hunters of my own. Hatfield still carried the brandy flask. He and I were still good friends. Unhappily alcohol proved in the end to be his downfall. He had been drinking quite a lot while at the University of Pennsylvania Medical School and was always getting into some sort of scrape. The most serious occurred while he was still a medical student. He went to a cocktail party in the country near Philadelphia and was driving home on a secondary road when he was stopped by a state policeman. He was very drunk. The police told him that a man had been knocked over and killed farther back on the road and that they were arresting him as a suspect. Chunky couldn't remember too much about the drive, but he didn't think he had hit anyone. It turned out later that the victim was wandering about the road with a bottle of liquor in his pocket; also, the time when he had supposedly been hit and the time when Hatfield left the party didn't quite tally. I went to Hatfield's trial to lend him support, but although not found guilty of manslaughter, he was convicted of drunken driving and given a term of three to six months in jail.

Chunky had been popular at medical school, and apart from me, a lot of character witnesses from the University, including the Dean of the Medical School, appeared on his behalf to point out that he was a first-class student and to suggest that the whole thing was an aberration. Hatfield spent his sentence working in the prison infirmary. He told me afterward that it really wasn't too bad, that in fact, it had been quite an interesting experience. The University allowed him to continue his training when he was released, but his misfortunes did not stop there.

One day, while still an intern, his hand slipped as he was performing an autopsy, and he nicked one of his middle fingers. Despite his having it dealt with immediately, the wound became infected, and he had to have the finger amputated. This experience seemed to make him quite depressed, but he finally qualified and eventually became a heart surgeon. He performed some interesting experimental work during World War II and was several times on television, although I hasten to add that I would not care to have been operated on by him. Hatfield married when he was about thirty, but later the drinking became worse, and he fell heavily into debt. I lent him small sums of money, but it transpired that he had borrowed larger sums from friends all around Philadelphia. Finally, still in his early thirties, he committed suicide. It was a sad end and deeply upsetting for all his friends.

I had been very attached to Chunky from the time of our first meeting ten years earlier at Cambridge. I not only remember the happy times we had together, but also many wonderful anecdotes that he was always ready to share. There is one in particular that stands out in my mind.

Chunky had a droll sense of humor, and an astringent way of sizing up people and the ways of the world. One day he was to meet a friend of his for lunch at the Yale Club in New York, and because his friend was late he had to cool his heels for a while in the lobby. It happened that the Yale Press had just published a learned work on evolution by a distinguished Yale alumnus, and had taken the opportunity to publicize the book by placing bronze heads of some of our various simian ancestors on tables and pedestals around the lobby's walls.

Chunky examined each one of the bronzes in turn, and was in that process when his luncheon host arrived. After greeting him, he said, "Tell me, my friend, are these the heads of some of your distinguished Yale alumni?"

Back in England, in the winter of 1935, the Scotts rented a beautiful old house in Gloucestershire called Bibury Court. Mary and I were at that time returning through England from our honeymoon in Egypt and Europe, and the Scotts asked us and

Jimmy Brady, my friend and Ruth Scott's brother, down for a few days' hunting. We had such a good time that the following winter, the winter of 1936, Brady and I took Bibury Court for a couple of months, the Scotts having bought a house elsewhere.

We arrived just after Christmas, with our wives. We had each shipped several of our own horses from America, and we supplemented these with two Irish hunters supplied by my steeplechase trainer Jim Ryan. Ryan was an Irish trainer and steeplechase rider who had settled in Unionville, Pennsylvania. Both Brady and I had a memorable winter, hunting about four days a week. We went out with the VWH—Cricklade, the Heythrop, the Duke of Beaufort's, and the Bathurst. Maurice Kingscote was Master of the Cricklade at that time. He was a rascally fellow but a fine horseman, who on one occasion years later hailed me with the words "Hello, Mellon. Have you still got plenty of money? I could do with some of it." It was not unusual for hounds to find a fox quite near Kingscote's house, a circumstance that seemed more than a little suspicious.

Brady's and my plans were upset when, on Monday, January 20, 1936, King George V died. Hunting was temporarily stopped in Britain in accordance with national mourning. We wondered what to do. We talked the matter over and decided that the best idea would be to go over to hunt in Ireland. We left with our wives that night on the train from Paddington Station and boarded the 2:30 A.M. ferry on Tuesday to cross the Irish Sea to Dublin.

After breakfast at the Shelbourne Hotel and the purchase of a sweepstake ticket, we set off by road for Adare, a four-and-a-half-hour journey through wind and driving rain. While we were swaying around on the rough roads in our old rented car, Mary had a bad attack of asthma, and finally we arrived to discover that there was no room for us at the Dunraven Arms. It was arranged that the Bradys would stay at the manor of the Earl of Dunraven, while Mary and I were put up by Dicky Adare, Lord Dunraven's brother, and his American wife, Nancy. Nancy was an old friend of my sister, Ailsa.

The next day Brady and I met up with a friend of the Adares

called Ned Fitzgibbon. Fitzgibbon, full of enthusiasm, offered to mount us there and then and go off hunting. We declined, under the excuse of not being dressed, but agreed instead to go and see his pack of harriers. Jimmy later wrote a note about this visit, saying:

> We were taken down to an old kitchen garden and, I might add, a huge one. On [our] opening the high wooden gates, an amazing sight greeted our eyes. In the left hand corner of the garden nearest to the gates were two pens full of howling Kerry beagles. In the middle foreground was a spring that ran off in a stream across the garden, and covering every other inch of ground space was the most astonishing collection of bones and carcasses I have ever seen. Needless to say, the smell was frightful and any close inspection of the hounds was impossible.
>
> After we had beaten a hasty retreat from the boneyard, I asked Ned—he is sixty-four years of age and as fit as a fiddle—how he fed them. "Sure," he says, "we bring the dead horse or cow, whichever it is, into the yard and leave it there. They're 'divils.' Sometimes in the summer, nobody sees them for a week. They're great hunters, and as tough as can be. We hunt both hare and fox and anything else we can find, and never have a dull day. For if there's no scent, or we can't find, I give my son Michael, who whips for me, the sign. He jumps off, puts aniseed on his horse's feet, and away he goes. Give him ten minutes start, and you'll never catch him. It's great sport."

Jimmy and I hunted with the Limerick Hounds and with the Galway Blazers. The first day we hunted with the Limerick. As we moved off from the meet and approached the first bank (you didn't jump these single banks; you just scrambled over them), there, lying just beside it, was a dead horse. I inquired of the nearest Irishman what had happened. "Broke his neck" was the reply.

The Galway Blazers hunt a country that is mostly thin stone walls, so thin that you see daylight through them like lacework. At our first meet with them, I was standing next to an immaculately dressed young man on a fine-looking horse. The hounds

were just being put into a small field surrounded by one of these loosely built walls, their sterns waving and their noses to the ground. The young man suddenly leaned out of his saddle and quietly pushed over about two feet of the wall. "Just in case!" said he. The banks and ditches were new to us, but the horses understood how to take these obstacles until, as Ned Fitzgibbon put it, you were "seasick with leppin'." The Galway stone walls were like ours at home.

A Dr. Costello was engaged to look after Mary and her asthma, but because his ministrations proved ineffectual, she sadly left for London. Dicky Adare paid the doctor a retainer of fifty pounds a year to care for the people on his estate and to look after his bees and occasionally a horse! He liked to tell the story of one of the doctor's diagnoses and treatments. It ended with the words "The patient's temperature is still in the period of rise and fall. He must continue to take hot drinks." The visit to Ireland had lasted a little over two weeks, after which the Bradys and I rejoined Mary in England.

Toward the end of the season, having more than qualified our horses by the number of days they had been hunted, Jimmy and I competed in five point-to-points: the Bathurst, the Cricklade, the Berkeley, the North Cotswold, and the Chiddingfold. I was second in the Bathurst and VWH-Cricklade members' races, riding my mare Makista, whom Ivor Anthony, my English steeplechase trainer, had found for me. Jimmy Brady was riding a fine big chestnut horse of his own called Speed Limit.

During our stay at Bibury Court I asked Raoul Millais* to paint a conversation piece of all of us. Jimmy and I were painted on two of our hunters, some of our other horses being held by a groom. Our wives were standing with a little terrier on the lawn in front of the house, and in the background was Bibury Court itself. Millais worked on the picture, getting Jimmy and me to pose sitting on the arms of chairs in our hunting clothes.

Sometime after the picture had been painted, when I was back

*Raoul Millais was the son of J. G. Millais, the noted wildlife painter, and the grandson of Sir John Everett Millais, the famous Victorian artist and President of the Royal Academy.

in America, I asked Jimmy's sister, Ruth, what had happened to it. "Oh," she said, "you wrote Millais a letter and wanted him to change something. That made him furious, so he tore it up." As a result, and bearing in mind my experience with Munnings, I mistakenly thought for years that I was responsible for the fact that the painting had been destroyed, for perhaps I had again suggested something in a letter. A recent meeting with Millais cleared the matter up: he was merely fed up with the painting because he thought it had become overworked. I would dearly love to have had the picture, even if it did not satisfy the artist, since it would have been a record of a very happy time spent at Bibury.

As things turned out, my dealings with Millais amounted to a catalog of misunderstandings. I wanted to be painted riding in a point-to-point on my successful mare Makista, but Millais turned up bearing a camera at the wrong point-to-point. Instead of Makista, I was mounted on Knight of the Galtees, a horse I had bought a year earlier in Virginia from Liz Whitney, Jock Whitney's former wife. Millais completed a small picture of me taking a large fence on this horse, but I never received it, and I imagined the reason was that Millais must still be angry with me over the Bibury Court painting. A few years ago Priscilla Hastings, the widow of my old trainer Peter Hastings-Bass, met Raoul Millais and was told that he still had the little painting of me on Knight of the Galtees. The next time I was in England Pris took me down to have lunch with him. He produced the point-to-point picture and, forty years after it had been painted, gave it to me.

I didn't know, when I bought him, that Knight of the Galtees had been retired from racing by Jock himself. The horse went to England with my other hunters, and because he had been such a success in the hunting field, I thought I might as well put him into a point-to-point. There were about fifteen runners in the open race at the North Cotswold point-to-point that year. The horse was going beautifully and jumping well for the first mile of the three-mile race. At this stage there was an uphill run, and from holding the lead at the bottom of the hill, I found

myself dead last by the time we arrived at the top. I was not experienced enough then to realize that I should certainly have pulled him up at that stage. I wanted to finish the race, but by the time I did so, I was twenty-five lengths behind the next horse. Worse than that, Knight of the Galtees was making a terrible roaring noise.

Back home in America I found myself in New York discussing some business matter with Jock Whitney when he said, "I hear you were racing an old horse of mine called Knight of the Galtees." I said I had hunted him for about six weeks and then put him into a point-to-point, but he had "blown up" (that is to say, became greatly distressed and short of breath, the indication of heart trouble). "I don't wonder," he replied. "I retired him because he had a shockingly bad heart." That afternoon I sent a cable to Ivor Anthony, because I had left Knight of the Galtees over in England for the Hastings' young daughters to hunt and to be ready for me the next season. I said in my cable that I had just been told that the horse had a history of heart trouble, and would Ivor please have him vetted. The next day I got a cable back telling me that the horse had been not only vetted but destroyed immediately on the vet's advice. It had been diagnosed that the horse's heart could have gone at any moment. I never mentioned the matter to Liz Whitney. Raoul Millais' painting of Knight of the Galtees carrying me over a large brush fence in the North Cotswold point-to-point now hangs in my sporting library at Oak Spring. It is a pretty good portrait of the horse, but I've often wondered what would have happened if he had fallen dead under me. It had certainly been a prime possibility.

Hunting was carried on in northern Virginia during the war, but on a much reduced scale. The local hunts—the Piedmont, Middleburg, and Orange County—continued to function, but those Americans who were still at home were affected by gas rationing, and many were involved in the war effort. However, when I was released from the Army in August 1945, I was able to return to the farm and begin hunting again that winter. I still had some of the horses I had kept at Fort Riley. A few years later, in April 1954, I was appointed Joint Master of the Pied-

mont with my neighbor, Mrs. A. C. "Theo" Randolph, and I kept the post for the next five years, sparing as much time for it as I could.

One day during my mastership Bunny was following the hunt in a car. She stopped at the side of the road because the hunt had had a check, and I suppose we were milling around, with hounds trying to find again. As she sat there, a car drew up alongside, and its driver rolled down his window and asked, "What's going on over there?"

Bunny replied, "It's a foxhunt. The hounds are looking for a fox."

"Oh," the man said, apparently satisfied. Then he added, "I thought that only happened on lampshades."

In 1960 I made up my mind to go back and try to repeat, nearly thirty years later, the experience of the season I had so much enjoyed before the war when Brady and I stayed at Bibury Court. I decided to take my own horses over to England, stabling them as I had done before in the Duke of Beaufort's country. It was, of course, a good deal simpler to fly horses across the Atlantic in the sixties than it had been to ship them by sea twenty-five years earlier. Travel by boat had meant sending them several weeks in advance so that they could become acclimatized and get fit enough to hunt after several weeks at sea. Now that they could be flown over, I sent four hunters by air.

Peter Hastings-Bass found stabling for them near the Hare and Hounds Hotel at Westonbirt, where I planned to stay. Two went to Badminton, to be looked after by Jack Windell, who farmed for the Duke of Beaufort. The other two were stabled near Tetbury with some horses belonging to a very nice couple named Philip and Eleanor Morris-Keating. Peter got Bob Turnell, a trainer and foxhunting man who was training a couple of my steeplechasers at the time, to hunt the horses a few times in the two weeks before I arrived. One of the hunters, Goldsmith, was a very bold mover. When Bob Turnell tried to rate the horse going into a stone wall, he hit it and cut his knee badly, putting him out of commission for the season. That left me with three horses, but they all went extremely well. They

were used to stone walls in Virginia, so that was no problem, but there was much more plow and more rain than there had been on my earlier visit, and the horses were not accustomed to such heavy going.

On the first day I went out on Enough Rope, a lovely big homebred thoroughbred with lots of speed. We were off like the wind. Everything was happening very rapidly when I suddenly realized that the standing martingale, the long strap that loops up from the girth to the noseband of the bridle, had broken. This meant dismounting in a hurry, loosening the girth, removing the martingale, leaping back into the saddle, and dashing off after the field. Not having hunted for a month or so, I got home absolutely exhausted. When I walked into the yard, Jack Windell eyed me, saying, "I see you've been having a ripping good time!" I happened to be wearing a rather tight black melton coat, one that I had hunted in while at Cambridge, and I discovered, on taking it off, that it was split right down the seam under one shoulder.

During my whole stay I had only one fall. I was again on Enough Rope in a freshly plowed field when the horse stumbled, sending me over his ears. Unfortunately I didn't manage to keep hold of the reins. The horse ran on, leaving me standing in the middle of the deep-plowed field feeling very embarrassed, while some kind soul went on to catch him. By the time I got my horses back to the United States they were just skin and bone. They were all thoroughbreds, not used to slogging in the mud.

This was the last of my hunting exploits in England apart from a few days in 1970 spent with the Middleton in Yorkshire, as guest of the Master, my old friend Lord Halifax, and his wife, Ruth. On this visit I had the misfortune more than once to fall into cold, deep, water-filled ditches, earning for myself the nickname the "Water Mellon" among the local farmers.

Apart from my hunting career, spanning some fifty years, I became interested after the war in trail riding. In the late fifties a group of enthusiasts started what was to become an annual

three-day event called the Virginia Hundred Mile Trail Ride, held at Hot Springs each April. The riders cover forty miles on the first day, forty on the second, and twenty on the third and last, over mountainous trails and through forest country. At night the competitors relax in the comfort of the Homestead or the Cascades Hotel, the latter being some five miles from Hot Springs itself. I first heard about this endurance ride from a young Middleburg woman called Peter Whitfield, who had taken part in the first one. She was full of enthusiasm and suggested that I sign up for the second, in the spring of the following year, 1959.

About thirty-five riders took part, approximately half of them being neighbors from the Piedmont, Middleburg, and Orange County hunts and the rest from Richmond and farther south or from outside the state. I had a sturdy gray hunter at that time called Silversmith, so I went along to discover that I knew quite a large number of fellow competitors from the hunting field. Not only did I enjoy the experience enormously, but I won the heavyweight class and the championship. I have always been fairly competitive, and I took part in the Hundred Mile Trail Ride at least seventeen times during the years between 1959 and 1979. In all, I won the championship five times, the last three in a row with my hunter Christmas Goose in 1977, 1978, and 1979.

The weeks before the ride see the competitors limbering up and getting themselves and their horses fit for the long, exacting ride over steep, narrow mountain trails. The weather in early April is always uncertain. I have ridden through driving snowstorms and pouring rain or, worse, on sweltering hot days with temperatures over eighty degrees. In some places in these beautiful mountains the trails are smooth and level, so that trotting and even cantering are possible, but one of the pitfalls is getting the horse lame on a sharp rock on the narrower and rougher trails or from a pulled muscle in a boggy place. I have been fortunate in that parts of my farm provide the ideal training ground, with rolling hills and mixed pasture and woodland, and until recently most of our state roads were unpaved. On the

ride, arrows nailed to trees mark the trail: red for the first day, white for the second, and blue for the third. If you miss one and take the wrong route, you have to find your way back and catch up—a very discouraging effort and not a great favor to your horse.

The ride is not a race, although there is a deadline for finishing. There are three judges, one of whom is a veterinary surgeon. They hide in the woods, observing the competitors without being seen, or they have regular checkpoints to examine the horses' legs and backs and to listen to their hearts with stethoscopes. The entire marking system is based on the physical condition of the *horse* (no attention is paid to the abject and drooping condition of the rider!). Each horse starts with a score of 100, and points are taken off for various shortcomings of condition, such as excessive sweating, sore back, lameness, etc.

One year, when I had been ahead on points, the daughter-in-law of a prominent member of the foxhunting fraternity was awarded the championship, after the veterinary surgeon, who was her husband's partner, pronounced my horse to be lame. In fact, the horse had a very slight stringhalt, which had been pointed out on the first day's inspection and which was, according to the rules, not supposed to count against it. The stringhalt would disappear after a few minutes' riding, but the horse had been left standing before being brought into the judging ring, and the stringhalt showed up very slightly. The veterinary judge marked that against me, and his partner's wife slithered into first place. So I consider that I have actually won the championship six times.

My head groom, the Reverend William Parker, onetime pastor of the New Hope Baptist Church, McGaheysville, Virginia, was a man of strong religious convictions and not a little innocent cunning. When he accompanied our guests out hacking on the farm, Parker would follow on his horse a few paces behind, asking over their shoulders whether they had been saying their prayers lately. I forbade these verbal sallies when he rode with me, but Parker still managed to get his evangelistic message

across by sending me an audiotape of one of his sermons deliv-
ered at his little church many miles west over the mountain. It
was very difficult not to heed Parker's passionate voice de-
manding repentance, amid constant interruptions, with cries of
"amen" from his congregation.

My friend Billy Wilbur, former Master of the Warrenton Hunt,
often rode one of my horses on the ride. My own scores were
almost consistently 99 or 98, while Billy would turn in a score of
98 or 97, earning him and the horse the reserve championship
rather than the championship. I believe he thinks to this day that
I slipped hundred-dollar bills to the judges throughout the ride!

Some of the competitors looked after their own horses, feed-
ing and grooming them during the event, but we were allowed
to bring our own grooms. We were usually followed by Bill
Parker, in a car, carrying refreshments and pre-mixed martinis
in plastic bottles, as well as water and rub rags for the horses.

One year we were ignominiously disqualified on account of
Parker's excessive zeal. Before setting out, I had shown Parker
the rule book, underlining the pertinent passages setting out
what the penalties were and what you could and what you
couldn't do. Of course, Parker paid no attention, believing that
it was his job to do all that he could to make sure that his em-
ployer won. As a result, when the judges went into the stable one
night to check the horses' backs, they found Parker in there bus-
ily applying liniment and cold compresses to the back of my
hunter Warlock, strictly against the rules. Someone came in dur-
ing dinner at the Cascades and told me that I should get down to
the stable quickly because the judges were there and my groom
was out of order. Knowing Bill Parker as I did, I didn't bother to
go and just accepted the disqualification with resignation, but
Parker got a good piece of my mind when we arrived home.

I still have a poem written by my collaborator John Baskett to
commemorate my taking part with Billy Wilbur in the Fifty Mile
Ride (an abbreviated form of the main competition, which Billy
and I entered when we got a little too old for the longer ride).
It is written in the style of Chaucer's verse and reads:

Whanne that Aprille with his shoures sote,
The droghte of Marche hath percèd to the rote,
And fields resound with nagges hooves a-ringen,
For folk make merry down at Hotte Springen.

The Mellon clept himself a symple country sport,
Yet ful hys house with cups of everie sort,
Quoth he, "I'll sitte back and let my raynes go loose,
For fifty mylen will not cook my Christmas Goose."

The Wilbur cantered up, a jolly stalwart oone,
Well could he carp about a hunting afternoon,
So mild was he, as any pusse catte,
Yet verrily he changed when in the saddle satte.

Thus set they forth, a liveley merrie crowde,
Under heavens blue, forsooth, with ne'er a cloude,
And who can say with certainty which oone will win?
I trow I wish they both were first a-cumen in.

One of the rare occasions when I was unable to take part in
the Hundred Mile Ride occurred after I had been kicked by a
horse at the Bath racecourse in England in 1975. I was walking
out of the parade ring, having looked at my horse and discussed
the forthcoming race with my trainer, Ian Balding, when an-
other racehorse, catching sight of my shadow, ran three paces
backward and delivered a vicious kick that caught me just under
my right rib cage. Winded, groaning horribly, and doubled up
in great pain, I was carried to the casualty room. Ian and an old
friend and racecourse official, Brigadier Roscoe Harvey, first de-
posited me on a nearby bench. Roscoe's immediate question
when I managed to gain a little control was "What will you have,
whiskey or brandy?" I opted for brandy, and it was a lifesaver!
Because of suspected damage to the liver, I was allowed no
painkillers, not even an aspirin. Following a long and painful
delay they got me to a hospital in Bath, where I came under the
care of a fine surgeon, Mr. John. After the first night he decided
fortunately that an operation wasn't necessary. With expert care
I gradually recovered, but there was to be no Hundred Mile
Ride for me the next year and no hunting the following season.
I later discovered that I immediately owed my life to the fact

that I was wearing a heavy Cordings raincoat and that I was further protected by my well-filled wallet and a silver Parker pen. The raincoat bore a clear hoofmark and the silver pen was bent in the middle at an angle of forty-five degrees. The raincoat hangs in a cupboard at Oak Spring, and the pen, set in plastic, resides on a desk in my office, both kept as relics that prevented my premature propulsion into the next world.

In December 1984 the Metropolitan Museum put on an exhibition inspired by Diana Vreeland called "Man and the Horse." Many of us in the horse world were asked to lend racing and hunting attire; we were asked for equine equipment, such as saddles, bridles, and horse blankets, for polo mallets and helmets, as well as sporting pictures of racing and the chase. The response was generous, and several exhibition rooms were filled with everything but the sounds and smells of the stable.

There was a grand opening dinner, to which those of us who had contributed clothes and artifacts were invited. Quite a few contributors were encouraged by Diana to wear the conventional foxhunting evening dress of scarlet tailcoats embellished with satin lapels representing the various hunt colors. Five of us complied, all in scarlet, Charlie Whitehouse and Jimmy Young wearing Orange County with white lapels, Billy Wilbur with Warrenton Hunt blue lapels, myself with Piedmont Foxhounds gold lapels (all from Virginia), and Frank Richardson with Essex Foxhounds apricot lapels.

We arrived at the Metropolitan at the appointed hour and were soon surrounded by press photographers, who were baffled but enthusiastic. Then, as we were released from the photographers and began to drift into the huge dinner in the court, other guests among the invited began to ask us not only who we were or what we represented but for *directions!* We soon realized that we were being mistaken for museum ushers. That quickly brought us down-to-earth, wishing we had opted for the more conventional evening black.

Racing in America and England

———◆———

When you lay me to slumber no spot can you choose,
But will ring to the rhythm of galloping shoes,
And under the daisies no grave be so deep
But the hooves of the horses shall sound in my sleep.
—WILLIAM HENRY OGILVIE
"Galloping Shoes"

I bought my first racehorse in 1933, two years after I came home from Cambridge. He was an Irish thoroughbred called Drinmore Lad, whom my trainer, Jim Ryan, had brought over to America as a three-year-old. Now I was an owner. While Drinmore Lad was still a three-year-old, he ran in a timber race at Far Hills, New Jersey, and won it, an encouraging start to his and my racing career.

Drinmore Lad went on to win a number of big timber races in the United States over the next three years, including the Middleburg Cup, the R. Penn Smith, Jr. Challenge Plate, the Carolina Cup, and the Deep Run Hunt Cup. Meantime, I had bought another horse at the Warrenton Horse Show, Chatter-play. I bought him as a hunter, but he turned out to be such a good timber jumper that soon I put him into training with Jack Skinner, a local trainer and jump rider, who ran a small establishment in Middleburg.

Inevitably a rivalry sprang up between my two trainers, and when I was away in England with Mary on my honeymoon in 1935, Ryan decided he would have a chance to win the Maryland

Hunt Cup with Drinmore Lad, and Skinner decided that *he* would like to win it with Chatterplay. Either of these propositions might easily have been realized. The Maryland Hunt Cup is a tough race with huge timber jumps, but it's a lot safer than the Grand National at Liverpool. In the first place, there are never more than about a dozen horses running, and although the fences are high and mostly unbreakable, you can see through them, without the added hazard of differences in ground level between takeoff and landing. Despite these factors, I cabled instructions that I didn't want either horse to be raced. If I had won, I would have been desolate not to have been there. I had a deep respect for the hazards of the race and didn't want either horse hurt. Both trainers were so keen to have their trial of strength, however, that each entered his horse and went so far as to badger my father, asking him to prevail upon me to change my mind.

On April 23, 1935, the Pittsburgh *Sun-Telegraph,* after talking with Ryan, confirmed that the two horses would run, saying, "Chatterplay won the Grand National Steeplechase two weeks ago at Middleburg, Va., setting a new course record. Drinmore Lad is the winner of the Camden Steeplechase Cup." Father's attitude toward horse racing could be encapsulated in his familiar laconic observation: "Any damn fool knows that one horse can run faster than another." However, he obligingly sent me a cable, saying that my two trainers were very anxious to see the horses in the race, and what did I want to do? Irritated now by both trainers, I cabled Ryan and Skinner that I still didn't want either of them to run. I also cabled Father from the Gleneagles Hotel in Scotland. I have the cable to this day, and it reads:

> Many thanks cable. Afraid publicity—equal horses running or not. Dislike risking injury to horses. Such a difficult and dangerous course especially in our absence unable to enjoy race. Bringing Drinmore Lad to England for training next year and want him here before we leave. Sorry to trouble you but consider this best judgement. Have cabled Ryan. Much love—Paul.

I have often wondered since whether this was a wise decision. I did, however, win the Cup two years later, in 1937, with a seven-year-old Irish-bred gelding called Welbourne Jake, a horse trained by Jack Skinner.

A few weeks before this contretemps I had met Ambrose Clark, a prominent American sportsman and hunt meeting owner, in London. Mr. and Mrs. Clark had won the Grand National in England in 1933 with Kellsboro Jack, a jumper trained by Ivor Anthony. The Clarks knew Drinmore Lad. I met Uncle Ambrose, as we all called him, for luncheon one day, and while we were talking, he suggested that I bring Drinmore Lad to England and put him in the hands of Ivor Anthony, with the purpose of eventually running him in the Grand National. (When war was declared in 1939, Uncle Ambrose brought their horses in England home to America. When someone jokingly asked him how he knew there was a war on, he replied, "I read it in the *Blood Horse.*")

Clark then took me down to the Hon. Mrs. Aubrey Hastings' training establishment at Wroughton and introduced me to her and to Ivor Anthony. I was given a tour of the stables and met Mrs. Hastings' son, Peter, then still a schoolboy. Mrs. Hastings' daughters, Diana, Joan, and Aubreen, were there and, of course, Ivor Anthony himself. Ivor had taken over the stables on the death of Mrs. Hastings' husband five years earlier. He was an ex-steeplechase jockey, who had ridden at least one winner in the Grand National.

I sent Drinmore Lad over to Ivor early in 1936, the year that Mary and I rented Bibury Court with the Bradys. A year later he was joint favorite for the Grand National with Golden Miller, the great horse who had won the race the previous year. Unfortunately, however, Drinmore Lad "blew up" in one of his preparatory races and had to be scratched.

The following year Drinny, as we called him, was expected once more to run in the National, but Mary and I learned, as we were on our way over to England on the *Europa* to see the race, that exactly the same thing had happened again. I had experienced my first big disappointment in racing. We retired Drinny

and brought him back to the United States, where I hunted him for one season. He was a wonderful hunter and a great jumper, but the veterinary surgeon told me that the horse really shouldn't carry on on account of his heart, so we put him out to grass.

The year in which Drinmore Lad had to be scratched from the Grand National for the second time, 1937, was also the year in which Welbourne Jake won the Maryland Hunt Cup, so I was justified in considering Welbourne Jake as a possible candidate for the Grand National the following year or later. The horse returned to Skinner's stables after the Hunt Cup, and I had him painted by our friend Frank Voss with Jack Skinner up. Skinner had rented a field on the other side of the road from his yard, and there he turned the horse out to graze. Welbourne Jake trotted quietly down toward the end of the field but suddenly stopped. He had broken the cannon bone of his off foreleg, so his career ended abruptly, and he had to be destroyed on the spot. That was my second big disappointment, and it underlined the hazards always to be expected in the racing world.

Before the war I had owned quite a few steeplechasers. Many of them were horses I had bought, but I had also bred some at Rokeby, and they all were trained by either Jim Ryan or Jack Skinner. Together we had some very successful hunt meeting horses. Hunt meetings ranked in those days somewhere between amateur point-to-points and more lucrative brush races at the big tracks, such as Belmont and Saratoga. They start in the South at courses like Camden, South Carolina. As the warmer weather spreads north, they are held at Richmond, Montpelier, and Middleburg, in Virginia, and then work north through Maryland and Pennsylvania to New York State, to carry on through the summer. The circuit is reversed in the autumn, the meetings heading south.

Ivor Anthony had sold me Makista, the mare on whom I had been second in the Bathurst and Cricklade point-to-points in England. She had been great fun, and I brought her back to the United States, but the firmer going didn't suit her feet. Just before the war I bred her to a stallion in Virginia called Gino.

While I was out at Fort Riley, she had a gray colt foal. In this manner I was launched in a small way into the breeding world and into the problems of naming the progeny. Makista's foal acquired his name by a particularly circuitous route. Jimmy Brady's sister Genevieve was married to Andy Fowler, another amateur steeplechase jockey who was in our group at Fort Riley, together with Reeve Schley and Bobby Davis. Andy and Gen Fowler rented a house on the other side of the street from Mary and me in Junction City. Gen Fowler liked drinking gin and Coke, so Makista's foal came to be called Genancoke. I had also bought a mare called Sunchance, and she foaled another colt by Gino, whom I named, more simply, American Way. American Way and Genancoke won over a hundred thousand dollars each in stakes, a large amount for steeplechasers in those days.

I have always enjoyed naming my horses. A few years ago I had a very good filly named Rokeby Venus, a play on our stable name and on the famous Velásquez painting in the National Gallery in London. In one of her early races in New York I was amused and delighted to see in the *Racing Form* that she was to be ridden by Jorge Velásquez. Not only that, but she won! Then the day on which my British art collection opened for its exhibition at the Royal Academy in London in 1964, I had a filly named Fine Arts running at Newmarket. She won, too! Later in England I had Morris Dancer, a big gelding who won a lot of races there, and in France, and Belgium. His name derived from a curious little event that occurred shortly after Bunny and I were married. We were returning to America from England and were being driven from my trainer's establishment at Wroughton to Southampton Docks. On the way we reached a dangerous crossroads at Ovington, and another car, approaching at a right angle, apparently failed to see us until it was too late. The driver jammed on his brakes and skidded into our car, knocking Bunny sideways, so that she broke two ribs. I was thrown hard against her. It was a very unpleasant accident, and we were dazed. As I looked out, I realized that there was a group of morris dancers on the edge of the village green adjacent to the crossroads. They were hopping around, all dressed in white, with flowers in their hair. Slowly

they came dancing over to the car to satisfy their curiosity, never missing a beat, until they had completely encircled it, still dancing. Our chauffeur and the driver of the other car were having a noisy altercation as to whose fault it was, while Bunny and I sat painfully gazing out of the windows at the dancers skipping about, silent, except for the musical accompaniment of the bells on their trousers and sleeves that tinkled merrily.

One other glorious chance for choosing an appropriate name came when I bought in England, through Ivor Anthony, a fine little chestnut gelding by Double Bed out of a mare named Fiancée. I called him Fatal Interview, and he went on to win a number of top timber races in the States.

When I came back from the war, I decided to carry on with breeding, but because I wanted to put it on a more serious level, I discussed my plans at length with Jimmy Brady. Jimmy's father had been very successful in the racing world, and Jimmy himself was knowledgeable on the subject, as well as being a close friend and foxhunting companion. He advised me to make up my mind to breed horses for the flat. He emphasized that it was very difficult to make ends meet with steeplechasers. There was not much money in them, and it took five or six years to school them. He further pointed out that all the best thoroughbreds ran in the big stakes like the Derby and the Belmont. It was natural that as someone who enjoyed hunting and point-to-pointing, I should find myself at home with steeplechasers, but the message was getting through to the best jump trainers, too, who began to realize that flat racing at the big tracks was more lucrative and would provide them with a better living. For my own part, I had every intention of trying to run my racing-breeding operations at a profit.

In England, when Peter Hastings-Bass returned from the war, he took over the stables at Wroughton and became the trainer. I had known Peter since he was a schoolboy. I had confidence in him and felt he would do well. Ivor Anthony was approaching retirement, so he became the assistant trainer and looked after one or two jumpers for me, while Peter began to concentrate on my flat horses and those of some other owners. Some

years later, in 1953, while he was only thirty-two, Peter bought Park House, at Kingsclere, from the ex-steeplechase jockey and trainer Evan Williams, and moved the horses there from Wroughton. Peter trained Midsummer Night II, one of our homebreds, to win the Cambridgeshire Handicap at Newmarket in October 1960. The horse ran in mist and driving rain against a large field at odds of forty to one. This was the first of my significant flat race victories in England. Unhappily my association with Peter was cut short by his untimely death from cancer, in 1964 at the age of forty-three.

I knew very well that it was not a good idea to have two trainers in the United States. For one thing, Ryan and Skinner didn't get on. I had been told that on occasion they had even been known to resort to fisticuffs at the races, and their rivalry was bound to be counterproductive. Quite apart from this, I felt that their talents lay with training steeplechasers rather than flat horses. Each tended to overwork his horses, breezing them too early as two-year-olds and giving them more work than they needed. Jim Ryan and I parted amicably after I had explained that I would prefer to continue with Jack Skinner, whose yard was only a few miles from Rokeby. It was easier for me to see my horses so much nearer home. Jack subsequently began to have heart trouble and was advised by his doctor to give up active training. He offered to help me find a new trainer, but I already had Elliott Burch in mind. Out of gratitude for his services in the past, and because I was very fond of him anyway (we were both ardent foxhunters), I said I would retain Jack as an adviser. But my racing interests had by now grown to such an extent that I thought I had better seize this opportunity to find a young but experienced flat trainer.

Elliott Burch was the son and grandson of famous trainers. His father, Preston M. Burch, had been trainer for Isabel Sloane (Mrs. Dodge Sloane), the owner of the famous Brookmeade Stable. Her breeding farm was near Upperville. Elliot had assisted his father and then taken over as trainer when Mr. Burch retired. He was very successful from the beginning as Brookmeade's trainer, but the stable was dispersed on Mrs. Sloane's death.

This happened at just about the time Jack Skinner had to retire. I decided not to consult Jack, who I knew would have grumbled about Burch's being too young, and instead I talked to Jimmy Brady to be sure that I was making the right move. I finally called Burch, only to discover that he planned to start a public stable, taking horses from a number of owners. I had at least twenty horses in training at that time, and I asked Elliott whether he would like to come and train for me instead. He was persuaded, and from 1963 until 1976 he trained for Rokeby Stables exclusively.

There were a few problems because I still consulted Jack Skinner; bearing in mind his heart condition, I didn't want to drop him suddenly. We went to the Saratoga sales together, and Jack pointed out a very well-bred filly to me. I was buying only fillies at that time because it seemed foolish to buy expensive colts when if things didn't work out racing, they would have little value. A well-bred filly, on the other hand, whatever she did on the racetrack, could be a good prospect as a broodmare. I paid the top price of the sale and bought this filly for eighty-three thousand dollars, very little these days, but a record at the time. After the sale a friend of mine came up to me and said, "Why do you let Skinner advise you about yearlings? He doesn't know anything about bloodlines. Anyway, Burch is your trainer now, and it's unfair to him." I replied that it was none of his business. In any case, the filly didn't turn out to be much good, nor did she produce anything worthwhile. A short time later Jack had a heart attack and died. I was glad that I had encouraged him up until the end.

Elliott's early successes were with horses such as Quadrangle, Arts and Letters, and Fort Marcy. In 1964 he trained Quadrangle to win the Belmont Stakes. This was the first American classic victory for Rokeby Stables. Elliott was responsible for the purchase of mares like All Beautiful, in foal to Ribot, who produced the immensely successful Arts and Letters. Arts and Letters won, among others, the Belmont, the Travers, the Woodward, and the Jockey Club Gold Cup and was a close second to Majestic Prince in the Kentucky Derby and the Preakness. He was

Horse of the Year in 1969. Fort Marcy was out of Key Bridge, a homebred mare, who was out of Blue Banner, a purchase recommended by Jack Skinner and trained successfully by him, winning several big stakes. Blue Banner was an excellent race mare and at stud produced several winners, but Key Bridge wasn't one of them. Key Bridge never raced, but she produced four stakes winners, Fort Marcy being the star. Fort Marcy won the Washington, D.C. International in 1967 and again in 1970. He was also Horse of the Year in 1970. Another of Key Bridge's foals was Key to the Mint, champion three-year-old colt in 1972. In 1971, the year in which Mill Reef created so much excitement in England, Run the Gantlet won the Washington, D.C. International and was voted champion grass horse. He was out of First Feather, a successful broodmare who had also been bought on Elliott Burch's advice.

By the time Elliott was training for me, a structure of command had established itself in the form of a very broad-based pyramid. It is an arrangement that has stood the test of time and still operates under my present trainer, Mackenzie Miller. I suppose I stand at the apex as a sort of chairman of the board with a veto that I almost never need to use. My trainer is Rokeby's chief executive officer. He does all the work, makes 98 percent of the mating decisions, and decides all the racing strategy but with constant reference to me. Together with Ian Balding, my English trainer, every summer at Rokeby we discuss which yearlings will go to England to race and which will remain in the United States, although I reserve for myself these final decisions.

A successful owner-breeder must find the right farm manager and the right stud manager, and they in turn are dependent on able help both at the farm and at the racetrack. They are responsible for the stable hands and the exercise boys or girls who break and ride the yearlings, and what more important period in the life of a racehorse can there be?

Even when you have the best personnel, you have to face the uncertainties of genetics, the vagaries of weather and track

conditions, the selection of the right jockey, the right races, the right schedule, and above all, there remains that unpredictable factor, luck. Beyond the knowledge of bloodlines and conformation, the insistence on good feed, good pasture, good management, and good barns, you still remain subject to the fickle wind of chance, and therein lies a great part of the attraction.

It would be ridiculous to close one's eyes to the fact that behind every stable, large or small, money rears its ugly head. As in any commercial enterprise, undercapitalization or wasteful methods can be fatal, and always having an eye on profit is essential. It may be thought undignified to point it out, but I know of no more solid proof of successful breeding and racing than large black figures on the bottom line.

The above thoughts are echoes from the speech I made on receiving the annual award of The Thoroughbred Club of America for distinguished service to the sport of racing, at Keeneland, Kentucky, in November 1975.

The speech was too long, but even so I was unable to restrain myself at the time from quoting some verses I had written for the occasion. I am repeating them here because it still seems to express my feelings about racing better than anything else I have said on the subject.

Thoroughbreds

The Day my final race is run
And, win or lose, the sinking sun
Tells me it's time to quit the track
And gracefully hang up my tack,
I'll thank the Lord the life I've led
Was always near a Thoroughbred.

I've had my share of falls and knocks
Pursuing the elusive fox.
I've heard the stirring cry of hounds
From Melton to the Sussex Downs.
Each spring I ride a hundred miles
(My tail bright red, my face all smiles).

And I have seen the thrilling pace
Of many a cutthroat steeplechase
And watched with breath and mind suspended
Until a classic race has ended,
For those high days can end in pain,
Or in a bottle of Champagne.

So, if the downward course is steep
Where smoke and flames and devils leap,
I'll hope I'm on a Hellish steed
Running his heart out, with no need
For voice or spurs or flailing whip
To guarantee he gets the trip.

But if, about the sixteenth pole
God should have mercy on my soul,
I hope He'll raise me to the clouds
Above the grandstand and the crowds
And there I'll take my ease, and wait
Behind the pearly starting-gate.

And long before I break God's bread
Or buy a halo for my head
Or sink into a starry bed
Or say the prayers I should have said
Before the donuts, rolls, or coffees
I'll find the secretary's office.

In my first interview, of course,
I'll ask St. Peter for a horse.
He'll lead me down the heavenly sheds
Past miles and miles of Thoroughbreds
And say, "Since you've escaped Old Nick...
They're on the house; just take your pick."

So when old Gabriel's golden horn
Echoes from cloud to cloud each morn
And "It is post time" rings out clear...
I will be ready with my gear;
My horse and I will not be late
(Though I'll be slightly overweight).

Then, free from every mortal sin
(Including Butazolidin!)
We'll gallop through celestial fields
Where neither mist nor mud conceals
The graceful movements of the horse,
The wide and green and endless course.

Though some may think, and I'll agree
That only God can make a tree,
Before God thought of trees, it's said,
His mind was on the Thoroughbred.

In 1976 Elliott had a serious illness, which meant that he would be incapacitated for at least a year, and I thought that under the circumstances we had to fill the gap. Elliott subsequently recovered sufficiently to resume his training activities, and for a few years before his retirement he trained for C. V. "Sonny" Whitney.

Charles Engelhard, owner of the famous Nijinsky, had died recently, and I knew that Mackenzie Miller, who had trained for him for thirteen years, was about to open a public stable and train for various owners. Mack Miller was born in Versailles, Kentucky. He had been with horses all his life and knew the business through and through, having gone from stableboy to trainer, then on to be the sole trainer of Engelhard's large racing stable. On Charlie's death, his widow, Jane, didn't want to continue racing, but she kept Mack on while he started to build up his public stable. In fact, he never really got it going because I acted promptly, and before he had time to sign up more than one or two owners, I asked him to come train for Rokeby. Mack agreed, and he has been training for me ever since.

Mack Miller trained Winter's Tale to win the Suburban Handicap, the Brooklyn Handicap, and the Marlboro Cup. Other successful homebreds include Key to Content, Hero's Honor, Wild Applause, Danger's Hour, Dance of Life, Glowing Honor, Crusader Sword, and Java Gold. In 1987 Java Gold won both the Whitney and the Travers at Saratoga and the Marlboro Cup at Belmont. Crusader Sword won the Hopeful in the same year. In 1984 Mack trained Fit to Fight to be winner of the Handicap Triple Crown (the Metropolitan Mile, the Suburban Handicap, and the Brooklyn Handicap). Fit to Fight was only the fourth horse to accomplish this feat since 1913. Mack is a very highly regarded and much admired figure in American racing, and in 1987 he was, like his predecessor Elliott Burch, installed in Racing's Hall of Fame at Saratoga.

Racing's Hall of Fame is an integral part of the National Museum of Racing that opened in Saratoga Springs in 1950, first housed

in the old Canfield Casino and later moved to a new Georgian-style building just across Union Avenue from the Saratoga race-track. The recently revitalized museum complex, a project I sponsored, includes within the Hall of Fame a hi-tech, wide screen showing the film *Race America*, narrated by none other than my trainer Mack Miller, who is photogenic, articulate, and knowledgeable in all aspects of the subject. The film, seen by visitors and laureates who are inducted each August, provides interesting vignettes of almost every facet of the thoroughbred racing and breeding industry. It was only one inspiration of the British designers who gave a new look to the Museum. I never tire of watching it and only fear that Hollywood might want Mack for a screen test!

Combining both my love for the horse and interest in sporting art, I have long been a trustee of the Museum in Saratoga. It was over the years a static and somewhat sleepy gallery containing paintings of the great champions as well as mementos of the turf, including shoes of Kentucky Derby winners and trophies garnered by owners of other winning thoroughbreds throughout American racing history. In the middle of the 1980s the Museum was on course to languish into oblivion as its traditional patrons died off and the general public sought more didactic entertainment and enlightenment. I proposed, and my fellow trustees accepted, the formidable task of first closing and then completely renovating and reorganizing the exhibition and other presentation spaces. Even as the board was deliberating, I already had in mind a team of designers who had mounted an exhibition at the Royal Academy in London in celebration of the two-hundredth anniversary of the Epsom Derby and who also had arranged the permanent installation of an English counterpart of our Museum in a wing of the Jockey Club at Newmarket. The designers Patricia and Kenneth Pearson and their counterparts Bridget and Ivor Heal accordingly were selected for our project following their presentations to the Museum trustees. More space became devoted to new and dramatic eye-catchers, such as a starting gate complete with bells. This leads

to an hour's walk-through experience which has been made more enlivening for the public and patrons of the turf, especially with regard to the exhibitions.

I was happy to participate in what turned into a two-year effort and was considerably relieved when the transformation of the galleries turned out so well. Some patrons of the old school would have preferred that their silks remain permanently displayed (not a good conservation practice anyhow); nevertheless, the board, led by Whitney Tower, a respected journalist and widely known figure in the racing world, never wavered.

Being seasonal and upstate, the attendance figures at the Museum do not approach those of metropolitan attractions or the Baseball Hall of Fame in Cooperstown. Nonetheless, the turnstiles are clicking at the Museum as well as at the track across the street, which augurs well for the future.

For many years wealthy Americans from the North (damn Yankees!) had been buying land in Virginia and forming large estates, but the process accelerated during the Depression years of the 1930s. In those years Virginia farmers were extracting only meager livelihoods from farming. Cattle raising and dairy farming had been considered the best methods of land use for the beautiful countryside of northern Virginia, with its rolling hills and winding creeks, but in keeping with the generally depressed state of the economy, land prices were much reduced. For many, raising beef cattle provided only a marginal existence. My mother had used Rokeby for this purpose and to grow corn for cattle feed, although she was there primarily because she wanted to ride and hunt.

Rokeby, when my father bought it, consisted of only four hundred acres. I decided, after I had bought it from Mother that I would try to add some neighboring farms as they came onto the market and use some of the increased acreage for my racing and breeding operation. The purchases started before World War II and continued after it, until I had expanded the original holding tenfold to somewhere between four thousand and forty-five hundred acres. After Mother's departure for Stamford, Con-

necticut, in 1935, I bought Oak Spring and Loughborough from the Fletcher family but continued to engage Robert Fletcher as farm manager. Then, also on the Oak Spring side, I bought Milan Mill and Spring Hill, situated on either side of Goose Creek. Later, on the Rokeby side of the estate, I acquired Edgewood and the old Robert Sterling Clark property called Sundridge.

I went on, as Mother had done, to raise cattle. The paddocks and fields near the house are, however, reserved for horses in order that we may have the pleasure of seeing them from the house or when we go for a walk. I don't think there is anyone who enjoys racing more than I do, or the sight of mares and foals grazing in green fields, or yearlings running wild and throwing themselves about, even though it puts your heart in your mouth. The sights and sounds of the countryside, as well as the color and action and excitement of the racecourse, are what turn me on: the mare suckling her foal, the renegade foal bothering all the others, the yearling who is boss of the field. I built a broodmare barn at Oak Spring, and other large barns were built for mares, foals, and yearlings. The stabling at Sundridge was brought back into use.

I was not alone in pursuing this policy, which prompted Ogden Nash's sour comment: "The Virginians from Virginia have to ride automobiles now, because the Virginians from Long Island are the only ones who can afford to ride horses." What Nash failed to point out, however, is that the preservation of land in large estates has effectively, so far, prevented the countryside from being ruined through development in spite of its proximity to Washington.

I try to take as active a part in overseeing the cattle business of the farm and our thoroughbred breeding operations as I can manage, although as in the past it has obviously been impossible on a day-to-day basis. Major purchases of cattle, forage, and farming equipment are routinely approved by me, and Bill Green, our farm manager, keeps me up-to-date with periodic reports, both verbal and written. Because thoroughbred breeding and racing have always been among my greatest lifetime

interests, I naturally spend a lot of time in the country looking at the current crop of yearlings or visiting the mares with their foals after their return from the breeding season in Kentucky. I often join Mack Miller and Bernie Garrettson early in the mornings during September and October to watch the newly broken yearlings being schooled. We have a large ring of sand in a field near our house where our young exercise men and women put them through their paces of walking, trotting, and cantering, and weaving tight figure eights through the grassy middle of the circle. At other times during the year I make a tour of the stables with Bernie, or with Ernie Bugg whose responsibilities lie mainly with the yearlings.

One of the serendipitous aspects of the combination of horse breeding and cattle raising is the fact that they are mutually advantageous in certain seasons, especially in early spring and late fall. For many years our chief adviser regarding the fertility of our pastures has been Dr. Roy Blaser, top agronomist at Virginia Tech in Blacksburg, Virginia. He has always been a keen advocate of using our large herds of cattle (Angus, Herefords, Shorthorns, and sometimes Charolais) to eat down the fast growing bluegrass and orchard grass early in the summer in order to give the clover and other legumes a chance to proliferate—the ideal population of native white clover being about 35 percent.

Large numbers of cattle therefore have to be shifted frequently from horse field to horse field, making it difficult for Bill Green and Bernie Garrettson to coordinate their schedules. It is a situation that I watch carefully, but I'm glad to say that the cooperation between these efficient managers is excellent, and I have never had to use my influence to quell an argument.

Twice a year, in late spring and in early autumn, we convene a group of department heads and outside experts in what we call Pasture Meetings. These would include Dr. Roy Blaser, the preeminent agronomist I mentioned earlier; our chief veterinarian Dr. John Mayo; Dr. David Kronfeld, head of the Virginia Tech Horse Forage Station in Middleburg (a nutrition expert from New Zealand); Mack Miller, my trainer; Henry White, who

oversees the breeding schedules and the welfare of our mares in Kentucky; Bernie Garrettson, our Rokeby stud manager; Bill Green, the farm manager; John Mayhugh and his son from M & M Consulting, Inc., an agricultural and environmental consulting firm; Tom Beddall, my former consultant responsible for advising me in respect to my charitable and educational giving, including funds for veterinary schools and horse-oriented foundations; Carroll Cavanagh, my principal business, legal, and charity assistant based in Washington; and last but certainly not least, Ron Evans, who is responsible for the supervision of every department of the farm, including arborists, carpenters, electricians, fence builders, mechanics, and painters.

I usually preside at these meetings, while Martha Tross records the discussions and writes the minutes, which, in view of the variable and sometimes highly technical nature of the questions raised as well as the ensuing debates, is a most exacting and frustrating task. There is no formal agenda, but for two hours discussions will cover veterinary problems such as equine epidemics and equine nutrition, the newest recommendations regarding vaccines, broodmare breeding and foaling problems, the uses and abuses of feeding supplements, the scheduling of cattle movements into the horse pastures, soil test results, blood test results from all the horses, and the interesting and sometimes baffling indications of vitamin deficiency in feed. Racetrack discussion is not neglected, and Mack Miller usually sums up the many facets of racing successes or failures, the occasions of great performances or devastating injuries, the triumphs and the disappointments that make up the bottom line of Rokeby Stables' racing eminence.

I find these meetings a great help in coordinating the various activities of farm and stable and a most interesting confluence of veterinary, agricultural, nutritional, and genetic information.

I began buying mares in 1946 for my breeding operation with the advice of my two American trainers, Jim Ryan and Jack Skinner. Ryan had access to sound advice from knowledgeable

people in England and Ireland, and it was he who recommended that I buy the mare Red Ray, featured in a Newmarket dispersal sale in the summer of 1949. She was then an unraced two-year-old filly, whose sire was Hyperion and whose grandam was a beautifully bred mare, Black Ray. Ryan went to England for the sale with instructions from me to bid up to ten thousand guineas for her. Lord Oaksey, formerly John Lawrence, amateur rider, racing correspondent of the *Sunday Telegraph,* and a well-known television commentator, furnished an amusing description in his book on Mill Reef of how Ryan was egged on into exceeding his instructions by a shrewd English racing journalist, Clive Graham, otherwise known as "The Scout." Even Graham, however, can have had little idea of the extraordinary breeding potential that lay within this purchase.

I secured Red Ray for twelve thousand guineas, and on returning to America, Jim Ryan offered to keep her if I didn't want her. I took her, however, sending her to stud immediately, and over the next four years, before she died of colic, she produced three foals. She had a colt, later named Claret, who went on as a gelding to have a lackluster career; a second colt who, as a yearling, was discovered in his field with a broken leg and had to be destroyed; and, finally, a filly by the successful American sire Count Fleet, whom I named Virginia Water.

Virginia Water was a beautiful gray mare, but she had rather puffy ankles. I realized that she might not remain sound if she were raced, so I bred her to Princequillo and, as Virginia Water's fifth foal, got Milan Mill (her first, Goose Creek, raced with considerable success in England).

Milan Mill ran a few times, but I retired her as a broodmare when she sustained an injury. Her first foal, Milan Meadow, foaled in 1966 by Never Bend, raced in the United States but didn't do much. I bred her again to Never Bend and on February 23, 1968, she foaled a colt who was destined to become one of the great classic racehorses of all time, Mill Reef.

Mill Reef's career is a legend. When he was a yearling, it was

clear that he was no ordinary horse, and on Preston Burch's advice that he might do better in England, he was sent there to Kingsclere.

When Peter Hastings-Bass was stricken with his fatal illness in 1964, he and his wife, Priscilla, knew they must eventually have an assistant since there were about sixty racehorses in the yard. They approached Ian Balding. Up until that time Ian had been helping his brother Toby at Fyfield and Herbert Blagrave at Beckhampton, as well as pursuing his passion for amateur steeplechase riding. He came to Kingsclere, and when Peter Hastings-Bass died later in that same year, Ian was prevailed upon by Priscilla Hastings and the owners, including Her Majesty the Queen and myself, to carry on as trainer. He was just twenty-five.

Ian has been training for me ever since, so if you add the eighteen years I spent with Ivor Anthony, eleven with Peter Hastings-Bass, and twenty-six with Ian, I have, at the time of writing, been with the same "firm" in England for well over fifty years. The "firm" was further reinforced when Ian married Emma, the delightful and knowledgeable daughter of Peter and Priscilla Hastings-Bass.

There is also my godson William, Peter and Priscilla's son, who is now training in England as well, although not for me. I am very fond of Willy and proud of his accomplishments as a trainer, but I have never wanted to put him into further competition with his brother-in-law, Ian Balding. He did, however, train *one leg* of a filly for me which Nick Brady, Jimmy Moseley, a third friend, and I claimed one day at Newmarket after a very good lunch. I don't know which leg of the filly I owned, but we have a trophy to prove that she did win at least one race for our syndicate.

Recently, William underwent a considerable change in name when he succeeded a cousin to become the Earl of Huntingdon. It reminded me that in 1971 he had served a few months apprenticeship at our Rokeby Stables in Virginia, and I am bemused to think that we once had an English Earl mucking out

our stalls. His meteoric rise into the aristocracy reminds me also
of Hilaire Belloc's Lord Lucky, who

> From living in a vile Hotel
> A long way east of Camberwell
> He rose in less than half an hour
> To riches, dignity and power.

Mill Reef had his first race at Salisbury in May 1970. It was a
five-furlong two-year-old race, and he passed the post an easy
four lengths in front. Geoff Lewis, wearing my English colors—
gold cross on black with gold cap—and racing under my own
name, as I do in England, rather than that of Rokeby, as I do
in America, said to Ian after the race, "This is the best horse
you've ever had—or ever will have," and history proved this to
be no overstatement. After winning the Coventry Stakes at As-
cot in June, he was second by a nose in the Prix Robert Papin
at Maisons-Lafitte following a miserable flight to Paris. He was
then entered for the Gimcrack Stakes at York. The Gimcrack
was designated after the brave little eighteenth-century race-
horse of that name.

My old friend Lord Halifax was president of "Ye Anciente
Fraternite of York Gimcracks," and it was the bicentenary of the
club's existence, so I had two good reasons for attending the
race. The Gimcrack is run in mid-August, not infrequently one
of England's rainier seasons, and this year was unfortunately
no exception. The rain had been pouring down for twenty-four
hours, and the course was not far from being waterlogged.
Shortly before the race I asked Ian whether he would withdraw
Mill Reef if I were not there. He replied that he would certainly
do so, and our jockey, Geoff Lewis, agreed with him.

I considered Ian's reply for a while before exercising my pre-
rogative to have the final word. I knew that what Ian and Geoff
Lewis were recommending was the sensible and conservative
thing to do, but I just had a *feeling*. Finally, having absolved
them from any blame if things went wrong, I told them that I
thought we should run. I'm glad to say the feeling proved right,

for over the six-furlong course Mill Reef quickly established a ten-length lead over his nearest competitor.

Later that year, as winning owner, I was invited to make the main address at the bicentenary dinner. After reflecting on the pleasures of racing in the United States, England, and Ireland, I went on to attempt to link my interest in horses with my devotion to art and literature. I said,

> In my own case, I came to hunting and 'chasing and flat-racing partly through sporting art and literature. In my early youth, I pored over innumerable old bound volumes of *Punch*, arrested always by the hunting and racing drawings and jokes. As an undergraduate at Cambridge, in addition to skimping on lectures and study for the pleasures of hunting and racing, I began acquiring sporting prints by artists such as Lionel Edwards and Munnings, as well as by the Alkens and Pollard—and books—Orme's *British Field Sports*, the lives of John Mytton and Squire Osbaldeston, Beckford's *Thoughts on Hunting*, and many others. While there, too, Newmarket beckoned to me, and I saw my first *live* English race—the Cambridgeshire of 1929. Later I was to admire York, Goodwood, Sandown, Cheltenham—yes—but I still hark back to those long, soft, eminently green gallops stretching to the horizon in the slanting afternoon sun, and the late October sunlight on the warm yellow stone of the old, high stands at Newmarket—the bright colours of the silks flashing by, the sheen of the horses' coats....
>
> To me, the enjoyment of British sporting art and literature has always been inseparable from the enjoyment of racing, 'chasing, and hunting. How often we see characters and caricatures from Alken, Rowlandson, or Surtees in the hunting field. When we go racing, there in the paddock, and on the course, are Seymours, Stubbses, Ben Marshalls.

The urge to versify again overcame me, and I closed my speech with a poem I had composed for the occasion. It was formulated as an acrostic, the initial letter of each line, when strung together as a column, reading "GIMCRACK SPIRIT." It went:

Grey was I, well-proportioned, but so small
In stature that I scarce could shade a child.
Many a master had I, from the mild
Callow young lad who rubbed me in my stall
Right on through Count Lauraguais, who asked all
And more of me, for which he was reviled.
Courage restrained me from becoming wild:
Kindness and English grass soothed my deep gall.

Swift as a bird I flew down many a course,
Princes, Lords, Commoners all sang my praise.
In victory or defeat I played my part.
Remember me, all men who love the Horse,
If hearts and spirits flag in after days;
Though small, I gave my all. I gave my heart.

The second verse features on the reverse side of the plinth of John Skeaping's bronze statue of Mill Reef at the National Stud at Newmarket. For me, it epitomizes Mill Reef's spirit as well as that of his famous forebear.

Mill Reef completed his two-year-old season by winning the Imperial Stakes at Kempton Park and the Dewhurst Stakes at Newmarket. When he reappeared on the racecourse as a three-year-old, he hadn't grown much, and he failed to win his first major race, the Two Thousand Guineas, run on May 1 at Newmarket. It was the one and only occasion when he ran against Brigadier Gerard, the horse who was to prove himself such a great miler. It was also the last time Mill Reef failed to win. His astonishing career then flowered during the summer of 1971 to see him winning the Epsom Derby, the Eclipse Stakes at Sandown, and the King George VI and Queen Elizabeth Stakes at Ascot. In the autumn he went on to win the Prix de l'Arc de Triomphe at Longchamp. He is still the only racehorse ever to have won the Epsom Derby and the Prix de l'Arc de Triomphe in the same season.

Mill Reef's first race the following season, the Prix Ganay, was again at Longchamp. The opposition was stiff, but the going was ideal, and having even made allowance for these factors, Mill Reef, now a four-year-old, left the rest of the field standing

and won by an official estimate of ten lengths. Many thought it was a good deal more, and an examination of the photograph of the field at the finish would convince anyone that it was more like fifteen lengths.

Mill Reef's last race was the Coronation Cup, run over the Derby course at Epsom in June 1972. He won by just a neck over Homeric. It was a brave performance because he was almost certainly suffering from the effects of a viral infection. All eyes, however, were looking toward the Eclipse Stakes, in which both Mill Reef and Brigadier Gerard were due to meet the following month. As the racing world well remembers, the trial between the two great horses in this mile and a quarter race never took place. On account of concern about the virus, which had spread throughout his stable, and because of Mill Reef's poor condition, Ian had to scratch him from the Eclipse and postpone what was to have been "the race of the century." As the infection left the stable, Ian hoped to run him in the Benson and Hedges Gold Cup at York in mid-August with a view to attracting Brigadier Gerard and as a run up to a second go at the Prix de l'Arc de Triomphe. Trouble with a pulled muscle prevented Mill Reef from racing at York, but he was well on course for the Arc when disaster struck.

While just cantering on the downs near Kingsclere, he broke the cannon bone of his near foreleg. Normally this would necessarily have meant his being destroyed, but Mill Reef's potential at stud was such that a complex and delicate operation was undertaken to save the leg. It was only through the skill of Edwin "Jim" Roberts, the veterinary surgeon, and the dedicated care of Ian Balding, John Hallum, Mill Reef's lad, and all the team at Kingsclere that the horse recovered.

I decided that since all his triumphs had been in Europe, I would not bring Mill Reef back to the United States but would send him to the National Stud at Newmarket, where he would be syndicated. Not only was he syndicated for a record sum, but during his fourteen active breeding years at stud he sired a remarkable number of successful offspring, including three Derby winners. Shirley Heights won both the English and the

Irish Derbies in 1978, and Acamas won the French Derby that same year. Reference Point won the 1987 Epsom Derby, as well as the King George VI and Queen Elizabeth Stakes, and was voted European champion as a two-year-old and as a three-year-old. Glint of Gold won the Derby Italiano and was second to Shergar in the Epsom Derby. Acamas's produce further won the Italian and Irish Derbies. Shirley Heights in his turn produced Slip Anchor, who won the English Derby in 1985.

The year 1971 saw me achieve every owner's dream. I had bred a classic horse, a great horse, whose name would always rank among the highest in the annals of racing. The name Mill Reef is taken from a winter club and a beautiful stretch of sea near our house in Antigua, in the West Indies, but for anyone who loves horses, it has only one meaning. Mill Reef's year was full of fragmented memories for me: of Ian Balding, caught in a traffic jam before the Derby, having to abandon his wife and mother-in-law in a car and run the last two miles to the race-course clad in top hat and morning coat; of Her Majesty the Queen Mother, appearing unexpectedly in the winner's enclosure at Ascot after the King George VI and Queen Elizabeth Stakes and saying to Bunny and me, "I simply had to come whizzing down to congratulate you on that wonderful little horse."

There was the memorable party after Mill Reef's victory in the Prix de l'Arc de Triomphe when we took Annabel's Club in London for the evening and entertained all our friends to dinner and to dancing late into the night. All those among our farm staff in America who had been connected with Mill Reef as a foal and as a yearling came over to Paris to see the Arc and then spent some days in England. Especially after the Epsom Derby I was exhausted but still euphoric, and I felt somehow disembodied, as if I were watching myself in the movies.

The most satisfying aspect for me was that we had bred all three generations of Mill Reef's immediate ancestors: Mill Reef from Milan Mill, Milan Mill from Virginia Water, and Virginia Water from Red Ray. One of the greatest racehorses of all time was a true product of Rokeby Farms.

I was fortunate to have commissioned John Skeaping, the eminent English animal sculptor, to make a half-life-size bronze of Mill Reef a few months before the horse broke his leg. It is a beautiful statue, and it has a place of honor in the middle of the courtyard of our main broodmare barn at Rokeby. I also donated a replica of this bronze to the National Stud at Newmarket, a third is displayed at the Virginia Museum of Fine Arts in Richmond as part of my collection of English sporting art, and a fourth stands in one of the yards of Ian Balding's Park House Stables at Kingsclere.

A curious sequel to the tragedy of Mill Reef's disastrous injury is told in John Skeaping's autobiography *Drawn from Life*. "A charming character and full of grace Mill Reef walked like a ballet dancer..." is how John describes the horse. After discussing the technical details of his work on the statue, he continues,

> One morning . . . when the work was well advanced, I went into the studio to start work. Removing the wet cloths which kept the clay moist, I found that all the clay had slipped off one of the forelegs and the armature was exposed at that point. Two days later I heard from Ian Balding that on the morning I made this discovery Mill Reef had broken that same leg in training. Make what you like of this, it was eerie indeed.

Many may scoff, but I for one am prepared to believe that such manifestations are more than coincidence.

CHAPTER 14

Collecting
and Collections

———◆———

La vie: C'est la femme que l'on a;
L'art, C'est la femme que l'on desire.
—Jean Dolent

Individuality is not competitive. The value
of an artist can be gauged only by the people
who find his/her works a contribution and
stimulus to their particular imaginative world.
—John Skeaping

Father's paintings were always around me in my childhood. I am sure I absorbed a fondness for them and an appreciation of them by a sort of mental osmosis. I remember especially Romney's "Miss Willoughby" in our Pittsburgh dining room, and every time I came home to Father's apartment in Washington during my college days, when I opened the front door and saw the full-length portrait of the "Marchesa Balbi" by Van Dyck on the opposite wall, a wonderful feeling of *rightness* came over me. She was beauty, youth, dignity, and grace personified.

Shortly after we were married in 1948, Bunny and I started visiting art dealers in New York and Paris. Bunny had always been interested in French history and in French nineteenth-century painting, partly inspired by her lifetime love of gardens and landscape gardening. It is impossible to describe the influence of visual objects in relation to my habits of collecting without saying how much Bunny's imagination and visual acuity have influenced me. It is not widely enough known that she is

270

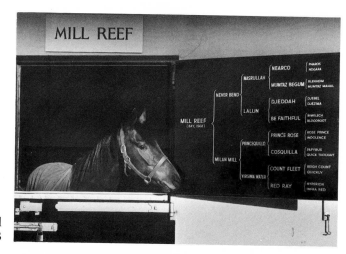

Mill Reef at the National
Stud, Newmarket, 1973

Taking part in the
Hundred Mile Trail Ride
on Christmas Goose,
with Billy Wilbur on
Mongogo

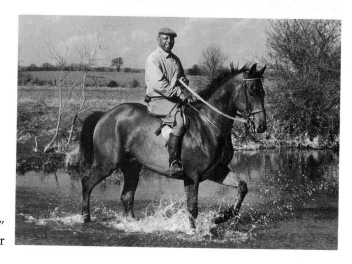

The Reverend William "Bill"
Parker

Jack Barrett

George Wyckoff

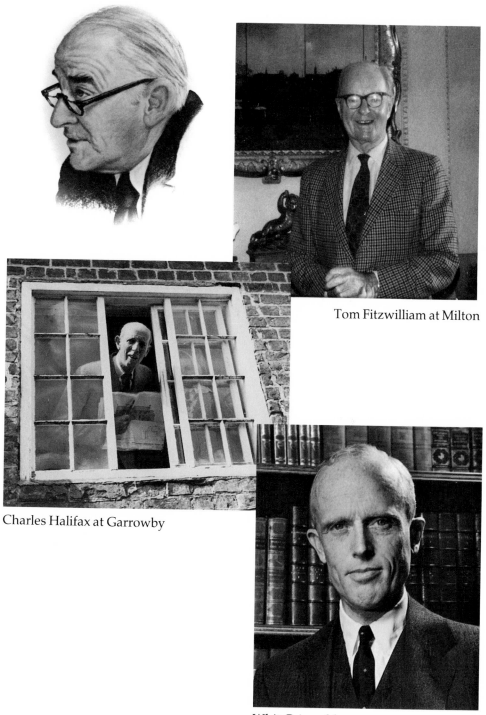

Jimmy Brady

Tom Fitzwilliam at Milton

Charles Halifax at Garrowby

Whit Griswold

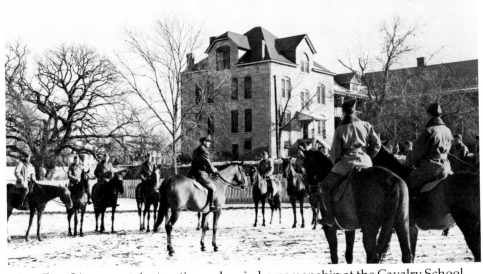

As a First Lieutenant, instructing a class in horsemanship at the Cavalry School,
Fort Riley, 1942

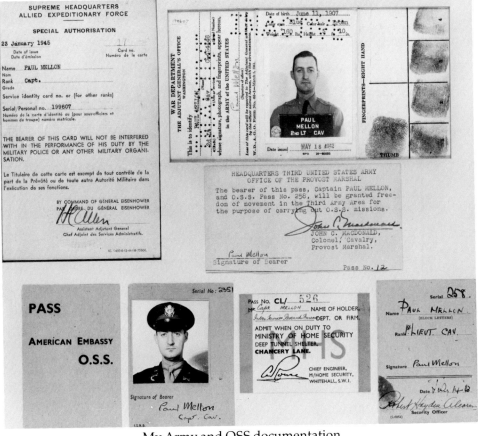

My Army and OSS documentation

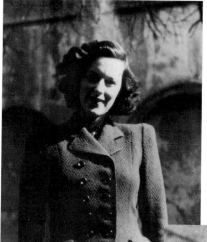

Valerie Churchill-Longman

As a Captain en route in an LCT for Omaha Beach, July 1944

As a First Lieutenant, Cavalry School, Fort Riley

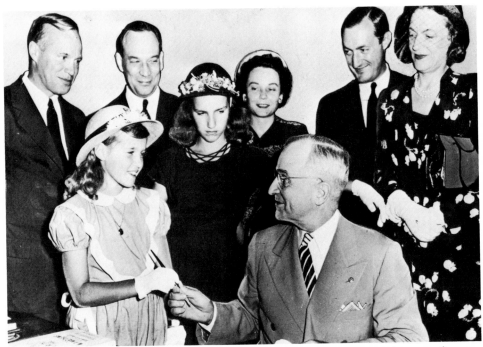

In the foreground, my daughter, Cathy, is receiving a presentation pen from President Truman. In the background (*from left*) are George Wyckoff, Adolf Schmidt, Ailsa's daughter Audrey, Mrs. Helen Mellon Schmidt, me, and Ailsa.

(*From left*) Tim, Stacy, Bunny, Cathy, and Eliza at Rokeby, 1949

My son, Tim, and Louise, his wife

Bunny on a holiday in Nassau

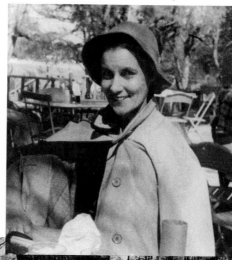

With Bunny and Eliza, her
daughter, at Oak Spring, 1963

My daughter, Cathy

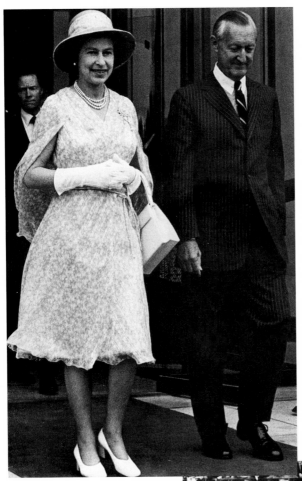

With H.M. Queen
Elizabeth II, leaving after
a visit to the National
Gallery of Art, 1976

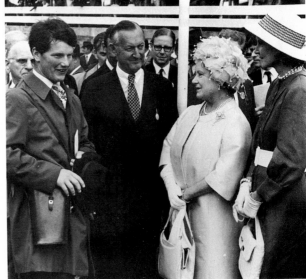

(*From left*) Ian Balding,
myself, H.M. The Queen
Mother, and Bunny after
the King George VI and
Queen Elizabeth Stakes,
July 24, 1971

Bunny and myself with Carter Brown, at the Andrew W. Mellon dinner on the occasion of my retirement as Chairman, 1985

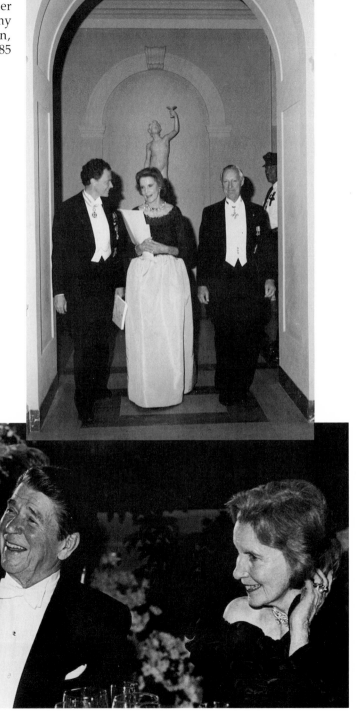

Bunny with former President Reagan at an Andrew W. Mellon dinner

Basil Taylor

John Baskett

Stoddard Stevens

Duncan Robinson

John Walker

With Carter Brown (*left*) and I. M. Pei in the East Building, the National Gallery of Art

Seated opposite Ted Pillsbury, with Christopher White on my right and Malcolm Cormack on my left, in conference at the Yale Center for British Art

The East Building,
the National Gallery of Art

The Yale Center for British Art

The Science Center
and the Paul Mellon
Arts Center, Choate
Rosemary Hall

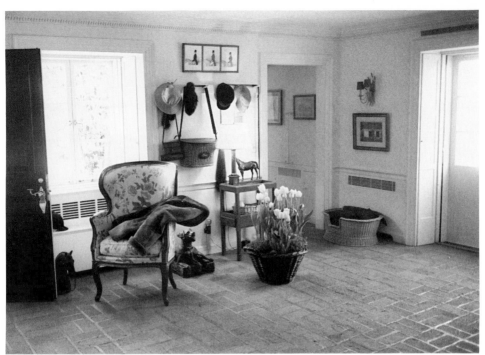

The hall at Oak Spring

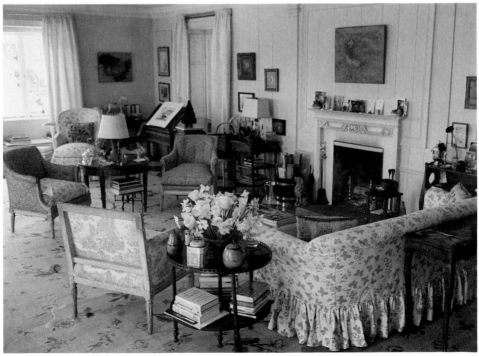

The living room at Oak Spring

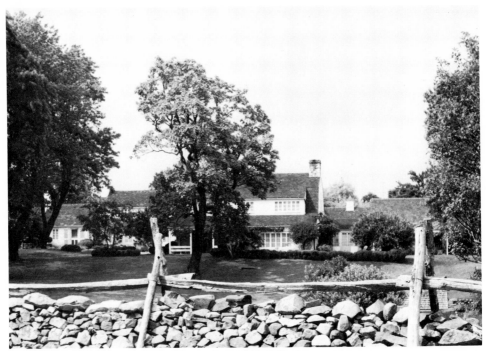

Front view of Oak Spring

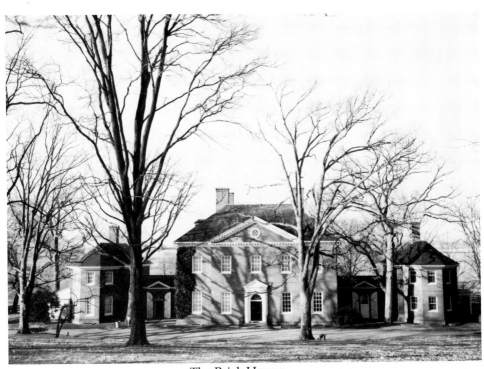

The Brick House

Bunny in her Oak Spring Garden Library, with Patrick

In the Gulfstream II, 1978

an amateur landscapist and gardener (although of professional capability), and her theories of landscape and of proportion in architecture (she reads blueprints far better than I) have certainly enlarged my own "interior" landscapes, as well as having educated me considerably while we pursued our joint venture of collecting French paintings. To see at first hand any of her personally designed and self-worked-in gardens is itself an immersion in what art can mean.

We were encouraged at this time by Chester Dale, who thought it would be a nice idea to take us under his wing and advise us about the pleasures and snares of collecting French pictures. Chester wasn't the easiest man to have around over the seven years from 1955 to 1962 that he spent as the President of the National Gallery of Art. I describe his volatile and forceful character in the next chapter, but the most lasting impression, as far as pictures were concerned, was of his extraordinary judgment and taste. I didn't particularly want to be under anybody's wing, but I was very aware, as a trustee, of the superb quality of the Chester Dale collection, and I wanted to encourage Chester to leave it to the Gallery. I also liked the Impressionists, so I was quite happy to go along with this spasmodic collaboration.

Chester, however, had a prejudice against small paintings, and he was always implying that their size made them unacceptable and "not of museum quality." Sometime after my sister Ailsa had bought the entire Molyneux collection, which consisted mainly of small canvases by the Impressionists, Chester implied that he thought it would be wrong for the National Gallery to accept them, or at least wrong to exhibit them along with the other Impressionists that had already been given or were expected to be given to the Gallery. As it has turned out, these paintings subsequently given by Ailsa have been welcomed by the public and have been exhibited over and over again in small galleries that enhance their intimacy and their human appeal.

This opinion of Chester's is one that I'm afraid has equal weight among many important collectors. My own feeling is that size has nothing to do with the quality or the importance of a

work of art, just as preliminary drawings or sketches in oil or pastel often have an immediacy and an emotional appeal far greater than the final canvas. Among many other examples I could cite are Constable's small oil sketches, which appeal to me equally with his larger paintings, and his techniques and mastery of the brush are as formidable in them as in his masterpieces. In the spring of 1991 I saw the comprehensive Constable exhibition at the Tate Gallery in London, and I am now even more convinced that small is beautiful.

There was still a plentiful availability of pictures coming onto the market during the fifties and early sixties, and we were fortunate enough to acquire a large number of fine Impressionist paintings. A unique opportunity occurred in October 1958, when seven pictures from the estate of Jakob Goldschmidt came up for auction at Sotheby's in London. I was able to buy three of them, including a famous Cézanne, "The Boy in a Red Waistcoat." In fact, my agent exceeded his instructions by quite a large amount, but I have no more reason to regret buying this superb masterpiece than I had when my trainer did exactly the same thing in purchasing the mare Red Ray, Mill Reef's great-grandam.

In 1966 the National Gallery marked its twenty-fifth anniversary with an exhibition of our Impressionist and Post-Impressionist pictures. The introduction and entries of the catalog, "French Paintings from the Collections of Mr. and Mrs. Paul Mellon and Mrs. Mellon Bruce," were written by John Rewald, whom I have often consulted over the years when in doubt about certain aspects of our purchases. At that time Bunny and I had been collecting for about fifteen years, and 184 of our paintings were shown in the exhibition; 62 canvases belonging to Ailsa were also exhibited.

There were pictures like the above-mentioned Cézanne, Degas' "Steeplechase—the Fallen Jockey," Manet's "George Moore in the Artist's Garden," Monet's "The Bridge at Argenteuil," Gauguin's "Te Pape Nave Nave—Delectable Waters, Tahiti," Van Gogh's "Green Wheat Fields, Auvers," to name but a few. What chance would one have of gathering together such treasures today? There were also strong representations in the

exhibition of lesser but nevertheless delightful artists like Bonnard, Vuillard, and Boudin.

In the 1950s and early 1960s the auction houses had not reached their present ascendancy. Quieter people were collecting at that time, and the auction houses were frequented more by dealers than by individual buyers. The market hadn't yet experienced the twin spurs of investment buying and of holding works of art as a hedge against inflation. Neither Bunny nor I have ever felt a driving urge to own any picture just because it is important and certainly not because we considered it a good investment. We both like to wander down the byways of art, too, looking for something that catches our eye or for minor works that nonetheless recall happy memories or otherwise appeal to our hearts.

Most of my French paintings were bought privately through dealers, principally Jay Rousuck at Wildenstein's, Carmen Messmore at Knoedler's, Sam Salz, and Alexandre Rosenberg. One day, when I was walking along 57th Street in New York, my eye was caught by a small landscape by Berthe Morisot, all whites and greens, with laundry fluttering on a line by a small cottage and a view of Paris in the distance. This was in the 1950s, and during that period I was often in New York and in and out of galleries in that part of town. Something about this small canvas intrigued me. It provided a breath of country air, a sense of tranquillity, some essence of the French countryside. I had passed this picture in the window of the Paul Rosenberg gallery perhaps half a dozen times, until one day I couldn't stand it any longer and I went inside and asked to see it. It was every bit as attractive as I had thought, and I realized that I had fallen in love with it at first sight. It now belongs to the National Gallery, but I think of it often and of the days I walked past it or stopped to enjoy it amid the noise of traffic and the importunities of a busy day.

Usually Bunny and I have gone to look at pictures together, especially in New York. If, on the other hand, Bunny happened to be on her own in Paris and saw something she thought we should add to the collection, she had only to call me, and I invariably told her to go ahead. I have never been casual when

making decisions about buying pictures, but I suppose my complaisance was just a mark of absolute confidence in her taste.

The sequence usually started with a dealer contacting us to say that he had something he thought we should see. If we liked it, I asked to have it reserved for a few days while I had a chance to think about it. I preferred collecting in this way. A period for consideration has always been very important to me whenever a decision has to be made. Like Father, I would often turn something down rather than be forced to make a snap decision. When a painting was reserved, I had all the factors before me, including the price, and the dealers could rest assured that they would get a call within a few days with a firm decision and, if it was favorable, prompt payment to follow. It was normally quite straightforward, although on occasion the arrangements got a little mixed up.

Once I went to see a dealer on 57th Street who showed me a rather beautiful Renoir. After leaving the gallery, I had a couple of calls to make before going to an appointment at another gallery. At the second gallery a director ushered me into a room, saying he had a very fine Impressionist painting to show me. There, on the easel, was the same picture that I had seen down the street only an hour earlier. I realized that both dealers had a financial stake in the painting, perhaps having bought it in half share, and that neither had told the other who his client was. I said nothing and examined the painting carefully once more. Such hiccups were uncommon, but I was amused, nevertheless, to think how secretive the New York dealers were with one another.

On another occasion, in 1955, Bunny and I paid a visit to Knoedler's in New York just for something to do. On a large table in one of the rooms there were approximately seventy wax sculptures, large and small, by Edgar Degas that the dealer had on consignment from the daughter of Degas' foundryman, A. A. Hébrard. While their condition seemed slightly vulnerable, the overall effect of the collection was overpowering, and one could feel the grace, the tension, and the movement of the dancers and the horses. These all had been molded by Degas' own hands and

kept in his studio, either as models for his paintings or, as it has been surmised, as practice in wax for his hands. His eyesight had been failing, and this medium could have provided an outlet for his creativity. The collection haunted me for days. We had been told that they were for sale, preferably *en bloc* or, failing that, one by one. It seemed an opportunity too fantastic to be missed, so I agreed to purchase the entire collection. The majority of these pieces are now displayed in the Brick House on my farm, in a room lovingly designed by Bunny. There are soft green velvet panels on the walls supporting brackets on which the statues rest. Some of the larger items have already been given to the National Gallery in Washington, while most of the remaining sculptures are promised to go there on my death. This group was exhibited in the spring of 1991 as part of an exhibition of "Promised Gifts" in celebration of the Gallery's fiftieth anniversary. In addition, four of the waxes have been given to the Louvre and three to the Fitzwilliam Museum in Cambridge.

We have already given the greater part of our French collection to the National Gallery, where it complements Chester Dale's and my sister Ailsa's bequests. Further works of art, of both the American and English schools, have gone to the National Gallery, while others are now in the Virginia Museum of Fine Arts and the Yale University Art Gallery. There are, however, some wonderful French paintings still hanging in our houses. They have been there for years, by a window or beside a table lamp, and they give the walls a life of their own, lending them character as if the artists' shades still dwelt there.

I recently disposed of a small group of these pictures, including a beautiful version of Manet's "Rue Mosnier," which used to hang in the house in Washington. I thought that I should raise some funds in connection with estate planning and also thought it best to deal with the matter during my lifetime rather than leaving the job to my executors. In making my choice, I naturally took Bunny's feelings into account, and I was also careful to pick out items that I thought were already well represented in the National Gallery.

My interest in British art is part of my fascination with British life and history. From childhood and from Cambridge days I acquired a fondness for the English landscape and for the ever-changing English light. I became interested in English history, in particular the period from the start of Robert Walpole's ministry to the accession of Queen Victoria, roughly from 1720 to 1840. I grew to love English country life and country sports. I became a lifelong devotee of foxhunting and racing. All these interests converged to make me ready to collect paintings, drawings, books, and prints, wherever the subject matter is related to English life in the eighteenth and early nineteenth centuries.

Apart from buying a beautiful Stubbs of the racehorse Pumpkin and some colorplate sporting books before the war, I didn't start collecting British art until I was well into middle age. There had always been something else to do. Marriage, St. John's College, the war, foxhunting and racing, the National Gallery, and foundation matters seem to have occupied my time. Bunny wasn't interested in British art, and looking back, I really needed someone to help get me going. The catalyst that caused me to launch out so suddenly, at the age of fifty-two, came in the form of the art historian Basil Taylor. It was one of those curious meetings in life between two individuals that are destined to have important consequences well beyond those of the relationship itself.

I met Basil when an exhibition of sporting paintings, to be called "Sport and the Horse," was in the process of being put together by Leslie Cheek, then Director of the Virginia Museum. It was a theme that was bound to go down well with the sporting fraternity of Virginia, and Leslie sought my interest and support, not only as a lender but as someone who could write to my English friends to invite them as well as persuade them to lend their sporting paintings.

It was the spring of 1959, and the show was scheduled for the following year. The trouble was that I was away at Hot Springs for my first Hundred Mile Trail Ride, and the letters needed to be sent off without delay. Leslie was not someone to let the grass grow under his feet. He drove over to Hot Springs

and asked me, decked out in boots and breeches for the first morning of the ride, whether as a trustee of the Virginia Museum I would be prepared to be Chairman of the British and American exhibition committees. He was very persuasive, and the theme of the exhibition appealed to me, so I agreed. The British committee comprised four Dukes, five Earls, a Knight, and a distinguished Major, and the American committee was no less impressive. Both were under the patronage of the President of the United States and the Queen of England. Leslie believed in going to the top.

The selection committee was made up of Leslie Cheek, as Director of the Virginia Museum; John Walker, then Director of the National Gallery of Art; Andrew Ritchie, then Director of the Yale University Art Gallery; W. G. Constable, who had spent many years as Curator of Paintings at the Museum of Fine Arts in Boston and who in his old age had become something of a guru in American artistic circles; and finally Basil Taylor, from the Royal College of Art in London. Basil was to write the catalog, and he became a key figure in the organization of the exhibition.

I arrived in London in June 1959 and asked Basil to have lunch with me at Claridge's. He was someone whose voice, mannerisms, facial expressions, and general deportment remained etched on the minds of anyone who met him. He looked vaguely like the Duke of Windsor and more than once was asked for his autograph under this mistaken apprehension. Basil's face was, however, much more alive. He had great unconscious charm and an analytical mind that, combined with a lively sense of humor, made him an entertaining and fascinating companion.

After Oxford and a teaching post at the Slade School of Art, he joined the staff of BBC Radio not long after the war, and there he played a large part in initiating the successful highbrow Third Programme. There were such offerings as that of an Oxford don reading passages from the eleventh-century meditations of Omar the Tentmaker in the original Persian (the stanzas were freely translated in the nineteenth century by Edward FitzGerald under the title *The Rubáiyát of Omar Khayyám*), and

there were frequent periods of silence between one program and the next. Basil served briefly under Sir Robert Witt and Sir Alec Martin as organizing secretary of the National Art-Collections Fund. This experience, he claimed, had taught him how to cope with shouting voices. He then went on to teach history of art and architecture at the Royal College of Art, where he became Librarian in 1953 and Reader in General Studies in 1958.

He was still working at the Royal College when he came to meet me at Claridge's. We sensed an immediate rapport and feeling of harmony, both being rather shy but both recognizing that British art was needlessly neglected and undervalued and that somebody ought to do something about it. We also discovered that we shared a keen interest in the English animal painter George Stubbs (1724–1806). By the time we were drinking our coffee, it had been more or less agreed that I was going to collect British art and that Basil would be my adviser. His only caveat was that in order to retain complete independence, he was unwilling to accept any remuneration from me. This condition turned out to be a little awkward when Basil started to run out of money.

Things began to move very quickly. John Walker directed my attention to one or two leading dealers in London, and Basil soon came to form contacts with a wider group as well. The art trade was very unspoiled in London at that period. Many of the older dealers had experienced the Depression years and had then gone through the war, either in the armed forces or on the equally hazardous home front through the blitz and bombings. The market had revived somewhat by the late fifties, but these dealers were still reflecting wistfully on the 1920s, when men like Henry Huntington and my father bought famous eighteenth-century portraits by Gainsborough, Reynolds, Romney, and Hoppner. There was as yet no clear indication of what was soon to come. The salerooms had only just begun seriously to promote their British offerings. Greed hadn't noticeably manifested itself, and the trade was grateful for what it got. I made my entrance, therefore, into a relatively subdued and down-at-heel British art market.

The British school was also a poor relation in the English museums. With the few noted exceptions of men like Carl Winter at the Fitzwilliam Museum, Graham Reynolds at the Victoria and Albert, Ellis Waterhouse at the Barber Institute in Birmingham, and David Piper at the National Portrait Gallery, the directors and curators of the national collections seemed to have turned their backs on British art. The Tate Gallery, the main repository of British art, had its Turners and Blakes and exhibited a dismally small display of historical British paintings. It had to wait for the curatorship of Martin Butlin before things started to change.

Basil Taylor began to haunt the dealers and made many friends among them, quickly earning their respect and affection. He soon found himself on intimate terms with those who shared his interest in British painting, finding that several had a very real knowledge and love of their subject. On one occasion he was called in to look at a picture at a small gallery just off Bond Street. The two directors were hot-tempered, and when one mentioned the name of an artist, to whom the picture they were about to produce was attributed, the other instantly came out with another name. Both clenched their fists and glowered at each other. Later that day, when Basil returned and opened the door of their gallery, he saw them wrestling on the floor, presumably still disputing the attribution, so he quietly closed it and left. He couldn't help noticing some of the little foibles and insecurities of even the most distinguished members of the trade.

Basil was even prepared to visit dealers he didn't care for if he thought they had anything worthwhile to offer. One or two of the more doubtful characters suggested kickbacks in one form or another. He told them he was not being paid by me, and he didn't propose to accept any consideration from them. If anyone felt very strongly that they would like to give him something, he was prepared to accept up to one case of wine at Christmas, preferably claret.

I came over to London at various times of the year, usually when my horses were running at Newmarket, Epsom, or Ascot.

As the knowledge of my collecting interests spread, I am told that on my arrival in the capital, the London dealers' windows filled overnight with English pictures. When I was in London, Basil and I did the rounds of the dealers. By today's figures, the prices all seem very modest and sometimes absurdly so. A beautiful oil painting of sailing ships by Richard Dadd was offered to me by a leading dealer for one hundred pounds; it hangs in my study in the New York house and still gives me enormous pleasure.

More important, the supply was still plentiful. I appreciated looking at everything I was shown. If it didn't interest me, I would tell the dealer that I understood that it was a very good picture, but for some reason that I couldn't explain, it just didn't happen to appeal to me. In this way I thought nobody's feelings were hurt. When I made a purchase, my shipping agent went to collect the work, and all the dealer needed to do was to send an invoice and, if necessary, apply for an export license. It was all so easy and so pleasant that when one of the dealers acquired a good picture, I usually seem to have had the good fortune to hear of it first.

Basil directed my interest, too, toward the excellence of English watercolors, and I was lucky enough to buy several whole collections to form a basis for my holdings in that area. Preeminent among them were the T. E. Lowinsky, Martin Hardie, L. G. Duke, Iolo Williams, and Thomas Girtin collections.

Even before my partnership with Basil Taylor, luck had played a certain role. There was the Stubbs "Pumpkin with a Stable Lad," which is still my favorite British painting. It was during our hunting tour in the Cotswolds back in 1936 that I met Angus Menzies, one of the partners of Knoedler's in London. He told me that the gallery had a beautiful Stubbs, and Mary and I agreed to go and see it. We both were bowled over by the charming horse, the young boy in a cherry-colored jacket, and the beautiful landscape background. The price was five thousand dollars, and I bought it immediately. It was my very first purchase of a painting and could be said to be the impetus

toward my later, some might say gluttonous, forays into the sporting art field.

Many years later, in October 1960, Basil Taylor told me that another Stubbs, Queen Charlotte's "Zebra," was coming up for sale at a most unlikely auction at Harrod's, one of furniture and household articles. We thought, "Ah, a probable bargain," but alas, others thought the same, and it wound up costing me twenty thousand pounds. But what would it, or "Pumpkin," be worth today?

A third Stubbs came to me in a most unlikely fashion. A lady in Manitoba, Canada, wrote to me saying she had heard that I was interested in Stubbs, that she and her family had a small Stubbs painting of a leopard on Wedgwood porcelain, which they had inherited, and would I be interested? I wrote asking if she would send me a photograph. Eventually a very badly light-flashed Polaroid arrived, but even I was pretty well convinced that the picture was right. I then wrote to her asking if she would entrust it to me and to Basil to authenticate and whether we might be allowed to have it cleaned by the Conservation Department of the Victoria and Albert Museum. She agreed to this and sent me the painting. Apart from being very dirty and having a crack running through it, it certainly looked Stubbsish and attractive.

Basil pronounced it genuine as soon as he saw it, and the V&A did a magnificent job of restoration. I reported all this to the lady in Manitoba and inquired whether she would like to sell it to me. I suggested that I get three independent experts to appraise the work and that I would, to be more than fair, pay her the amount of the highest estimate. This appraisal turned out to be fifty thousand dollars, and the deal was consummated. We never corresponded again, and I have often wondered if she is still happy with the transaction, whether she is still in Manitoba or in heaven.

Even at one remove, I was lucky with Stubbs. I saw in a Phillips (New York) auction catalog a rather unattractive painting by him of a hunter. Knowing that I wouldn't want to bid

on it, I thought nonetheless as I walked past Phillips' office on Madison Avenue that it *was* a Stubbs, and perhaps I should just have a look at it. It was hanging in a small office and, as I thought, did not appeal to me in the least. Just below it, however, was a small Ben Nicholson abstract watercolor that was to be sold at the same auction, and I fell in love with that immediately. I discussed the Stubbs at some length with the Phillips representative, but *not* the Nicholson, which I was able to buy for quite a reasonable sum when it was sold.

In the autumn of 1961 I engaged John Baskett, on Basil Taylor's recommendation, as my first Curator. John had spent a number of years as a student in the Department of Prints and Drawings at the British Museum and in European print rooms and had also acted as assistant to his father in the London firm of Colnaghi's. So he had experience in both the museum world and the art trade and was able to take two years' leave of absence from his firm to come and help me. Up to that time Bunny and I had been in the habit of going about the house with a bag of nails and hanging pictures where we chose. The volume of pictures arriving had, however, suddenly increased, and a disciplined structure of accessioning and dealing with them had become necessary.

I haven't given up hanging our own pictures, and I think everyone knows of my penchant for hammering nails into walls. I do only rough measurements, with my fingers, so that frames may be off center by a quarter to half an inch when I have finished. Experience tells me that this slight inaccuracy improves the final impression. In any case, I love doing it and have a feeling that it is a mild form of occupational therapy.

Speaking of therapy, not long ago I was out at the Mayo Clinic for an operation. (My experience at the Mayo Clinic would require a whole new autobiography, with the serious probability of a libel suit on its publication.) I asked Bunny, who was unable to get there until after the operation, to bring me a small picture, *any* picture, from our house at the Cape or Oak Spring. She brought a charming little landscape by Harold Sterner, with a horse and jockey in the distance, which we hung facing my bed,

and I assure you its healing powers were immense.

During another bout of illness, this time at home in Oak Spring and in my own bed in my own room, I found myself constantly rearranging in my mind the hanging of the twenty or so small paintings and drawings on its four walls. Occasionally I had an idea for a substitute that I was able to arrange after I had recovered. For many long bedridden periods this practice took my mind off minor pains and discomforts and was one of the best analgesics I have ever encountered. As an added advantage, the colors, compositions, and subjects of those pictures are forever indelibly imprinted on my mind.

To return to the subject of my collecting, the Brick House at the farm, empty since we left it some ten years earlier, found a new life and a new purpose. It was adapted to house the collection of British art. There was ample accommodation for hanging pictures and for bookshelves on the first floor. My Librarian, Willis Van Devanter, had his office there.

Then there was a large library on the second floor, which housed the magnificent collection formed by Major J. R. Abbey and purchased on the advice of that noted bibliophile John "Jake" Carter, between 1952 and 1955. It comprised colorplate books published during the period 1770–1850, and these volumes were cataloged under the titles *Life in England, Scenery of Great Britain and Ireland,* and *Travel in Aquatint and Lithography.* Also on the second floor was the collection of studies by Degas in wax and plaster.

On the third floor John Baskett had his offices. Also located there were the art reference library that he had started to form for me, racks for picture storage, and a room where the collections of drawings and watercolors were kept in solander boxes. The latter were made by a craftsman from the Windsor Castle Library in his spare time. I had a portable leather box made up at a Washington saddlery to contain miniature three-by-five-inch photographs of all my paintings, with brief descriptions on the back of each, so that I had a visual record at my fingertips all the time. I appeared sometimes early on Saturday mornings, often dressed for hunting, and we would run through any

points that had cropped up during the week. John mounted small exhibitions that he knew would have only one visitor, but a very attentive and appreciative one.

In 1959 I was offered the surviving intact portion of the library of John Locke. The great seventeenth-century philosopher's collection consisted of about a dozen manuscripts, a portrait drawing of Locke by Sir Godfrey Kneller, and 835 volumes in their original vellum and leather bindings, all cataloged and shelf-numbered in Locke's meticulous hand. Shortly after I had heard of this offer, I read the biography of Locke by Maurice Cranston, published two years earlier. I found Locke's life fascinating, especially his punctilious method of annotating his books.

I bought this entire collection from the Robinson brothers, who had them on consignment from Lord Lovelace, a direct collateral descendant of Locke. For eighteen years they were housed in a small room in the east wing of the Brick House. Bodley's Librarian, J.N.L. Myres, had been very loath to see the collection leave England, so I gave the manuscripts to Oxford at the time of the purchase, keeping a life interest in the bound books for myself. It had been my intention to retain them during my lifetime, but I decided in 1977 that since I had little leisure to read or study the books, I should let the Bodleian Library have them immediately.

I knew I would miss them, but their usefulness to scholars and students far outweighed any sentimental attachment I might have had for them. The people at Oxford installed the books in a special Locke room in the Clarendon Building, arranging them on the shelves in the same order as that in which Locke had classified them (as had I), and they kindly asked me to the opening of this room, on March 8, 1978.

While on the subject of books, I should mention my interest in William Blake. His haunting poetry with its arcane mythology and his beautiful illuminated books have always held a special appeal for me. This interest naturally brought me into contact with Sir Geoffrey Keynes, the distinguished Blake scholar and brother of John Maynard Keynes, and I was drawn into the

Blake Trust, an institution established by Geoffrey Keynes and others after the Second World War. I became an associate trustee in 1962, and helped with some of the Trust's most ambitious projects: facsimile editions of some of Blake's most important work. These were produced by the Trianon Press in Paris, using a collotype and stencil process that was expensive and painstaking but very accurate.

Trianon was run by Arnold Fawcus, a lively and somewhat eccentric character. Fawcus sometimes invited me to a small reception for the trustees at "The Travellers" club in London. If on arriving I saw several glasses containing large dry martinis on a tray, I guessed, usually correctly, that further financial assistance was required!

Although I personally am drawn to Blake's paintings, drawings, and prints by their graceful imagery, their color, and their imaginative quality, William McGuire, in his book *Bollingen, an Adventure in Collecting the Past,* points out that there is a connection between Blake and Jung. In writing of Kathleen Raine's *Blake and Tradition* (given as The Andrew W. Mellon Lectures in 1962), he says she discovered that Blake "was drawing upon the same sources as Jung: the Western esoteric tradition, the 'perennial philosophy,' in which both were looking for what Coleridge called 'facts of mind.' "

During the period when I was most active with my English collecting, I found piles of photographs from dealers on my desk each morning. They were normally accompanied by a letter from Basil Taylor expressing his views on the material offered. Photographs and transparencies, to say nothing of real drawings and paintings, shuttled across the Atlantic by the boatload and planeload, and the overseas telephone knew no rest. Basil's letters were typed on airmail blue paper on a portable typewriter that had seen better days. The carriage and the platen slipped, so that the typeface was subject to both pitch and roll. Further, the content, which might be described as "stream of consciousness," wandered from one subject to another. It was full of amusing anecdotes and of critical judgments on the pictures he

had seen. Sometimes the typing ran off the bottom of the paper, so that the signature had to be superimposed in the corner.

I looked forward to these missives with the intense pleasure that some people experience as they pick up the morning paper. In return for the letters, I telephoned Basil once or twice a week to discuss the pictures and to pass on my decisions to the dealers or to ask him to arrange to bid for them at auction.

Basil's temperament resulted in his forming fiercely loyal friendships, which were matched with equally strong antipathies. To cite one example, I asked him to have dinner one evening at my Washington house. I had to attend a dinner elsewhere but said I would be back later, and we could have a chance to talk about some unfinished matters then. When Basil arrived at the house, the door was opened by Markham, our English butler, who has since retired. Markham was a professional, well-trained, and very agreeable man but, when he took Basil's coat, they exchanged glances, or rather Basil looked at Markham with a baleful, stony stare. With almost canine sensibility each took an immediate and intense dislike to the other. Later in the evening, when Basil had retired from the dining room to take coffee in my study, he became aware that Markham was framed in the doorway. As he looked up, Markham said, "Excuse me, sir, but have you *entirely* finished your dinner?" Basil indicated that he thought he had, when Markham added, "There is as yet, sir, *another* course." Basil had entirely forgotten about the dessert, so he had to put down his coffee and return to the dining room to eat it.

When Basil departed from Washington the next day, he inadvertently left his overcoat at the house. A few weeks later Markham approached John Baskett in some distress to say that by some dreadful mistake, not of his making, the coat had been sent back to England, *postage due*. Markham knew that I would be upset if I were to discover what had happened and asked John please to extend his sincere apologies to Mr. Taylor. When John returned to England, he passed on the message and saw Basil's face light up with a mischievous smile as he said, "Good, that's one all." After this clash Basil and Markham had a more

cordial relationship, but things didn't always turn out so well.

Shortly after John Baskett's arrival in America, I told him that Basil had resigned from the Royal College of Art after differences with the Principal and that he was now concentrating entirely on advising me over my collecting activities. Since Basil still refused to be paid for his services, he was running out of money, and I asked John to try to persuade him to change his mind and accept a salary. Taking Basil out to dinner in Washington, John explained that it would be a great help to me if he would agree to take remuneration, which in turn would allow him to continue in his role of adviser. John added that he knew him to be someone of cast-iron integrity and that it just made sense for Basil to give in this once.

Basil spent about an hour explaining to John, with faultless logic, why such a course would damage his relationship with me and why it was better that he should withdraw from the arrangement altogether rather than continue on what he thought to be an unsound basis. He cited the shadow cast on Bernard Berenson's reputation as a supposedly disinterested adviser to Duveen as a warning. John was entirely convinced and returned to report to me.

Having got to know Basil a little by then, I was not particularly surprised. The problem came to be solved shortly after, when The Paul Mellon Foundation for British Art was established in London, and with it, Basil's appointment as the salaried Director.

Within two years of my starting to collect British art, the National Gallery of Art in Washington held a small exhibition of my English watercolor drawings. A much more substantial showing of paintings and drawings was projected for the following year in Richmond at the Virginia Museum of Fine Arts. Planning for the Richmond show started in 1962. I was to make the selection with Basil, and he was to write the catalog and arrange the hanging of the pictures. Leslie Cheek, the Museum's Director, was to provide facilities for the exhibition and organize the opening.

Leslie Cheek and Basil Taylor had very different personalities.

Basil was a scholar, and Leslie was well thought of as Director but was also somewhat of a showman. It was a promising combination because Basil's scholarship was sound and imaginative and Leslie's showmanship was extremely good and was devoted entirely to furthering the interests of the Museum. In practice, the relationship didn't work out at all. Basil, who had been involved with Leslie already on the "Sport and the Horse" exhibition three years earlier, thought his ideas on the presentation of the current exhibition vulgar and unworthy of my collection, while Leslie thought Basil secretive and obstructive.

Neither criticism was really valid. Basil visualized the exhibition as an opportunity for the public to see my current holdings of British paintings, together with a selection of English watercolor drawings. This introduction to British art would be accompanied by an instructive two-volume catalog in which all the paintings and some of the drawings would be illustrated and there would be brief biographies of the artists represented. Leslie dreamed, on the other hand, of a magnificent opening night attended by dignitaries from both sides of the Atlantic. There would be a grand champagne reception with music, a sumptuous dinner, followed by a speech from me in the lecture theater, and then, to round off the evening, a viewing of the collection. It was to be an evening that the residents of Richmond would not easily forget.

Happily, as things turned out, the hopes of both parties were fully realized. During the period when the exhibition was being organized, however, neither was speaking to nor corresponding directly with the other. Instead, each wrote to my Curator, John Baskett, who passed the messages on, making them more affable in the retelling.

During the months before the opening Basil became more and more frantically engaged in his role. While he and John were staying at the St. Regis Hotel in New York, he burst into John's room shortly before six o'clock one morning, bearing a sheaf of photographs of paintings under his arm. He told him he had been up for the last two hours, creating a mock-up of the picture-hanging arrangement for the exhibition, and he wanted to

know what John thought of it. John sat yawning in his pajamas while Basil started casting these photographs about the floor and constructing their hanging, room by room, to match the measurements of the little cardboard model of the exhibition walls.

Back in England, Basil had completed his catalog and was so anxious that everything should be right that he went along to the printers in order to see the first bound copies coming off the press. To his horror, and through no fault of his own, there was an unfortunate typographical error (Henry C. Prick instead of Henry C. Frick) on the first page of the introduction. The sheet on which the offending word appeared had to be removed from every copy and a replacement tipped in by hand. In the early sixties air cargo was not viable for heavy consignments, and the catalog had to be shipped by sea. Time was short, and an anxious Leslie Cheek flew up to New York to intercept the shipment on the dock only a few days before the exhibition was due to open.

In April 1963, when the great day arrived, there were many fresh faces in Richmond, Virginia. Apart from the British Ambassador, Lord Harlech (then Sir David Ormsby-Gore), there was a contingent of representatives from the British fine art trade. Some, like James Byam Shaw, had never been to the United States before and arrived on transatlantic liners in their heavy English suits, watch chains, and felt hats, carrying gold-capped walking sticks and looking decidedly uncomfortable in a temperature of a little over ninety degrees.

The exhibition's opening evening was an unqualified success, although it was marked in my mind by a sad event, boding ill for the future. Leslie was entertaining his guests at drinks before dinner when it was noticed that Basil Taylor was absent. John Baskett volunteered to look for Basil and eventually found him in his room at the hotel. He was semirecumbent on his bed, his back propped against the wall, and his frightening appearance was that of a lifeless puppet doll. Apart from forcing an apologetic smile onto his face, he was clearly incapable of any movement or speech.

Basil's wife, Kay, seated on the other side of the room, saw

John's shocked expression and said, "I'm afraid Basil won't be coming to the dinner this evening. You go along now and enjoy yourself." When John protested that he would like to help, she added, "There is nothing you can do. I have seen it all before. He has overexerted himself and had a relapse but will probably be all right tomorrow." John walked back to the Museum, perplexed but unaware of the real significance of Basil's condition and concerned that Leslie Cheek would interpret Basil's absence as some Machiavellian plot to discomfit him. Leslie, to his credit, did no such thing and just quietly passed the message on to Bunny and me.

After dinner everyone adjourned to the lecture theater, and I gave my speech outlining my reasons for forming the collection. Reviewing my collecting activity, I said,

> I don't believe many motives in life are clear-cut or self-evident. Collecting especially is such a matter of time and chance—intellectual bent, individual temperament, personal taste, available resources, changing fashion—and the psychologists tell us, even very early child training—and my own motives as a collector seem to myself extremely mixed. Although temperamental trends or subjective impulses were perhaps uppermost, I won't say it was done entirely without thought, without reason, without plan. English Art, as well as being personally desirable, seemed to me long neglected or even abandoned, not only in this country but also in its homeland.
>
> So that expanding the Collection, increasing its breadth and depth, filling in important historical or chronological gaps as well as adding artists and schools in which we were weak, or which we lacked entirely—all seemed part of a logical, deliberate attempt to say to ourselves and to the public—*this* is English Art, not just the *Duchess of Devonshire*, or the *Age of Innocence;* let's take it seriously, let's reevaluate it, let's look at it, let's enjoy it.
>
> Here is an English tree, therefore, transplanted to Virginia soil. It has grown from a sapling almost too rapidly, perhaps, to have gained full strength or stature—it may grow new branches, brighter leaves, as time goes on. It may even require in the future a certain amount of judicious

pruning. But far beyond the confines of this Collection and exhibition, I hope the high qualities of English Art will more and more be enjoyed throughout the Western World and that the pleasure inherent in it, and its beneficent influence, will gradually become better and better known.

The exhibition comprised 324 paintings and 127 drawings hung in thirteen galleries devoted to landscape, man and society, animals and sport, and subject pictures. All aspects of British art were portrayed, with the exception of those formal portraits and fancy pictures so beloved by my father's generation, which I considered already well represented in American collections. There were already by then outstanding examples in the collection of works by England's leading practitioners of the periods under survey. We had the Leeds version of Hogarth's "Beggar's Opera." Then there was "The Lord Mayor's Procession: The Thames at Westminster Bridge," painted by Antonio Canaletto while he was in England, the large Richard Wilson version of "The Destruction of Niobe's Children," Zoffany's "Drummond Family," Gainsborough's charming "Richard Lloyd and His Sister," Constable's "Hadleigh Castle," Turner's "Port Ruysdael," and a number of examples of Stubbs, responding to Basil's and my own particular passion. These included the "Zebra" and the "Poodle in a Punt."

The Richmond showing came to be seen as only the nucleus of my collection, but it seems that it relaunched British art, and for this I think we have largely to thank Basil Taylor. Later in the following year the greater part of the exhibition went to London, where it was shown at the Royal Academy from December 1964 to February 1965, and it subsequently returned to the United States to be seen at the Yale University Art Gallery in the spring of 1965. The London showing was well attended, but the press reports asked why a man of my wealth should be buying English paintings when I could be spending much larger sums of money on French pictures. What had happened was that British culture in all its aspects had gained a foothold in the United States in the form of a collection that was shortly to enter the public domain. It is sad, in my view, that the reverse has

not turned out to be the case with American art in Britain, where it is the least satisfactorily represented of all Western schools.

In July 1963 John Baskett came to have lunch with me at the Metropolitan Club in Washington. I told him that I had been thinking about a suitable repository for my collection of British art and that my preferences were to be either Washington or Yale. In Washington there was a possible site in the form of a house we own, next door to the one we live in while in town. Appropriately this house is located opposite the main Lutyens facade of the British Embassy, but it is doubtful whether it would have provided a large enough space, and there would undoubtedly have been problems over zoning and parking. The only other destination for the collection in Washington would have to have been the National Gallery itself. The Gallery was already at that time beginning to experience problems over space, and I realized that if the collection were to go there, it would, because of its very nature, not be possible to exhibit more than a few of the more important pictures, quite apart from the collections of books and drawings. My thoughts turned increasingly toward Yale, where the collection would provide a visual stimulus in the context of a University long noted for its strength in British studies.

I would like to add that I did not give up collecting British art after the main part of my collection subsequently left for Yale. As anyone who has started to collect anything knows, it is impossible to stop. While taking a keen interest in what is going on at Yale, I have concentrated on enlarging my collection of sporting paintings, and the gaps left on the walls of the Brick House were soon being filled. For many years my friend and adviser Dudley Snelgrove worked from an office in Dover Street, helping me with my sporting collection. There he was joined by Judy Egerton, and together with John Podeschi in America, they wrote a four-volume catalog of the sporting paintings, drawings, prints, and books in the collection. These books were published between 1978 and 1981 by the Tate Gallery for the Yale Center for British Art.

Some years ago I walked past a shop in New York called The Incurable Collector and remember thinking at the time that the title could equally well be applied to me. I have been a collector of collections when opportunity has arisen. This might seem a symptom of greed or at best an indiscriminate appropriation of widely different and incompatible congeries of books, pictures, sculptures, or other objects of art. To this charge I plead innocent, for in each purchase of a whole collection I have always had a probable or possible eventual repository in mind. Not only that, but in every case it has seemed an opportunity of a lifetime and almost a *duty* to prevent the dispersal of the collection in question. It bothered me to think of beautiful objects or literary treasures, which had always been kept together, being sold one by one, never to be reassembled.

Among those collections that immediately come to mind are the J. R. Abbey collection of British colorplate books, which is now at the Yale Center for British Art; the collection of 125 sheets of comparative anatomical drawings by George Stubbs of the tiger, the fowl, and man, now also at the Yale Center; the Lord Lovelace collection of books, which had belonged to the philosopher John Locke and is now at the Bodleian Library at Oxford; the collection of 389 cartoons in oil of American and South American Indians by George Catlin, which has been divided among the National Gallery of Art, the Virginia Museum of Fine Arts, the Buffalo Bill Museum in Cody, Wyoming, and the Amon Carter Museum in Fort Worth, Texas; a large portion of the Heeramaneck collection of the art of Indian Asia, which I secured years ago for the Virginia Museum; and last, the unique collection of Degas waxes I have already referred to.

I am so often asked, "What makes you admire and want to own one work of art more than another?" I think I've always had a keen visual sense (unlike most people I dream mostly in colors). One of the reasons I've always liked riding, foxhunting, racing, or just walking around in the beauty of the countryside—green fields, bright autumn leaves, sunsets, rainbows, high wedges of flying geese and their eerie honking, cattle grazing, cattle lowing in the distance—is that these scenes long re-

main vividly in my mind's eye. It is an inner picture gallery that I can return to in quiet moments.

When I buy a painting, some feature about it may remind me consciously or unconsciously of some past event, thought, feeling, moment of pleasure or even of sadness. It might just be a fortuitous combination of colors, or a certain calmness, or a beautiful sense of proportion. In the case of a portrait, perhaps it is the sitter's character, air of intelligence, or hint of humor. Would I *like* her or him? It seems to me that art makes one feel the essence of something, turning the ordinary, everyday object or scene into a universal one. Like poetry for Wordsworth, it is "emotion recollected in tranquillity."

I find most critical writing, most statements about art, to be totally misleading. Critical analysis of art is quite different from literary criticism. You can translate Sanskrit into English and analyze the meaning, but when you try to sum up the meaning of the "Alba Madonna" or Cézanne's "Boy in a Red Waistcoat" in words, it all seems to go off the rails. As Tom Wolfe phrases it so neatly in *The Painted Word*, "I had assumed that in art, if nowhere else, seeing is believing. Well—how very shortsighted! Now, at last, I could see. I had gotten it backward all along. Not 'seeing is believing,' you ninny, but 'believing is seeing,' for *Modern Art has become completely literary: the paintings and other works exist only to illustrate the text.*"

One of my failings as a collector may be my lack of curiosity about the lives of the artists, their social and political backgrounds, and their places in history. I am also little interested in their techniques, their materials, or their methods of working. I sometimes worry about it, but then I say to myself, "Why should I have to?"

In giving my works of art to public museums, I have made a practice of imposing certain restrictions that have always seemed to me to be necessary for the protection of the works themselves as well as to provide guidance for future boards of trustees, directors, and their staffs. The first is that no gifts may ever be sold. I believe in one or two cases I have named other museums to which works may be passed on in case of the dis-

solution of the original recipient. The second proviso is that paintings on panel are not to be lent on any condition. In regard to attributions, I would always hope that the latest and best scholarship should prevail, let the chips fall where they may.

I have also encouraged the recipients of certain illustrated rare books, including my large holdings of Blake, to remove the interiors from bindings, unless the bindings are contemporary or are of great aesthetic interest. In fact, although I know it goes against the grain for most book curators, I have no objection to the *original* bindings being removed because they can always eventually be replaced. This process enables the leaves of the texts and their beautiful illustrations to be separated and shown individually or in groups, in protective cases, instead of being confined to the exhibition of only two pages of an opened book. There is even a more compelling reason to follow this procedure. The individual pages (leaves), after separation, can be mounted on acid-free mounts and preserved in lightproof solander boxes. Students and more serious scholars can then study each page without handling the original and—even more important— without thumbing through many bound pages, a very destructive process.

Most of my decisions in life, whether in collecting, in philanthropy, in business, in human relations, and perhaps even in thoroughbred racing and breeding, are the result of intuition rather than mental analysis. My father once described himself as a "slow thinker." The description applies to me as well, but the hunches or impulses that I act upon, whether good or bad, just seem to rise out of my head like those word-balloons in the comic strips. It is very difficult, however, for me to analyze my reactions to paintings and other works of art. Let me give you an example. The only modern British artists whose works I admire (in fact, the only modern works that I have liked enough to collect for myself, as distinct from buying with an institution in mind) are Barbara Hepworth's sculptures, Ben Nicholson's paintings, and John Skeaping's sculptures and drawings. I had an unfocused, intuitive feeling early on that each of these artists was expressing the same unconscious concepts. It was only

much later in my collecting years that I discovered that the three were connected by marriage at one time or another: first Skeaping to Barbara Hepworth, then Ben Nicholson to Barbara Hepworth. I still grope for a meaning of what these random conjunctions mean, but the explanation eludes me.

I think I can truthfully say that I have not collected in order to hoard, and I hope the pleasure I have derived from my collecting activity is shared by those who now visit the National Gallery, the Yale Center for British Art, and the Virginia Museum of Fine Arts.

CHAPTER 15

The National Gallery
of Art

———◆———

Every man wants to connect his life with something he thinks
eternal.

— ANDREW W. MELLON
on his motive for collecting

...a giver who has stipulated that the Gallery shall be
known not by his name but by the nation's.

— FRANKLIN D. ROOSEVELT
March 17, 1941

My election in 1930, at age twenty-three, to the original board
of trustees of the A. W. Mellon Educational and Charitable Trust
gave me my first experience of foundation work and led to a
long and enjoyable involvement with the National Gallery of
Art. Father had established the E.&C. Trust, as we called it,
primarily as a vehicle for transferring his collection of paintings
to ultimate public ownership and for funding the construction
costs of the National Gallery. He put me on the board, as he
was to put me on so many other boards, but he didn't consult
me about his collection or about the projected gallery. This
wasn't surprising since at the time I was still an undergraduate
at Cambridge, and in the following years my time was mostly
spent working at the Mellon Bank, getting married, and trav-
eling. Looked at in the broader context, however, my trustee-
ship marked the beginning of a special relationship with the
Gallery that became fully established following Father's death
in 1937.

In the course of the final years of Father's life he was closely involved in the planning stages of the National Gallery building. During his last months he had been shown outline plans by his architect, John Russell Pope, but illness and old age denied him the pleasure of watching his grand scheme come to fruition. In all meaningful discussions about the Gallery Father consulted David Finley, who was to become the Gallery's first Director. He also had many discussions with Joseph Duveen, the art dealer. Duveen was thought to have great personal charisma, but I regarded him with distaste and thought of him as an impossibly bumptious and opinionated ass who took advantage of any opportunity that presented itself to burnish his image and to further his own interests. I have never entirely been able to understand how Father, normally a sound judge of character, should have fallen under his spell, although I suppose one must bear in mind that Duveen had by that time made himself one of the very few sources of fine pictures.

In 1936 David Finley asked me to take the preliminary designs for the National Gallery of Art to England, where I could show them to Kenneth Clark, at the time Director of the National Gallery in London. Father had always been impressed by England's National Gallery. He often visited it with Frick and later with Duveen, and it was to a great extent his model for a National Gallery in Washington. I thought it was encouraging of Finley to involve me, even if it was largely a courteous gesture.

I was still at Yale when I first met David Finley, who, at that time, was my father's assistant in the Treasury in a general factotum, speech-writing, and advisory capacity. He was very gregarious by nature and enjoyed the social and diplomatic life of Washington enormously. He always took me under his wing at vacation time and saw to it that I went to my share of dinners and dances at embassies and elsewhere.

We often talked about pictures in Father's collection and about the exciting coups being hatched by Duveen and the people at Knoedler's. I felt at that time that David Finley was certainly more of an amateur curator working out of our apartment than a financial wizard helping Father in the Treasury.

When I returned to the National Gallery as a trustee at the end of the war, it did not seem in the least odd to me that David fitted in so well as the Director. It was almost as though he had inherited the collection from Father. His single-minded pursuit of other great collectors—Mr. Widener, the Kresses, Lessing Rosenwald—had my hearty approval, and in the cases of Widener and the Kresses he took me along with him on several of his piratical forays. I can't think of anyone who would have made a better Director or who would have got the new Gallery off to a better start.

After Father's death it was left to me, together with my co-trustees in the A. W. Mellon Educational and Charitable Trust—namely, Donald Shepard (Father's former legal adviser) and David Bruce (my brother-in-law, who had been appointed a trustee in 1934) to see the plan through.

Construction work on the Gallery had started in June 1937, two months before Father's death. By an extraordinary coincidence, Pope, the architect, died twenty-four hours after him, leaving the building to be completed by his associates Otto R. Eggers and Daniel Higgins of New York. This work was overseen by me and my co-trustees. We pursued a policy of keeping ourselves fully informed of developments but interfering as little as possible. One of the few occasions on which we stepped in was when we vetoed the architects' idea for decorating the exterior of the Gallery with statues, preferring the simplicity of blind niches and a plain architrave. We also overruled their rather fancy designs for marble flooring in the rotunda, the sculpture halls, and garden courts, preferring the simplicity and severity of black and gray-green marble to the architects' multicolored layout.

On March 17, 1941, at the dedication ceremony, I presented the National Gallery of Art together with the Andrew W. Mellon Collection, to President Roosevelt, who accepted it on behalf of the American people. I said in my speech that "I hoped that the Gallery would become a joint enterprise on the part of the Government, on the one hand, and of magnanimous citizens on the other, and that it would not become a static but a living insti-

tution, growing in usefulness and importance to artists, scholars and the general public."

The President made his reply, remarking that "the giver of the building has matched the richness of his gift with the modesty of his spirit, stipulating that the Gallery shall be known not by his name but by the nation's. And those other collectors of paintings and of sculpture who have already joined, or who propose to join, their works of art to Mr. [Andrew] Mellon's have felt the same desire to establish, not a memorial to themselves, but a monument to the art they love and the country to which they belong." The President's generous and much quoted words about my father seemed to me a little wry, considering the behavior of his tax bloodhounds, but perhaps he had come to realize that Father really had been a public-spirited man.

Father's faith in the generosity of other donors was amply borne out, and four major gifts transformed the Gallery's holdings. First of all, it was fortunate enough to secure as a gift from Joseph Widener the wonderful collection of Old Master paintings, sculpture, and decorative arts formed by his father, Peter A. B. Widener, after the Civil War. During the war the elder Widener had made a fortune from contracts to supply the Union Army with meat. He subsequently acquired the paintings to embellish his mansion near Philadelphia. My father had discussed with old Mr. Widener his plans for a National Gallery, but it was only through David Finley's diplomacy, from the time of his first visit to Joseph Widener at Lynnewood Hall, in 1937, that the collection came to Washington. I recall accompanying David on one of these visits, in December 1938, and being impressed by his charm and tact.

In 1938, three years before the Gallery was opened to the public, David Finley went to see Samuel Kress, the five-and-ten-cent-store millionaire, in his New York apartment and persuaded him to forgo his plan to give his large collection of Italian Old Master paintings to the Metropolitan Museum of Art or to a museum he planned to build himself, and to give it instead to the National Gallery. There were problems, owing to the fact that although there were very fine paintings in it, Kress had

formed his collection on a representative rather than a qualitative basis, and of course, Father had stipulated that only paintings of the highest quality should be accepted. These problems were tactfully ironed out by David Finley and John Walker, the latter newly returned from Italy to take up his post of Chief Curator. After Sam Kress's stroke in 1946, his brother Rush continued, with John Walker's advice, to build further quality into the original Kress gift. For many years after the initial gift, the Kresses were the main source of funds for new acquisitions by the Gallery.

In 1941 Lessing Rosenwald, the retired Chairman of Sears, Roebuck, began to donate his remarkable collection of prints and drawings. His 1943 deed of gift reserved the right to make additions of a similar nature. Over the following years the Gallery acquired, either by gift or bequest, some twenty-two thousand items from the famous Rosenwald collection.

Finally, in 1962, Chester Dale, a Wall Street millionaire, bequeathed his superb collection of French Impressionist paintings. Chester was a stockbroker who had bought an interest in the Georges Petit Gallery in Paris. His interest turned from the stock market toward the art market, and he was encouraged to collect by his first wife, Maud, an artist in her own right and a woman of impeccable taste. John Walker recognized Chester's developing passion for collecting and directed him toward the National Gallery.

Many gifts also came, of course, from Ailsa and from Bunny and me. Ailsa helped with purchases through her foundation and also bequeathed a group of beautiful French paintings. Bunny and I have given mostly French Impressionist and Post-Impressionist paintings, drawings, and sculpture together with American art and a small selection of British paintings. To these, hundreds of smaller but important donations have been added since the Gallery opened its doors in March 1941. Together, the gifts have brought the National Gallery of Art to the forefront of the world's museums in a period of just over fifty years.

My active association with the National Gallery really began

during the period between Father's death in 1937 and my joining the Army in 1941, shortly before World War II. I was elected President in March 1938 but resigned a little over a year later, and two years after that I volunteered for military service. I rejoined the board as a trustee shortly before my discharge from the Army at the end of the war in 1945, became Vice President in 1961, and took on the presidency again in January 1963, following the death of Chester Dale. I held this position until 1979, when Chief Justice Warren Burger requested that he be relieved of the chairmanship because of his onerous duties at the Supreme Court. I was then elected Chairman of the board of trustees and continued in this role until my retirement in 1985, by then my association with the Gallery had continued over a period of forty-seven years.

Looking back on my early years as President of the Gallery, I am reminded of a series of events whose unfolding now fills me with wry amusement, but which at that time seemed very portentous and worrisome.

In 1964, a year after I had become President, Dillon Ripley was appointed Secretary of the Smithsonian Institution. In that capacity, it meant that he was also automatically an ex-officio trustee of the Gallery. He took his responsibilities to the board of the Gallery seriously and attended our meetings with regularity.

For legal reasons that have always been somewhat obscure to me, the original legislation creating the National Gallery of Art placed the Gallery under the somewhat tenuous oversight of the Smithsonian as a "bureau" of that Institution. In addition to the National Gallery, there were eight other "bureaus" at that time. Since the National Gallery's board of trustees was an entirely independent body with five private or "general" trustees and only four ex-officio trustees (the Chief Justice, the Secretary of State, the Secretary of the Treasury, and the Secretary of the Smithsonian), the self-perpetuating general trustees being in the majority, it is obvious that we were not, and are not, a subsidiary of the Smithsonian. In addition, the Gallery has its own endowment and receives substantial funds for maintenance and

security directly from the United States Congress and is not in any way dependent on the Smithsonian for financial support.

It happened that the year after Dillon Ripley's accession, 1965, fell upon the two hundredth anniversary of the Smithsonian founder's birth. The founder was James Smithson, a British citizen who admired American democracy and who perhaps had some quarrel with the policies and social inequalities of his own country.

At that time, shortly after his appointment, Dillon seems to have been overcome with theatrical ambitions, or had at least been infected with mild institutional euphoria. He decided to mount a tremendous celebration of the Bicentenary, including days of academic lectures and seminars and nights of social entertainment, culminating in a grand academic procession across the Mall with university dignitaries from all over America and abroad sporting their colorful robes and gold-tasseled hats. As an added majestic touch to the glory of the occasion, Dillon had persuaded Professor Tubby Sizer at Yale to design special armorial banners to represent each of the then fifteen bureaus whose representatives would march in the procession. A final aura of royalty would also enhance the ceremony by the introduction of a large processional mace designed by an English silversmith and encrusted with precious stones from the Smithsonian's collection. This was to be carried by the Secretary at the head of the procession.

All of this brouhaha was looked upon somewhat askance by many of the older denizens of political and cultural Washington. In addition, it would seem that Dillon had stepped on a few toes, not only in his own bailiwick but throughout the city.

As President of the National Gallery, I happened to be one of those whose toes were stepped upon. I received a memorandum addressed to "Heads of Bureaus," which contained the following pertinent paragraph:

> Order of preference in each column [of the procession] will be determined on the basis of the date on which the bureau was organized, the senior bureau to the front.

It is requested that you designate by name the banner bearer and two members of your staff who will be representing your bureau in addition to yourself.

Now I had no intention of letting representatives of the Gallery march in the procession, particularly since by reason of the date of our establishment we would bring up the tail end of the column. So I called up Dillon and told him politely that we did not wish to walk as a unit, that we did not consider ourselves a real "bureau" of the Smithsonian, and that we didn't want a banner. He hastened over to see me at my office on H Street, and we had a long and serious talk. I insisted that the Gallery was not a bona fide "bureau," and I said that as far as I knew we already had a nice government flag flying outside the building next to the Stars and Stripes. He was not very pleased.

As far as I was concerned that was the end of it. In due time Jock Whitney (my friend and co-trustee) and I both received our badges as ordinary citizens to march in the procession along with the Yale University delegation. Jock and I were happy to be part of the celebration in our private roles, and when the great day came I think we both participated. I remember that I wore my bright scarlet robe as an Honorary D.Litt. bestowed by Oxford, perhaps hoping that it would catch Dillon's eye during the orations!

A few days later I had a call from the office of Chief Justice Earl Warren asking me to come to his chambers to discuss a Gallery matter about which he was concerned. (The Chief Justice of the United States was at that time both Chairman of the Board of Regents of the Smithsonian and Chairman of the Board of Trustees of the National Gallery.) I was in his chambers at the appointed time, and the first thing the Chief Justice said to me was, "Tell me, Paul—is it true that Dillon Ripley sent badges to you and Jock Whitney for the Bicentenary celebration each marked *Employee?*" I couldn't help laughing, and replied, "No, Mr. Chief Justice—our misunderstandings haven't been nearly as bad as that; but I must admit that we have had our tussles regarding the relationship between the Gallery and his Institu-

tion. I appreciate your interest and hope you will explain to Mr. Ripley our concern regarding that relationship, and our understanding, in which I hope you concur, regarding the realities of the situation."

From that time on our relations with the Smithsonian have been smooth, businesslike, and cordial. It is true that the National Gallery is still technically a bureau of the Smithsonian, and every year a short report from the Director of the National Gallery appears in the Smithsonian's annual report. But I don't think that anyone these days thinks of the Gallery as being part of that Institution's immense, albeit prestigious bureaucracy. Shortly after my conversation with the Chief Justice, I had the small-lettered subheading "Smithsonian Institution" removed from all Gallery stationery and from most of our publications.

And what about Dillon and myself? I would like to think that we have become fast friends and sincere admirers of each other. As time passed, I felt that he had developed a more realistic outlook about his own mission and about the future of the Smithsonian. I admired his guts in persisting in launching the *Smithsonian Magazine* in the face of opposition within the Institution and of Washington gossips at large. I think he deserves tremendous credit not only for the success of that venture, but also for the many popular and ingenious programs, exhibitions, and discrete internal scientific and artistic divisions within his domain. One has only to think of the addition of the National Air and Space Museum, the Hirshhorn Museum and Sculpture Garden, the Museum of African Art, and the Sackler Gallery, all of which were either planned or built during his tenure. A brilliant ornithologist himself, he has produced volumes of ornithological research of the highest order.

We lunch occasionally in Washington, and there are no echoes of our contretemps of many years ago. It is a pleasant example of a very small but valued "mutual admiration society."

David Bruce resigned his trusteeship and the presidency of the Gallery after he and my sister were divorced at the end of the

war. Samuel Kress became President, but his stroke totally incapacitated him, so that he was unable to preside over a single meeting of the trustees and remained bedridden in New York until his death, nine years later. Lammot Belin, a prominent Washingtonian, stood in as acting President until 1955 when Samuel Kress died and Chester Dale was elected President.

Chester Dale was a tough, hard-bitten stockbroker with a crisp turn of phrase and a taste for stiff martinis. He might have seemed an odd choice, but his collection carried a great attraction for the Gallery. He had made the exciting discovery that the machinations of the art world were even more Byzantine and more of a challenge than those of Wall Street. Further, he discovered in himself a sense of taste and judgment about pictures that continued to manifest itself long after his first wife Maud's death and after he had married Mary, his second wife. The result is the stunning collection of French paintings that now graces the walls of the Gallery.

A very trying period for me, as a trustee, came in 1955 and 1956. David Finley, the Gallery's Director, had reached an age when the trustees considered it would be appropriate for him to retire, and a decision had to be made about his successor. Finley had undergone no formal training in art history, but he had excellent judgment and had been a great help to Father, from 1927 on, over the formation of his collection.

During its early days, when Finley was at the helm with a small staff, the National Gallery wasn't the highly sophisticated institution we know today. For years the public perversely insisted on calling it the Mellon Museum. Of course, things changed with the passage of time and the Gallery's inexorable growth, but even up until the early sixties there was a feeling of "family" about the place. Nearly all the guards had been there from the first day. Things had to change.

I had always favored John Walker as the next Director. John, a Pittsburgher and a friend of mine from childhood, had been appointed the Gallery's first Chief Curator on my recommendation in 1939. Unfortunately, in 1955, with the appointment of a new Director in the offing, it so happened that Chester Dale

had just been elected President of the Gallery, and he had a different candidate in mind.

Chester had got it into his head that the Gallery's Secretary and General Counsel, Huntington Cairns, was the right man to succeed David Finley as Director. This was partly because he thought Cairns was the more amenable of the two men and the more likely one to accede to his, Chester's, demands in the future. Huntington was a highly intelligent and very personable man. Apart from his legal training, he was deeply interested in the classics, philosophy, and poetry and had written on these subjects. He would like to have been Director but had not in any way asked for the job.

Chester was prepared to give in to opposition only if he was really alarmed, and he didn't frighten easily. His technique of imposing his will was to summon anyone who needed a little persuasion to his house in Southampton, Long Island, in the summer, to his house in Palm Beach in the winter, or to his apartment in the Plaza in New York, where he would first anesthetize them with large martinis. He drank a similar amount himself, but the liquor just seemed to disappear into the proverbial hollow leg, and meanwhile, he harangued his visitor with whatever theme was on his mind. The sentences often began with "I have news for you" and terminated with "Get it?" in case the message had not sunk in. It was a brutally persuasive performance.

Before this new idea of Chester's was broached, I took David Finley to lunch to sound him out over his successor. David was reticent and only advanced the view that Walker wasn't necessarily the right person and that the trustees should proceed with caution. I concluded from this interview that David was far from eager to retire.

A little while later I received a call from Chester, who was in Southampton, saying he wanted to see me. I was then at our house at Osterville on Cape Cod, so I flew to Long Island for an evening with Chester. We had two or three martinis before dinner. Then after dinner Mary Dale left us drinking champagne. Chester started on his campaign, insisting that Cairns,

not Walker, had to be our choice. I was in a very difficult position. If I didn't agree, I foresaw the risk of the Chester Dale collection being removed from the National Gallery with the same lack of ceremony with which it had previously been taken away from the Art Institute of Chicago and the Philadelphia Museum, both of which had elected him to their boards. In any event, I reluctantly agreed.

I had become used to a certain amount of bullying on Chester's part. Some of the trustees had decided that the name of Duncan Phillips, the renowned collector, should be recorded on the benefactors' plaque in the Constitution Avenue entrance to the Gallery in recognition of his donations to the Gallery. It was an automatic action normally taken when the value of donated works of art or money from the benefactor had reached a certain monetary value.

Chester hated Duncan, and the feeling was mutual. They were at different ends of the spectrum in personality, and I suspect that Chester was jealous of Duncan's collection and his reputation as a connoisseur. In the course of several informal meetings, Chester had consistently refused to let us put Duncan's name on the wall, in spite of our insistence that the gesture was officially necessary and in spite of my own argument that Duncan had been a loyal trustee *and* a personal friend of my father. At a one-on-one meeting in Chester's apartment at the Plaza, I had put in a strong plea for the plaque, only to be brought up short by Chester going into the next room and coming back with his will and then reading the pertinent paragraphs regarding the bequest of his collection! As regards wills, one of Chester's most frequently expressed aphorisms, which he always put forth as though conceived by himself, was: "Don't forget, a shroud has no pockets."

Finally, just before a regular trustees' meeting, I told Chester that I insisted on the Phillips matter appearing on the agenda and that I intended to push it through. This was in the President's office. He suddenly became red in the face and began to shout, pounding his desk with his fist. The tirade lasted about two minutes. He calmed down slightly, reached into his pocket

for a gold pillbox, and extracted a small red pill. I nervously poured him a drink of water.

I have never quite been able to make up my mind how much of Chester's behavior was acting and how much was genuine, but I cannot help thinking about him without a note of nostalgic amusement and grudging affection. The resolution, authorizing the addition to the benefactors' list, by the way, was passed unanimously.

To return to the matter of the directorship, shortly after my visit to Southampton and my agreement to go along with the proposal to appoint Huntington Cairns as Director, he and Chester came to a meeting at my house at the Cape. Huntington offered to talk with David Finley and with John Walker and explain to them the outcome of the discussion. He thought the job had been offered to him and later virtually told Finley that he would be taking over. Finley was naturally very angry.

I then invited John up to the Cape and told him what had happened. He took it well. He said that he was naturally disappointed and that he thought the trustees were making a big mistake but that he would have to go along with it. By now I was feeling extremely unhappy about the way in which events were developing. When I got back to Washington, with its close-knit social scene, in the late autumn, I discovered that three camps had formed: the David Finley camp, the Huntington Cairns camp, and the John Walker camp.

Shortly after my return I attended a large National Gallery dinner. There was a buzz of gossip and speculation about the new Director, and a lady seated next to me turned and said, "I think it is simply awful that you are making David Finley retire." I explained to her that David had been there since Father's day and that he was now sixty-five. Tongues, however, were wagging, and I was worried that the press might get hold of the true story at any moment. At that point Chief Justice Earl Warren called us to his chambers and warned Chester and me that if Chester wanted to secure the appointment for his nominee, he would have to call a meeting of the full board and submit it to a vote. Even Chester could see that the situation was getting

out of hand, and at this late stage he chose to call in his lawyer, Stoddard Stevens. Stoddard always claimed that Chester never approached him for advice until he was in real trouble.

A dinner was arranged at Evermay, the Washington house of Lammot Belin, who had stood in as acting President at the Gallery during the war, while David Bruce was abroad, and after David's resignation. Belin invited his old friend John Foster Dulles, a senior partner in Sullivan & Cromwell and, as Secretary of State, an ex-officio trustee of the National Gallery. He also asked Florence and Huntington Cairns, Mary and Chester Dale, Marian and Stoddard Stevens, and Bunny and me. I felt myself to be in an embarrassing position. I had Rush Kress's full support. He had never got on with Chester and used to refer to him disparagingly as "that redheaded chippy chaser." Stevens and Dulles were also fully aware of my feelings on the matter. I knew that I was supporting John's candidacy solely because I thought him the right man for the job. During the evening Stoddard Stevens and Foster Dulles talked privately to Chester Dale and by dint of persuasion, logic, and warnings of disaster brought him around to our point of view. Chester had great confidence in the validity of Stoddard's advice, and on this occasion he felt himself obliged to lower the flag. Huntington Cairns gracefully stepped down, and a crisis was averted.

Stoddard Stevens thereafter sat in on board meetings at the National Gallery to provide legal advice and was subsequently elected a trustee at my suggestion. As in any other undertaking, 95 percent of the business was routine, and any small differences of opinion between the trustees were resolved easily enough.

One important issue concerning picture conservation found our trustees in complete accord. During John Walker's directorship there was a very simple policy in regard to the care of paintings. John saw to it that there was neither a cleaning nor a restoration program, as distinct from conservation. This might appear to have been a rather unenterprising policy, but it was, in my opinion, one of the wisest decisions of his directorship. There were

at that time very few highly skilled restorers in the United States. The Gallery simply employed a sound part-time conservator, Frank Sullivan, who confined himself to minor work.

One of the darkest paintings in the National Gallery of Art, Rembrandt's "The Mill," from the Widener Collection, also happened to be one of John's favorites. The "golden glow" of old, discolored varnish had, with the passage of time, lent the picture a compelling air of mystery. Some scholars even questioned whether the painting was by Rembrandt because the picture was so dark that it was almost impossible to study in detail.

Late in 1977, just as I was leaving for a meeting in Pittsburgh, I was glancing through the "Style" section of The Washington Post when my attention was suddenly drawn to photographs of Rembrandt's "The Mill," with an accompanying article stating that the recently formed Conservation Department at the National Gallery had begun to clean it. Carter Brown had succeeded John Walker as Director in 1969, and I should explain here that when Charles Parkhurst left the Baltimore Museum of Art in 1972 to join Carter as Assistant Director and Chief Curator, he brought with him three conservators, including Victor Covey and Kay Silberfeld, who became the Gallery's first staff conservators.

On reading the newspaper article I became very disturbed and angry to realize that as President of the Gallery I had been left to find out about the cleaning of the Rembrandt in a newspaper article. I also wondered why the conservators should have begun with, above all, what many considered one of the Gallery's most important and perhaps most controversial paintings. I showed the article to John Walker, who happened to be at the Pittsburgh meeting. He went white with rage, saying, "They'll absolutely ruin it." When I got back to Washington, I went immediately to the National Gallery to see Carter and told him I wanted a moratorium put on any further work by the Conservation Department until the trustees found out exactly what was going on.

Another picture, "Deborah Kip, wife of Sir Balthasar Gerbier, and Her Children" by Peter Paul Rubens, purchased with funds from the Andrew W. Mellon Fund in 1971, had recently been

sent to an outside conservation laboratory for treatment and was also causing concern. I decided to invite Michael Jaffé, the Rubens expert from Cambridge, England, and Geoffrey Agnew, the noted London dealer, to come over and discuss the matter with the trustees. I then organized a dinner at our Washington house to which I invited Professor Jaffé, Geoffrey Agnew, co-trustees Dr. Franklin Murphy, Jack Stevenson, Jock Whitney, and Carlisle Humelsine, Carter Brown, the Director, and the New York restorer Mario Modestini. We talked about what should be done at that stage and sought to formulate a policy with regard to the future cleaning and restoration of pictures and other works of art. The next day we went down to the Gallery, and Jaffé and Agnew showed us where they thought things had gone wrong with the cleaning of the "Gerbier Family."

Over at the Conservation Department the staff was up in arms. Its members wrote letters to Parkhurst saying that this investigation was a terrible slur on their reputation and did the Gallery a grave disservice. Because they were federal employees, their jobs were secure, and despite a convention of confidentiality, they could, of course, say openly whatever they liked. One letter took a swipe at me by referring to the "arrogance of wealth." I replied indirectly through Parkhurst, explaining my position and pointing out the responsibilities of trusteeship. In their anger a few of them leaked strongly critical statements to the press. I knew this would be the obvious reaction and decided to pay no attention to it. They would naturally disregard the fact that my purpose was to bring conservation under the surveillance of the President and the trustees, not just the Director and his staff, for ultimately the trustees, as the name implies, are responsible for the collections.

Meanwhile, the trustees resolved to confer with a number of respected museum directors, curators, and restorers to sound them out on their views on what would constitute a sensible policy toward conservation. Anyone who has talked to restorers will appreciate that the issue of picture cleaning and restoration is very subjective. A thorough scientific knowledge and grounding in the methods and materials of the Old Masters and later

painters has to be supplemented by art historical knowledge as well as an innate artistic sensibility toward the artists' original ideas and objectives. I was not altogether surprised that the panel of experts, comprising among others such eminent museum men as Sherman Lee from Cleveland and Otto Wittmann from Toledo, produced conflicting reports. Those who opted for "scientific" restoration approved the Conservation Department's activity, but others who looked for a more aesthetic approach as well were moderately critical.

The trustees then gave the Conservation Department permission to complete the cleaning of Rembrandt's "The Mill," but in face of protests from Parkhurst, they asked Modestini to rerestore the Rubens "Gerbier Family." Once the whole issue had settled down, an article appeared in *The Washington Post* saying that the Conservation Department had been exonerated and that everything would go on as usual. As always in journalism, the most important facts were minimized and left to the end—i.e., that in the future, before any work was taken to the department for restoration or conservation, approval must be sought from the Curator of the department, the Chief Curator, the Director, and the trustees. To this day every meeting of the trustees' Arts and Education Committee has before it a list of paintings, drawings, sculpture, or whatever is going to be worked on, with detailed descriptions of the proposed methods, and with the experts' comments and recommendations. The list is then approved or disapproved by the Committee. I was satisfied that I had made my point.

There is a curious postscript to the cleaning of Rembrandt's "The Mill," the picture that had started all the fuss. Many had imagined that when cleaned, it would turn out to be either a masterpiece or a fake. In fact, it revealed itself to be neither one nor the other. It has been widely accepted as perfectly genuine but seems to many to be a little disappointing as a work of art. Whether the magic had been affected by cleaning or whether it had only existed earlier in the eye of the beholder is difficult to say. The Rubens, on the other hand, was certainly improved by Modestini's treatment.

As a result of our discussions over conservation, we all were determined to find an internationally renowned restorer to oversee the care of the museum's collections. David Bull, who came to the Gallery in 1985, is presently Chairman of painting conservation. He and his team have recently demonstrated their highly professional skills in cleaning one of the Gallery's most beautiful and fascinating pictures, "The Feast of the Gods," painted by Giovanni Bellini and subsequently altered by Dosso Dossi and Titian.

John Walker retired in 1969, to be succeeded as Director by Carter Brown, as mentioned earlier. John had been grooming Carter for the job over the previous eight years and clearly intended that there should be no more dramas such as those that had surrounded his own appointment. Just as David Finley and John Walker nurtured the Gallery and helped enrich it with that wonderful group of gifts, so Carter, as is widely known, has displayed remarkable capabilities as a museum director, overseeing the East Building project to completion, mounting many important special exhibitions, expanding the educational department, and seriously developing the curatorial aspects of museum activity. He has brought the Gallery to the point where it is regarded as a leading international institution.

As a sentimental afterthought to the subject of the "old" National Gallery, I must add my tribute to Prince, the large Alsatian dog who guarded it for a while. He was a magnificent example of his breed. Earlier there had been a lot of concern about security. We used to read newspaper reports about thefts from other museums. In one case I read of a thief who had secreted himself in a telephone booth in a museum shortly before closing time and had then been able to steal a picture when the doors opened the following morning. Apart from worries about theft, we had at that time a lot of trouble with drunks lying about in the shrubbery outside the Gallery, and I had read of organizations using guard dogs to prevent this sort of thing.

I had a word with Carter Brown and the security people at

the Gallery and suggested that they, too, might like to get a dog. They agreed, but it turned out to be anything but simple. For one thing, the dog needed a handler, and both handler and dog required a lengthy training period. In addition, the handler had to be part of the guard force, hence in the Civil Service. Finally we got Prince. After about four to five months, when the training course was nearly completed, the guard unfortunately tripped and fell on top of Prince. Prince, overcome with surprise and confusion, bit him. This produced a canine mental trauma. He had bitten his best friend and, as a result, suffered a sort of nervous breakdown. The program was set back another four or five months because the handler had to rehabilitate Prince by extra kindness and many more hours of training. I even recall that a dog psychiatrist was consulted. Eventually guard and dog came to work at the National Gallery. It worked pretty well for a few months, but by that time Prince was getting old and the guard was due to retire, so that was the end of canine security. "Good night, sweet Prince!"

I suppose the most significant development since Father's original vision of the National Gallery has been the addition of the East Building. Father had shown extraordinary foresight not only in having John Russell Pope design a building far larger than was needed to house his own collection but also in requesting the government to reserve the plot of land just to the east of its site, an area then in use as tennis courts, as a place for the Gallery's future expansion.

I remember strolling through the new National Gallery shortly after the opening ceremony in 1941. It looked very empty, and a number of rooms had no pictures in them at all. Personally I found the paucity of paintings in relationship to the available wall space mildly depressing, and this feeling was echoed in a sly joke at the time pointing out that the guards were there not so much to protect the works of art as to guide visitors to the next painting. In addition, a story was circulating that one lady, seeing the paintings on her first visit to the Gallery, had exclaimed, "How simply Duveen!"

By the time the Gallery's twenty-fifth anniversary came around in 1966, however, the situation had changed drastically. The walls were covered with paintings, and it was proving increasingly difficult to make space for special exhibitions. Furthermore, there were no proper facilities for exhibiting the Gallery's growing collections of graphic art and sculpture, and the library was bursting at the seams.

Apart from the problems of space, there was the question of scholarship. When John Walker finally left Italy and his position as Assistant Director and Professor of Fine Arts at the American Academy in Rome to take up his post of Chief Curator at the National Gallery on January 1, 1939, his old mentor, Bernard Berenson, had urged him not to overlook the educational role played by a public museum. In 1961 John initiated a popular program of art education in schools throughout America known as the National Extension Service.

The original plans for expansion, put forward in 1966, envisaged only a small building on the site previously reserved by my father. The idea was for this to be used for administrative purposes, thus freeing up more exhibition space in the Pope building. John was still very eager to promote the educational side of the museum, however, and he consulted a number of art historians and specialists who were of the opinion that if we were to have a properly equipped study center, we were going to have to enlarge drastically the Gallery's existing art reference library and establish an extensive photographic library as well.

Carter Brown, at the time still the Gallery's Assistant Director, although he was to succeed John Walker during the period of the construction of the East Building, discussed the enterprise with Pietro Belluschi, formerly Dean of the School of Architecture at the Massachusetts Institute of Technology. Belluschi very sensibly pointed out that the Gallery would be well advised to make the most of its one and only chance to expand onto this site, and he recommended providing sufficient space to exhibit more works of art both there and in the old building and to provide for a study center. John came to Ailsa and me, telling us that the costs of this revised plan were estimated to be in the

region of twenty million dollars. I won't bore you with all the details of the countless meetings, the escalating costs, and so forth, but in the end, when the East Building opened in 1978, the final figure had risen to slightly over ninety-four million dollars.

We were unlucky in that construction took place during a period of heavy inflation, which brought with it labor disputes and sharply rising estimates. Ailsa was very supportive up to her death in 1969. We managed to get through with funding that she and I were able to provide, as well as with substantial help from The Andrew W. Mellon Foundation. I attended over seventy meetings of the Building Committee and am told that I never missed one.

One of our most attentive members of the Building Committee was John Hay "Jock" Whitney, whom I had been able to persuade to join us as a trustee several years before the East Building was conceived. I had known Jock from the thirties when we were both concerned with Yale alumni matters (he was a fellow member of Scroll and Key), and when we met occasionally to discuss the growing pains of the new *Newsweek* magazine, of which we were both original stockholders. In addition, we had overlapping terms of office as Stewards of the Jockey Club and were friendly rivals on the racetrack, being represented respectively by his and his sister Joan's Greentree Stables and my Rokeby Stables. Jock was a wise and generous trustee of the Gallery, his generosity having been notably demonstrated by his substantial grant to the Patrons' Permanent Fund and his bequest of a small select group of American and French paintings. Illness overtook him a year or so before the actual completion of the East Building, and he was regrettably unable to attend the dedication or to see the final grand structure before his death.

In addition to the funding, I was very anxious that we should find the right architect. I had some experience in this area, having myself, and through our foundations, provided buildings for Choate, Yale, and other institutions. I had also had some education in building through Bunny. We invited a number of

architects to submit photographs of their work. We drew up a
short list of these, and Carter, who would oversee the project,
Stoddard Stevens, and I set off in my plane to inspect various
buildings around the country. Among those we looked at were
the Everson Gallery in Syracuse, New York, and the National
Center for Atmospheric Research in Boulder, Colorado. Both
these buildings had been designed by I. M. Pei, an architect who
had risen rapidly to the top of his profession. He was also about
to build the Paul Mellon Arts Center at Choate Rosemary Hall.

I have come to know I. M. Pei well over the years. My respect
for him as a man and my admiration for his professional and
creative abilities have grown steadily. I. M. realized that a build-
ing in the modern idiom was indicated, but that it should har-
monize with its neighboring buildings: to the east the Capitol
and to the west Pope's original gallery, both designed in the
neoclassical style. This effect was partially achieved by facing
the new building with marble from the same Tennessee quarry
that was used for the original Gallery.

Whenever I visit the East Building, I cannot help feeling ex-
cited. Its outward form has such pure surfaces and presents
such dramatic perspectives. As I walk into the atrium, there is
every urge to look up at the cunningly contrived straight lines
and angles. In a way it reminds me of those wonderful prints
by Giovanni Battista Piranesi called "The Prisons." Hardly a
suitable comparison, you may think, but to my mind I. M. has
managed to achieve in this building a sense of fantasy compa-
rable with that of the great eighteenth-century architectural
draftsman and engraver. I. M. told us later that the trapezoid-
shaped ground plan of the site was one of the most difficult he
had ever had to contend with. In any event, he made a virtue
of necessity and divided the trapezoid into two triangles, one
of which shared the axis of the old building.

The division of the new building in this fashion had the added
attraction of reflecting its double function. The larger triangle
provides public spaces and exhibition galleries, while the
smaller performs a more restricted role, housing administrative
offices, the library, and the Center for Advanced Study in the

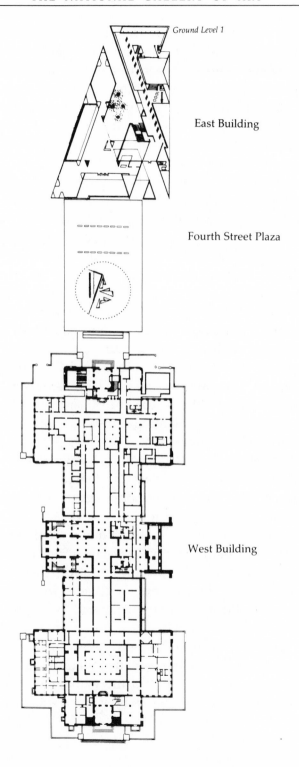

Ground Level 1

East Building

Fourth Street Plaza

West Building

Visual Arts. When walking around inside the building, I am entertained by I. M.'s sense of fun in introducing trapezoid and triangular shapes into the flooring patterns and even the elevators. The main part of the building is however highly flexible in order to accommodate large crowds and temporary exhibitions of different types and sizes. Miraculously, I. M. managed to do this without making the interior divisions look impermanent.

Locating the administrative offices and the library in the new building freed a great deal of space in the West Building, as it is now called, and an underground link was built to connect these two buildings and to provide space for a large cafeteria, museum shops, and storage space. Renovation of the West Building's ground-floor spaces then took place, and this project, named Operation Breakthrough, required dismantling heavy equipment in the West Building's fan room and circumventing or, after the construction of new supports, breaking through structural barriers, hence the project's name. As luck would have it, the A. W. Mellon Educational and Charitable Trust in Pittsburgh, the foundation established by Father in 1930, was being liquidated in its fiftieth year in 1980, and plans were under way to distribute its remaining funds. Among its terminal grants, with my encouragement, the Trust provided a sum of five million dollars toward Operation Breakthrough, and this, along with some assistance from the federal government and my own contribution of a little more than three million dollars, helped see the enterprise through.

The opening ceremony of the East Building took place on June 1, 1978. It was one of those very warm late-spring days for which Washington is renowned. The guests sat on chairs under the broiling sun outside the shimmering facade, while I turned the building over to President Jimmy Carter, "to be dedicated forever to the use and enjoyment of the people of the United States." My father never witnessed Pope's plans for the West Building come to fruition, but were he to return, I think he could not but be pleased at the sight of the whole museum complex of the West and East buildings as they stand today.

CHAPTER 16

The Yale Center
for British Art
and the Virginia Museum
of Fine Arts

———◆———

Art is a Rum Go!
J.M.W. TURNER, R.A.

In a considerable departure from collecting the Impressionists and from my involvement with the National Gallery, my foray into British art in the fifties and sixties (my forties and fifties) resulted in the establishment of another museum, the Yale Center for British Art.

When you think of it, collectors differ a great deal in their motivation. It seems to me that there is a certain type of individual who, later in his life, withdraws more and more from business and social life and treats works of art as his friends and companions. With some notable exceptions, these have nearly always been men. Then there are artist collectors who enjoy being surrounded by their fellow artists' work. There is the man whose collection is going to be his key to immortality, as he sees his name attached in perpetuity to the institution to which he prepares to leave it, or the collector who is not very sure of himself, whose collection lends him security and social standing. There is the investor who is planning his sale even as he buys. I don't think I have been collecting for any of these reasons, but I will admit that it is an incurable habit.

Collecting is the sort of thing that creeps up on you, prompted

by a number of influences, some of which you are not even conscious of. Bunny's interest in French nineteenth- and twentieth-century painting undoubtedly stimulated mine in that direction. The fact that my father collected Old Master paintings must have had its effect on me, and undoubtedly my meeting with Basil Taylor encouraged me to start collecting British art. Basil's energetic and enthusiastic scouting for me in England, and the impetus provided by my financial resources coupled with the ample availability of British art at the time, meant that I very soon had to consider what I was going to do with this rapidly growing collection. Not only were paintings arriving in large numbers, but whole collections of drawings were being purchased as well as hundreds of books and prints.

I think the shows of British art from 1963 to 1965 in Virginia, in London, and at Yale really marked for me the watershed between the concept of a private and a public undertaking. Andrew Ritchie, Director of the Yale University Art Gallery, advocated giving the collection to Yale, while Leslie Cheek, Director of the Virginia Museum, suggested a new wing to house it at his museum. Yale was perhaps the most important center in the United States for British studies, particularly those of the eighteenth century. One of my former English professors, Frederick Pottle, was editing the journals of James Boswell, and our mutual friend, Wilmarth "Lefty" Lewis, in nearby Farmington, was editing the voluminous correspondence of Horace Walpole, including his own large collection of letters to and from Walpole that was eventually given to Yale.

I shared my thoughts with Basil Taylor, and we agreed on the importance of making the museum/study center an independent institution, separate from the Yale University Art Gallery. Basil's view was that although we both knew that Andrew Ritchie appreciated what I had in mind, a future Director of the University Art Gallery might not be sympathetic to the cause of British art.

In December 1966 Yale announced that I intended giving it my collection of British paintings, drawings, prints, and books together with a building to house them, along with endowment

funds for maintenance of the building and for academic and curatorial purposes.

Shortly after Yale President Kingman Brewster had agreed to a separate administration for the Center, he appointed a committee headed by Louis Martz, a distinguished scholar of seventeenth-century English literature, to make policy recommendations. The committee met throughout the summer and autumn of 1967 and at the end of that year produced its report, in which it outlined an elaborate academic and scholarly program. The main recommendation was that Yale should establish an interdisciplinary study center devoted to "British culture and society within the period 1625–1850, with the Paul Mellon Collection of British Art as the focal point."

I would be the last person to denigrate scholarship in historical and sociological studies—rather the opposite—but I thought the report missed the point of why I had formed the collection in the first place. I fully appreciate that when one looks at pictures, it increases the pleasure to have an understanding of the social and economic backgrounds of the periods in which they were painted. Other factors, from literary connotations to the history of costume, also play their part, but paintings, insofar as they are works of art, stand or fall on their own merits. Richard Wilson in Rome, George Stubbs at Newmarket, J.M.W. Turner in the Alps, or John Constable on Hampstead Heath were, in my view, committing to canvas their wonder at the splendors of nature and at the beauty of light. In other words, I thought of the Center as an ideal institution for the study of British art and only incidentally of British manners and customs, of its history and mores.

My objective in giving these collections to Yale was largely to give young men and women an opportunity to enjoy them at a period in their lives before age and familiarity dulled the immediacy of their visual impact. I would have been saddened if the only purpose the pictures were going to serve was to replace lecture slides. Accordingly I wrote to Jules Prown, a member of the committee who became the first Director of the Center and was one of the leading enthusiasts for interdisciplinary studies,

telling him I was concerned about the Center's becoming a vague nexus of "cross-fertilization," rather than a place for the study of British art.

I thought I had better leave it at that, as I am always hesitant to step in where angels fear to tread (although not all academics are "angels"). Yale is, after all, a teaching institution, so I assented to the Martz committee's report. As things turned out, I need not have worried because as happened with the East Building of the National Gallery of Art, costs rose sharply during the course of construction. In the Yale Center's case, many of the committee's recommendations had eventually to be abandoned as part of a cost-cutting exercise.

In the spring of 1969, after Jules Prown's appointment as Director, he and I had to start our search for an architect. Like me, he was attracted by the work of Louis Kahn, the eminent Philadelphia architect. Kahn produced a plan, but it turned out that severe inflation in building costs had so eroded the purchasing power of the funds I had provided that Yale could no longer afford the impressive design. As a result, Kahn had to revise his plan. Because the original one had been more than ample, he was able to provide adequate exhibition and storage space while assuring a building of elegant style and fine proportions. To tell the truth, I liked the revised plan much better than the original one.

Unhappily, in 1974, Kahn died suddenly from a heart attack in the Pennsylvania Station in New York. He had been generally slow in producing architectural drawings, and many of his ideas for completing the building, especially its interior, had not yet found their way onto the drawing board. Marshall Meyers (who had worked with Kahn for years) and Anthony Pellecchia were appointed to finish the building, doing the best they could with the sketches Kahn had left and borrowing ideas from his earlier buildings. As things turned out, I think the building and in particular the interior have been a resounding success.

Not long after Kahn's death Jules Prown announced that he wished to resign the directorship at the end of 1975. It was good

of Jules to stay on as long as he did. He was a tremendous help during the period of construction, and it could have been little comfort to him to know that he was a museum director without a museum and with a collection stored elsewhere. I had realized for some time that as a University professor he was longing to get back to teaching. There was a protracted search for a new Director, and several candidates turned down the post. There might have been a feeling at the time that the directorship was outside the mainstream of American museum jobs. In the end, President Brewster and I persuaded Edmund Pillsbury, the Curator of European painting in the University Art Gallery and a lecturer in the Art History Department, to succeed Jules.

Ted turned out to be an inspired choice. He stepped into an unenviable situation. The building, due to open in 1977, still wasn't finished. Inflation continued to erode construction funds. The Center's programs had not been worked out in any detail, and many staff positions remained unfilled. Ted's first duty was to formulate a realistic budget analysis. This study projected a considerable overrun in building costs as well as large annual deficits in the Center's operating expenses. His researches also brought to light certain fees and charges that were being imposed by the University on the Center's funds, funds I had donated.

Stoddard Stevens and Frederick Terry, my lawyers from Sullivan & Cromwell, as well as Ted Pillsbury and myself, worked out future financial requirements over many weeks with the Yale officials, and Ted managed to get the building completed, the collections installed, and a staff hired in time for the Center's scheduled opening. He shared my feelings about the Center being primarily a museum, and he did not attempt to promote interdisciplinary studies, focusing attention instead on the collection and the exhibition of its contents. There was a week of festivities accompanying the opening of the Center in April 1977.

From the beginning Ted proved to be the ideal person to head the Center. While he may initially have encountered difficulties in assembling and directing his staff (he was, after all, quite new

to the game of administration), he nonetheless set about assuring that the Center had a firm financial base. Never shy, he stood up to the subtle bullying of the then Treasurer of the University and wasn't afraid to lay his frustrations before the President, doing so in no uncertain terms.

At the very beginning he quite sensibly obtained from me certain guarantees regarding future endowment of the Center, pointing out succinctly its present fragile underpinning. I explained to him that I would prefer to underwrite the Center's annual deficit for at least five years, which would give us time to estimate more accurately what the eventual endowment should be. This seemed to both of us a fair and practical method of assuring the Center's well-being. I have been underwriting the annual deficit personally ever since, so that by now it is clear what the minimum endowment should eventually be, and I have made sure that a testamentary bequest will adequately protect the Center for the foreseeable future.

Ted relinquished his directorship in 1980 to take up the position of Director at the Kimbell Art Museum in Fort Worth, Texas. Louis Martz then served as interim Director until the arrival of Duncan Robinson in 1981. Duncan had been at Clare College as an undergraduate and, as a result of having been awarded a Yale-Clare Fellowship, had previously been at Yale as a student. Later, he held the post of Curator at the Fitzwilliam Museum. It is not just as a Fellow Clare College man that I declare my friendship with and confidence in Duncan. He has proved himself equally adept at opposing extraneous University inroads into the Center's financial structure. His relationship with those departments most academically related to the Center—i.e., History of Art, History, and English—has always been generous and friendly. To that it must be added that his relationship with the Center's own people, from Curators to maintenance and security staffs, has been pleasant and helpful. I frequently fly up to New Haven for the day, and it is always a great pleasure for me to meet with the staff and to have an opportunity to look again at the paintings and drawings, the books and prints that I had such fun collecting.

There are two other organizations, one now gone, related to the Yale Center. The first was The Paul Mellon Foundation for British Art, a London-based publishing house that saw its rise and fall before the Yale Center opened; the second, its successor, The Paul Mellon Centre for Studies in British Art, has developed as the London subsidiary of the Yale Center or, one might say, its partner.

The Paul Mellon Foundation for British Art in London was established in a roundabout fashion. It was not entirely unconnected with the return to paid employment of my friend and adviser Basil Taylor. You may recall that Basil had resigned his post at the Royal College of Art late in 1961. From then on he spent most of his time looking out for potential new acquisitions in the English field for my collection, but because he still refused to accept any payment from me for these services, he was bereft of income.

It so happened that a collection of English watercolors from the Martin Hardie estate became available for sale in 1961. Martin Hardie had been Keeper of Prints and Drawings at the Victoria and Albert Museum as well as a practicing watercolor artist in his own right. He was one of that small band of enthusiasts, who also numbered Paul Oppé, Leonard Duke, and Iolo Williams, that before the war, and with a few shillings in their pockets, haunted antique shops on weekends in and around London in search of English watercolor drawings. In his retirement Hardie had written a book on the subject. His collection contained a large number of interesting items, and Basil recommended that I buy it *en bloc*. While arrangements were being made about the purchase, Hardie's widow told Basil and me that she very much hoped to see her late husband's book published.

Negotiations had been entered into with several publishers, including Batsford, but they were in abeyance because of costs, and the book really called for thorough reediting. Hardie's style of writing was dated and flowery, and although his work contained a great deal of excellent material, the results of more

recent research needed to be included. Basil Taylor discussed the manuscript with Sir Herbert Read, the poet and art critic, who was a Director of the London house of Routledge & Kegan Paul, C. G. Jung's London publishers. Through this firm he had formed a close association with Bollingen Foundation and hence had become a friend of mine.

As a result of protracted discussions among Herbert Read, Basil, and myself, it was decided that I would underwrite the overhaul of Hardie's book, and I also asked Basil to draw my attention to any other writings on British art that were looking for a publisher. Within this context grew the concept of a publishing venture aimed at promoting a wider understanding and knowledge of British art. A nonprofit Charitable Trust was then established with independent self-governing British status and with its own board of trustees, to publish "Studies in British Art." The new project started life under the wing of the Bollingen Foundation but was shortly afterward transferred to the financial control of the Old Dominion Foundation and named The Paul Mellon Foundation for British Art.

Basil Taylor was appointed Director, and in 1963 he started the whole enterprise from scratch, engaging staff, setting up a design team, appointing an in-house art photographer, contracting work out to printers, etc. The offices were established on two rented upstairs floors at 38 Bury Street, St. James's. It may have been a bad omen that the Director's office looked directly across the street toward the "gentleman's chambers" that had been occupied by the nefarious Curphey more than fifty years earlier. Basil lost no time in engaging authors. He persuaded Dudley Snelgrove, whose interest was in research, particularly in the field of English watercolor drawings, to take early retirement from the British Museum in order to join Jonathan Mayne from the Victoria and Albert Museum in editing the Martin Hardie manuscript. Hardie's book, *Water-colour Painting in Britain*, subsequently appeared in three volumes (1966–68). It was not published by the Foundation but appeared under Batsford's imprint and is now considered a standard work on its subject.

The Foundation's first three books were published in 1967.

Dr. Robert Raines wrote a monograph, *Marcellus Laroon*, on the soldier-singer-artist who lived from 1679 to 1772. Sir Roy Strong produced a book on Hans Holbein at the court of Henry VIII, the theme deriving from a lecture he had delivered at the Frick Collection and at the National Gallery of Art in the spring of 1965. Sir Oliver Millar wrote an extended essay on the subject of Johann Zoffany's painting "The Tribuna of the Uffizi." Each of these scholarly works was beautifully produced, and a contemporary reviewer commented, "Two or three great names apart, British art puts the fear of bankruptcy into publishers all over the world . . . it will, I hope, be clear that our much abused British School is at last being treated as it deserves." Further titles followed, such as Benedict Nicolson's splendid two-volume study *Wright of Derby*, Denys Sutton's *An Italian Sketchbook by Richard Wilson*, Mary Webster's *Francis Wheatley*, and *The English Icon* by Sir Roy Strong. More were in preparation, including the Mitchell Prize-winning *The Paintings of J.M.W. Turner* by Martin Butlin and Evelyn Joll, *The Diaries of Joseph Farington*, edited by Kenneth Garlick and Angus Macintyre and later by Catharine Cave (both subsequently published by the Yale University Press for the Foundation's successor). Basil's energy knew no bounds.

Why, then, did the undertaking go so disastrously wrong? I think the answer must surely be found in Basil's own self-destructive psyche. His moods oscillated between periods of great creative energy and spells of mental exhaustion. He appeared to many of us to be developing a distressing mental illness, the nature of which can only be guessed at but which harbored symptoms of manic-depressive psychosis. Primarily, his "sense of mission," as he put it, to rehabilitate the reputation of British art was impelled by a visionary spirit that had the hallmark of genius, but then, on the other hand, there was some deep-seated insecurity that led him to say openly, "I have to test all my friendships to the breaking point." This urge doubtless accounted for his previous numerous changes of employment, and it was to bring about the end of the Foundation in which he had invested so much of himself.

As Director of The Paul Mellon Foundation for British Art, Basil was directly dependent for financial support on the Old Dominion Foundation, which provided subventions at the beginning of each calendar year. The Old Dominion Foundation trustee with whom he found himself dealing with chiefly was Stoddard Stevens. Basil and Stoddard had nothing in common, and Basil, who regarded Stoddard as a hard-nosed Philistine, conceived a virulent dislike for him. For his part, Stoddard considered Basil amateurish, effete, and financially irresponsible. Basil decided he would bypass Stoddard and deal directly with me, on the ground that we enjoyed a mutual confidence. What I couldn't get Basil to understand was the fact of his dependence on the Old Dominion Foundation for money. Stoddard was right in thinking that Basil had very little understanding of money. Basil knew that he wanted to organize and direct the study of British art in a "coherent and purposive way," and he knew that I had a deep pocket, so he thought that was all that was needed.

On one occasion, while Basil was talking to Stoddard Stevens in the latter's Wall Street office, Stoddard referred to a letter Basil had written to me on the subject of the English Foundation's finances. Stoddard picked up a telephone and had the pertinent file brought in. From it he extracted the letter and continued the conversation as he examined it. Basil expostulated that Stoddard had no right to have the letter, that the letter included passages about his personal affairs. Stoddard explained that all material containing business matters relating to the Foundation wound up in his files and added, as he thought, soothingly, "Basil, I know you're an artist."

Basil glowered at him and replied, "I am *not* an artist, Mr. Stevens. I am an art *historian*."

Another time, when financial matters were being discussed, Stoddard offered to double Basil's salary and met with a furious rebuff, Basil saying that his cooperation was not to be bought. Basil claimed that in all the legal arrangements Stoddard set up for me, there was invariably a trapdoor and that Stoddard was always sitting there contemplating the lever. Stoddard's prob-

lem, however, was trying to persuade Basil to constrain himself to operate within the annual budget set by Old Dominion.

Apart from its role as publisher, The Paul Mellon Foundation for British Art funded university lectureships at York and Leicester; it assisted with the costs of several museum exhibition catalogs; it helped to mount exhibitions of British artists, notably at the Aldeburgh Festival; and it lent support to the Suffolk Records Society with its publication of *John Constable's Correspondence*, edited by R. B. Beckett.

All these activities could have been contained within the budget, but there was one undertaking whose projected costs went soaring far beyond it. This was a comprehensive art dictionary to be known as *The Paul Mellon Biographical Dictionary of British Painters in Great Britain and Ireland, 1530–1950*. It was to consist of fifteen volumes, each of about 750 pages, and there were to be approximately fifty thousand entries. It was also hoped there would be a multivolume full-plate illustrated supplement. We were later informed, in 1969, one year after Basil had resigned, that the production costs of the Dictionary were estimated at about 1.4 million pounds for an edition of five thousand copies. With inflation, the costs would have risen much higher. Despite the fears of the Old Dominion Foundation trustees that the finances were getting out of hand, Basil was determined to see this scheme through to completion. He turned to me for support, saying to his Assistant Director, Angus Stirling, "I've got to test this relationship with Paul Mellon. I've got to test whether he is a true friend of mine or not, and I've got to go and make these demands because only then will I know that he's really willing to support me and the Foundation."

Angus Stirling told him that he couldn't do that and it would be putting me in an impossible situation. Meanwhile, Stoddard advised me that if Old Dominion were to increase its subventions to The Paul Mellon Foundation for British Art too sharply, it could well lead to criticism in Congress about excessive tax-exempt foundation funds being siphoned off for use overseas. Stoddard was doubtlessly remembering Congressman Wright Patman of Texas, a populist who never missed an opportunity

to attack foundations in general and our family in particular, and who in 1969 was to describe the Bollingen Foundation as having been concerned with grants for "the development of trivia into nonsense."

It has only been during the course of research for this book that I have come to know the full details of the sad story of these distant events. I personally very much regret that the Dictionary never appeared and cannot help feeling that if things had been handled differently and if Basil had had a more equable nature, it might have been possible to overcome the problems.

Basil pressed home his demands directly on me through letters and telephone calls. I remember that some of the latter lasted well over an hour. He would start out with bitter recriminations and a long list of grievances, while I would try to calm him down with soft answers and indirect compliments. This often worked, and the call would end on a friendly and positive note.

Basil threatened to resign on a number of occasions, and toward the end of 1968 he carried out his threat in stages. In August he announced that he intended to resign from the board of trustees; then, in October, he asked the trustees in London for a three-month leave of absence. He subsequently resigned his directorship also.

He walked out, leaving Angus Stirling to administer the Foundation and another colleague, Colin Sorensen, to take care of the publishing side. Basil had, in fact, led each of them to believe that he would be the only Director. Having two directors was a very unsatisfactory arrangement, but they struggled on. Angus Stirling made valiant efforts to straighten out the finances, interrupting a holiday in Italy in November to fly to the United States with Sir Charles Whishaw to talk with Stoddard and our Old Dominion co-trustees. Whishaw, senior partner in Freshfields, the eminent firm of London solicitors, was head of the Gulbenkian Foundation's English organization and also served as Chairman of the trustees and spokesman for The Paul Mellon Foundation for British Art.

I had met Angus Stirling only once, when Basil had brought

him along to a luncheon at Claridge's. Stirling, who went on to
have a distinguished career with the Arts Council and as Direc-
tor General of the National Trust, later said he thought that he
and Colin Sorensen made a mistake in not trying to co-opt the
services of a leading figure in the art world, who might have
retained my confidence and that of the Old Dominion trustees.
They were young and relatively inexperienced when this crisis
was suddenly thrust upon them, and I, for my part, was not
fully aware of the difficulties that were facing them. I have al-
ways liked to act through individuals whom I have known well
and who have enjoyed my trust, friends like Jack Barrett at Bol-
lingen, Ernie Brooks at Old Dominion, and Adolph Schmidt at
the A. W. Mellon Educational and Charitable Trust, so I consid-
ered that now Basil had left, my direct role in The Paul Mellon
Foundation for British Art had come to an end.

With planning for the Yale Center for British Art going for-
ward, it became clear to the people at Yale that an outpost would
be needed in England. It seemed appropriate to President Brew-
ster and his advisers on the Center's Committee on Academic
Policies and Programs that the University should take over the
Foundation in London, and since I thoroughly agreed, I gave
them an endowment of five million dollars to enable the Uni-
versity to put the organization on a sound and permanent foot-
ing. It was subsequently established under the name of The Paul
Mellon Centre for Studies in British Art.

Jules Prown flew to London in September 1969 with the task
of informing the trustees of the London Foundation of some of
Yale's plans. Brewster and others at Yale were quite frank about
wishing to make the London Foundation an appendage of the
Yale Center, and Jules explained to the trustees by stages (per-
haps he couldn't bring himself to spell it all out at one time) that
Yale wished to discontinue a number of the Foundation's activ-
ities, including direct publishing, the backing of exhibitions, and
the Dictionary of British Artists.

The London trustees and the staff of the Foundation became
very alarmed, regarding Jules' plans as devious and demeaning.
Sir Charles Whishaw complained that future policy had already

been decided by Yale, that Jules had set about altering the Foundation without consulting anybody in England, and that he feared for the Foundation's independence. I went, in the company of Stoddard Stevens, to visit the English trustees in London in December 1969, attempting to allay fears and explaining that the Foundation's essential work was now endowed rather than being dependent on appropriations from an American foundation. It seemed very difficult to get them to understand, however, that neither an American foundation nor an American university could allow a foreign foundation to operate without some control over its funds.

During the same month there was a conference to discuss the Dictionary. Jules Prown advised the London trustees that the Dictionary would not go forward as originally planned and that as a result, most of the staff would have to be dismissed. Tempers flared and, in an atmosphere of deteriorating relations, misunderstandings crept in. Jules stated that he had not undertaken to arrange for six months' payment to be made to all those on the staff who would have to leave, because some had only recently been employed. Staff salaries were absorbing by far the largest part of the Foundation's appropriation. Whishaw claimed that Jules had made such a promise. Jules went back to England in February and March 1970 to take care of various details and to form an advisory committee. Whishaw told him that he and his co-trustees were not prepared to serve on such an advisory board. The English trustees then tried to raise funds in England with a view to bringing the Foundation under English control, but when it became clear by the middle of 1970 that they were not going to succeed with this plan, they agreed reluctantly to hand over the Foundation's assets to the new Centre. At this stage Jules set about establishing a reconstituted Yale-directed London Centre, with an advisory council and a much-reduced staff.

It was sad that a scholarly enterprise, undertaken with such high hopes, should have ended with feelings of deep resentment on both sides of the Atlantic. Basil entered into a part-time advisory arrangement with the London dealers Spink & Son, a

post from which he resigned on a friendly basis in November 1972. He was later offered a University appointment in England but did not accept it.

He knew his mental health was deteriorating and sought psychiatric help. He distanced himself from a number of his friends, myself included, and it upset me to think that he had really turned against me. Although closely supported by his family, he became very isolated in his unhappiness. In 1975 everyone who had known him was deeply distressed, not only for him but for his wife Kay and their son, Michael, when they learned that he had committed suicide.

After the opening of the Yale Center for British Art in 1977, I invited Kay Taylor over to America, and together we visited the Center, so that she could see how much her late husband had accomplished. I recently purchased a fine marble bust for the Center of the eighteenth-century poet Alexander Pope by Louis François Roubiliac, and Duncan Robinson and I are arranging that there should be an inscription on the base reading "Gift of Paul Mellon in memory of the British art historian Basil Taylor, friend, mentor, and generous source of wise advice in the course of assembling this collection of British art."

Jules Prown found premises for the newly established Centre in London at 20 Bloomsbury Square, in part of a building that it was to share with the Yale University Press. Most important, he persuaded Sir Ellis Waterhouse, the eminent art historian, to take the position of Director of Studies, a post he held from 1970 to 1973. Naturally the character of the new Paul Mellon Centre for Studies in British Art was very different from that of the old Foundation. In broadest terms it is fair to say, however, that the Centre more or less shared the aims of the Foundation it replaced. The Dictionary was scuttled, but the Centre took over a number of projects initiated under the Foundation, including Ronald Paulson's study of William Hogarth, published in October 1971 on the day the new quarters at Bloomsbury Square were officially opened. It ceased, however, to be an autonomous publishing house, and in July 1970 an agreement was reached

between the Centre and Yale University Press whereby if each party so wished, manuscripts were handed over for publication by the Press.

A steady stream of major publications has since appeared from the Press under the Centre's name, including Andrew McLaren Young, Margaret MacDonald, Robin Spencer, and Hamish Miles' *The Paintings of James McNeill Whistler*, Martin Butlin's *The Paintings and Drawings of William Blake*, and Graham Reynolds' *The Later Paintings and Drawings of John Constable*. The Centre has also continued some of the Foundation's other activities, including the photographic archive and the program of grants. An early project of the old Foundation was revived when Sir Brinsley Ford donated his voluminous material on British artists in Italy to the Centre. Brinsley had worked on this subject for many years, and Basil had hoped to adopt the project. However, he was soon lamenting that Brinsley suffered from that old academic problem of not being able to stop writing. Incidentally, Basil shared this failing in the preparation of his intended magnum opus on George Stubbs, a book that unfortunately never finally appeared. In Brinsley's case, however, he has made the material available. It has been taken in hand and is being edited by Kim Sloan as *A Dictionary of British Visitors to Italy in the Eighteenth Century*. Clare Lloyd-Jacobs is similarly occupied on a project for a chronologically arranged archive of reviews and comments relating to art exhibitions in London that appeared in eighteenth-century newspapers and periodicals.

More and more, however, the Centre has come to serve Yale directly. Christopher White, who succeeded Waterhouse as Director of Studies in London from 1973 to 1985 and who became Associate Director of the Yale Center in 1976, continuing in this role until 1985, sought a "closer rapport" between the University and the London Centre, especially as the Yale Center for British Art neared completion. He achieved this mainly by sponsoring educational programs for Yale undergraduates. Students were provided with courses based in London, and this tuition, incidentally, supplemented the Centre's income. In 1977, the year

in which the Yale Center for British Art opened, the first summer school was held at the London Centre, offering students courses on British art. It was sufficiently successful to encourage Christopher to introduce in 1981 a yearlong "Yale in London" program, extended to courses in British history and literature as well as British art. In 1985, when Dr. White became Director of the Ashmolean Museum, Professor Michael Kitson, formerly Deputy Director of the Courtauld Institute, took over as Director of Studies of The Paul Mellon Centre for Studies in British Art.

The third museum with which I have been closely associated is the Virginia Museum of Fine Arts in Richmond. My relationship there goes back to 1938, when I was elected a trustee of what was, from its foundation, the first state-supported art museum in the United States. At the time of my election the Museum was just two years old. I continued to serve as trustee for forty-one years, until I resigned, because of my age, in 1979. The Museum receives appropriations from the legislature for capital funds and general operations, while relying on private donors to provide money for acquisitions and special projects.

In 1954 the Museum embarked on the construction of a north wing to provide additional gallery space for its expanding collection and to accommodate storage facilities for its statewide exhibition services. Planning had begun in 1948, and construction was to have started in 1950 but was delayed by the Korean War. The Commonwealth of Virginia appropriated one million dollars for this project, but as the program advanced, further sums were needed, and Old Dominion Foundation was among the contributors. Old Dominion also provided funds for a project that was very close to the heart of Leslie Cheek. Leslie, whose energetic directorship lasted over twenty years, had a passion for imaginative display, publicity, and theatrical presentation. This approach occasionally threw him into conflict with some of the Museum's more traditionally minded supporters, but there was no doubt that his activities brought the Museum to the attention of a much wider public within the state as well as in the country at large.

Leslie wanted to make the Museum into a popular cultural center, and one of his greatest needs, which he enthusiastically pressed home on me and my fellow trustees at Old Dominion, was for a theater for the performing arts. It would offer a variety of music, dance, film, and drama performances featuring both amateur and professional talent. Funds from the Foundation enabled the Virginia Museum Theater, incorporated within the structure of the Museum itself, to be completed by 1955. It has been a great success.

Another of Leslie's enthusiasms was the outreach program: taking art to the people of the far-flung towns and villages of Virginia. He formed local museum chapters and affiliates to increase membership and had a large panel truck fitted out as a miniature museum on wheels to travel about the countryside. He once persuaded me to lend some French Impressionist paintings to decorate the walls of this "Artmobile." It made its first stop at the Community Center in Middleburg, Virginia, in September 1962 and was hung with pictures by Monet, Renoir, Manet, and Gauguin, works that for the most part are now in the National Gallery or the Virginia Museum. I can't remember whether any of them was insured; probably not, but art prices were not as flagrant and security problems were not as urgent as they are today.

I really can't say that I was neglected by Leslie. I used to receive at least two letters a week from him, and after the 1960 loan exhibition "Sport and the Horse" and the 1963 showing of part of my English collection entitled "Painting in England, 1700–1850," he approached me to try to persuade me to give or bequeath the English collection to the Museum. To make the prospect more attractive, he suggested the construction of a new west wing to house it and included with his request schematic drawings of the proposed structure. As I have explained, Andrew Ritchie at Yale had already broached the subject, and I was disposed to favor a location where the collection could be enjoyed within a university environment. However, I admired Leslie's enterprise and started to consider what I ought to do for his museum in the way of gifts and bequests.

In the mid-seventies I reopened discussions on the possibility of giving part of my collection to the Museum. By that time Leslie had retired. I had long been a close personal friend of Dr. William H. Higgins, Jr., a Richmond physician, who had been President of the Museum board of trustees, so I took up the matter with him in September 1977. I sent Bill a letter outlining my intentions and explained to him that whereas I had been much preoccupied over the previous decade with the East Building at the National Gallery of Art and with the Yale Center for British Art, I now thought it was time to talk about Richmond's needs. I asked him if he would be prepared to act as intermediary between me and the Museum, its President, and board of trustees, and he agreed to do so. As our plans progressed, it transpired that Frances and Sydney Lewis of Richmond were making similar plans regarding their collection of contemporary art, Art Nouveau, and Art Deco objects. There was no question but that the Museum would need more space to exhibit all the works of art we and the Lewises were proposing to give. In 1979 I met informally with the Lewises and Museum officials to discuss building plans and funding. The following year Governor John Dalton expressed support for the scheme in his "State of the Commonwealth" address and promised additional capital funds. The West Wing took three years to build and was dedicated on December 3, 1985. There followed opening celebrations during the week of January 16, 1986, when the Museum marked its fiftieth anniversary. So it came about that the West Wing, which Leslie Cheek had dreamed of fifteen years earlier, became a reality.

Malcolm Holzman, of Hardy Holzman Pfeiffer Associates of New York, was the architect. The building is constructed of buff-colored Indiana limestone, and the large central hall, or atrium, is of striking Italian marble quarried near Verona. As you enter from the atrium and approach the side of the wing containing the collections Bunny and I have donated (Frances and Sydney have their collections displayed in the matching area on the other side of the West Wing), you walk past a group of animal sculptures by Herbert Haseltine. Beyond them is hung a collec-

tion of eighteenth- and early nineteenth-century British sporting paintings, drawings, and prints, to which is added a room of American nineteenth-century paintings. Upstairs on the next floor are French pictures, drawings, and sculpture, representing the major periods of art history from Romanticism to Impressionism and Post-Impressionism to Cubism and Surrealism. In addition, a small room houses a collection that Bunny and I have lent (ultimately to be given) of objets d'art in gold, enamel, and semiprecious stones. These were commissioned by Bunny and created by Jean Schlumberger, the talented jewelry designer.

Our collections are now being cared for by Malcolm Cormack, who has recently succeeded the late Pinkney Near as Paul Mellon Curator. Malcolm was formerly Chief Curator at the Yale Center for British Art, having, like Duncan Robinson, spent the earlier part of his career at the Fitzwilliam Museum in England.

CHAPTER 17

Simplifying
My Responsibilities

———◆———

"If seven maids with seven mops
Swept it for half a year,
Do you suppose," the Walrus said,
"That they could get it clear?"
"I doubt it," said the Carpenter,
And shed a bitter tear.

—CHARLES DODGSON (Lewis Carroll)
Through the Looking-Glass

I was at a period in my life during the fifties (my forties) when my engrossing interests were at their zenith, from collecting Impressionist paintings and drawings, British art and rare books, to hunting, racing, and thoroughbred breeding.

But paralleling these varied interests were growing concerns about my ability to handle more real responsibilities: my trusteeships at the National Gallery and the Virginia Museum, at the Mellon Institute in Pittsburgh and the Virginia Polytechnic Institute (VPI, now known as Virginia Tech), at the Fund for the Advancement of Education (an offshoot of the Ford Foundation) and the Conservation Foundation. Although I found them all interesting and their problems intriguing to work on, I still had a lingering feeling of inadequacy from childhood and a constant worry that I wasn't pulling my weight and that all my colleagues, whether in business or in educational and artistic activity, were much brighter than I was.

I had been in analysis with a Washington Freudian psychoanalyst named Dr. Jenny Waelder-Hall from the early fifties. Bunny and I had been married for about five years, and we both

(history repeats itself) needed psychological help or at least support and counsel. We consulted Clem Fry of the psychiatric department in the Yale Department of Health, who guided us each to a Freudian analyst. I had known Clem only slightly at Yale. After meeting him years later on a voyage on an ocean liner in 1947, when Jack Barrett and I saw a good deal of him, I came to think of Clem as a down-to-earth and wise counselor.

Clem arranged some sessions for Bunny with a well-known Freudian in Washington. It was a hopeless project from the beginning. On her second visit, which happened to be near Christmas, she took the analyst some flowers from our greenhouse. The psychiatrist not only refused to accept them but immediately began questioning her motives. Well, if you knew Bunny, you would realize why this was the end of that session *and* the end of the treatment, and I thoroughly sympathized. It seemed to me at the time that the rules of the Freudian game (no apple for the teacher, no social relationships; just lie on the couch and forget the listener behind you) were anathema to certain types of people. In any case, Bunny went elsewhere for counseling and eventually was helped greatly by one or two psychiatrists of a more human and understanding type.

As far as I was concerned, I had always felt a curiosity about Freud and his theories and perhaps an unconscious temptation to submit to its rigors. One must bear in mind that by its nature, analysis has to be a costly and time-consuming process, so it cannot be a practical option for many people. I was given to understand that it was more difficult to carry through an analysis with a middle-aged individual than with a younger person. I was not able to do the usual five hours a week on the couch and had to work in my appointments with the analyst to fit my busy schedule, sometimes interrupting the sessions for months at a time. I remained an analysand, however, for perhaps eight years altogether. There were, unlike my interviews with Dr. Jung, long periods of probing my childhood experiences, particularly my memories of Father, Mother, and even Curphey during the first five years of my life, and other long, wearying, and maddening investigations of random thoughts, as well as the excavation of

hidden fears and frustrations in dreams and fantasies.

There came a moment during my analysis with Dr. Hall when I suddenly thought, "Is this person a truly well-trained analyst? Did she really come from Freud's circle in Vienna? Does she really know what she is doing?" I suppose this panic is typical for a great many people in analysis and perhaps comes at a crucial moment, an important turning point in the whole difficult process. I had been in England in 1959 for an extended visit and was returning home by one of my last Atlantic steamer trips when the dilemma seemed to hit me forcibly. Perhaps it was the thought of returning to the forbidding couch that made me do what I did.

Whether because of my own analysis, or because I had always been interested in psychiatry, or because I had received an appeal from The Anna Freud Foundation on behalf of The Hampstead Child-Therapy Course and Clinic in London, I had visited the Clinic and had on several occasions talked with Anna Freud, Freud's daughter and founder of the Clinic and an analyst in her own right. I had found her interesting and sympathetic, and had been most favorably impressed by the work in progress, particularly pertaining to the training of child therapists. Dr. Hall had mentioned that she had been a friend of Anna Freud in Vienna days, so it was natural that it occurred to me to turn to Miss Freud for advice, particularly for reassurance in respect to Dr. Hall's qualifications. I have lost my letter written from the *Queen Mary*, but I think her reply below not only reflects my concern at the time but also throws some interesting light on what is known as the "transference" problem. I think it gives one a nice glimpse of "Annafreud," as she always signed herself, as well.

 20, Maresfield Gardens,
 London, N. W. 3.
 HAMPSTEAD 2002.
 8. 11. 59.

Dear Mr. Mellon,
 Your letter from the Queen Mary reached me only two days ago, otherwise you would have had my answer earlier than this. I am very glad that you liked what you saw in

our place. I am sending you now with the same post some accounts of our work which are not just figures: a report on our various projects as I gave it here to the Royal Society of Medicine and, since you liked our Nursery Schools, the Annual Reports of both, the normal and the blind group. (On second thoughts I also add the Annual Report of our Well Baby Clinic which you might like.)

Now about your question: how should an analysand ever correctly evaluate his analyst, once analysis has begun? This is, really, a difficult matter since, during analysis, and towards the analyst, the rational and objective processes mean so little and the emotional, subjective ones so much. This is as it should be since these swings in evaluation bring back all the old doubts and ambivalence of the child-hood-relationships. Young analysts are often confused by it and have to be taught that they are neither as good nor as bad as their analysands see them.

When I was a beginner and my patients shared the same waiting-room with my father's patients, I used to complain to him that all my patients really wanted to leave me and go to him. To which he answered: "Never mind, all my patients want to leave me and go to you!" This just shows how irrational the whole relationship to the analyst can become.

All this does not answer the analysand's recurrent question: is my analyst really good? I think the proper time to settle this question rationally is to find out before starting analysis and then, together with the analyst, to watch the swings of the transference to extract knowledge of the past from them.

But now about your analyst: I hope Dr. Waelder-Hall will not reproach me for interfering if I say that she is one of my oldest colleages [sic] (not "old" as age goes, but long-standing in association) from Vienna times when we all studied under my father and taught each other, in endless discussions and seminars, to apply what we had learned. There are few people whose analytic judgement and technique I know as well or value more highly. If Hitler had not sent us to all the corners of the earth, we should still be working together.

This letter has grown longer than I meant it to be. I mark it "Personal" as you suggested.

Yours sincerely
Annafreud

I can truthfully say that my whole outlook on life, on my interests and responsibilities, on my relationships with my family, my friends, and my business and foundation colleagues, was changed for the better through my analysis with Dr. Hall. I knew then that I would be able not only to clean out the Augean stables, as I perceived the many and varied problems and the troubling personalities of the various organizations I was connected with, but also to enjoy doing it. I'm glad to say the outcome was quite unlike the negative prediction in the Walrus and the Carpenter's colloquy. For the next few years, in fact up to the present, I have greatly enjoyed not only these responsibilities and interests but all the rest of my pleasures and relaxations as well.

It was at this same period, and in connection with the National Gallery, that I met Stoddard Stevens. I had been impressed by Stoddard's performance in the matter of John Walker's appointment as Director of the National Gallery, and it was after this that I looked to him for advice and to represent me as my lawyer. The association lasted twenty-six years and was terminated only by Stoddard's death in 1981. Stoddard took a liking to me and became interested in the various problems I talked to him about, including the contretemps involving Chester Dale. I think I had come to a point where everything was getting me down, that I thought of myself as a kind of jack-of-all-trades and a master of none and that the distraction of traveling so much (Washington, Pittsburgh, New York, New Haven, Richmond, etc.) was making me psychologically dizzy. I had also been persuaded by Robert Maynard Hutchins, then President of the University of Chicago and Director of the Ford Fund for the Republic, to join the board of directors of the Fund for the Advancement of Education, another Ford Foundation subsidiary. I served on the board and its Executive Committee from 1951 to 1957 with, among others, Walter Lippmann. In addition, because I knew Fairfield Osborn, longtime President of the New York Zoological Society and author of *Our Plundered Planet*, I joined him on the board of the Conservation Foundation during its early years from 1949 to 1956.

My responsibilities seemed to be getting more and more dif-
fuse and out of hand until, one day in 1957, in order to give
Stoddard a graphic example of my predicament, I wrote down
and then typed an organizational chart showing all the organi-
zations with which I was connected either as a chief executive
officer or as trustee or in some ongoing capacity. On subsequent
pages I described, under the heading of each organization, the
makeup of its board and its top staff, as well as giving a brief
outline of the primary purposes, problems, and future plans
each was confronted with. (See Appendix C for the explanatory
notes that followed the chart.) When I finished the chart, I was
somewhat relieved to see that I wasn't wrong in suspecting that
I had several horses by the tail and was being pulled in too
many directions at once.

Like John Foster Dulles, Stoddard was a partner in the well-
known New York law firm of Sullivan & Cromwell. He was by
nature a combative sort of man and very competent in his
profession, and there was nothing he enjoyed more than finding
that he had a fight on his hands. He was ideally suited to be
Chester Dale's attorney. Chester was himself prone to lay down
the law, and Stoddard knew how to stand up to him. In fact,
Stoddard Stevens was the only man I know who was not in the
least afraid of Chester, and Chester appreciated that. I, too, was
impressed by Stoddard's dialectical approach to legal problems.
I needed a lawyer who could help me in the complexities of
foundation matters without any woolly thinking or prevarica-
tion, and he was just such a clear-thinking and able man.

Over the years Stoddard performed invaluable services for
me, keeping a watchful eye on the recipients of foundation ben-
efactions and generally guiding me through the legal entangle-
ments connected with the exercise of trusteeship. It would be
difficult for me to say which individual, Stoddard Stevens or my
Washington psychoanalyst, Dr. Jenny Hall, was more effective
in clarifying my thoughts in respect to what my responsibilities
really were and indirectly bringing me around to a belief that I
was really a useful and reasonably intelligent human being.
From being a squirrel in a revolving cage, one might say, I be-

came rather a bird dog, a pointer perhaps, guiding others toward various artistic, charitable, and financial efforts that I thought needed undertaking or improvement.

I suppose, however, that nobody is perfect, and looking back I have come to realize that Stoddard was a man for whom the exercise of power had great attraction. I am, and I hope I have always been, extremely circumspect in using any power stemming from my inherited wealth. It may be that this introspection on my part encouraged Stoddard to come to regard himself too literally as my watchdog. As a result, I have some reservations over how this relationship should have been conducted. I now know that I should have kept him on a somewhat shorter leash. For instance, in the course of our association I went to visit Stoddard at his New York office with Lauder Greenway, who had been an old and close friend of Ailsa's. The purpose of the visit was to discuss some business about Ailsa's estate after her death, and we found ourselves seated opposite Stoddard at his desk. Instead of coming straight to the point, he kept us waiting while he looked through some letters and shuffled papers. He considered Lauder a wimp, and this was obviously a technique he employed with clients in order to gain the upper hand. But it annoyed me at the time, and I wish now that I had later taken him aside and given him a short lecture on good manners and his proper role as my representative.

Stoddard regarded anyone connected with me as a potential adversary, and this extended even to the family. As a result, he was not much loved by Bunny, who once asked Jack Barrett whether he thought that Stoddard, then in advanced years, would ever die. Jack, who, as Editor of Bollingen Series, had had dealings with Stoddard over a long period, replied, "Bun, I don't think the Lord wants him any more than we do."

In spite of his often boorish behavior, his attitude of a public prosecutor in cross-examining certain staff members of the foundations or the National Gallery during meetings, and his somewhat abrupt manner, even to me, I still think of Stoddard as a loyal upholder of my own wishes and purposes, as a wise mentor who helped guide me through a wilderness bristling with

diplomatic dangers, legal obstacles, obstructive personalities, and financial tangles.

He may be seen in this memoir as a father figure, a belated incarnation of what my father *could* have been if he had been younger and if he had had the time or the impulse to educate me in the intricacies of the fields of life that so engrossed him. I didn't myself think of Stoddard as a father, but more as a wise companion, perhaps an older brother who sensed my intermittent bewilderment and wanted to help me find a balance.

One of the first tasks I undertook at this time, with Stoddard's help, was to deliver a family-founded institution from under the aegis of family control. This was the Mellon Institute of Industrial Research, an imaginative enterprise that was founded by my father and my uncle Dick at the beginning of this century. It all came about when Father happened to read a book entitled *The Chemistry of Commerce* by a professor from the University of Kansas named Robert Kennedy Duncan.

In the book Duncan writes of wedding science and industry by means of fellowships for industrial research. It was not an entirely new idea, but it fired Father's imagination. To me, it was an odd contradiction that while Father was so unimaginative in his personal relationships, he sometimes demonstrated extraordinary vision when it came to matters of public interest such as this and the National Gallery of Art.

Father discussed the idea with Uncle Dick, and as a result the Mellon Institute of Industrial Research and School of Specific Industries, to give it its full name, was formally established in 1913 under the wing of the University of Pittsburgh. Two years later, in 1915, it moved into its first building (I remember going as a schoolboy to see it with Father), and then, in 1927, it was separated from the University of Pittsburgh, acquiring its own board of trustees.

Duncan, who had been invited to get the project going, died in 1914, and in 1921 Dr. Edward Weidlein became Director. Ed Weidlein served for thirty-five years, until 1956, the last six of them as President. He was not only the Chief Executive Officer

but also the Chief Scientist. The Institute flourished under Weidlein's leadership. More and more companies established "fellowships," and the whole project expanded to the point where a new building was needed. This imposing new building, funded by Father and Uncle Dick, was constructed in the Oakland area of Pittsburgh, in a space roughly equidistant from the Carnegie Institute of Technology and the University of Pittsburgh, and was dedicated in May 1937. That was just three months before Father's death and was his last public appearance. I succeeded Father on the board of the Institute as a trustee in the same year, but to tell the truth, although I made annual financial contributions, I didn't take any great interest in it until sometime after the war.

By the 1950s there were over five hundred Fellows at the Institute, working on nearly seventy different projects, and supported by a staff of over two hundred. More and more companies, however, were establishing their own research and development departments, often under the guidance of the Institute. The trustees, therefore, decided to seek advice from a committee of four distinguished scientists. This group was called the Mellon Institute Trustees' Scientific Advisory Board and was first convened in 1956. It was headed by Dr. Lee A. DuBridge, President of the California Institute of Technology, and included George O. Curme, Jr., Director of the Union Carbide Corporation, Dr. Warren Johnson, Dean of the Division of the Physical Sciences of the University of Chicago, and Dr. William O. Baker, Vice President of Research at Bell Telephone Laboratories.

The chief recommendation of this group was that the Mellon Institute would in the future be more usefully employed in fundamental research. It was thought that fundamental research would take up the slack, financially and administratively, caused by the diminution of its sponsored, or applied, research. At a meeting in New York in December 1956, Dick Mellon, Alan Scaife (Dick's brother-in-law and also a trustee), and I decided to create a Fundamental Research Trust within the Institute, with funds donated by each side of the family. My recollection

is that the fund was made up by a contribution of five million dollars each from Dick and his sister Sarah, and of ten million dollars from the A. W. Mellon Educational and Charitable Trust.

Following Ed Weidlein's departure, we began to establish a new organizational structure. My cousin Dick was a great friend of General Matthew Ridgway, who had retired after the Korean War. Ridgway had had a distinguished United States Army career, planning and executing the 82d Airborne Division's 1943 invasion of Sicily and leading its D day airborne assault on Normandy in June 1944. In 1951, following Truman's removal of General MacArthur from command, Ridgway was appointed to succeed him as Supreme Commander of UN forces in Korea and as Allied Commander in Japan, with the rank of full General. Dick and Alan Scaife were convinced that General Ridgway was the man to guide the Institute. Dick always had military leanings, and he liked to be addressed as General, a rank he held in the Pennsylvania National Guard and in the Army of the United States during World War II. Dr. Paul Flory, a distinguished chemistry professor from Cornell, was engaged to be Executive Director for Research. (He was named Nobel laureate in 1974, some years after he had left the Institute.)

It was at the time of Ridgway's appointment as Chairman of the Board in 1955, and Flory's appointment a year or so later, that the trouble started. Flory's approach was somewhat ivory tower; he had a lofty attitude toward applied research and an even more disdainful one toward General Ridgway and his military outlook and directives. In addition, although the Fundamental Research Trust we had established was large, it was not so large that the Institute could dispense immediately with the funds that came from private industry.

There was a very bad mix of personalities. I got on perfectly well with Flory and admired his "pure science" approach, but it was clear that Ridgway and Flory couldn't continue together under the same roof. In 1960, therefore, I persuaded Ridgway to take early retirement and I, more in desperation than common sense, succeeded him as Chairman of the Board and Chief Executive Officer. Shortly thereafter Flory himself resigned his

directorship and left. He was angered that the Institute was not changing over fast enough to fundamental research.

I realized, of course, that I had neither the time to spare nor the training to administer a large scientific body, but I felt like the Dutch boy with his finger in the dike and knew that *somebody* with authority had to hold the thing together until help came. I attended many meetings and spent long hours on the telephone but had no intention of going back to live in Pittsburgh. Fortunately a very capable Vice President from the Mellon Bank, Jonathan S. "Jake" Raymond, had just retired and was on hand to help me with the everyday running of affairs. At the same time I brought in Stoddard Stevens again, and he too became a trustee of the Institute.

It wasn't just the conflict of personalities that bothered me, or the deep division between the fundamental and applied scientists. I was much more concerned about steering the Institute toward a proper environment for its future. Times were changing, and the Institute's existence as an independent organization was being called more and more into question, as were many privately established and funded institutions. I felt strongly that developments in the scientific field pointed toward the necessity of a closer relationship with, or even absorption by, a university. We couldn't, as a family, go on funding the Institute forever, and I also felt it to be unrealistic for us to seek to keep control indefinitely.

In addition, I was intent on strengthening the intellectual and administrative power of the board of trustees—all of us except Weidlein had been amateurs—and after some arguments with Dick and Alan, I was able to bring about the election of all the scientists from the advisory board as trustees, plus two new members, James R. Killian, Jr., former President of MIT, and Charles A. Thomas, Chairman of the Board of the Monsanto Chemical Company.

I had many consultations with these new members of the board and had a great deal of encouragement from them on behalf of my plans to bring about a merger with a university. Despite its long history of having been under the wing of the

University of Pittsburgh, it was obvious to our scientific advisers and me that the Carnegie Institute of Technology, being far better known and respected in most scientific circles, was the wiser choice.

Possibly because I had become Chairman and was actively engaged in the Institute's affairs, Dick Mellon began to withdraw from discussion of the problems and let me get on with it. He didn't seem miffed about his friend General Ridgway's retirement, but he was always somewhat jealous of me and perhaps suspicious of my motives. He was not at all in favor of the addition of the independent scientists to the board and made it plain that he considered a merger with a university a foolish giveaway on the part of the Mellon family. As discussions with Carnegie Tech began to come to fruition, he and Frank Denton, Chairman of the Board of the Mellon Bank, strongly opposed the move as being a black eye for the University of Pittsburgh. Nevertheless, we eventually called a special meeting of the Institute board, and I and my confederates were given the green light to work out a consolidation between the Institute and Carnegie Tech.

In the meantime, it was decided that the Chairman would no longer be the Chief Executive Officer, and the post of President, last held by Weidlein, was restored. After a long search Dr. Paul Cross, a chemistry professor from the University of Washington, was appointed in 1961. He remained President and Chief Executive Officer until the merger with Carnegie Tech.

In 1966, after long negotiations, we were able to announce a merger between the Mellon Institute and Carnegie Institute of Technology. The following year, during a commencement ceremony in which I was given the honorary degree of Doctor of Laws, I made it known that the new institution would be called the Carnegie Mellon University.

The last President of Carnegie Tech, H. Guyford Stever, went on to become Carnegie Mellon's first President. Stever, who resigned in 1972 to become Director of the National Science Foundation, was succeeded by Richard Cyert, Dean of the Graduate School of Industrial Administration.

During the ten or so years it took to bring about this transformation, I don't think I have ever worked harder or spent longer hours on the telephone and in meetings, but in retrospect, I feel that it was well worth every minute and that it was a positive accomplishment of which I could be justifiably proud.

Right after the war, in 1946, my cousin Dick thought up the idea of having a family company or organization that was intended "as a medium for collaboration in connection with the business enterprises in which the members of the family are financially interested." The "family" consisted of R.K. and his sister, Sarah Mellon Scaife, and myself and my sister, Ailsa Mellon Bruce.

The organization, T. Mellon & Sons (named after the original bank founded by Judge Mellon), was overseen by a board of governors, which included representatives of the principals and some of the principals themselves. Dick, the prime mover behind the enterprise, was President for the whole life of the organization. The board of governors met monthly in the organization's offices on the thirty-ninth floor of 525 William Penn Place in Pittsburgh. The board considered a broad range of matters, including the general business outlook, the state of companies in which family members had substantial holdings of stock, civic affairs in Pittsburgh, and family philanthropies.

I had a very poor opinion of the whole enterprise, thinking that it had nothing very much to do with my own family or my own financial affairs and that we were like a lot of small children sitting around and playing "business." Most of the time George Wyckoff represented me at the meetings and in conferences with R.K., although in its last few years I attended quite a few of the meetings just to make my presence felt and, as Stoddard Stevens used to say, "to keep my finger on my number."

By 1958 I thought T. Mellon & Sons had outlived its usefulness and hinted to Dick that it might be time to think of disbanding. However, he wanted to keep it going. I assented but wrote to him, saying that I would not be in favor of T. Mellon & Sons continuing beyond his or my lifetime, whichever one of us died first. T. Mellon & Sons carried on for a while, but Dick

died in 1970. And as I was the last survivor of the founding members, I dissolved the organization at the end of that year.

In later years I have found it convenient to bring together my closest assistants and my legal, financial, and charitable advisers for a meeting twice a year at my office in New York. We meet once in the spring and once in the autumn, and we discuss a loose budget for the current year, tax consequences, projected educational and charitable contributions, and the general economic outlook. The group usually consists of Nate Pearson, my longtime financial adviser, who is still based in Pittsburgh; Carroll Cavanagh, my principal assistant overall; Tom Beddall, who for years handled much of my eleemosynary efforts in Virginia and elsewhere but who is now retired and working on a consulting basis; Donald Osborn and Frederick Terry, my legal advisers who are partners in the firm of Sullivan & Cromwell; Casey Linehan, my financial administrator; Beverly Carter, my curator; and Janet Stewart, my Washington secretary and valued assistant in coordinating and executing my charitable projects.

I don't know when it first started, but long ago I began calling this scheduled assembly our Apalachin Meeting. You may recall that in 1957 the New York State Police rounded up a large group of Mafia representatives who were meeting in a small town in upstate New York named Apalachin, all having arrived in their large black limousines. Although they claimed their meeting was a purely friendly and social one, the participants were charged with conspiracy of one kind or another, but I remember they were acquitted for lack of evidence. In any case, the idea of all those black limousines winding up a long hill into that small town has always stuck in my mind, and my early joke at one of our first meetings took on a life of its own. I don't think my associates are really Mafia types; on the other hand, perhaps I am a kind of Godfather.

CHAPTER 18

Foundations:
Contributions to
Educational Institutions

———◆———

There is a common fallacy—and even some foundation ex-
ecutives may not be immune from it—that money can create
ideas, and that a great deal of money can create better ideas.
. . . [But] there is no substitute for brains. The difficulty is
the lack of men with fertile spirit and imagination—men
with basic training or with flaming ideas demanding expres-
sion. For them there is no alternative; without them money
will purchase nothing but motion and futility.

—RAYMOND B. FOSDICK
Chronicle of a Generation (1958)

Although I abandoned the idea of a formal academic career at
the time I went to Cambridge, I think perhaps I was still looking
for a near-academic substitute. I came to realize that I could
provide a more meaningful career for myself by directing part
of my considerable inheritance toward helping broaden the ho-
rizons of young men and women in the field of higher educa-
tion. I also know that my temperament would never have
helped me pursue the scholar's aim of "learning more and more
about less and less."

I'm sure Father's motivation in wanting me to make a career
at the Mellon Bank and as a director of many companies was
primarily dynastic. He had always been consumed with a pas-
sion for business, and he hoped I would be, too. Oddly enough,
he never seemed to me to be particularly interested in the idea

356

of amassing wealth for his or his family's sake, but rather because the formation of capital was a good thing in itself, both positive and patriotic. In the end he spent the latter part of his life giving his time to public service and to his vision of a National Gallery.

I had no aptitude for business, and quite apart from that, I saw no point in making more and more money just in order to take part in some sort of competition to be one of America's richest men. I saw far more interesting opportunities in the useful disbursement of the fortune I already owned. I should add here that I have always been careful to retain more than adequate funds to provide for my family and to maintain a very comfortable way of life. But considering the size of the fortune I inherited, it soon became apparent that personal needs could take up only a very small portion of it.

I'm sure that I wouldn't enjoy being down-and-out, but it is true that some of life's pleasures do not have a great deal to do with money. Being with friends, looking at paintings, and taking part in a game of Scrabble bring their own pleasures, and even more important, I am thankful that for most of my life I have enjoyed excellent health.

It is amusing that all those years ago, while I was still at school, my friend Jimmy McKay should have had the foresight to suggest that one day I would be a philanthropist. Philanthropy in America has been carried out by foundations, among other methods, for more than a hundred years. I think that this form of distributing wealth, provided it is not abused, can be very productive and that a great deal can be done with imaginative direction and a small dedicated staff. It was in Pittsburgh, in Andrew Carnegie's day, that the foundation as an organized form of philanthropy came into being.

Just before America's entry into World War II, on the advice of my father's tax lawyer, Donald Shepard, my sister Ailsa and I established our Avalon and Old Dominion Foundations. The state of Virginia is sometimes referred to as the Old Dominion, having been one of the early English colonies. Although I served as President of Old Dominion in its earlier years and later as

Chairman, I was of course absent while in the Army until 1945. Old Dominion's policy in respect to grants came to be aimed largely in the direction of higher education, but also toward the arts, conservation, and mental health. It proved a very useful vehicle for providing funds for, among others, Yale University, St. John's College in Annapolis, the Center for Hellenic Studies in Washington, and general education outside the universities.

Ailsa's Avalon Foundation and Old Dominion were run by small semiprofessional staffs providing grants for a great number of different organizations. Apart from myself, the trustees of Old Dominion at various times included my first wife, Mary, Ernest Brooks, Donald Shepard, Adolph Schmidt, George Wyckoff, Jack Barrett, Stoddard Stevens, and Dr. William O. Baker.

I remember Ernie Brooks, who was both an officer and a trustee of the Old Dominion Foundation from 1948 to 1969 (he served at various times as Vice President, Secretary, Treasurer, and General Counsel as well as Secretary to the Bollingen Foundation). He was industrious, serious, and devoted to the educational policies of the Foundation, and particularly to its conservation and environmental endeavors. Upon his retirement in 1969, he became a Vice President of the Audubon Society and later Chairman of the Conservation Foundation. I realized very soon that his serious demeanor was perhaps only an office and daytime mask since he urged me to join him and his wife on their weekly visit to a jazz jam session at some SoHo hotel! He was also an ardent bird-watcher, and he spent many early spring mornings in Central Park, binoculars at the ready. What Ernie lacked in *joie de vivre* he made up for in thoroughness of project investigation and clarity of meaning in proposals and reports, and he was certainly not without a certain subtle sense of humor. We all liked and admired him.

In general, Old Dominion's grants were not intended to be full and continuing support for its recipients, but rather to encourage new ventures when they were most in need of assistance. As Guy Friddell, writing in the December 1957 number of *The Commonwealth: The Magazine of Virginia*, explained, "The public sometimes regards a foundation as a glorified poorhouse

for tottering causes, but Old Dominion avoids clinging-vine ventures, and encourages projects that can grow to become self-supporting or branch out and find new sources of revenue."

Over the period of its life from 1941 until 1969, the Old Dominion Foundation disbursed over eighty-six million dollars. As a result, it was the poorer relation when it was merged with Ailsa's Avalon Foundation in the spring of 1969, hers having been less active and therefore accumulating greater funds up to that time. Further, when Ailsa died later in that year, the newly formed The Andrew W. Mellon Foundation, resulting from the Avalon-Old Dominion merger, found itself the beneficiary of the entire monetary residue of her estate.

The Andrew W. Mellon Foundation makes grants annually to several hundred institutions, covering not only higher education but also medicine, public affairs, cultural projects, conservation, and the environment, from the proceeds of its endowment totaling just under two billion dollars. The professional staff is small, located in a group of modest brownstone houses on East 62nd Street in New York, formerly occupied by the Bollingen and Old Dominion Foundations. I served as a trustee from 1969 to 1985 and from then on as an honorary trustee. These days I frequently attend its meetings, mainly to keep myself informed.

When I became deeply involved with foundation work after the Second World War, I felt the need to do something more than just be an overseer. I am fully conscious that in the matter of giving money away, it is just as easy to do harm as to do good. Without wishing to be a busybody breathing down the necks of the professionals, I wanted to play a part in foundation policy, particularly concerning a small group of beneficiaries with which I had been personally connected. Everyday decisions and the handling of the finer brush were naturally concerns to be left with those who had time and were competent to deal with them.

As I have mentioned, my first contact with foundations came when I was elected to my father's A. W. Mellon Educational and Charitable Trust, of Pittsburgh, in 1930 (not to be confused

with The Andrew W. Mellon Foundation). In 1932, on my return from Clare College, Cambridge, I suggested to my co-trustees on the E.&C. Trust that a fellowship be established to encourage travel and academic work abroad. There were at that time already grants, such as the Rhodes Scholarships and Commonwealth Fellowships available to American students for study at Oxford and Cambridge. What I had in mind was an *exchange* fellowship between Yale and Clare, a graduating senior to be chosen each year from Yale to attend Clare for two years, and a Clare man similarly chosen to spend two years at Yale. In a way the recipients of the fellowship would be following the pattern of my own university career in one direction across the Atlantic or the other. These Yale-Clare Fellowships began in 1932 but were suspended during World War II and for three years following. In 1948 they came under the direction of the Old Dominion Foundation, to be awarded again in the 1948–49 academic year. From then on, until the merger into The Andrew W. Mellon Foundation in 1969, they were funded by Old Dominion. After the merger they became the responsibility of The Andrew W. Mellon Foundation until 1988. The Foundation, viewing the Fellowships as somewhat at variance with its own policies regarding higher education, reluctantly withdrew its support as of 1990. I then agreed to finance the Fellowships personally from 1990 for the foreseeable future. I have also arranged for a suitable endowment by future bequest. So the Fellowships are still awarded today, nearly sixty years after their establishment, but are now named the Paul Mellon Fellowships. There is no question in my mind that they have been very worthwhile, and I have received many letters from past Fellows confirming the positive influence the Fellowships have had in their personal and professional lives.

About 140 Fellows, including Duncan Robinson, the Clare-educated English Director of the Yale Center for British Art, have taken part in the program since its inception. The Fellowship has not only strengthened Anglo-American ties but also provided perspectives of another country for many students at a critical stage in their lives.

My gifts to my old school, Choate, started in 1938 by the provision of a science building (my father had already given the school a library in 1925). Later I gave it a new library wing, designed by Page Cross and completed in 1962, as an addition to the Andrew Mellon Library. The next undertaking was the Paul Mellon Arts Center. I have occasionally allowed my name to be attached to projects to which I have contributed, but usually the recipients have suggested it, and it seemed discourteous to refuse. In other cases, such as my founding of the Yale Center for British Art, I insisted that the organization *not* bear my name, in the hope that other future donors of works of art and of funds would be more likely to be forthcoming. If my father had created the "Mellon Gallery of Art" in Washington, would other donors of art or money, let alone the Congress, have been willing to support it?

The Paul Mellon Arts Center at Choate, which was dedicated in 1972, was designed by I. M. Pei. It was my first connection with I. M., and he had been chosen by Choate as architect before I became involved in the project. The Arts Center contains an eight-hundred-seat auditorium, which is used as a theater and concert hall. The building also has a smaller recital room and exhibition space as well as a communications center, studios, and classrooms. While the Center was being built, Choate merged with Rosemary Hall, which moved from Greenwich, Connecticut, to the Choate campus in Wallingford. The Center opened at the end of the first year of the two institutions' joint operation and became an important focal point between them. It not only is used by Choate Rosemary students but is also open to the community of Wallingford and other institutions throughout Connecticut.

My latest benefaction to Choate Rosemary Hall has been a new Science Center. Charles Dey, who has guided the school so successfully as Headmaster and Principal for the last eighteen years, and who succeeded the famous Seymour St. John, wrote to me in 1984, telling me that the original science building I had given them was bursting at the seams. The new science facility,

which contains an auditorium given by my Choate contempo-
rary George Getz, was also designed by I. M. Pei and opened
in October 1989. With my help the school has renovated the
original science building, turning it into a Humanities Center, a
solution I look on with enthusiasm. It is a beautifully propor-
tioned building, in the brick colonial style of so many other
Choate buildings, and was designed in the late thirties by the
architect Charles Fuller, of New York.

Apart from the British Art Center (the name by which the Yale
Center for British Art is generally known), my interest in Yale
has revolved largely around efforts to strengthen the educa-
tional values of its residential college system. The Yale colleges,
of which there were ten initially, were built in the 1930s, just
after I had graduated. They were modeled on the colleges of
Oxford and Cambridge. The entire English system is different,
with the semi-independent colleges not only providing accom-
modation for undergraduates but offering facilities for study and
for receiving tuition. Like nearly all American universities, Yale
has always been a much more centralized institution, where the
departments and their University-wide disciplines are para-
mount, although I would say that it is now more Oxbridge in-
fluenced.

 One of the most active proponents in the cause of educational
functions for the colleges was my old friend and classmate Whit-
ney Griswold, a fellow of keen wit and great intelligence. Whit
had strong feelings, which I shared, about trying to preserve
liberal arts education in the face of the postwar tide of mass
education with its specialization and what might be termed "caf-
eteria-style" choice of subjects. Whit became President of Yale
in 1950, and shortly after his appointment he approached the
Old Dominion Foundation and me with a view to securing an
endowment to support formal educational activities, including
seminars, in the colleges. Ideas for similar schemes had been
advanced on earlier occasions in American educational circles,
but Whit was pressing his plan for all it was worth, and he
believed it was particularly necessary for Yale.

It was Whit's philosophy and Whit's convictions, when he became Yale's President, that persuaded me and my Foundation colleagues to further the influence of the individual colleges by strengthening the Program of Directed Studies in the Liberal Arts and Sciences that had been designed by Dean William Clyde DeVane and first offered in 1946. (Clyde DeVane was my instructor in freshman English in 1925, and his encouragement and brilliant teaching added greatly to my already keen interest in *words* and in English literature. It was perhaps his suggestion that prodded me into trying for the Edward T. McLaughlin Prize for the best English essay by a freshman, which I won.)

It was Whit who persuaded us of the absolute necessity of building two new colleges, Morse and Stiles. It is probable, too, that my experience on the "Oldest College Daily" (in which we used to editorialize about the advantages of the college system and the English tutorial system) set my mind in these directions. As undergraduates Whit and I used to talk education well into the night (and probably well into the bottle).

Old Dominion Foundation made two gifts at this period to Yale, one in 1952 and the other in 1958. The first gift, of five million dollars, was intended to support various educational programs, such as Directed Studies and Scholars of the House. Directed Studies prescribed courses for freshmen and sophomores in the spirit of the St. John's program—i.e., a true liberal arts curriculum. The Scholars of the House program was for a limited number of seniors, who were freed from course work in order to pursue individual creative work in writing, art, and music and for special scholarly projects. This 1952 gift also funded the introduction of sophomore seminars, the first educational program to be held within Yale's individual colleges. It also made possible the reconstruction of historic Connecticut Hall as a center of faculty and student activity.

The other factor to become a matter for growing concern was enrollment, which had expanded enormously after World War II in America's colleges and universities. The increase was partly a result of the GI Bill, which offered financial aid to veterans. This in turn was putting a severe strain on the living accom-

modations in the colleges. Overcrowding lowered the quality of college life, and lack of privacy was taking its toll both educationally and socially. In his 1956 report to the Yale alumni, Griswold pointed out that the University badly needed two new colleges. This was likely to be an expensive undertaking. The first ten colleges had been built in the 1930s, when construction costs were much lower on account of the Depression.

By 1958 a crisis had developed, and the University was having to consider further dormitories for its ever-increasing number of students. Whit wrote me a long letter saying that he thought the new colleges would be "the greatest investment in Yale's future anybody could make." I discussed the matter thoroughly with my co-trustees at Old Dominion, and we decided to make a second grant, this time for fifteen million dollars, half of which would be used for the construction of two new colleges to house five hundred students. A portion of the rest would be used as a temporary endowment for maintenance and operations, but this figure would be absorbed in time into the balance, which was to provide a special educational endowment to fund seminars in all the colleges. The two new colleges, named after early Yale alumni Ezra Stiles (graduated 1746) and Samuel Morse (graduated 1810), were designed by Eero Saarinen, who unhappily did not live to see their completion. They were dedicated in the fall of 1962. Whit Griswold, too, died the following year. He had been a remarkable President, a wonderful friend, and a brilliant catalyzer for the intellectual life of the University.

The two new colleges were badly needed then, but within a few years of their completion *all* the colleges were again filled to capacity and overcapacity. When my son Tim was a senior in 1964, he and three other undergraduates shared a suite that had originally been meant for two. So much for the "quality of college life" and the need for privacy.

By the 1950s St. John's College, which, as the reader may recall, I attended for a few months before the war, was operating at a substantial deficit, a deficit that the Old Dominion Foundation had been underwriting for a number of years. There had earlier

been a growing fear that the neighboring United States Naval Academy might appropriate the ground on which the College stood, forcing it to relocate. Fortunately this project had been abandoned, thanks to a timely decision by the Secretary of the Navy, James Forrestal. The problem, however, lay primarily in the fact that many St. John's alumni had been alienated by the introduction of the "New Program" in 1937 and, as in all American universities, these alumni should have been the ones providing the main source of funds.

The College was very fortunate when Richard Weigle was appointed President in 1950. Dick Weigle, whose father had been Dean of the Divinity School at Yale, was also a near classmate of mine. He was dedicated to the promotion of the St. John's program and, not that he enjoyed it very much, became a tireless fund-raiser. He and I decided that it was necessary to secure an endowment fund in order to put an end to the yearly operating deficits, and during the course of the 1950s and 1960s Old Dominion awarded a series of grants on a matching basis with a view to securing this goal. In addition, the Foundation contributed substantially to new buildings, including a heating plant and a new dormitory (Campbell Hall) that were necessary when the college became coeducational. It also provided most of the funds for a new science building and an auditorium.

Dick Weigle's determination to "spread the gospel" took the form of a second campus at Santa Fe, New Mexico, despite misgivings on my part and on the part of my co-trustees in Old Dominion. There was already very bad feeling and mutual mistrust between Stoddard Stevens and Dick Weigle, and this was greatly exacerbated in 1963, when Dick, finding the Santa Fe institution desperately short of money, "lent" it two million dollars from the Annapolis endowment, contrary to his understanding with the Foundation. As a result, several trustees were offended, and the Foundation temporarily suspended matching gifts for endowment to Annapolis. Although I was never sold on the idea of the second campus, I had a very high regard for Dick and for all that he had done, so I personally made a gift to the Santa Fe undertaking in 1970.

By the mid-1960s St. John's was flourishing and its financial position had improved enormously. The "New Program" occupied a respected place in higher education, even if it had not become quite as influential as the founding fathers, Stringfellow Barr and Scott Buchanan, might have wished. At this stage the Foundation's role came to an end at St. John's, although I have continued to provide support.

I have a great affection for Clare College, Cambridge. Although I have to admit that rowing and foxhunting overshadowed my academic pursuits during my time there, I have maintained a warm interest in the College and in the University. I have been glad to make gifts toward the Clare War Memorial Building (153 Clare men died in the Second World War) and to make a contribution toward its purchase of Henry Moore's "Fallen Warrior," now located in Thirkill Court. Then, in May 1964, I was approached by Sir Eric Ashby, now Lord Ashby of Brandon and at that time Master of Clare, with an interesting proposal. In response to an appeal by the University, Clare was contemplating building a British center for visiting graduate scholars. These would be men and women of all nationalities performing advanced research on mainstream projects and on new cross-discipline subjects, like molecular biology.

I arranged for Sir Eric to discuss the matter of financial assistance with the staff of Old Dominion Foundation. Ashby made it clear that the College had already underwritten the construction of a building for Clare Hall, as it was to be called, but that it had no further money for grants or fellowships. The permanent Fellows would be supported by their University posts, and many of the visiting Fellows would be coming to Cambridge bolstered by their own grants, but Clare Hall also wanted to attract certain unsupported scholars by providing them with grants. Ashby therefore asked Old Dominion for an endowment, the income from which would support, in varying degrees, about ten visiting scholars a year.

In June 1964 the trustees awarded Clare about half the amount Ashby had been looking for, indicating that they might consider

an additional grant once the new establishment was under way. Clare Hall's building was not completed until September 1969, although Old Dominion Foundation Fellowships had started to be awarded three years earlier. By 1969 Clare Hall had ninety-one scholars in residence, and Ashby asked for the further sum of money, which Old Dominion granted. The endowment was then turned over to Clare College to be administered by Clare Hall. It continues to support visiting scholars today, although not as many as before, inflation having taken its toll. Fortunately, however, Clare Hall has found other sources of support, and in 1984 it received its own charter of incorporation, Clare College turning over to Clare Hall the assets, including the Old Dominion endowment, that the College had previously held in trust.

Late in 1980 I received a letter from Robin (Robert) Matthews, who had succeeded Eric Ashby as Master of Clare, outlining the College's need for a new, modestly sized but technically advanced library. My own contribution, together with two other contributions made in England, encouraged the College to go ahead with an appeal to raise the rest of the money. My friend and contemporary Nick Hammond, a former Fellow and now Honorary Fellow of Clare, was directing the appeal, and Robin came over to the United States with a view toward furthering the project here and to enlist the aid of American alumni of Clare. I urged Matthews and Hammond to lean rather heavily on Clare alumni for funds. Appeals to alumni had never been pressed to any great extent before by Clare, and in fact alumni giving had never been a heavily worked vein in English institutions. We had a dinner for a few American alumni at the National Gallery in November 1982, followed by a luncheon for the New England alumni at the Yale Center for British Art. Between the large body of Clare alumni in England and the American graduates, the appeal was fully subscribed by the end of the following year.

The library's architect, Sir Philip Dowson, designed an octagonal building, containing music and computer rooms in addition to the usual library spaces. The library divides Memorial Court,

the western portion of which was renamed Ashby Court. Ground breaking took place in July 1984, and the building went rapidly forward. It is called the Forbes-Mellon Library, Mansfield Forbes having been the distinguished and eccentric English literature don who had been there in my day and who wrote a voluminous history of the college. I had the pleasure of attending the dedication, which took place in the presence of the University's Chancellor, the Duke of Edinburgh, on June 11, 1986, my seventy-ninth birthday.

Huntington Cairns, onetime Secretary and General Counsel at the National Gallery, was a classical scholar as well as a lawyer. His anthology of poetry and prose entitled *The Limits of Art*, containing passages from literature with critical commentary, was published in Bollingen Series in 1948. He had always been deeply interested in Greek civilization and, with Edith Hamilton, coedited an edition of *The Collected Dialogues of Plato* for the Series. During the 1950s Huntington talked to me about an idea that I immediately found appealing. His suggestion was for an institute, which he chose to call "The Residence," to house permanent Fellows who not only would engage in scholarly research but would also seek to spread humanistic ideals in American life. The Residence would be concerned mainly with the civilization of ancient Greece.

Despite the obvious attractions of Cairns' proposal, I thought we should proceed cautiously, and I put together a committee of Old Dominion trustees to look into it. This Committee of the Humanities, as we called it, sought opinions in the academic world but got preponderantly negative responses. Even Nathan Pusey, the President of Harvard, thought there were too many flaws in Cairns' proposal. Luckily, just as we were about to give up, Pusey suggested a modified version that seemed to us to answer the major objections. Pusey recommended that a small institute be established where young scholars, recent Ph.D.'s in the first stages of their careers, could come and devote a quiet year to scholarship, freed from the distractions of teaching. Such opportunities were rare for young classical scholars at that time,

so we decided at Old Dominion to support the proposal. As a result, in 1961, the Foundation furnished Harvard with a grant to establish the Center for Hellenic Studies.

We soon acquired a site on which to build the Institute, a tract of land across the street from my house on Whitehaven Street, in Washington. This was donated to the Old Dominion Foundation in 1956 by Mrs. Marie Beale, a friend of Cairns', shortly before she died. The land came with a curious stipulation, however, spelled out in her will, that was to complicate our discussions. If we (or another organization to which we gave the land) established an institute for classical studies on it, most of the rest of her estate, which came to over four million dollars, would go to Harvard. If an institute was not established, both her land and the four million dollars were to be given to the State Department (her husband having been an ambassador). Naturally Harvard was anxious to have us go ahead with the project.

The Center, with buildings designed by Page Cross, houses eight Fellows, most of whom live and work there. Fellows come from both here and abroad. Bernard Knox was Director of the Center from 1961 to 1985. He was born in England and went up to Cambridge in 1933. After joining the International Brigade and taking part in the Spanish Civil War, in which he was wounded, he emigrated to America in 1939. During World War II he served in the American Army and, as a fluent French speaker, was recruited by OSS for operations in occupied France. After the war he obtained his Ph.D. at Yale, where he joined the Classics Department and established his reputation as a scholar of Greek tragedy. From Yale he went to the Center. Since its founding, more than two hundred scholars have studied there, and many of the Center's alumni now occupy prestigious teaching posts throughout the world.

Bernard was succeeded by Zeph Stewart. Zeph was a long-time member of the Center's administrative committee and had been appointed to head the committee to search for Bernard's replacement. After a long search it became clear that the committee needed to look no further than the head of the table.

Zeph had been an undergraduate at Yale and had gone to Harvard for graduate study. He became a Junior Fellow in Harvard's Society of Fellows and then joined the Classics Department. For many years he was also Master of Lowell House (the Harvard houses are the equivalent of Yale's colleges). Zeph had the right combination of scholarly and administrative experience for the post, and he has done an admirable job as Bernard's successor. He has, among other things, introduced new technology to the Center (even the study of ancient civilization benefits from the availability of modern computers), and he has also managed, over the years, to save and put aside something out of the annual budget for necessary future capital improvements, no easy task these days.

CHAPTER 19

Foundations: Contributions to Environmental Projects

———◆———

They will have disappeared like so many other native and natural resources in the past; the great stands of beech trees and other native hardwoods, many of our forests and much of our grassland: like the clear water from our springs, wells and rivers: like much of our topsoil that has spilled into the sea. They will have disappeared like the passenger pigeon, the heath hen, the Eskimo curlew, the wild turkey, the Atlantic salmon, the Eastern puma. It is a sobering thought that no amount of money in the world, not all the resources of all individuals, foundations, or governments can ever buy back one passenger pigeon. And at one time they darkened the skies, even here.

—From my remarks at the dedication of the Cape Hatteras National Seashore, April 24, 1958

I hesitate to say that I am interested in conservation and the environment because these words are so generalized and the subject is so broad and so complex that any discussion can become meaningless unless it is held between informed specialists. For all that, I think many of us feel unhappy that the requirements and pressures of modern civilization are causing a steady deterioration in our surroundings. I personally have always enjoyed visual awareness. It is perhaps the most developed of my senses, so I find myself unconsciously depressed at

the sight of a long stretch of hardtop road punctuated with bill-boards and concrete gas stations. The danger is that one gets used to this negativity, this commercial jungle. It doesn't even possess the hellish quality of smoky old Pittsburgh with its mills belching fire (shades of William Blake's dark satanic mills).

All I have been able to do personally, and through the foundations, is to play a small part in trying to hold back this tide, but I am glad that at last there is a widespread awakening to the problems we all face over fouling our nest. Old Dominion and Avalon Foundations provided consistent support for, among other organizations, the National Park Service, the Conservation Foundation, and the National Audubon Society.

Before the 1950s there were no coastal areas in America preserved and protected as national seashores. By that point opportunities to establish protected ones had become severely limited as most of the coast had been subject to development. One of the few suitable areas left was the Outer Banks of North Carolina, a chain of narrow sandy islands like a fleet of low-lying ships guarding Pamlico Sound and the North Carolina mainland from the ravages of the Atlantic. This was indeed regarded as the prime site for preservation on the Atlantic Coast. In 1937 Congress had authorized the establishment of the first national seashore there, but World War II intervened before extensive land acquisitions could be made. The moving force behind the fulfillment of the idea after the war was Conrad Wirth, Director of the National Park Service. The federal government was to provide limited funds for land acquisition, but the majority would have to come from elsewhere. The state of North Carolina appropriated a substantial sum for acquisition with the stipulation that this be matched by private gifts. The private funds were offered in 1952 by Old Dominion and Avalon, each agreeing to give half of what was needed to match the state grant. By these means, something like 28,625 acres were acquired for inclusion in the Cape Hatteras National Seashore.

I arranged a visit in my DC–3 plane in April 1955 to the Hatteras region, accompanied by Connie Wirth and most of our Old

Dominion trustees. Congressman Bonner of North Carolina was also with us, as well as Monroe Bush, Assistant Director of Old Dominion who was responsible for foundation projects involving Virginia charitable and educational projects and who was very knowledgeable about environmental matters. We spent three days in the Hatteras area, staying at the Carolinian Hotel at Nags Head. The weather was perfect, and on our second day there we were whisked from place to place by Coast Guard helicopters that had been requested by the Park Service.

It would be difficult to exaggerate the impact of the beauty and the magic atmosphere of these islands of the Outer Banks, with their great dunes sloping down to the deep blue of the sea, the sparkling inlets that divide them and provide access from Pamlico Sound to the Atlantic Ocean, and the charming fishing villages dotted along their inner shores. A picnic was provided for all of us on a wide sandy beach at the base of the enormous Hatteras Light. (Unfortunately, in later years this beach has eroded considerably and is now the center of a controversy regarding the many proposed artificial means of saving it.)

At the end of this enthralling day, we returned to Nags Head in the helicopters. I personally am not very happy in helicopters, but this time I felt quite safe in the copilot's seat of the leading craft, since it was piloted by Rear Admiral H. C. Moore, Commander of the Fifth Coast Guard District. Admiral Moore, I was told, had been a famous World War II PB-Y flyer and a hero of antisubmarine warfare. The noise was so great that we had to converse by intercom. At one point I asked him how long he had been flying choppers? He replied, "About two years. I knew I ought to be able to fly whatever the men I command fly—but it was a mistake." I asked what he meant. His reply was, "Because they're dangerous as hell!" Just then we were flying about two hundred feet over the ground, the great bird was vibrating like an aspen leaf, and the noise was hellish. I've never been gladder than when we landed at Nags Head and my feet touched the ground.

In April 1958 I attended the dedication of the Cape Hatteras

National Seashore Recreational Area and made a speech as a trustee and representative of both Old Dominion and Avalon Foundations. In my speech I said, "Of all the undertakings and appeals that have come across my desk as President of Old Dominion Foundation and as trustee of several others, this was the most appealing, self-selling, and most unanimously acceptable one in my experience."

The experience regarding Cape Hatteras tremendously quickened my interest in coastal preservation. I asked Connie Wirth if there were other such areas worthy of protection. He responded that there undoubtedly were but that the Park Service lacked basic knowledge of the state of our coasts. What was needed first were detailed surveys of American coasts that identified sections of prime importance for preservation. In 1954 Old Dominion and Avalon Foundations agreed to underwrite a survey of the Atlantic and Gulf coasts. Part of the study was published in 1956 as *Our Vanishing Shoreline*. Stirred by the report, many states made efforts to acquire lands it had identified as important for protection. The success of the survey also led the Park Service to undertake similar surveys, with the support of Old Dominion and Avalon Foundations, for the Pacific coast and the Great Lakes. These led to efforts by public officials in the regions concerned to acquire ocean and lake shore areas for preservation.

Our Vanishing Shoreline had identified two areas on the Atlantic coast as of particular significance: the Great Beach of Cape Cod and Cumberland Island off the coast of Georgia. There was a good deal of public interest in Massachusetts in preserving the Great Beach as well as on the part of a number of important state officials. In 1956 Old Dominion and Avalon Foundations provided funds for the creation of a master plan that served as the basis for subsequent preservation efforts. Several bills to establish the Great Beach as a national seashore were introduced in Congress in the late 1950s, including one sponsored by Massachusetts Senators John F. Kennedy and Leverett Saltonstall. A bill finally passed in August 1961, by which time Senator Kennedy had become President Kennedy, and he eagerly signed

it. The bill authorized the establishment of Cape Cod National Seashore—the second national seashore after Cape Hatteras—designating 26,660 acres for inclusion.

Cumberland Island proved a more difficult case. Georgia officials evinced little interest in creating a national seashore on the island. Most of the island was in the possession of about a dozen descendants of Thomas Carnegie. They disagreed on what to do with the island, and negotiations between the heirs and the National Park Service proceeded slowly in the 1950s and 1960s. At last all of the Carnegie heirs and the Candlers, another family that owned a substantial tract of land on the island, came around to the idea of a national seashore.

Congress had not yet authorized the establishment of a protected area on Cumberland Island so the Park Service was not in a position to acquire the land. However, a recently established private organization called the National Park Foundation could hold property in trust for the National Park Service, awaiting the establishment of a national seashore. The National Park Foundation approached The Andrew W. Mellon Foundation (which by then had been created by the merger of Old Dominion and Avalon Foundations) to enable it to acquire 8,500 acres—about 60 percent of the island—for the Cumberland Island National Seashore.

Of all my philanthropic endeavors during my lifetime, I think I can safely say that the saving of these beautiful natural areas has given me the profoundest pleasure and the most heart-warming satisfaction.

I like the idea of cooperation between the federal or state government and the private sector. To cite a small example, in the mid-1960s the National Park Service asked Old Dominion for a grant in connection with the renovation of Lafayette Park, the "President's Park" in Pierre L'Enfant's plan of Washington. Later named after the Marquis de Lafayette, it is just across Pennsylvania Avenue north of the White House. It had become very scruffy and run-down, so a program undertaken by the National Park Service sought to renovate the nineteenth-century town houses that surround the park on three sides and to re-

store the park to its nineteenth-century appearance and character. Old Dominion's gift was used for repaving the modern concrete sidewalks with brick, installing two new fountains, and further landscaping the park.

There are two further examples of conservation work in which I have found myself personally involved. On occasion I have been able to act single-handedly, as when I purchased, in 1973, an eleven-hundred-acre tract of land on the slopes of the Blue Ridge Mountains in Virginia (later augmented to more than fifteen hundred acres), near my home in Upperville. We heard just in time that developers were planning to use it for luxury houses with a country club, equestrian facility, and shopping center. I'm glad to say it now belongs to the state of Virginia and has been established as Sky Meadows State Park.

Closer to home I have placed most of Rokeby in a permanent land conservation program administered by the Virginia Outdoors Foundation, in consultation with Tyson B. Van Auken, its Executive Director. The dedication of my land to open-space use assures that only compatible uses will be permitted in our beautiful countryside. Fortunately, both Tyson and I were able to persuade many of my closest neighbors to do likewise so that our part of Fauquier County will always be protected.

Trying to restrain the hand of the developer may seem like a losing battle, but it is one aspect of a struggle that we must continue with if we care at all about the sort of world our children and grandchildren will inherit.

CHAPTER 20

Retirement

———◆———

Do memories plague their ears like flies?
They shake their heads. Dusk brims the shadows.
Summer by summer all stole away,
The starting-gates, the crowds and cries—
All but the unmolesting meadows.
Almanacked, their names live; they

Have slipped their names, and stand at ease,
Or gallop for what must be joy,
And not a fieldglass sees them home,
Or curious stop-watch prophesies:
Only the groom, and the groom's boy,
With bridles in the evening come.

—PHILIP LARKIN
"At Grass"

When I reached the age of seventy-eight in 1985, I decided to resign from my trusteeships in The Andrew W. Mellon Foundation and the National Gallery of Art as well as the office of Chairman of the latter. Before my resignation from the board of the Gallery, to become honorary trustee, and aware that I would not be around indefinitely to lend it financial support, I headed a fund-raising drive by the trustees known as the Patrons' Permanent Fund that aimed at securing fifty million dollars as an endowment for art purchases. As well as contributing to it myself, I attended functions and gave luncheons and dinners for likely donors.

Common to most fund-raising exercises there were some surprises in store. The generous gave generously. Some who might

have been expected to sign large checks gave nothing, while others from whom nothing might have been expected didn't hesitate to subscribe bountifully. For me, asking for money was a painful but bracing and instructive experience. The goal was reached, indeed well surpassed, so I was able to retire in the knowledge that the Gallery would henceforth not be entirely dependent on individual donors of art to add to its collections.

I am still taking a direct interest in the Yale Center for British Art, the Virginia Museum, and the National Museum of Racing at Saratoga, and of course, the horses are still running over here and in England, so there is not much likelihood that I will succumb to boredom in my retirement.

I am happy that I have lived long enough to have approved the preliminary, and later the detailed, drawings of the two handsome structures that already house large segments of my English and French collections and to have witnessed their construction and completion—namely, the Yale Center for British Art and the West Wing of the Virginia Museum of Fine Arts in Richmond. It is doubly pleasing that I have been available, and to a limited extent have helped, to plan the mode of the exhibition of the works of art that occupy them. For it has always been Bunny's and my intention, indeed our pleasure, to share the majority of our collections with the public before it was too late to observe the public's pleasure in viewing them. I was also fortunate to be able to follow closely the establishment of the East Building of the National Gallery from its conception to its dedication. As a matter of fact, I have commissioned a variety of works of art during my lifetime—family portraits, watercolor elevations of our houses, bronzes of favorite racehorses—but only one great work of art. This was the East Building. To me it seems a majestic marble sculpture, to be seen in the round with its massive walls of marvelous proportions and the precision of its many surprising angles. The choice of I. M. Pei as architect was ultimately mine, and I shall always be proud that I made that choice.

Over 250 people work for me in one capacity or another. The farm in Virginia and the houses in New York, Washington, Cape

Cod, and Antigua each have their own staffs. It would be a happy thought if all of them, from the Caribbean to the Cape, were to foregather with Bunny and myself for a group photograph in the manner of an Edwardian household. There are so many friends among them, so many loyal, likable, and even lovable characters.

When George Wyckoff retired, Nate Pearson became my sole representative in Pittsburgh, not only regarding my financial affairs but also as a listening post to interpret the appeals of those few Pittsburgh charities I continue to support. Recruited by Wyckoff, who had known him when he was working for the Carborundum Company at Niagara Falls while Wyck was a Director, Nate joined my staff in the early fifties. He and Wyck made a fine team in looking after my investments and tax affairs, and our relationship always seemed to me more like a partnership than one as between boss and employee. Like Wyck, Nate became a Director of several large companies. Nate not only has been extremely capable in financial matters but has represented my family with great courtesy and tact. Working under the guidance of Wyck and Nate, William W. Wissman, an expert accountant, kept my books and watched over any tax problems. We relied on his diligence, knowledge, and loyalty for many years.

The calendar has not changed a great deal for us over the last thirty or forty years. One of the saddest aspects of old age is that of losing close friends. Bunny enjoys the friendship of Jackie Onassis and Hubert de Givenchy, both of whom she has known for many years. She designed the Rose Garden at the White House for President Kennedy and later designed, with Jackie, the Arlington gravesites of President Kennedy and of Robert Kennedy. I have been less fortunate in the matter of having close friends still around. As with many people, my long-standing friendships have naturally been those that I now miss most. The reader will remember that Ailsa, my sister, died unexpectedly in 1969 of cancer at the age of sixty-eight. After her disturbed childhood she had gone on to lead a rather sad life. Following marriage and divorce she became somewhat withdrawn and in-

decisive, living in an apartment in New York and at a beautiful house in a parklike setting, but surrounded by suburbia, in Syosset, Long Island. For Ailsa, the loss of her daughter Audrey, who disappeared, together with her husband Stephen Currier on a chartered flight from Puerto Rico to St. Thomas in 1967, was a further tremendous blow to her peace of mind. She took some comfort, however, in her continuing grandmotherly relationship with the three very young Currier children, Andrea, Lavinia, and Michael.

Like me, Ailsa collected French paintings. Her indecisiveness must have been harrowing to the art dealers who often waited many months for a decision. Sometimes I might find myself looking at a picture with Jay Rousuck of Wildenstein, and he'd say that he had just shown it to Ailsa. My reaction was always to insist that he not tell her that I was interested in it since that would goad her to make up her mind and she would snap it up! I kept in close touch with Ailsa throughout her life and saw a lot of her during her later years.

Close friends like Jimmy Brady (father of Nicholas Brady, the current Secretary of the Treasury), George Wyckoff, Chauncey Hubbard, Fran Carmody, Jack Barrett, Tom Fitzwilliam, Charles Halifax all are now gone. I still see a lot of my foxhunting and Hundred Mile Ride friend and neighbor Billy Wilbur, who keeps me laughing and abreast of local doings. Although of another generation, I am still on friendly and lighthearted terms with Nick and Kitty Brady, and with Nick's brother and sisters and their spouses. And John Baskett, my coauthor of this book, has been a close friend for thirty years.

After Christmas, Bunny and I usually leave for Antigua with a few friends or family members. There is a landing strip on the farm that accommodates our Gulfstream, so it is just a matter of driving to it and leaving the cold weather behind. There are three flagpoles at the strip, one flying the Stars and Stripes, the second reserved for the national flag of our guests, usually the Union Jack or the French tricolor. The third pole is reserved for our gray and yellow Rokeby Stables flag, with its wheat sheaf emblem, which is always flown when I am returning from a

With two yearlings at Rokeby

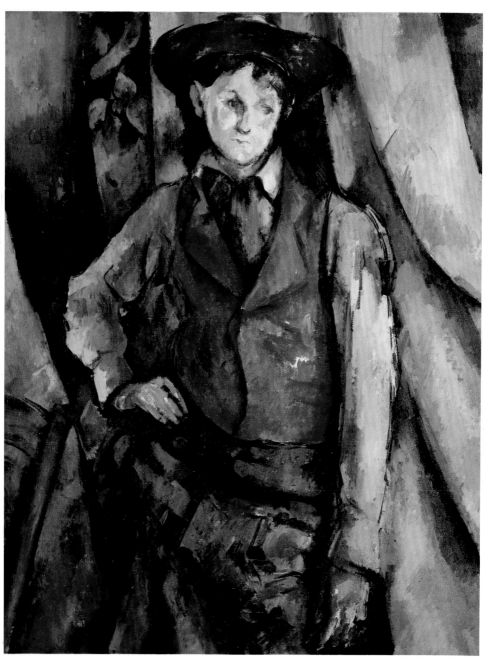

Paul Cézanne (1839–1906), "Boy in a Red Waistcoat"

With Patrick in front of my twenty-three-foot sloop, *Cornflower*

John Singer Sargent (1856–1925), "Miss Beatrice Townsend"

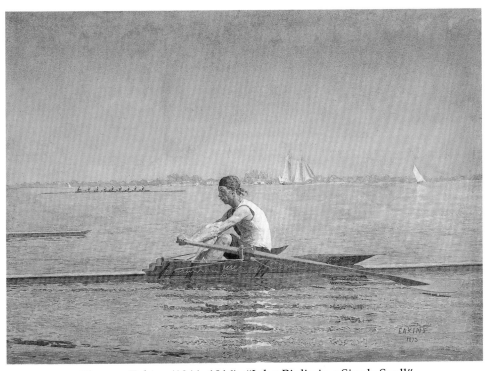

Thomas Eakins (1844–1916), "John Biglin in a Single Scull"

Winslow Homer (1836–1910), "Dad's Coming"

J.M.W. Turner (1775–1851), "Dort or Dordrecht: The Dort Packet-Boat from Rotterdam Becalmed"

John Constable (1776–1837), "The Church at East Bergholt"

Thomas Gainsborough (1727–1788), "The Gravenor Family"

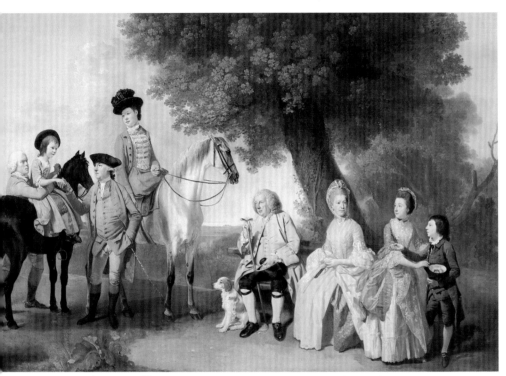

Johann Zoffany (1733–1810), "The Drummond Family"

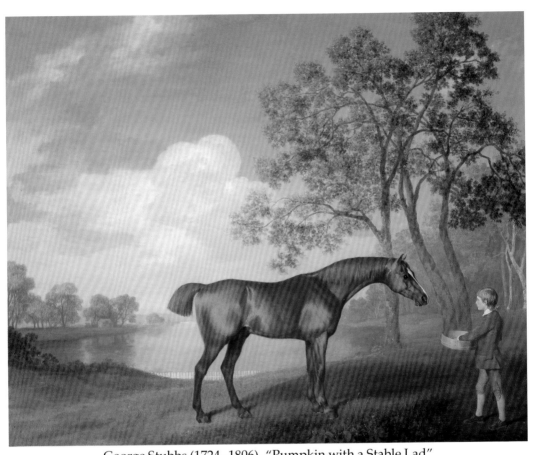

George Stubbs (1724–1806), "Pumpkin with a Stable Lad"

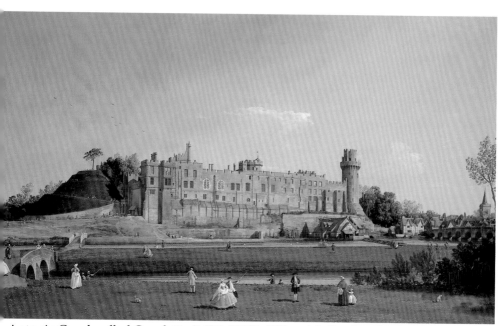
Antonio Canal, called Canaletto (1697–1768), "Warwick Castle: The South Front"

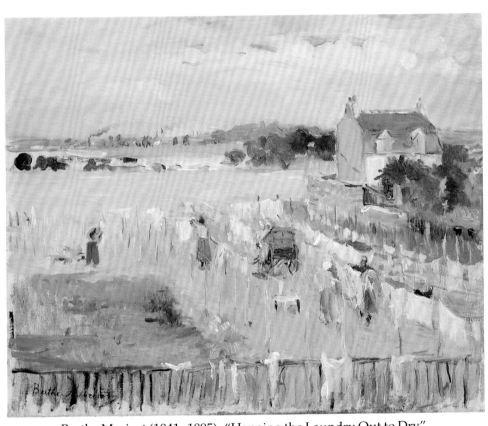
Berthe Morisot (1841–1895), "Hanging the Laundry Out to Dry"

Vincent van Gogh (1853–1890), "Green Wheat Fields, Auvers"

Claude Monet (1840–1926), "Field of Poppies, Giverny"

Edgar Degas (1834–1917), wax models of horses

Edgar Degas (1834–1917), "The Dance Lesson"

winning race. We have a few very small pictures hanging in the cabin of the plane: a Braque watercolor, a Klee, a Raoul Dufy, and a Ben Nicholson among others. Walt Helmer, our retired chief pilot, did wonders in allaying Bunny's fear of flying by never flying her in bad weather and by always explaining what was going on. Now we are well looked after by Norman Cain, Jerry Myers, and Ron Greto, backed up by Bob White, our skilled maintenance manager. The flight time to Antigua is about three and a half hours. On arrival, Oscar or Alvis, our local taxi drivers, take us across the island over the potholed roads, past the sugarcane and sea island cotton plantations, with occasional glimpses of the surrounding deep blue sea.

The house itself is reminiscent of an old West Indian plantation house. It has an open plan of rooms and courtyards, so that wherever you are standing you enjoy a view into a brick-paved courtyard, filled with lime trees, breadfruit, and olives, or out over the bay toward a coral reef, or into another white-walled sparsely furnished room. There is an indescribable feeling of peace, with the warm air softly cooled by the trade winds. Because of limited accommodation, guests never number more than three or four. Dinner is in the candlelit dining room. A huge bowl of tropical fruit serves as a centerpiece on the table, and the warm night air is filled with the sound of tree frogs and the surf breaking gently on the beach a hundred feet below. Cora will have prepared a delicious meal. Periodic shrieks of laughter emanate from the kitchen as the staff watches *The Jeffersons* on Antiguan television. Merriment is not confined to the kitchen, and after dinner the party adjourns to the drawing room for coffee. At this stage I ask solicitously whether anyone would be interested in having a game of Scrabble. The old hands recognize this as a command and draw their chairs up to the table. I take the game seriously, and after I have returned from the bar with drinks, I look suspiciously at the board, pretending to see if there has been any cheating. Finally it is bedtime, and the guests leave me to close the shutters and blow out the candles while they walk under the acacia and black willow trees to their rooms in the nearby guesthouse.

We commissioned the late Page Cross to build the Antigua house. He did an outstanding job, but it was very much a collaborative effort with Bunny, whose hand can be seen everywhere. The gardens have now grown to maturity and have brought the whole place to perfection. The Antiguans are universally good-natured and have a relaxed attitude to life. Bunny and I have tried to repay Antigua for the pleasure it has given us. Some years ago Bunny made over a field to the islanders to form a collective, enrich the soil, and grow vegetables for sale to the hotels. Unfortunately most of the island was for centuries covered with acres of sugarcane, and as a result of the poor soil, the hotels have had to import nearly all their vegetables. Alas, the renowned lethargy in that part of the world defeated Bunny's plans, and the field has reverted to scrubland, an overgrown memorial to a noble enterprise.

Many medical facilities on Antigua were primitive, and modern medical equipment has been in short supply on the island. So Bunny has now, with professional medical advice, equipped a laboratory and clinic fully staffed by trained men and women mostly from the islands.

At the end of our stay in Antigua I often fly home via Aiken, South Carolina, where Mack Miller trains the racehorses during the winter. We get to the training track early to watch the morning workouts. The horses are paraded in front of us, and we discuss their condition and their prospects. Then it is home to the farm. Later in the summer Mack and I, along with Ian Balding, spend a day at Rokeby to decide among us which of the yearlings are to go to England.

At home in Virginia I usually start my day in my sporting book library or its small adjacent office, dealing with my correspondence and consulting Martha Tross, my secretary, by telephone at the farm office. Martha Tross, who has been with us for over forty years, lives in the old Oak Spring farmhouse, the one we had moved to the Rokeby side of the farm. Apart from looking after my correspondence in the country, Miss Tross also runs the accounting side and much of the day-by-day business of the breeding and racing operations. It is usually she who

sends those welcome messages if I have had a lucky day on the turf, either here or in England.

I try to keep my affairs in good order. I always set my watch three minutes fast to be sure that I am on time for appointments, and although I am not a man to work from a cleared desk, everything is in its place and squared up. I keep my horse list booklet in an envelope in my pocket and jot down possible horse names and other reminders there.

If it is the foaling season, I might phone Bernie Garrettson, my stud manager, and ask him to join me to see the latest foals. I drive over to the Rokeby barns in my ancient (1968) Mercedes. I feel that, like me, it has worn pretty well. Bernie and his men will bring out a mare or two with their foals or some yearlings for me to look at, and we will talk about their conformation and their prospects. Once, when Ruth Halifax, widow of my old friend Charles, offered her expert opinion that one of the yearlings did not look very promising, Bernie said to her, "I love them all, madam," and that just about sums up his attitude and the feelings of his staff.

On the way back from seeing the horses I will probably call in at the Brick House to look around at the paintings and catch up on art matters with Beverly Carter, my curator. These days the Brick House is hung almost entirely with my collection of sporting paintings, the bulk of the English collection having long since gone off to the Yale Center for British Art. I never tire of looking at the paintings, drawings, and sculptures, and as Patrick our Norwich terrier will confirm, we have made countless visits to enjoy them over the years.

I suffer occasionally from insomnia. I get to sleep easily enough but sometimes wake up at some unearthly hour. I have benefited from this misfortune by sitting up in bed and reading. I got into the habit of reading early in life, and I rather agree with Thomas à Kempis when he wrote that "everywhere I have sought rest and found it not, except sitting apart in a corner with a little book." I'm afraid my reading matter is not always as elevated as his because I like to keep a spy thriller or some other trash going at the same time as something more serious.

Bunny and I get together before dinner for a drink and discuss the day, the dogs, and the future. I have always had a fondness for dry martinis, and for what it is worth, I have a formula I strongly recommend. I prepare the mixture well in advance in several decanters so that it has a chance to settle and because it saves time when you don't have to mix each drink individually. Each decanter contains two-thirds Smirnoff vodka and one-third Bombay gin, to which an inch of Stock vermouth is added. Sometimes, after dinner, Bunny and I watch TV or a videotape before going to bed. We both love looking at tapes of "Upstairs, Downstairs," "Flame Trees of Thika," "A Town like Alice," or other *Masterpiece Theater* productions. And there is always *60 Minutes* and Andy Rooney.

Once or twice a month I fly up to New York. We have owned the New York house on East 70th Street since before World War II. One day, about ten years ago when I was staying there, I had a visit from Vanessa Redgrave, who is a very distant relation. Her mother, Rachel, was a famous actress as well, and she was the niece of my aunt Maud, Uncle Percy's wife, so there is a vague connection. I had received a letter from Vanessa asking to see me because she had something very important to talk to me about. She was in New York at the time, so I asked her if she would like to come to tea. She arrived dressed in jeans and some kind of Daniel Boone leather jacket. I hadn't realized until that time how tall she was, very tall and very pretty. We went to the living room, and I asked her whether she would like a drink or would prefer tea. She said she would rather have tea, so I rang for it, and in due course, Peter, our English butler, arrived with a large tray on which were sandwiches and a silver kettle with a methylated spirit burner under it, all very formal.

Vanessa, meantime, was explaining to me in her quiet voice that she was raising funds for the revolution and that she wanted some money from me to help her in her fight for the proletariat. I tried to explain to her that for my part, I was not really in favor of a revolution and furthermore, I thought it would be nearly impossible to organize one in the United States,

but she seemed already to have formulated her answers. When it came time to leave, it appeared that another actress had come to pick her up. I walked with her to the door, where she delved into a large portfolio and handed me a newspaper that she said she thought I ought to read. With that she departed, leaving me standing there, holding a copy of the *Daily Worker*.

We all have close calls in life. At age eighty-four, as I review the many places I have been and all the things I have done (many of the latter pretty foolish), I marvel at the great luck I have had and the special quirks of fortune that have seemed to protect me through accidents, acts of war, illnesses, and potential assaults.

It was in New York that I had what I hope will have been the last of my narrow scrapes in this life. My family is noted for longevity, and this must be in the genes, but you will recall how I nearly met a sudden end sixty-three years ago, as a student at Yale, when I left the road and turned my car over in a field. Then there was that wartime voyage through submarine-infested waters and, in France after D day, the raging fever with double pneumonia. There was the racehorse that nearly finished me off at Bath in 1975 when he kicked me in the liver, but I suppose my closest call was not that many years ago, when I was the victim of an abortive mugging in New York. I was walking home from a dinner party (in those innocent days when one thought it was absolutely safe to walk the streets there at night) and had just turned into 70th Street. Ahead of me, by about the entire length of the block, I saw two black youths, one very tall, the other short, walking away from me. So I continued toward my house, which is in the middle of the block. Just as I neared the house, I saw, to my horror, the two youths rapidly coming toward me on my side of the street. I was just able to reach the front door and press the bell (we have a night security man), but by that time the tall one, who had followed behind me, pointed a long, thin, sharp kitchen knife directly at my stomach, just as I quickly turned and put up my hands. His short pal was beside him. There was no sign of the security guard. I said,

"Everything you want is in my right inside pocket. Take it."

Just then there was a sound behind me, the door opened, and the not-so-alert security man merely said, "What's going on?"

The two muggers almost knocked themselves over turning to run.

I said to our man, "Where's your gun? Go get 'em!"

But it was too late, and they were already streets away. But what if the door hadn't opened? A quick jab to the stomach, a quick grab into the pocket, and I *could* have been lying there in a pool of blood.

Of course, people get maimed and killed by way of broken necks while foxhunting, but I have never thought of it as a dangerous pastime, so interesting and healthful and exciting it has always seemed. And I had well-schooled horses, mostly thoroughbreds, so the jumping was always safe and my mounts had lots of stamina to carry me. As Jorrocks said, "It's the image of war without its guilt and only five-and-twenty per cent of its danger."

I certainly don't consider myself accident-prone or that my life has been fraught with danger. But I do consider myself fortunate in the positive outcome of things that *have* happened to me or might have happened to me. I often wonder why I have been so favored, so protected. Has it been the warning bell of intuition? Has it been pure luck? Has it been God?

Our Washington house is located just off Massachusetts Avenue behind the British Embassy. It is run by Oliver Murray, a perfect butler, who hides his professionalism behind a cloak of relaxed informality. I have never revealed the fact to Murray, but I really don't know what we would do without him. While in Washington, I usually spend a morning in our office on H Street. My secretary Janet Stewart fills me in with what has been going on, and we deal with the current correspondence. I usually wander down the corridor to have a chat with Carroll Cavanagh. Carroll relinquished his position as Secretary and General Counsel to the National Gallery of Art to join me as my general business

and legal adviser. It has always been my policy to let everyone run his own department without undue interference from me. They all understand, however, that I like to be kept fully in touch with developments and that I want to put in my oar if I see fit. My main business office used to be in New York, but when Carroll arrived, we transferred all its operations to be computerized under one roof in Washington. We kept the office on Park Avenue because it is very near our house. I find it handy for meetings, and it is also used by Bunny's secretary, Anita Engel, and a small staff. Further, it provides more wall space for some of my sporting pictures!

Our several visits to Antigua take place between Christmas and March. In the summer, roughly from early August until a week or so after Labor Day, we leave for our house near Osterville, Cape Cod. There is a shared quality between the farm and the houses in Antigua and the Cape. Page Cross, the architect, was involved in all of them, and Bunny's touch permeates every nook and cranny, extending of course to the gardens. The Cape is getting a little overcrowded nowadays, but we are very fortunate on our small island of Oyster Harbors, where things are pretty much unchanged. The waves on Nantucket Sound are broken by Dead Neck, a long, thin sandy island covered by dune grass, which is separated from our house by a narrow river, or estuary. During the season, when it is patrolled by the Audubon Society, this dune grass neck of land is inhabited by thousands of nesting terns that, with the gulls, keep up a constant cry.

My daughter, Cathy, has a house on an inlet very near us and may be there with one or more of her three grown-up children and her grandchild. I have recently become a great-grandfather! Bunny's son, Stacy, usually comes up during the summer holidays from Washington with his two young boys to stay in the Putnam house, an old Cape Cod clapboard house on part of our property. My son, Tim, and his wife, Louise, often stay with us. Tim has pursued his childhood passion for railways into a career of owning and running them. He is Chief Executive Officer of the Guilford Transportation Company, con-

trolling the Boston and Maine, Maine Central, and Delaware and Hudson railroads. We may from time to time see Eliza, Bunny's daughter, who lives partly in New York and partly at a country house at Little Compton, Rhode Island.

I'm not sure that our children have at all times had a proper reverence for the art displayed on the walls of our houses, although Cathy has a neglected talent for painting and drawing, and Eliza has become a professional artist herself. One day, when Eliza was still at Foxcroft School, she brought several of her friends home for Sunday lunch. As they came in the front door, one of the girls looked up at our Van Gogh, "Green Wheat Fields, Auvers," which hung at that time in the front hall, and said, "Oh, who paints?" Eliza, never at a loss for words replied, "Nobody here. Da buys them at the store."

I have a small twenty-three-foot sloop at the Cape, the *Cornflower*, which I can easily manage single-handed, and I love to go out in her and feel the wind in my face and hear the cry of the gulls. She is a Crosby Curlew, one of a class of about eight wooden sloops built in the fifties at the old Chester Crosby Boatyard in Osterville. She was designed by Danny Knott of the boatyard with my son, Tim, who also used to love to sail. It's a lot of fun, but Nantucket Sound waters are shallow and the navigable channels tricky. You can easily, and you often do, find yourself aground on a sandbar.

During August at Oyster Harbors we usually have Charles Ryskamp staying with us for his holiday. He is an old friend, whom we have known since his teaching days in Princeton, before he took up his directorship first of the Morgan Library and later of the Frick Collection. He often sails as crew in the *Cornflower*, and if the waves aren't too big or the sea gulls too loud, we rack our brains for names for the current crop of Rokeby yearling colts and fillies, consulting their pedigrees on a very damp sheet of paper. It is a great advantage to have the services of a Princeton professor of English!

One evening, when I was swimming in the river before dinner, I heard the voices of two vacationers who were just passing in a motorboat. We all know how sound travels over water, so

I was able to hear one of the men say in a loud voice to the other, "See that house over there? The guy that owns that house isn't just a millionaire, he's a *bil*lionaire, but that little sailboat over there is the only one he owns."

We swim in the tidal estuary, between our house and the narrow island full of terns, in water warmed to perfection in the shallow stretches of Nantucket Sound. It is a far cry from the mighty surf of the great Atlantic beaches and from the Southampton beach where both Bunny and I, in our childhood, used to dive through the huge curling waves, just before they tumbled with a roar onto the sand. In recent years Bunny has bought, with a legacy from her father, a large stretch of land on the Atlantic side of Nantucket, where she often goes to oversee the return of the land to its original state of meadowland and wildflowers and where she loves to hear the waves beating on the shore with the same rhythm and deep roar that she remembers from her early days at Southampton. Much of her land will eventually belong to the Nantucket Conservation Foundation for its perpetual preservation.

I try to go over to England to see my friends and relatives and to watch my horses run at least two or three times a year. The timing of my visits usually depends on the races, but I am almost invariably there for Royal Ascot. I will always try to get down to Kingsclere to see Ian and Emma Balding and Emma's mother, Priscilla Hastings, and make the rounds of "evening stables." There I see each horse in his stall, bedded down for the night. Until 1986, when Mill Reef died, I used to make the journey to Newmarket, too, to see him at the National Stud, but he, like so many of my old friends, is now gone.

For a number of years from the late seventies, I made annual trips from England with John Baskett to visit the major European art galleries. In a sense these journeys echoed those my father made with Frick a hundred years ago, the only difference being that while we enjoyed the airplane and rented cars, they were dependent on the railways and stagecoaches.

I have lived through most of this century and have seen many

tremendous changes, not all of them salubrious. I saw my first airplane in the air in 1914. I don't recall any scheduled air services to New York or Washington until the early thirties, the era of Ford Trimotors and Lockheed Vegas. It required three hours or more to fly to New York from Pittsburgh or, at best, two and a half hours to Washington. But we usually took the overnight train, the *Pittsburgher*, to New York, or the Baltimore & Ohio sleeper to Washington.

I remember old John Moore cranking our cars to start them, and on long trips there would always be several punctures and tire changes.

While I was at Choate in the early twenties, some of us had primitive crystal set radios that never seemed to receive anything. My first sight of a TV screen was in Gerald Brockhurst's studio in London, in 1936, when he was painting Mary's portrait. It was very small, very experimental, strictly black and white, with some moving dancers hazily seen.

Air conditioning became noticeable in a few offices and movie theaters in the early thirties, but it was certainly unknown in our houses or in school.

There was no air travel abroad until just before and during World War II. In any case, how much more enjoyable, comfortable, healthy, and relaxing were the great ocean liners that used to ply between New York and England, or France, or Italy. Our own voyages were usually in ships of the Cunard or White Star lines, whose floating palaces made regular weekly runs across the Atlantic: the *Aquitania* and *Mauretania*, the *Majestic* and *Olympic*. During the thirties, however, until Hitler's ravings became completely outrageous, we were more likely to book on the North German Lloyd liners *Bremen* and *Europa*. All these ships were the embodiment of romance, of immense power and lofty beauty, and even if you were earthbound and living in the middle of Manhattan, the farewell of their deep-throated foghorns blowing as they crept out of New York Harbor would tingle your spine and kindle thoughts of escape.

What a pleasure it was to have five days of reading and talking and sleeping on the way to Southampton, Cherbourg, or

Genoa, as opposed to a quick zip on the Concorde to Paris or London, or overnight to Rome, overfed and jet-lagged. We had long walks on the open deck in the fresh Atlantic wind, quiet hours of reading in deck chairs cosseted in warm blankets, swimming in the pool with friends, cocktails in the lounge, delicious meals, and, for those who wanted a little gambling, the auction pools on the prognostications of the days' runs in nautical miles. It was a life of luxury, where time and responsibilities were suspended in a large, peaceful capsule. Of course, there were sometimes queasy periods in stormy weather, but they could often be dispelled in a turn around the open deck.

I have had one transatlantic voyage (in the *Queen Elizabeth* 2) since "the old days," and believe me, the magic has gone out of it. My most heartwarming memories are full of those old voyages, replete with friends, books, walks, drinks, and sometimes an ephemeral romance among the moon-spread shadows of the boat deck.

I'm told that money is power, and I expect many have wondered why I haven't used mine for that purpose; to prevail in business, to seek public office or an ambassadorship, to see my name in the papers more often. For many reasons the idea of power has never appealed to me. What *has* appealed to me is privacy. To me, privacy is the most valuable asset that money can buy.

I once told the graduating class at a Foxcroft School commencement, "What this country needs is a good five-cent reverie." My whole address that day was a plea to those children not to take life too seriously, to temper future responsibility with pleasure, to take time out to smell the flowers. Those children are now middle-aged women, and occasionally one will tell me that what I said still means a great deal to her. Perhaps that is power!

I have been an amateur in every phase of my life; an amateur poet, an amateur scholar, an amateur horseman, an amateur farmer, an amateur soldier, an amateur connoisseur of art, an amateur publisher, and an amateur museum executive. The root of the word "amateur" is the Latin word for love, and I can

honestly say that I've thoroughly enjoyed all the roles I have played. But in these later years I have grown to look on myself more and more as an anachronism, an incongruity, a sort of latter-day Jorrocks, an emissary of the past, and well, yes—a perennial student, wondering, but innocent of the great complexities of the day, and staring speechless at the swift march of science, the tides of faster and faster computers, the giant strides in genetics, and man's seemingly infinite probes of the universe.

I hope I have made no excuses for a lack of what most of the world considers success, just as I hope that I have not overstated whatever contributions I may have made to my fellow humans or fallen into the trap of excessive pride. I have always been aware of the tremendous advantages the circumstances of birth have brought me; but I have also learned that immense wealth has its unpredictable and often devastating effects. The beautiful paintings on the walls were not all that was reflected in the silver spoon.

As my life draws toward its close, lines by George Dillon from his poem "Elegy," in *The Flowering Stone*, seem to sum up my feelings and provide a fitting ending to this book:

> I know the way. I shall lose part by part,
> So all is lost but the insensible thing—
> The dream, the image not of sound or sight:
> It is a wild perfume upon the world, it is the bright
> Perpetual honey in the hive of spring,
> It is the broken bell whose legends ring
> Fatally and forever in my heart.

Appendices

Course of Instruction
The Cavalry School, Fort Riley

Course of Instruction
The Cavalry School, Fort Riley

———◆———

**Department
of
Weapons**

81 mm Mortar
37 mm A T Gun
Cal. .50 Machine Gun
Heavy Machine Gun
Light Machine Gun
M1 Rifle
Thompson Submachine Gun
Cal. .45 Pistol

**Department
of Horsemanship
and Horsemastership**

Horsemastership
 Animal Management
 Horseshoeing
 Pack Transportation
Horsemanship
 Basic Equitation
 Marching

**Department
of General Instruction
and Publications**

The Army of the United
 States, Its Components
 and Mobilization
Training Management
The Military in Domestic
 Disturbances
Military Courtesy and
 Customs of the Service
Efficiency Reports
Troop Administration
Technique of Instructing

**Department
of
Tactics**

Map and Aerial Photograph
 Reading
Estimate of the Situation,
 Combat Orders,
 Operation Maps, and
 Messages
Command Functions,
 Communications, Staff,
 and Logistics
Engineer Activities in
 Support of Cavalry
Reconnaissance
Security
Attack
Defense

Principal Stakes Won by Rokeby Horses 1955–1991

Principal Races Won by Rokeby Stables' Steeplechasers 1934–1991

Principal Stakes Won by
Rokeby Horses
1955–1991

———◆———

The Belmont
1964 Quadrangle
1969 Arts and Letters

Jockey Club Gold Cup
1969 Arts and Letters

The Wood Memorial
1964 Quadrangle

The Futurity
1990 Eastern Echo

The Travers
1964 Quadrangle
1969 Arts and Letters
1972 Key to the Mint
1987 Java Gold

The Laurel Futurity
1963 Quadrangle

The Whitney
1972 Key to the Mint
1987 Java Gold

The Hopeful
1987 Crusader Sword

The Jim Dandy
1969 Arts and Letters
1977 Music of Time

The Brooklyn
1972 Key to the Mint
1980 Winter's Tale
1984 Fit to Fight

The Lawrence Realization
1964 Quadrangle
1985 Danger's Hour

The Metropolitan
1969 Arts and Letters
1984 Fit to Fight

The Woodward
1969 Arts and Letters
1972 Key to the Mint

The Suburban
1973 Key to the Mint
1978 Upper Nile
1980 Winter's Tale
1983 Winter's Tale
1984 Fit to Fight

The Marlboro Cup
1980 Winter's Tale
1987 Java Gold

In 1984 Fit to Fight was the first horse since Kelso in 1961 to win the Handicap Triple Crown, and only the fourth in history.

Principal Stakes Won by
Rokeby Horses, 1955–1991 *(cont.)*

The Tidal (Turf)
1967 Fort Marcy
1969 Fort Marcy
1971 Run the Gantlet
1987 Dance of Life

The United Nations (Turf)
1970 Fort Marcy
1971 Run the Gantlet
1981 Key to Content
1984 Hero's Honor

The Man O' War (Turf)
1970 Fort Marcy
1971 Run the Gantlet
1986 Dance of Life

**San Juan
Capistrano** (Turf)
1976 One on the Aisle

**Washington, D.C.
International** (Turf)
1967 Fort Marcy
1970 Fort Marcy
1971 Run the Gantlet

Coaching Club Oaks
1972 Summer Guest

The Alabama
1972 Summer Guest

The Diana
1957 Pardala
1967 Pride's Profile
1968 Green Glade
1976 Glowing Tribute
1984 Wild Applause
1988 Glowing Honor
1989 Glowing Honor

The Test
1955 Blue Banner
1976 Ivory Wand

The Spinster
1974 Summer Guest

Horse of the Year
1969 Arts and Letters
1970 Fort Marcy
1972 Key to the Mint
 (3-year-old champion)

Principal Races Won by
Rokeby Stables' Steeplechasers
1934–1991

The Maryland Hunt Cup
1937 Welbourne Jake

The Grand National Point-to-Point Maryland
1935 Chatterplay

The Grand National Steeplechase
1948 American Way (Belmont Park)
1990 Molotov (Far Hills, NJ)

In 1948 American Way was the leading steeplechaser and the leading moneywinner. American Way and Genancoke (both Rokeby bred) each won over $100,000, a record for those days.

The Carolina Cup
1935 Drinmore Lad
1939 Faction Fighter
1940 Faction Fighter
1941 Memory Lane
1942 Rustic Romance
1967 Dunotter
1991 Molotov

The Middleburg Hunt Cup
1934 Drinmore Lad
1937 Welbourne Jake
1938 Corn Dodger
1947 Paul Revere
1971 Chapel Street
1974 Chapel Street
1975 Chapel Street

The Deep Run Hunt Cup
1934 Drinmore Lad
1935 Drinmore Lad
1937 Welbourne Jake
1939 Rustic Romance
1941 Rustic Romance
1947 Paul Revere
1971 Chapel Street
1976 Chapel Street

The Sandhills Cup
1938 Corn Dodger
1939 Faction Fighter
1942 Rustic Romance
1963 Sunless Sea

The Virginia Gold Cup
1974 Mongogo
1975 Chapel Street

In 1936 Drinmore Lad was shipped to England. In 1937 he won the Valentine 'Chase of roughly 2½ miles over the Aintree Grand National Course. Thereafter he won many races including a dead heat at Gatwick with Golden Miller, twice winner of the Grand National.

In 1948 Blakely Grove won the Stanley 'Chase of roughly 2½ miles over the Aintree Course, and in 1964 Red Tide won the Topham Trophy over the same course.

Explanatory Notes
That Followed the
Organizational Chart

1.

P.M.

Washington

The National Gallery of Art

Purposes, Plans, Problems

Officers
- Chester Dale, President
- Lamot Belin, Vice-President
- Stoddard Stevens (Counsel)
- John Walker, Director
- Huntington Cairns, Sec.,Treas.
 Counsel
- Ernest Feidler, Administrator

Board
- The Chief Justice,
- Earl Warren, Chairman
- Secretary of State
- Secretary of the Treasury
- Secretary of the Smithsonian
- Chester Dale
- Lamot Belin
- Rush Kress
- Duncan Phillips
- Paul Mellon

1. Need better public relations
 & governmental relations.

2. Need for better educational
 plans. Publications
 Movies & TV
 Slides & lectures
 Guidophones
 Scholarships
 Library

3. Need to strengthen Board.
 Install age limitation.
 Consider availability,
 business experience.
 etc.

4. Need to revise by-laws &
 Trust Indentures.

Old Dominion Foundation (Washington Office)

Officers
- Ernest Brooks Jr. President ⎫ in N.Y.
- John D. Barrett, Vice-Pres. ⎭
- Monroe Bush Jr. Assistant to ⎫
 President and responsible for ⎬ in D.C.
 investigations & grants in ⎭
 Virginia.

Board
- Paul Mellon, Chairman
- John D. Barrett
- Ernest Brooks Jr.
- Adolph W. Schmidt
- George W. Wyckoff

Personnel: see New York
 (Old Dominion Foundation)

1. Should we increase Board ?

1. Advisory Board for Virginia
 projects: (Bruce, Darden,
 Cheek, Bemis etc.) ?
 with new Board

2. Set up separate Fund for
 Virginia projects?

3. Make Bush responsible to
 Bruce, or the Advisory Board,
 some other representative, or
 to an enlarged Board?

4. Define & study projects Va.
 a. Survey of Historic Buildings
 b. Preservation of " "
 c. Conservation & Forestry
 d. Health & Education
 e. Libraries : improve & build
 f. Strengthen University of Va.
 " V.P.I.

6. Study Foundation or Instit-
 ute for Humanities
 (see below)

2.

Washington (cont.)

Foundation or Institute for the Humanities

Present committee: P.M. Others to Consult ?

 John Barrett (& Brooks)
 Huntington Cairns Pusey (Harvard)
 Goheen (Princeton)

Advisors to date: Abraham Flexner de Vane(Yale)
 Whitney Griswold Heald (Ford)
 Nicholas Hammond (Eng.) Josephs(Carnegie)
 H.D.F. Kitto (Eng.) Horton (Wellesly)
 (although Barrett & Cairns have conferred Blanding(Vassar)
 with many more) Faust (Ford)
 Lippman
 Haskins (Carnegie
 Institute)
 etc.

 The problems here are so varied it is impossible
to cover them all. See Huntington Cairns letter "Dear X" and subsequent
memorandum. The principal consideration here is that I believe strongly
some well-supported or endowed Foundation or institution should be con-
ceived to rectify the seemingly great over-emphasis on the physical sciences
in Education, and through mass-media. In other words, to strengthen the
Humanities through education, research, publication, scholarships, grants
for original work, grants to schools & colleges etc. It seems a fairly
generally accepted truth among humanists that of all humanistic learning,
the Greek & Roman Classics of Literature, Philosophy, and Science have been
most neglected, and that of these, a return to and study of Hellenic thought
and Philosophy is at the present time most essential.

 In line with this, two extremes of action have been
suggested (although obviously gradations between have been discussed and are
possibilities.) The first is the establishment of what Huntington Cairns calls
a Residence, where in the first instance, and perhaps for years, a small body
of older, retired or about-to-be retired famous scholars would live with, teach,
advise, and inspire younger classicists from the Universities who would come
for limited periods. They would also pursue their own studies, research, writing;
and ample funds for the publication and dissemination of their work would be
available. (Some extension of the present Bollingen Series of books has been
envisaged, as well as subsidies for University Presses, a Journal etc.)

 The second possibility is the incorporation of a
Foundation for the Humanities forthwith. According to Abraham Flexner, the
mere appearance of such a body with such a name would serve to revivify and
encourage Humanists throughout the world. While studying the possibility of
establishing a Residence or Academy, the Staff & Board of such a Foundation
would be in a position to make grants to schools, universities, & individual
scholars for work in the Humanities & for the reestablishment of education
in the Classics. and encouragement

3.

Washington (cont.)

With the above in mind, the following general & specific problems
occur to me:

1. Foundation for Humanities: ⟋ *A New Foundation*
 a. Would ~~we~~ be able to accept Mrs. Beale's property and *Can O.D. Re-assign it ?*
 hold it until some plan of a School or Residence were
 adopted? The property <u>has</u> been accepted by Old Domibnion.
 How and when can the Will be tested, and by whom?

 b. Need for strong Board of Trustees : Academic, Foundation,
 Business & Legal experience intermixed.

 c. Should we begin with Advisory Board to Old Dominion Foundation?
 (Griswold, deVane, Pusey etc.)

 d. Bollingen is now in effect "For the Humanities." Possibility
 of slowly expanding: enlarge Board: make grants to Schools,
 Universities etc. Expand aid in form of subventions to Univ-
 ersity Presses.

 e. If a new Foundation is set up : (1) Start with endowment?
 or (2) Guaranty income x years?

 f. Where should its headquarters be?

2. "Residence" or "Institute" for the Humanities, or Classical
 Studies:

 a. Is it necessary or advisable to limit to Classical studies?

 b. What would be the attitude of the Universities to such an
 outside body of scholars? Would there be cooperation?

 c. Would the wise and learned older men really be attracted?

 d. Should it be situated in Washington (i.e. Library of Congress
 and neutral position among Universities, north & south etc.)?

 e. Couldn't with equal success be placed in a University town,
 if not directly attached to a University? (Institute of
 Advanced Study at Princeton.)

 f. Need for detailed study of organization
 costs
 building needs
 Mrs. Beale's Will
 possible Directors
 Board of Trustees

4.

Pittsburgh

A.W. Mellon Educational & Charitable Trust

> A.W. Schmidt, President
> Phillip Broughton, Secretary
> etc. *And others .*

Board

> Paul Mellon, Chairman
> Ailsa Mellon Bruce
> Adolph W. Schmidt
> George W. Wyckoff

> George D. Lockhart, Counsel
> (not on Board)

Purposes, Plans, Problems

1. Capital funds now stand at 40 million (market) and stated policy is to spend all in Pgh. and Pgh. area. Target 1960.

2. School of Public Health (Thomas Parran, Dean) part of University of Pgh only major grant to date. *[Excep National Gallery]*

3. Three possibilities being considered (now leaning toward cultural *(Project),* Art, Humanities & Liberal Arts:)

 painting

 a. Museum for old & modern, with special educational pattern & historical slant. To be part of civic cultural center: Symphony Hall, etc. *Playhouse etc.*

 b. Establishment of A.W.Mellon Professorships in Liberal Arts in University of Pgh. (10 million suggested.)

 c. Strengthen Mellon Institute of Industrial Research and provide endowment for basic research, chemistry & physics (10 million suggested *As This Foundation's share.*)

4. First & most obvious problem *Steps*: Increase Board of Trustees *And* Conduct more thorough survey of situation.

Personnel: Adolph W. Schmidt. Pittsburgher, *age* (53?) Princeton '26 (?) Harvard Business School. Mellon National Bank.[Bonds, statistics etc.]Employed about 1948 as Executive V.P. of A.W. Mellon E & C Trust. Also Trustee of Old Dominion Foundation and Governor of T. Mellon & Sons.

Phillip Broughton. Assistant to Schmidt. Ex- advertising man. Chiefly interested in medicine, and helpful for legwork in setting up School of Public Health.

Ailsa M. Bruce . Sister of P.M.; Chairman of Avalon Foundation.

George W. Wyckoff: Classmate of P.M. Yale '29. Governor of T. Mellon & Sons. Trustee Old Dominion and A.W. Mellon E & C.: P.M. & A.M.B. representative in T. Mellon & Sons. Director of Mellon National Bank, Carborundum Co., Pitts. Consol. Coal etc.

5.

Pittsburgh (cont.)

((?)

Mellon Institute of Industrial Research
(founded about 1910 by A.W. & R.B. Mellon)

Board
of
Trustees

[Director: *DR.* Paul J. Flory

[Gen. Matthew Ridgeway, Chairman

Richard K. Mellon
Paul Mellon
Alan M. Scaife
Dr. Bowman (former Chancellor
 Univ. of Pgh.)
George W. Wyckoff
Dr. Edward R. Weidlein (?)
 (past Director
 Mellon Institute.)

Purposes, Plans, Problems

1. Increase Board of Trustees.
 (esp. consider men with
 knowledge physical science.)

2. Study advisability (although
 we are already committed) of
 engaging in basic research,
 atomic research etc.

3. If advisable to engage in
 basic research, should applied
 & industrial research be
 continued on large scale (if
 at all.) ?

4. Is further endowment (priv-
 ate funds from Mellon family)
 necessary, or could funds be
 gleaned from industry alone?

5. If necessary, what amount?
 (20 million from entire fam-
 ily estimated by Ridgeway + Flory. Of this, 10
 could come from A.W. Mellon
 Educ. & Charit. Trust.)

T. Mellon & Sons

Governors
&
active
members

[Richard K. Mellon, President

Richard K. Mellon
Paul Mellon
Alan M. Scaife
Arthur Van Buskirk }
Joseph Hughes } (RKM)
Edward B. Clark
George W. Wyckoff }
Adolph W. Schmidt } (PM)
John F. Walton }(W.L. M.
(husband Rachel M.) } family)

sp. ?

NATHAN PEARSON PM

Personnel: Hughes & van Buskirk are lawyers
 representing R.K. Mellon & sister.
 Clark + Schmidt (several also).
 Nathan Pearson is asssitant to
 Wyckoff in my personal office; also
 a director of Carborundum. They and one
 bookkeeper attend all my personal business in Pittsburgh.

Purposes

1. Clearing house for family
 financial & invest. infor-
 mation:
 Sales & purchases securit.
 Charitable donations
 Companies' reports &
 progress.
 Gen. business & financial
 info.
2. General supervision &
 direction through repres-
 entatives on Boards:

 Mellon Nat'l Bank
 Aluminum Co. America
 Carborundum Co.
 Gulf Oil Corp.
 Pgh. Consol. Coal
 Koppers Co.
 etc.

6.

New York

Avalon Foundation (Inc.)

Offic-
ers
 Lauder Greenway, President
 Francis T. Carmody, Administrator
 George White, Vice Pres. & Sec.

Trustees
 Ailsa Mellon Bruce, Chairman
 Lauder Greenway
 Paul Mellon

Purposes, Plans, Problems.

1. Increase Board of Trustees.
3. Need for more defined policy
 & to avoid "scatteration".
4. Need for special advisors or
 consultants in special fields?
2. Need for strong professional
 Director or Administrator.
5. *Now has* Large capital (50 million)
 and increasing income annually

Since Donald D. Shepard's retirement, Avalon has been administered by
Francis T. Carmody, chiefly in consultation with Lauder Greenway. (and
other Trustees.) There is hardly any specialization, although emphasis
has been placed on Medicine, youth rehabilitation, social service etc.
Many grants in New York (the Founder's residence). Avalon Foundation has
also participated with Old Dominion in purchase of the Cape Hatteras
region for the National Park Service, and in endowment for Woodlawn
Plantation in Virginia, and in several minor grants.

Assisted by R. George White

Carmody is with Law firm (Whitman, Ransome, Coulson & Goetz.) He is
retained at 15,000 per year, but spends well over half his time *on Avalon*. He has
notified us he will have to relinquish soon, since he realizes we cannot
continue at present fee. This will give us an opportunity to employ a
top Foundation Executive.
Mrs. Bruce needs *sound advice* & intelligent direction in handling these large
funds. Although genuinely interested in spending money wisely, she is
unfortunately either unwilling or unable to authorize further special-
ization or surveys to produce wise outlets for funds. *In view of
lack of foundation experience and occupation with other affairs of officers
& Trustees, this seems quite understandable.*

Personnel:

 Lauder Greenway: Old personal friend of Mrs. Bruce.
 Chairman of Board, Metropolitan Opera.
 Graduated Yale '25 or '26. Subsequent PhD. Yale.
 Son of Dr. Greenway (*formerly of Yale.*)
 Financially independent. Mother a Carnegie.
 Francis Carmody: Yale '29. (Classmate P.M.)
 Yale Law School
 LeBoeuf, Winston & Lamb. (*New York*)
 Whitman, Ransome, Coulson & Goetz. (*New York.*)
 George White: Mrs. Bruce's financial assistant.
 (Originally bookkeeper from Pittsburgh, but
 has developed *extremely well* in common sense & initiative.)
 Supervises books & accounts, sales & purchases,
 household accounts. *etc.*
 Liaison with George Wyckoff of T. Mellon & Sons.
 *Assistant Secretary & Assistant Treasurer,
 Old Dominion Found.*

7.

New York (cont.)

Old Dominion Foundation (Inc.)

Officers
> Ernest Brooks Jr. President
> John D. Barrett, V.P. & Sec.
> Monroe Bush, Assistant to Pres.
> (in Washington offiyce.)
> A. W. Schmidt, Treasurer
> R. George White, Ass't. Sec & Treas.
> and others.
> ~~etc.~~

Trustees
> Paul Mellon, Chairman
> John D. Barrett
> Ernest Brooks Jr.
> Adolph W. Schmidt
> George W. Wyckoff

Purposes, Plans, Problems

1. Increase Board of Trustees.

2. If Foundation for Humanities founded, Old Dominion might become ~~oriented~~ limited to Virginia & donor's personal charitable gifts only.

3. Or, it might continue present activities in other fields:
 Conservation
 Psychiatry
 Historic Preservation
 etc.

4. At present, several important possible committments:

 Yale University (Buildings and/or Endowment.)
 St. John's College "

 National Park Service
 Cumberland Island
 Coastal properties

 National Trust for Historic Preservation
 Virginia Survey
 Virginia project

5. Many possible future grants:

 National Gallery, England (in honor A.W.M..?)
 Louvre, Paris

 International scholarships
 like Rhodes + Commonwealth etc.
 (such as present Yale-Cambridge
 Scholarship.

Personnel: **Ernest Brooks Jr.** Yale '30. Harvard Law School.
Practised law (forget firm?)
Does most Bollingen Foundation & Old Dominion Foundation legal work.
Active head, interviewer, letter-writer, investigator, report-writer both organizations. Excellent relations with grantees & organizations.

John D. Barrett Yale '26.
Editor last ten years, Bollingen Series.
President, Bollingen Foundation, since last year.
(It is mainly, if not solely, his judgement that gives character and direction to Bollingen Foundation & Series.)

(for others see Pittsburgh)
Monroe Bush Jr. Ex-Presbyterian Minister. Young (35?)
Writes well, good contact, but inclined to take bit. Specializes in conservation, forestry etc. Does all Virginia investigation, interviews, letters + initiates projects.

8.

New York (cont.)

Bollingen Foundation (Inc.)

(Founded by Paul & Mary Mellon)

Officers
- John D. Barrett, President
 & Editor, Bollingen Series Books.
- Ernest Brooks Jr., Vice President.
- Miss Vaun Gilmor, Assistant to Pres.

Trustees
- Paul Mellon, Chairman
- John Barrett
- Ernest Brooks Jr.
- Huntington Cairns (& Consultant to
 Bollingen Series.)

Purposes, Plans, Problems.

1. Increase Board of Trustees.
2. Purposes & fields:
 a. Publication scholarly
 & creative works.
 b. Grants for scholarship,
 research, writing etc.
 c. Contributions to other
 organizations:
 University Presses
 Council Learned Soc.
 Archaeological exped-
 itions.

 Fields: Art, archaelogy,
 comparitive religion,
 symbolism, mythology,
 philosophy, psychology,
 anthropology, history,
 criticism etc.

3. Bollingen Poetry Prize
 (administered by
 Yale University Library)

Bollingen Foundation (named for town of residence of Dr. C.G.Jung, famous Swiss psychologist, in whose work Founder's since wife and himself were interested. Bollingen Series now publishing Collected Works of Jung etc.) The books began under aegis of Old Dominion Foundation, but new Foundation formed because Counsel (D.D. Shepard) believed risky to Old Dominion through possibility of obscenity (books) or subversion (books or grantees.) i.e. might become "controversial".

Founder made grant of approximately 3 million as stabilizing fund to take care of obligations (publications, grants, pledges, salaries etc.) in case of his death, on theory he did not wish continuance of Foundation too long after his death. This fund remains more or less intact, and Founder makes contribution of approximately operating costs each year. With great increase in number of publications and other grants, this contribution has grown to approximately 1 million per year.

Most grants, publications, contributions decided by committee action of Barrett & Brooks,(Mellon when possible) after consultation regular consultants or specially employed advisors. (including Huntington Cairns.)

Bollingen Series published by PANTHEON under contract. Editorial work done by Bollingen Foundation. Printing, binding, distribution, selling by PANTHEON under contract. Bollingen distributes many to regular list of Libraries, Colleges etc. as contributions.

9.

New York (cont.)

Andrew W. Mellon Biography Project : I have discussed this problem with
 many people over a period of years:
 Jack Barrett, Huntington Cairns, Stoddard
 Stevens, Bernard Baruch, David Finley,
 Donald Shepard, David Bruce etc. I have
 now put Jack Barrett in charge of pulling
 the project together and making definite
 recommendations regarding:

 1. Revision of Hendricks MS. if possible.
 2. Selection of new author/ researcher.
 3. Selection of and advice from best
 Publishers of this type of work.

 With Ernest Brooks, he is looking into
the legal aspects of the contract with
Hendricks. I have asked him especially to
consult with:
 Stoddard Stevens
 Bernard Baruch (who knew AWM
 well and might
 have much to add.)

 Collateral with the above project will be
the collection (mostly at Pittsburgh now)
of all A.W. Mellon's papers & letters. They
will need thorough appraisal re importance or
interest (there seems to be ~~much junk.~~ little of value?) If
anything important or interesting retrieved,
the Library of Congress has indicated a desire
to have it.

13. Jan. '57 Paul Mellon

Honorary Degrees and Other Awards

Honorary Degrees
and Other Awards

HONORARY DEGREES
Oxford University, England (Hon.) D.Litt., 1961
Carnegie Institute of Technology, Pittsburgh (Hon.) LL.D., 1967
Yale University, New Haven (Hon.) L.H.D., 1967
Cambridge University, England (Hon.) LL.D., 1983
Royal Veterinary College, University of London (Hon.) D.Vet.Med., 1991

OTHER AWARDS AND HONORARY MEMBERSHIPS
Associate Fellow, Berkeley College, Yale University, 1933
Yale Medal, 1953
Horace Marden Albright Scenic Preservation Medal, 1957
Honorary Fellow, St. John's College, Annapolis, 1959
Honorary Fellow, Clare College, Cambridge, England, 1960
Award for Distinguished Service to the Arts, National Institute of Arts
 and Letters, 1962
Benjamin Franklin Medal of the Royal Society of Arts, London, 1965
Member, American Philosophical Society, Philadelphia, 1971
Skowhegan Gertrude Vanderbilt Whitney Award, 1972
Honorary Knight Commander of the Order of the British Empire, 1974
Corresponding Member, Royal Academy, London, 1977
Honorary Member, American Institute of Architects, 1980
Knight Grand Officer of the Order of Orange-Nassau, 1982
National Medal of Arts, 1985
Thomas Jefferson Memorial Foundation Medal in Architecture, 1989
World Monuments Fund Hadrian Award, 1989
American Philosophical Society Benjamin Franklin Award, 1989

Educational and Charitable Contributions

Major Beneficiaries—Contributions by Paul Mellon and Old Dominion Foundation, 1933–1991

(Thousands Omitted)

	PAUL MELLON	OLD DOMINION FOUNDATION
	\$ (000s omitted)	

THE ARTS

AMERICAN SHAKESPEARE FESTIVAL THEATRE,
 Stratford, Connecticut
 1955–1965
 Building fund and general support

		550

AMON CARTER MUSEUM, Fort Worth
 1986–1991
 Works of art and other

	638	

BUFFALO BILL HISTORICAL CENTER,
 Cody, Wyoming
 1986
 Works of art

	1,500	

THE CARNEGIE, Pittsburgh
 1991
 General support pledged

	1,000	

FITZWILLIAM MUSEUM, Cambridge University
 1971–1991
 Works of art, general support pledged, and
 other

	3,553	

JOHN F. KENNEDY CENTER FOR THE
 PERFORMING ARTS, Washington, D.C.
 1963
 Building fund

		500

LINCOLN CENTER FOR THE PERFORMING
 ARTS, New York
 1961–1963
 Building fund

		600

NATIONAL GALLERY OF ART,
 Washington, D.C.
 1941–1991
 East Building and Operation Breakthrough
 A.W. Mellon Lectures in the Fine Arts
 Works of art and acquisition funds
 Research funds for artists' materials at Mellon
 Institute
 Patrons' Permanent Fund
 Addition to endowment fund and other

	142,741	636

NATIONAL HORSERACING MUSEUM,
 Newmarket, England
 1981–1991
 Works of art, building funds, and other

	510	

	PAUL MELLON	OLD DOMINION FOUNDATION
	$ (000s omitted)	

THE ARTS (*cont.*)

NATIONAL MUSEUM OF RACING, Saratoga | 2,277 |
1974–1991
Works of art, renovation fund, and other

THE PAUL MELLON FOUNDATION FOR | | 991 |
 BRITISH ART, London
 1964–1969
 General Support

PEABODY MUSEUM OF SALEM, Massachusetts, | 817 |
 including China Trade Museum
 1974–1988
 Works of art, building fund, and other

PHILLIPS COLLECTION, Washington, D.C. | 505 |
 1983–1991
 General support

PITTSBURGH SYMPHONY | 907 |
 1939–1964
 General support

TATE GALLERY, London | 1,028 |
 1979
 Works of art (sporting paintings)

VIRGINIA MUSEUM OF FINE ARTS | 48,116 | 977 |
 1938–1991
 North Wing and Theatre
 West Wing and curatorial endowment
 Works of art and acquisition funds
 Artmobile and other

YALE CENTER FOR BRITISH ART | 164,038 |
 1966–1991
 Construction and improvements
 Operation and program endowment
 Works of art, books, acquisition funds, general
 support, and other
 Endowment of The Paul Mellon Centre for
 Studies in British Art, London

YALE UNIVERSITY | 5,168 |
 1940–1991
 Works of art and general support for Yale
 University Art Gallery

TOTAL CONTRIBUTIONS (The Arts) | 372,798 | 4,254 |

	PAUL MELLON	OLD DOMINION FOUNDATION
	$ (000s omitted)	

EDUCATION

AMERICAN COUNCIL OF LEARNED SOCIETIES 1968 Endowment fund		500
AMERICAN PHILOSOPHICAL SOCIETY 1971–1991 Building fund, general support pledged, and other	1,392	
BODLEIAN LIBRARY, Oxford University 1960–1977 John Locke books and manuscripts	846	
BOLLINGEN FOUNDATION 1943–1965 General support (see also Princeton University)	11,060	271
CALIFORNIA INSTITUTE OF TECHNOLOGY 1964 Old Dominion Foundation Fund for the Humanities		500
CARNEGIE MELLON UNIVERSITY 1986–1991 Endowment pledge Center for the Performing Arts pledge	15,000	
CHATHAM COLLEGE, Pittsburgh, formerly Pennsylvania College for Women 1940–1982 Andrew W. Mellon Faculty-Student Center	2,354	
CHOATE ROSEMARY HALL 1933–1991 Paul Mellon Science Building Paul Mellon Arts Center Choate Rosemary Hall Science Center Addition to Andrew Mellon Library Conversion of old Paul Mellon Science Building to Humanities Center Arts Center maintenance and endowment General endowment and other	28,204	1,292
CLARE COLLEGE, Cambridge University 1952–1984 Forbes-Mellon Library Fellowships for Clare Hall Paul Mellon Fellowships endowment pledge General support and other	1,768	500

	PAUL MELLON	OLD DOMINION FOUNDATION
		$ (000s omitted)

EDUCATION (*cont.*)

COLUMBIA UNIVERSITY 899
 1952–1991
 Old Dominion Foundation Professorship in the
 Humanities
 Support for Oral History Research Office and
 other

CORNELL UNIVERSITY 600
 1964–1967
 Old Dominion Foundation Professorship in the
 Humanities
 Humanities fellowships

FOXCROFT SCHOOL 1,185
 1941–1988
 Building and endowment funds and other

HAMPTON INSTITUTE 490
 1963–1967
 Old Dominion Foundation Professorship in the
 Humanities and other

HARVARD UNIVERSITY 689 5,984
 1956–1991
 Center for Hellenic Studies and other

INSTITUTE FOR PHILOSOPHICAL RESEARCH 735
 1952–1972
 Research and publication program and other

MASSACHUSETTS INSTITUTE OF 600
 TECHNOLOGY
 1961–1967
 Old Dominion Fund for the Humanities
 Center for Advanced Visual Studies

NATIONAL SCHOLARSHIP SERVICE AND FUND 347
 FOR NEGRO STUDENTS, INC.
 1948–1966
 Various programs

PIERPONT MORGAN LIBRARY 1,561
 1954–1991
 Building fund and endowment
 Books and other

	PAUL MELLON	OLD DOMINION FOUNDATION
	\$ (000s omitted)	

EDUCATION (cont.)

PRINCETON UNIVERSITY	2,733	805
1961–1969		
Publication fund to continue Bollingen Series		
Old Dominion Foundation Senior Fellowship in the Council of the Humanities		
Building fund, Princeton University Press		
Library fund and other		
ST. JOHN'S COLLEGE	5,972	7,623
1940–1991		
Building funds		
275th Anniversary Fund for Annapolis and Santa Fe campuses		
General support, endowment, pledged support for Annapolis campus, and other		
TRINITY COLLEGE, Hartford, Connecticut		1,313
1950–1969		
Building and cataloging funds for the Watkinson Library of Reference		
VASSAR COLLEGE	594	3,004
1939–1990		
Mary Conover Mellon Fund for Advancement of Education		
Mary Conover Mellon Professorships in art and music		
Art Center addition building fund and other		
VIRGINIA FOUNDATION FOR INDEPENDENT COLLEGES		445
1957–1966		
General support		
VIRGINIA HISTORICAL SOCIETY	556	253
1957–1991		
Building fund		
Battle Abbey addition fund, publications, and other		
YALE UNIVERSITY	8,115	22,125
1933–1991		
Renovation of Connecticut Hall		
Morse and Stiles Colleges		
Support of education programs		
Yale-Clare and Paul Mellon Fellowships, including endowment pledge		
A. Whitney Griswold Memorial Fund		
William C. DeVane Professorship		
Books and manuscripts for Yale University Library		
Purchase and editorial funds to Yale University Library for the Boswell papers		
TOTAL CONTRIBUTIONS (Education)	82,029	48,286

	PAUL MELLON	OLD DOMINION FOUNDATION
	\$ (000s omitted)	

CONSERVATION AND PRESERVATION

CONSERVATION FOUNDATION
 1949–1989
General support and special projects

		1,317

NATIONAL AUDUBON SOCIETY
 1943–1968
Various programs

		490

NATIONAL PARK SERVICE
 1952–1965
Funds for acquisition of coastal areas for
 Cape Hatteras National Seashore
Surveys to identify coastal areas for
 preservation
Rehabilitation of Lafayette Park and other

		1,139

NATIONAL TRUST FOR HISTORIC
PRESERVATION IN THE UNITED STATES
 1950–1972
Endowment funds and other

		1,350

NATURE CONSERVANCY
 1952–1968
Funds for acquisition of natural areas
 and other

		842

THOMAS JEFFERSON MEMORIAL
FOUNDATION, INC.
 1991
Restoration fund for Monticello

500		

VIRGINIA, COMMONWEALTH OF
 1975
Sky Meadows State Park

1,065		

VIRGINIA OUTDOORS FOUNDATION
 1979–1991
Funds for acquisition of addition to
 Sky Meadows State Park
Aldie Mill restoration funds
Rokeby Farms open space easements and other

11,789		

WILDLIFE PRESERVES, INC.
 1955–1963
Acquisition of natural areas

		298

WORLD MONUMENTS FUND
 1991
Funds pledged for preservation in
 Great Britain

1,000		

TOTAL CONTRIBUTIONS (Conservation and
 Preservation)

14,354		5,436

	PAUL MELLON	OLD DOMINION FOUNDATION
	\$ (000s omitted)	

PSYCHIATRY AND RELIGION

	PAUL MELLON	OLD DOMINION FOUNDATION
ANNA FREUD FOUNDATION, London 1973–1983 Hampstead Child-Therapy Course and Clinic	365	290
MENNINGER FOUNDATION 1951–1991 Training programs		375
PROTESTANT EPISCOPAL THEOLOGICAL SEMINARY IN VIRGINIA 1949–1965 Building funds and endowment		405
TRINITY EPISCOPAL CHURCH, Upperville, Virginia 1941–1991 New church, parish house, rectory, and general support	4,922	
UNION THEOLOGICAL SEMINARY 1955–1967 Psychiatry and Religion program		609
WASHINGTON NATIONAL CATHEDRAL 1947–1991 Building fund and other	419	
YALE UNIVERSITY 1949–1957 Support for Division of Psychiatry and Mental Hygiene		2,086
TOTAL CONTRIBUTIONS (Psychiatry and Religion)	5,706	3,765

SCIENCE

	PAUL MELLON	OLD DOMINION FOUNDATION
GRAYSON–JOCKEY CLUB RESEARCH FOUNDATION 1956–1988 Equine research	695	
MELLON INSTITUTE,* Pittsburgh 1936–1961 Building fund, general endowment, and other	3,235	

*Mellon Institute merged with Carnegie Institute of Technology to form Carnegie Mellon University in 1967

	PAUL MELLON	OLD DOMINION FOUNDATION
		$ (000s omitted)

SCIENCE (*cont.*)

NATIONAL ACADEMY OF SCIENCES 1960–1978 Einstein Memorial Building fund and other	100	504
ROYAL VETERINARY COLLEGE, University of London 1984–1991 Works of art, research funds, building pledge, and other	5,433	
VIRGINIA POLYTECHNIC INSTITUTE AND STATE UNIVERSITY 1947–1991 Carol M. Newman Library and Brown Continuing Education Center Land, buildings, professorship in horse nutrition, research funds, and general support for Middleburg Forage Research Station Equipment and research funds for Marion duPont Scott Equine Medical Center Agricultural research and other	3,476	1,737
TOTAL CONTRIBUTIONS (Science)	12,939	2,241

GENERAL CHARITIES

AMERICAN FRIENDS SERVICE COMMITTEE 1936–1962 War relief funds and general support		989
AMERICAN NATIONAL RED CROSS 1939–1989 War relief funds and general support	165	874
WINCHESTER MEDICAL CENTER, Virginia, formerly Winchester Memorial Hospital 1948–1986 Building funds	503	154
TOTAL CONTRIBUTIONS (General Charities)	668	2,017

	PAUL MELLON	OLD DOMINION FOUNDATION
	\$ (000s omitted)	
OTHER BENEFICIARIES 1933–1991	35,978	20,995
TOTAL CONTRIBUTIONS	\$ 524,472	\$ 86,994
COMBINED CONTRIBUTIONS	\$ 611,466	

GENERAL NOTES

Paul Mellon's contributions (1941–1964) to the Old Dominion Foundation were \$ 90,211,000.

The value of Old Dominion Foundation assets, when it was merged with the Avalon Foundation on June 30, 1969, to form The Andrew W. Mellon Foundation, was \$ 97,743,000.

This appendix does not reflect grants by The Andrew W. Mellon Foundation.

APPENDIX F

Select Bibliography

————◆————

Select Bibliography

———

Avalon Foundation, *Report of Avalon Foundation, 1940–1950*. New York, c. 1951.

The A. W. Mellon Educational and Charitable Trust. *A Report on Its Work for the Fifty Years, 1930–1980*. Pittsburgh, c. 1981.

Bollingen Foundation Report, 1945 through 1965. New York: Bollingen Foundation, 1967.

Brady, James C., Jr. Unpublished notes on trip to England and Ireland, 1936.

Burnham, David. "The Abuse of Power: Misuse of the I.R.S." *The New York Times Magazine*, September 3, 1989.

———. *A Law unto Itself: The IRS and the Abuse of Power*. New York: Random House, Inc. 1989.

Egerton, Judy, Dudley Snelgrove, and John B. Podeschi. *Sport in Art and Books: The Paul Mellon Collection*, 4 vols. London: The Tate Gallery for the Yale Center for British Art, 1978–1981. (Catalog of the Mellon collection of British sporting and animal paintings, drawings, prints, and books on the horse and horsemanship.)

Hersh, Burton. *The Mellon Family: A Fortune in History*. New York: William Morrow & Co., 1978.

Holbrook, Stewart H. *The Age of the Moguls*. Garden City, N.Y.: Doubleday & Co., Inc., 1953.

Horn, Huston. "A Rampart of Pedigree." *Sports Illustrated*, February 11, 1963.

In Praise of Paul Mellon. 1987. (Sixteen essays privately printed and presented to Mr. Mellon on his eightieth birthday.)

Koskoff, David E. *The Mellons: The Chronicle of America's Richest Family*. New York: Thomas Y. Crowell Co., 1978.

Lindquist, Eric N. *The Origins of the Center for Hellenic Studies*. Princeton: Princeton University Press, 1990.

Lorant, Stefan. *Pittsburgh: The Story of an American City*. Garden City, N.Y.: Doubleday & Co., 1964.

McGuire, William. *Bollingen: An Adventure in Collecting the Past*. Princeton: Princeton University Press, 1982.

Mellon, Paul. *Address by Paul Mellon on Receiving the Annual Award of The Thoroughbred Club of America, Keeneland, November 9, 1975*. Privately printed, 1975.

―――. *A Collector Recollects: Remarks by Paul Mellon at the Opening of the Exhibition, Painting in England, 1700–1850*. Richmond: Virginia Museum of Fine Arts, 1963.

―――. *An Address by Paul Mellon at the Two Hundredth Annual Dinner of the York Gimcrack Club*. Privately printed, 1970.

Mellon, Thomas. *Thomas Mellon and His Times*. Privately printed, 1885.

Mellon, William Larimer, and Boyden Sparkes. *Judge Mellon's Sons*. Privately printed, 1948.

Murphy, Charles. "The Mellons of Pittsburgh," *Fortune Magazine*, 1967.

National Gallery of Art. *A Twenty-Five Year Report*. Washington, D.C.: National Gallery of Art, 1966.

Oaksey, John. *The Story of Mill Reef*. London: Michael Joseph, 1974.

Old Dominion Foundation. *Report, 1941–1966*. New York, c. 1967.

Rewald, John. *French Paintings from the Collections of Mr. and Mrs. Paul Mellon and Mrs. Mellon Bruce*, Washington, D.C.: National Gallery of Art, 1966. (Exhibition catalog.)

Ryan, Pat. "A Man of Arts and Letters." *Sports Illustrated*, March 16, 1970.

Skeaping, John. *Drawn from Life: An Autobiography*. London: William Collins Sons & Co., Ltd., 1977.

Taylor, Basil. *Painting in England, 1700–1850: Collection of Mr. & Mrs. Paul Mellon*. Richmond: Virginia Museum of Fine Arts, 1963. (Exhibition catalog.)

―――. *Sport and the Horse*. Richmond: Virginia Museum of Fine Arts, 1960. (Exhibition catalog.)

Tompkins, Calvin. "Profiles for the Nation." *The New Yorker*, September 3, 1990.

Walker, John. *Self-Portrait with Donors: Confessions of an Art Collector*. Boston: Little, Brown and Company with the Atlantic Monthly Press, 1974.

Wilmerding, John, ed. *In Honor of Paul Mellon, Collector and Benefactor*. Washington, D.C.: National Gallery of Art, 1986. (Twenty-seven articles published as a *festschrift*.)

Index

437

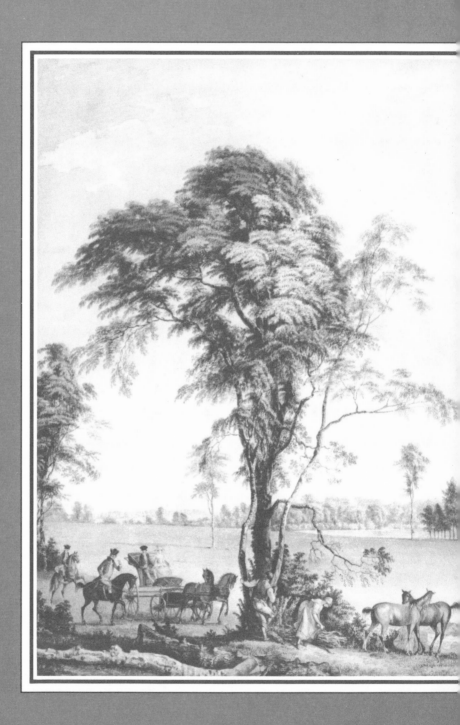